Overlay

Also by the author

The Graphic Work of Philip Evergood

Pop Art

Surrealists on Art

Dadas on Art

Tony Smith

Changing: Essays in Art Criticism

Six Years: The Dematerialization of the Art Object

From the Center: Feminist Essays on Women's Art

Eva Hesse

Ad Reinhardt

Get the Message? A Decade of Art for Social Change

A Different War: Vietnam in Art

Mixed Blessings: New Art in a Multicultural America

Fiction

I See/You Mean

Cracking (with Charles Simonds)

Risky Business (with Jerry Kearns)

OVERLAY

Contemporary Art and the Art of Prehistory

by Lucy R. Lippard

Pantheon Books 🏛 *New York*

All rights reserved under International and Pan-American Copyright Conventions. Published in the
United States by Pantheon Books, a division of Random House, Inc., New York, and simultaneously
in Canada by Random House of Canada Limited, Toronto.

Small portions of this book have appeared in articles written over the last decade, primarily the
following: "Quite Contrary: Body, Nature and Ritual in Women's Art" (*Chrysalis*, no. 2, 1977); "Body,
House, City, Civilization, Journey" (*Dwellings*, Institute of Contemporary Art, University of
Pennsylvania, Philadelphia, 1978); "Complexes: Architectural Sculpture in Nature" (*Art in America*,
Jan.–Feb. 1979); "Back Again," (*West of West: Ancient Monuments in Ireland*, travelling exhibition,
England, 1979–80); "Gardens: Some Metaphors for a Public Art" (*Art In America*, Oct. 1981);
"Breaking Circles: The Politics of Prehistory" (in Robert Hobbs, ed., *Robert Smithson: Sculpture*,
Cornell University Press, Ithaca, 1981).

Library of Congress Cataloging in Publication Data
Lippard, Lucy R.
Overlay: contemporary art and the art of prehistory.
Bibliography: p. 253
Includes index.
1. Art, Modern—20th century—Themes, motives.
2. Conceptual art—Themes, motives. 3. Performance
art—Themes, motives. 4. Art, Prehistoric—Themes,
motives. 5. Art, Prehistoric—Influence. 6. Symbolism
in art. I. Title.
N7428.L56 1983 700′.9′04 82-22331
ISBN 0-394-51812-8
ISBN 0-394-71145-9 (pbk.)

Typographic design by Sara Eisenman

Manufactured in the United States of America

9 8 7 6

For more information on Nancy Holt's *Sun Tunnels* (cover), see pp. 106 and 107.

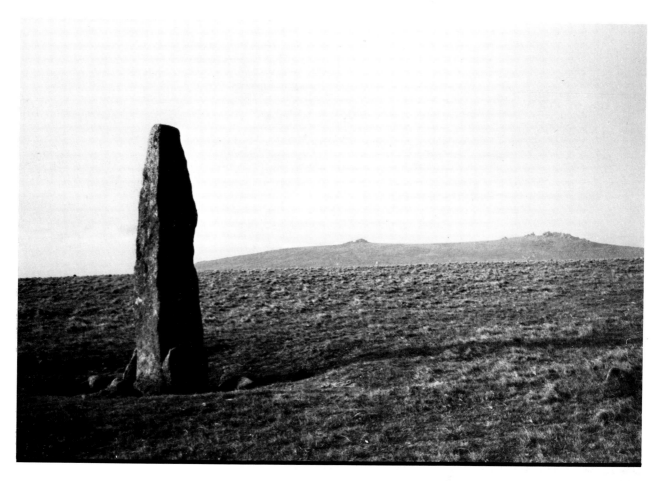

This book is dedicated to my
"family" at Ashwell Farm in
South Devon—to Janet and Robert
and Richard Boyce, to Rex and
Peter Kneebone, Genny Clark,
and not least to the memory of
Gnasher—the black and white sheep
dog who shared all my adventures;
to my son Ethan Ryman, whose
time at Ashwell produced growth
and change, and to Charles Simonds,
who has contributed much to
my understanding of the ties
between art and myth. Finally
to Ashwell Farm itself, and
the land surrounding it, where
I walked daily—the real ground
on which this book is built.

Contents

List of Illustrations

Color Plates

Introduction

Stones

Feminism and Prehistory

The Forms of Time: Earth and Sky, Words and Numbers

Time and Again: Maps and Places and Journeys

Ritual

Homes and Graves and Gardens

Acknowledgments

The following people have been supportive and informative: Richard Demarco, Peter and Cathy Kiddle, Cesar Paternosto, Anna Sofaer, Michelle Stuart, Mary Beth Edelson, Susan Hiller, and many more of the artists included in the book. I especially want to thank my editor, Nan Graham, for patience and persistence; Sue Heinemann for a more-than-copy-editing job; Sara Eisenman for her design, and calm in the face of extra pictures; Agnes Zellin and Jerry Kearns for photography; and Lanie Lee, who shared all the traumas of research and checking.

Overlay

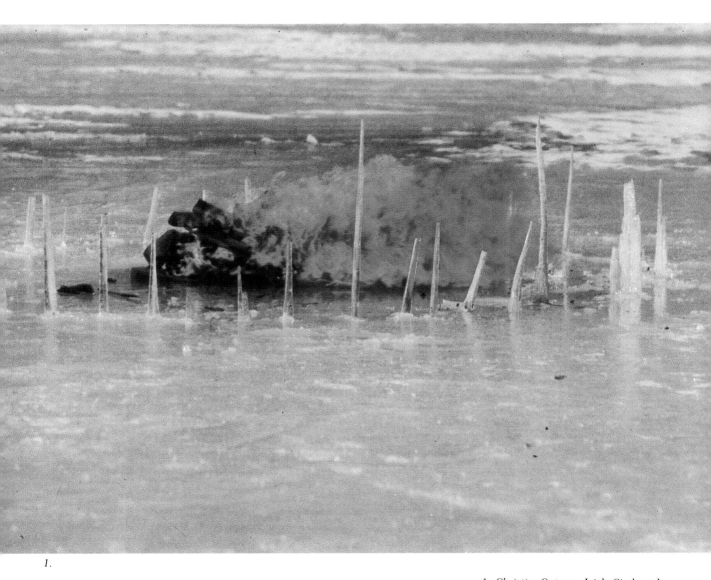

1.

1. *Christine Oatman*. Icicle Circle and
Fire. *1973. Lake Tahoe, California. A
Callanish-like ring of ice needles on a
frozen lake was ritually returned to the
elements when the central flames melted
it. Evoking a combination of stasis and
change that constitutes nature (and
circles), it might be an illustration of
Heraclitus' concept: "Fire lives the
death of air, and air lives the death of
fire; water lives the death of earth;
earth that of water." (Photo: Iris Laudig.)*

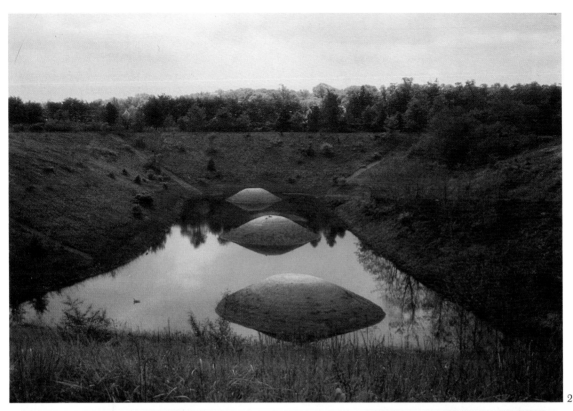

2.

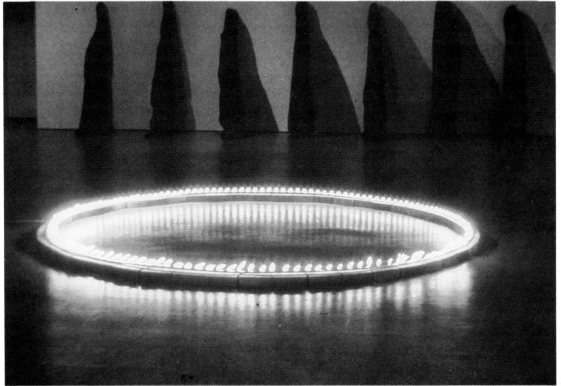

3.

2. *Judy Varga. Geometry of Echoes Converge. In recharge basin, Old Westbury, New York. 1980. Gravel, medium-grain sand, fine sand. c. 38′ diameter, 12′ high. Size and shape of the work varies according to the weather. The artist writes: "The mounds, in their apparent orbit on a vertical/horizontal axis, are intimately bound with the generating forces of nature. They are the loci around which the elements dance, spin, link and scatter. The water and the winds are at once form and content, the container and the contained. The nexus which binds the three mounds with the water exists at the equator of each mound — the edge of reflection, of echo." The echoes are also from and into the past, where such mounds may have been used for similar worship of natural forces. (Photo: Judy Varga.)*

3. *Mary Beth Edelson. Fire Ring. 1977. From "Your 2000 Years Are Up!" Woman's Building, Los Angeles. Copper tubing, propane gas and fire on bricks. Background: Mourning Coats. (Photo: Mary Beth Edelson.)*

4. *Charles Simonds. Dwelling. 1973. East Houston Street, New York City. Clay bricks ½″ long. (Photo: Charles Simonds.)*

4.

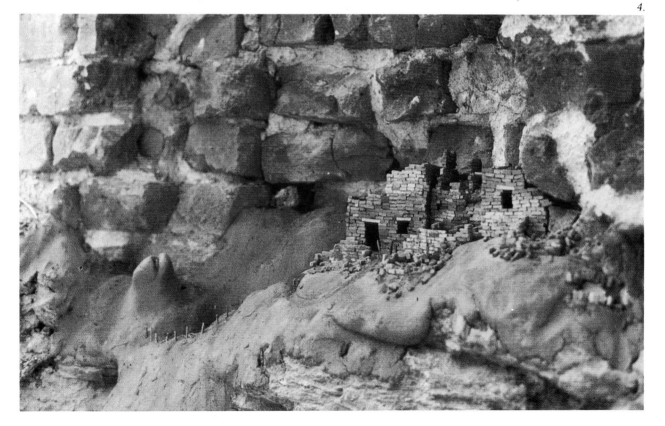

5. *Dennis Oppenheim.* Whirlpool: Eye of the Storm. *August 1973. El Mirage Dry Lake, California. From 16 mm film of ¾-mile × 4-mile configuration traced in sky using standard white smoke discharged from airplane. (Photo: Dennis Oppenheim.)*

6. *Michelle Stuart.* Stone Alignments/ Solstice Cairns. *1979. Columbia Gorge, Oregon. c. 1000' × 800'; inner circle, 100' diameter. (Photo: Michelle Stuart.)*

7. *Peter Kiddle, et al.* RainDough. *1978. Harbertonford, South Devon, England. Detail of communal procession and performance commissioned for the May Fair celebrations. Devised by art and theatre students from Dartington College of Arts, from a scenario by Peter Kiddle; designed by Karen Larsen Watts; choreographed by Nancy Udow; directed by Peter Kiddle. (Photo: Lucy R. Lippard.)*

8. *Ana Mendieta.* Silueta de cohetes. *1976. Mexico. Fireworks. Life-size. (Photo: Ana Mendieta.)*

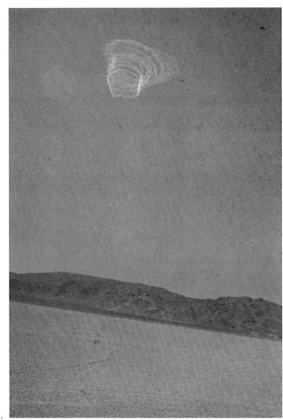

5.

6.

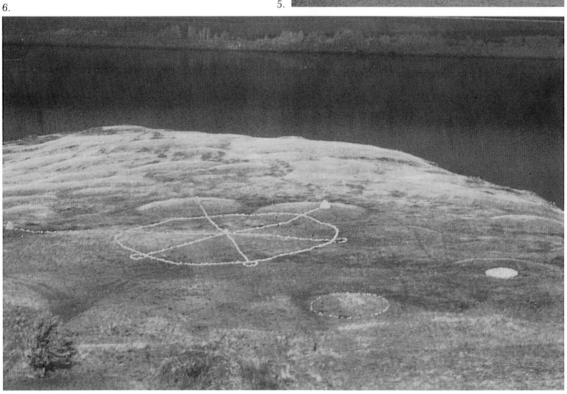

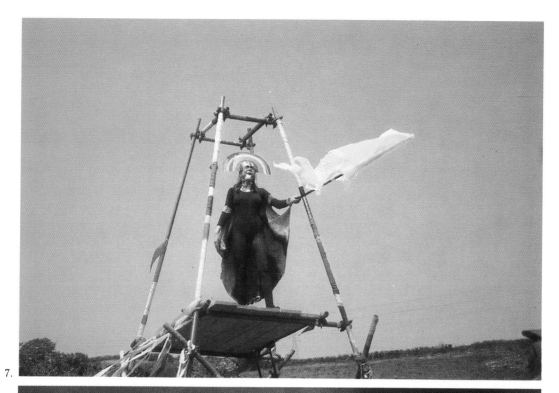

7.

8.

9. *"The Sanctuary," Drizzlecombe, Dartmoor, near the source of the river Plym. Bronze Age. The Drizzlecombe complex includes two large cairns, four smaller barrows (two within stone circles), three stone rows (with terminal stones as tall as 14'), as well as a* kistvaen *grave, hut circles and pounds, all inter-related. The ceremonial area may have originally stood in a clearing near cultivated fields, and unfinished projects indicate it was used over a period of time, perhaps by different peoples. (Photo: Lucy R. Lippard.)*

10. *Remains of a circle, Standing Stones of Stenness, Orkney, Scotland. c. 2700* B.C. *The diameter was 100'; the stones are the tallest in any known circle. Stenness, the Ring of Brodgar, and the corbel-chambered mound of Maeshowe (2800* B.C.*) formed the extra-ordinary ritual center of the Orkney mainland. (Photo: Lucy R. Lippard.)*

11. *The Ring of Brodgar, Orkney, Scotland. c. 2100* B.C. *(also dated 1560* B.C.*). 340' diameter. (Photo: Lucy R. Lippard.)*

12. *Stone rows at Kerzehro, near Carnac, Brittany, c. 2500–2000* B.C. *(Photo: Lucy R. Lippard.)*

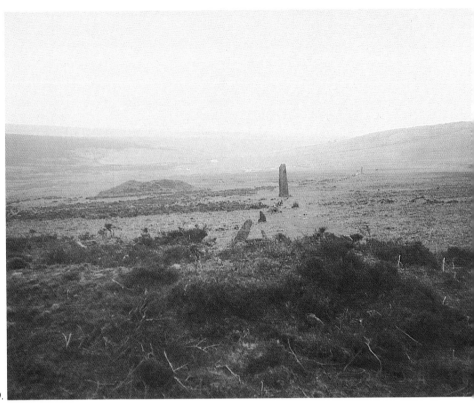

9.

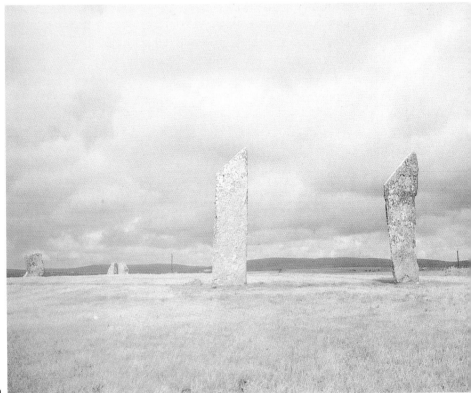

10.

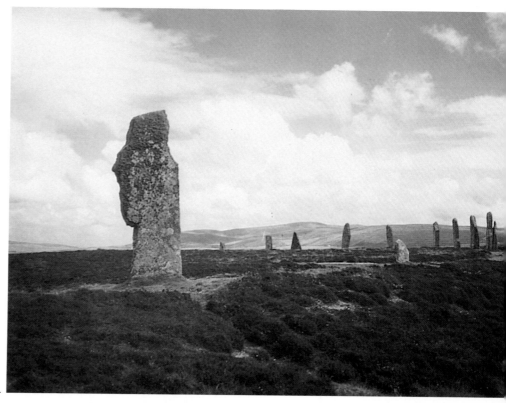

11.

12.

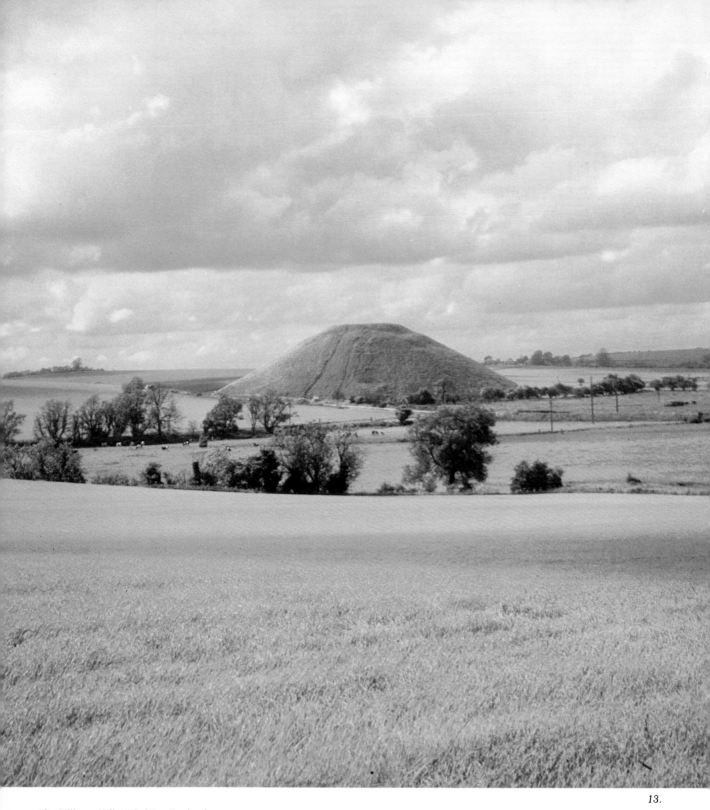

13. *Silbury Hill, Wiltshire, England.*
2660 B.C. 130' high. (Photo: Lucy
R. Lippard.)

Introduction

1.

In 1977 I went to live for a year on an isolated farm in southern England. I thought I was escaping from art—from a complicated urban life of criticism, organizing, and activism. I wanted to walk, to read, and to write a novel. Nothing else. The reading and writing went as planned, but the walking led straight back to art. Hiking on Dartmoor, with nothing further from my mind than modern sculpture, I tripped over a small upright stone. When I looked back over my shoulder, I realized it was one in a long row of such stones. They disappeared in a curve over the crest of the hill. It took me a moment to understand that these stones had been placed there almost 4,000 years ago, and another moment to recognize their ties to much contemporary art. I looked around that vast open space; the dog waited expectantly; I leaned down and touched the stone. Some connection was made that I still don't fully understand, and that led to this book—an overlay of my concern with new art on my fascination with these very ancient sites. Later, a second level of that overlay emerged: the sensuous dialectic between nature and culture that is important to me as a socialist/cultural feminist, and the social messages from past to present about the meaning and function of art, exposed by the tensions between two such distant and disparate times.

This book, then, is an exercise in breaking away from conventional ways of looking at the visual arts. My subject is not prehistoric images *in* contemporary art, but prehistoric images *and* contemporary art. What I've learned from mythology, archeology, and other disciplines is the overlay's invisible bottom layer. My internal method is that of collage—the juxtaposition of two unlike realities combined to form an unexpected new reality. I have tried to weave together the ideas and images of very different cultures by making one a metaphor for the other, and vice versa. Primal peoples made sense of the universe through visual metaphors that linked their experiences: The snake was associated with water in part because its movements reproduced the form of a stream and its coils that of a spiral spring; the discovery of whirlpools deep in the sea and nebulae turning in the heavens offered the synthesizing symbol of a cosmic mill.

Creating a new culture is not just a matter of individuals making "original" discoveries but also, and above all, of disseminating already discovered truths—of socializing them so to speak, and making them the basis of vital action and an element of coordination and intellectual and moral effort.

—Antonio Gramsci

1. *Stone Row, Trowlesworthy, Dartmoor, South Devon, England. Bronze Age. Stones under 1' to almost 3' high. The Trowlesworthy Group consists of a retaining circle, a double row, a single row, and a small menhir. (Photo: Lucy R. Lippard.)*

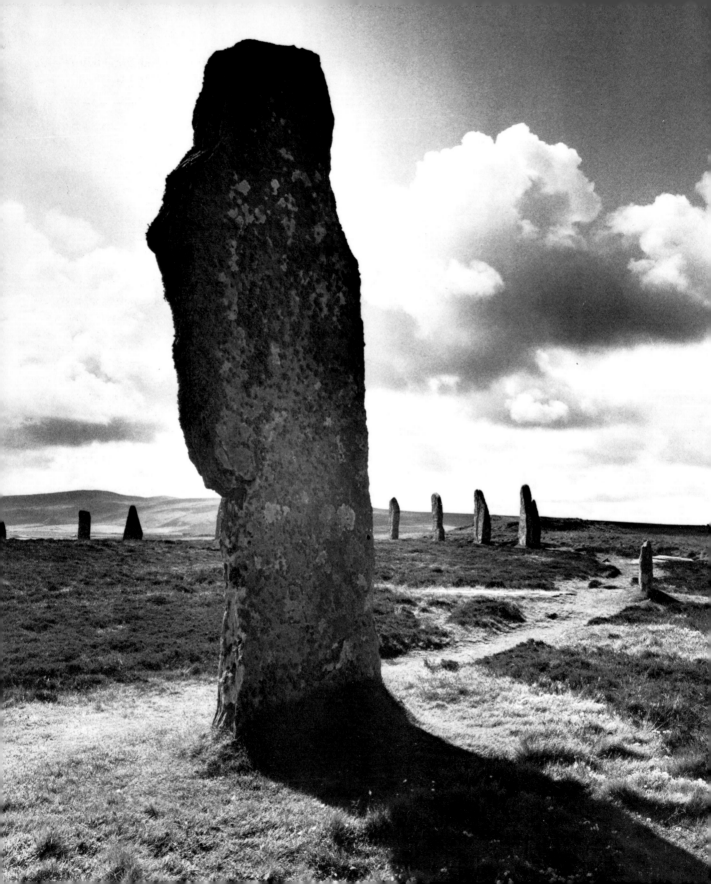

The external structure of the book is also borrowed from nature—its physical layers, its generative function and spiraling returns.

As a contemporary art critic, speculation is my element. I am a surrogate for the audience, a receptacle for all the collective speculations deriving from diverse backgrounds, associations, and psychologies. Like everybody else when confronted with an unfamiliar experience, I ask myself, "What do you suppose it means?" Such ruminations, combined with the few available facts, are the only source of "accuracy" in a shifting field. There is no such thing as "objective" art criticism, only degrees of longing for objectivity. I suspect the same applies at times to archeology.

What interests me most about prehistory is precisely what cannot be known about it. The new "speculative history" of the megalithic cultures offers a way back into the labyrinth partially closed off by traditional archeology and its fear of the unproven. In this field the gap between specialists and nonspecialists is narrower than in most, since it is unlikely that many hard facts about the socioreligious life of prehistory will ever surface from their burial places. Some speculation is necessary at every juncture. I have learned from visionary "amateurs" as well as from "professionals." This book is a compilation of ideas intended to spark one another, to form channels of thought which may then dissolve into others, which in turn may illuminate our own culture. The often conflicting ideas surrounding the megalithic cultures keep both them and us alive. As well as understanding the various fictions that pass for history, we have to be able to imagine a past and a future different from those to which conventions accustom us.

The evolution of this book is all too compatible with its prime image of radiating growth. Early on, I found it impossible to limit myself to the British Isles in the Stone, Bronze, and Iron Ages. I realized the impossibility of omitting references to the Celts, to ancient Egypt, Crete, and Greece and their relationships to even later cultures. Marija Gimbutas' fascinating research into Old Europe, between the seventh and fifth millennia B.C., Alexander Marshack's theories about scientific knowledge in Paleolithic cultures sent me still further back into the past and were crucial to understanding the origins of the megalithic monuments.

The field expanded geographically as quickly as it exploded in time. There are stone circles, rows, and mounds on every continent and on innumerable islands in between. Proposals that North America might have been settled by megalithic peoples, long before Columbus, raised still more unanswered questions and demanded some familiarity with Native American and other pre-Columbian cultures. Everything seemed to be connected to everything else. Every idea led to two more. Nothing was irrelevant. I was clearly in the clutches of the Spider Woman.

The *Overlay* of the title, then, can be understood in several ways. It is temporal—human time on geological time; contemporary notions of novelty and obsolescence on prehistoric notions of natural growth and cycles. The imposition of human habitation on the landscape is an overlay; fertility—"covering" in animal husbandry terms—is an overlay; so are the rhythms of the body transferred to the earth, those of the sky to

2. *The Ring of Brodgar, Orkney, Scotland. c. 2100 B.C. (also dated 1560 B.C.). 340' diameter, average stone just under 10', surrounding ditched henge cut 10' into rock. A perfect circle laid out on a megalithic yard unit, it originally had 60 stones placed 6 degrees apart, and was probably part of a lunar observatory complex with the nearby Stones of Stenness and related outliers. (Photo: Chris Jennings.)*

2.

the land or water. Christianity is overlaid on "paganism," urban on rural, stasis on motion. Artists working today from models of the distant past are consciously or unconsciously overlaying their knowledge of modern science and history on primal forms that remain mysterious to us despite this knowledge. The enigma of Stonehenge, for instance, simply increases with the burgeoning information about its use as an astronomical observatory, since that in turn suggests the possibility of other uses and meanings.

Trekking across the vast, undulating, deceptively featureless landscape of the English moors—depending as much on intuition as on map and compass—sighting a distant silhouette against the sky (sheep? the promised stone circle?), or coming suddenly upon a single standing stone, I was glad there were no markers, no car parks, no brochures, glad to maintain a sense of discovery. The unpeopled megalithic sites and earth monuments, like more recently abandoned ruins, bring us back to art in an unselfconscious context. Freedom from my own daily space opened up new views of history. I began to perceive places as spatial metaphors for temporal distance. Such a dialectic is a major part of the Stones' attraction. They offer a framework within which to explore the crucial connections between individual desires (to make something, to hold something) and the social values that determine what we make and why.

The simplest explanation for contemporary artists' current attraction to ancient images, artifacts, and sites is nostalgia—not only for those periods we now imagine offered a social life simpler and more meaningful than our own, but also for any time when what people made (art) had a secure place in their daily lives. When I cross a moor on which no tree, habitation, or person is visible, and come upon a ring of ragged stones, a single rough-hewn pillar, a line curving away over a hill, a gently rounded mound or cairn of stones, I know this is human-made. I think neither of a boundless nature nor of gods or goddesses, but of the *people* who made these places. Art itself might be partially defined as an expression of that moment of tension when human intervention in, or collaboration with, nature is recognized. It is sufficiently compelling not to be passed by as part of "amorphous nature." One stops and asks oneself: Who made this? When? Why? What does it have to do with me? One of art's functions is to recall that which is absent—whether it is history, or the unconscious, or form, or social justice.

As Anton Ehrenzweig has pointed out, these absences have obsessed modern artists:

It is perhaps due to the fact that our own modern art is often content to work from low irrational levels of the mind alone, that our civilization has become so receptive to the art of other civilizations, prehistoric, historic, primitive and exotic. What alone seems to matter to us is the complex diffuse substructure of all art. It had its source in the unconscious and our own unconscious still reacts readily to it, preparing the way for ever new reinterpretations.[1]

Overlay is about what we have forgotten about art. It is an attempt to recall the function of art by looking back to times and places where art was inseparable from life. In very different ways and with diverse results,

this has been a major impetus in American art since the 1940s, when the Abstract Expressionists sought some sort of subject matter other than that which was around them.[2] Ironically, they were rebelling against social and regional realism, while today many artists using the same mythological sources are doing so to rediscover social roots and communal meaning for their art. As Otto Rank said prophetically 50 years ago, "the modern artist is seeking collective forms to justify and liberate himself."[3]

While American artists in the '40s and '50s arrived at mythological themes primarily via classical sources, today's vanguard tends to be less interested in classical periods and has been primarily attracted by the archaic and prehistoric. These artists are rebelling against reductive purism and an art-for-art's-sake emphasis on form or image alone with a gradual upsurge of mythical and ritual content related to nature and to the origins of social life. Paralleled by a fascination with the subtly simple forms of pre-classical architecture and by the development of the "fetishistic object" (with connections to primitive art via Surrealism and Dada), this tendency has been interpreted by some as formally and politically retrograde, anti-progress as well as anti-progressive. In fact, however, it is made up of a complex combination of reactionary and progressive elements. Tracking them down and understanding them is one of the goals of this book. By bringing together the deeply moving vestiges of a past so distant it is virtually unknowable and images made by artists today which are culturally familiar and yet lacking some necessary depth in history, I hoped to understand better the original connections between art, religion, and politics, the ways in which culture contributes to and functions in social life. Conflicts between nature and culture, between historical awareness and the supposed universality of art, clearly did not exist in prehistory. But they do now. Many artists today are trying to overcome such false dichotomies by resurrecting lost connections within a contemporary framework. I, in turn, hope to use their discoveries to suggest some new models for the communicative function of art.

This book is written on the premise that art has social significance and a social function, which might be defined as the transformation of desire into reality, reality into dreams and change, and back again. I see effective art as that which offers a vehicle for perceiving and understanding any aspect of life, from direct social change, to metaphors for emotion and interaction, to the most abstract conceptions in visual form. Such art is not, however, effective simply by being created, but by being created and communicated within carefully considered contexts. The social element of response, of exchange, is crucial even to the most formalized objects or performances. Without it, culture remains simply one more manipulable commodity in a market society where even ideas and the deepest expressions of human emotion are absorbed and controlled. I resist the notion that in modern times the task of image and symbol making should be relegated to one more frill on the "quality of life."

Despite the fact that many of the "movements" of modern art have been devoted to blurring the boundaries built up over the millennia to separate art from life, art is still overdefined in Western society, to the

point where its function is limited to decoration or status symbol. The contemporary works I will discuss here *are* "Art," whether I like it or not. They are made by "Artists," most of whom have studied in art schools and aspired to the limited fame and fortune available to artists in a society that pays a lot of lip service to "creativity" but has little actual respect for art as an integral social function, as a "profession" or work, much less a necessity. The reintegration of art into social life means risking "exposure" and denial of the treasured myth of embattled individualism, of the artist as alienated hero. Artists are isolated in our society, and for some, the "genius" notion may be psychologically necessary to survival or to self-esteem—justifying an apparently inescapable situation.

While some artists have never questioned the current marginal and passive status of art and are content to work within the reservation called the "art world," others have made conscious attempts over the last decade to combat the relentless commodification of their products and to reenter the "outside world." In the late '60s, after a period in which most avant-garde art was drastically divorced from social subjects or effects, many artists became disgusted with the star system and the narrowness of formal "movements." They began to ask themselves larger questions. When they looked up from their canvas and steel, they saw politics, nature, history, and myth out there.

Immateriality and impermanence were the two prime esthetic strategies designed to combat overemphasis on "precious objects" and to open up new audiences for experimental art. Although they produced some provocative innovations, they succeeded in expanding art's meaning in daily life only rarely, when content was revolutionized along with form, when individual esthetic achievement was balanced and affected by communal response. Feminism and the civil rights and gay rights movements encouraged autobiographical and psychological exploration, which in turn led during the next decade to deeper roots—less personalized, more collective—with individual memories growing dimmer as a sense of common history invaded the psyche.

It is ironic that the most recent archeological impulse in avant-garde art in America arose in the late 1960s, just at the time of the greatest recent rebellion against political, institutional, and esthetic tradition. Yet it is also appropriate. Many of these artists turned to prehistory for inspiration and encouragement because of a fundamental dissatisfaction with American society; many felt disenfranchised in an affluent nation that supports its arts so poorly and peripherally. For some, "primitivizing art" was an escape; for others, it was a way of sharing their individual psychic experiences with their audiences by using the common language of the collective unconscious or politicized consciousness.

The real challenge to a socially aware artist working in this mode is to make the resurrected forms meaningful *now*, not in terms of nostalgia, but in terms of present struggles and dreams and hopes and fears. The German curator Herbert Molderings has observed that during periods of deep crisis such as our own times, "moments of the past may gain a new and extraordinary significance. . . . Many of the historical experiences, which seemed to be of no more value for life and therefore had fallen into oblivion for . . . years, suddenly come back to the surface."[4]

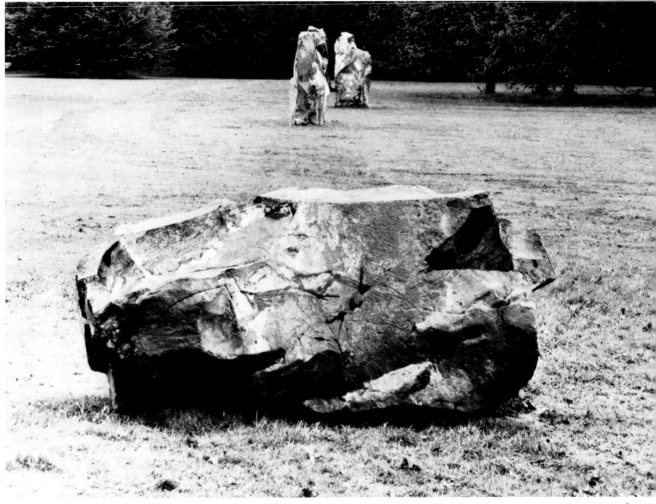

3.

3. *Robert Morris. Detail of* Untitled.
1977. Documenta, Kassel, Germany.
Basalt granite, five stone components.
(Photo: courtesy of Leo Castelli Gallery.)

I am attracted to the prehistoric sites and artifacts because I imagine they were not separated from their social contexts. As I wrote this book, I found that the bits and pieces of individual and communal beliefs I was weaving together applied unexpectedly often to my own life and work. Like the artists and perhaps like the ancient peoples I was writing about, I found the cumulative powers of myth entered my daily round and became tools for analysis as well as randomly pleasurable sparks off the rocks of ages. They offered ways of translating ideas into images and images into ideas that illuminated my dogged attempts to integrate criticism and fiction, art and activism, different groups of friends, loves, hates, and needs. I realized at some point in the process that I was exploring the collective components of the origins of art—which lay, of course, in religion. As an atheist, I was somewhat appalled to find myself studying religion. Yet the more I did so, the more I understood that if art is for some people a substitute for religion, it is a pathetically inadequate one because of its rupture from social life and from the heterogeneous value systems that exist below the surface of a homogenized dominant culture.

Art and politics and religion share the capacity to move people, through emotion and to action. They do so, of course, in different ways, reinforcing each other on different levels of experience. When Émile Durkheim stated almost 70 years ago that "the idea of society is the soul of religion,"[5] that only the intensity of collective life can awaken individuals to new achievements, fertilize them with dialogue and the urge to communicate, he might have been talking about the necessity to integrate art and social life that obsesses me and many of the artists working with primal images today. Durkheim's view of society itself as "a creative power" is one which visual artists have been denied in the modernist period. Those working with themes of regeneration and dissemination, as well as those working with overtly political issues, share a need to see art become *useful* again, beginning with a recognition of the insights it can provide into life and nature—their human significance in an age of dehumanized technology.

There is a mysterious, romantic element to wondering about the past, however critically one goes about it. The ancient sites and images are talismans, aids to memory, outlets for the imagination that can't be regulated, owned, or manipulated like so much contemporary art because so little is or ever will be known about them. Unlike a towering skyscraper, a towering standing stone in the landscape seems not so much to dominate its surroundings as to coexist sensuously with them. It confirms the human need to touch, to hold and to make, in relationship to natural forces and phenomena. Even if we as individuals are cut off from any communal belief system or any collective work system, something seems to flow back to us through these places—which we see perhaps as symbols of lost symbols, apprehended but not specifically comprehended in our own socioreligious context.

I'd like this book to suggest the restoration of symbolic possibility in contemporary art. Artists may be aware of this subterranean layer, but the art public (as opposed to the lay public) has been conditioned to ignore it by the dominant art-for-art's-sake ethos. Symbols are syntheses of changing multiple realities—higher forms than the simple commodity because they are both the vehicles of several levels of reality and of several levels of communal need. Perhaps what the prehistoric stone monuments still communicate is simply people's need to communicate and the need for a symbolic intermediary that has always allowed the desires of makers and receivers to merge or intersect.

Much has been said in the last 20 years about art replacing religion as a way of extending or communicating the meaning of life in these pragmatic, aspiritual times. Critic Jack Burnham has suggested that "as mythic structures deteriorate, the archetypes vanish and it is the trials and psychodramas of the individual that provide us with our sense of direction."[6] Yet at the same time, artists of all kinds might be seen as the keepers of human racial memory—natural archeologists. Dennis Oppenheim, whom Burnham has used as a model of "the artist as shaman," said in 1977, "Now that we're armed with all these intellectual weapons, can't we go back into something more challenging in its range of reality? What art needs now is to bespeak its origins."[7]

While there is definitely a burgeoning belief in believing among artists, few are willing to introduce specific beliefs into their art, and still fewer have realized the potential for the broad collective fusion of belief and its physical products, which is in fact an important aspect of ancient art as we envision it. It is common to find ancient or foreign or "primitive" cultures plundered for their mysterious (or, at worst, merely picturesque) qualities. Contemporary artists borrow images from the past so as to say things impossible to express in a modernist visual language. Sometimes an artist with an eye on the bandwagon and the market will borrow the form but drain the content from his or her source in a mood of scholarly tourism—handouts on the Golden Boughery. Some artists fortify their forms or emotional instincts with anthropological information, or superficially graft such information onto currently fashionable styles. Others work from inside, arriving at primal images from their own needs, overlaying personal on historical and perhaps even biological memory. Among these artists are many feminists, trying to overcome the imposed polarization between "the personal and the political," nature and culture.

Why do modern artists—highly sophisticated and relatively able to understand the high tech of their own age—build immense cairns and walls over which the sun will rise on the summer solstice, or perform their own versions of ancient rituals in ghetto streets? On the negative side, it might be said that by doing this, they simply reinforce the marginality of contemporary art, that they both condescend to their modern audiences and trivialize their archaic sources. Such a judgment is too harsh, though it exposes the contradictions with which such artists are working. There is still the possibility that when art is accessible—not necessarily to huge numbers, but to a cross-cultural, cross-class audience—some viewers will be so directly touched by the experience that they will be led to make esthetic, personal, or political statements of their own.

Crucial to an analysis of the overlay that is my subject is an understanding of the way artists are educated today. "Primitivization" is one way of rebelling against the false dichotomy taught in art schools: You can't make art if you want to be involved in the world and you can't be involved in the world if you want to make art. Take your choice. This attitude also incorporates the insidious notion of the artist as political innocent whose domain is mystery, not reality, and who is thus equated with the "childlike," "primitive" innocent in a kind of extended racism. Applied to "archeological art," such separatism recalls sinister precedents in the Blood and Soil programs of the Nazis, who also glorified nature and the distant past, using them as reactionary propaganda to send people back to their proper places, their proper classes, their proper gender roles. After all we have learned from Marxism about the necessity to "demystify" social structures and ensure their accessibility to all classes, a wholesale "remythologization" would be a terrible mistake.

Yet a passion for the past need not exclude commitment to change in the present. For me, the most effective contemporary artists working with primal images and ideas are those who are keenly aware of the abyss that separates the maker of a "primitivist" object today and the maker of the ancient (or contemporary, but foreign) objects that inspired it. At the same time, I think many of these artists feel a real kinship with the

mythical maker who worked thousands of years ago (or works in a contemporary culture at as great a cultural distance). The heightened tensions that arise from a conscious and critical relationship to the past, overlaid on a personal or collective fantasy about the past, enable some of this art to be viable as social commentary in the present. The best of it looks to the past for formal and emotive models, to the future for social models related to those of the past, and remains firmly rooted in the needs of the present. In fact, the very distance of the past provides room for criticism. The critical element is carried by references to the past that question current assumptions about the function of art.

Many of the artists whose work is included in this book were attracted to ancient images because of the ways in which those images formally resembled modern art—for a certain geometric simplicity, large scale, directness, or, less often, for a certain surrealistic chaos. In the process of working with and understanding ancient images, many artists began to understand how they connected to them and why they were so moving—not because of the form alone, but because of the content. Many of the artists were, or had been, Minimalists, who first adopted the dictum "less is more" and later came to agree that "less is more—but it's not enough."[8] Those few who did fill their *tabula rasa* with images and forms associated with ancient or foreign cultures often discovered new links with abstraction in the process.

Now commonly considered a noncommunicative and anti-populist mode, abstraction originated as precisely the opposite. Otto Rank has proposed that the naturalism of the prehistoric cave paintings developed in an individualistic, nomadic society whose members aimed for a one-to-one command over each specific aspect of nature. Abstraction, on the other hand, originated later in a common agrarian understanding of a more expansive and generalized Nature (and may have arisen from a new fear of naming its forces overtly). Early abstraction was a collective form understood by everyone in a group or society, and probably constituted the earliest written language. As early as 1842, Franz Kugler wrote that the intention of primitive art was less the imitation of nature than the "presentation of ideas."[9] This combination of collectivism and conceptualism is the point at which prehistoric and contemporary art most significantly meet.

At the same time, modern art and primal art are ideologically opposed. Primal art is integrated with daily life and modern art is set totally outside daily life—either above it all, as the product of some mysterious superior activity, or below it all, as "useless." Both art and religion were once inseparable aspects of collective life. Art in fact was the concretizing vehicle that permitted the abstract ideal of religion to be communicated and thereby survive. Today, as Rank observed, the forces of religion are "concentrated in single creative individuals, whereas before they animated a whole community." We now "take refuge in art" rather than finding in it an "expression of life." Rank concluded (and I agree) that if modern art "is to have some general influence, it must manipulate some collective content of general human significance."[10]

Certain forms have survived the intervening millennia as the vehicles for such a vital expression. The concentric circle, the spiral, the meander,

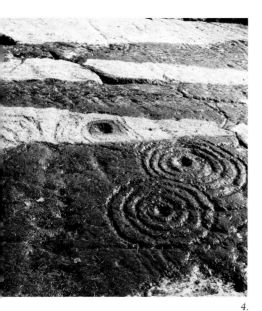

4.

4. *Cup-and-ring marks, Achnabreck, Argyll, Scotland, probably before 1600 B.C. Possibly the greatest number of rock carvings at any one site in the British Isles, the Achnabreck Farm outcroppings are randomly patterned with "cup-and-ring marks" (concentric circles), some with cometlike tails. They are variously thought to relate to the origins of writing, to be predecessors or parallels of womblike labyrinths and spirals, which often accompany them, or surveying devices. Such marks are particularly mysterious since they are found all over the world. (Photo: Chris Jennings.)*

the zigzag, the lozenge or diamond shape, the line in the landscape, the passage and labyrinth and welcoming, terrifying shelter are still meaningful to us, even if we cannot cite their sources and symbolic intricacies. These forms seem to have some basic connection to human identity, confirming bonds we have almost lost with the land, its products and its cycles, and with each other. Symbols are inherently abstract. Certain images, rooted then uprooted, can still carry seeds of meaning as effectively as the most detailed realism, even to our own individualist society, estranged as it is from nature.

The symbolic content of abstraction today is subterranean, inaccessible to the majority of its viewers. We need the artist to tell us what it means because there is no longer a cultural consensus outside of that imposed on us by commerce. The meaning of abstraction in contemporary esthetics is no longer that of a distillation of content still comprehensible to an entire community, but that of an independent form which may mean any number of things to any number of people. The spiral, for instance, is seen as a dynamic but meaningless shape—ironically, as a consequence of education rather than lack of it. The spiral now has an *acquired* abstraction, laid over its varied cultural significances. Symbols, energy-inducing placements, and celestial orientations well-known to prehistoric "artists" have become abstract to us in the broadest and emptiest sense.

Our lack of shared beliefs and values contributes to our fascination with ancient images and monuments. They are often attractive precisely because their meaning cannot be deciphered. This leaves a free field, a *tabula rasa* in itself, where an artist can be formally influenced by these images as though they had no meaning, and at the same time can capitalize on meanings sensed, if not seen. The contradictions involved in this phenomenon are the same ones on which our culture is based. We are caught between too little information and too much information, which keeps us listening to the "specialists" instead of thinking for ourselves.

Little-known as the prehistoric sites may be, they are attracting an increasingly passionate and knowledgeable international following that ranges from UFO enthusiasts to mystics and counterculture dropouts; from the intellectually curious to artists, workers, visionaries, and scholars probing the relationship of art to our society. (When I lecture on this subject, archeologists sometimes come up afterwards and say they too feel isolated, stuck in the past; they are glad to see all this art being made from "their" subject matter; it gives them a sense of connection to the world, which is how many artists feel.)

To some extent, an interest in archeology, anthropology, geology, and mythology has become a substitute for an interest in art. Because experimental art has become the exclusive territory of the ruling and upper-middle classes, the hunger for art felt by everyone else must find less oppressive outlets. These range from pop culture and kitsch to gardening and nature worship. The fact that avant-garde art is seen by many as a "put-on" is indicative of class antagonism. Many young people, discovering art's separation from ordinary people and life, have turned to nature itself as a substitute. Ancient art, wiped clean of its class and religious content by the ages, seems almost *natural* in its distance—a dis-

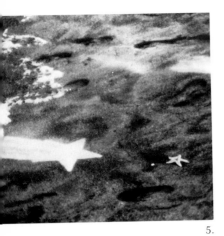

5.

5. Christine Oatman. Star Rise. 1975. Pacifica, California. Stenciled in white sand on beach. "I had a dream: that in the night stars fell into the sea and in the morning were found washed up along the shoreline—like shells, perhaps a good omen. I decided to make this dream come true by stenciling sand stars on this otherwise dead beach.
". . . The surf, which was very rough, hissed up to the stars as I was stenciling them and dragged them out—which gave them comets' tails and made them look like shooting stars. . . . Strangely, the same morning, in the exact spot I had chosen to stencil my stars, real starfish were washed up on the sand. . . . It was the first time I had ever seen anything alive on that beach." (Photo: Iris Laudig.)

tance that allows it to become, paradoxically, more intimate than the art of our own times.

Avoiding art by seeking sensuous and esthetic pleasure in the natural environment, I was seduced back into art by artifacts that had almost returned to nature. The stones raised tantalizing questions about nature and culture, about the domination of nature—which historically has gone hand in hand with the domination of humanity, and is inextricably entwined with the domination of women by men in "civilized" history. The gradual overlay of culture on nature in prehistoric times; the subsequent overlay of physical nature on that "pagan" culture when the earth reclaimed its ruins and, with them, ancient (often matriarchal) beliefs; and now the overlay of our new perceptions of the culture lying beneath the "almost natural" forms—all this suggests a powerful merger of the two elements from which art springs. It is all the more tantalizing to feminists, working to understand where nature got separated from culture and how women became associated with an "inferior" natural line.

The fact that it is difficult to separate—visually and intellectually—the prehistoric stones and mounds from nature itself is significant. Most remaining sites are in the countryside; in cities, remains have long since been buried or destroyed in the name of progress. The rural monuments have become inseparable in our imagination from the landscapes in which they stand or are buried—landscapes they imperceptibly alter. (In my early enthusiasm, I began to see every lump and bump in the English countryside as a prehistoric remain.) Nature is considered relaxing. We don't have to think about it or "appreciate" it; we can just enjoy it. Banal statements about sunsets and lovely views are acceptable, whereas "Art" seems to demand more and give less. It is puzzling, weighted with history and class pretensions. It is "man-made," and human-made objects must be approached warily, while natural things, though they too can be destructive, are more simply embraced. Our attitudes toward nature are in turn a major component in the romanticization of ancient sites and artifacts. We tend to confuse our own romanticism about nature with the original purposes of the stones, mounds, and ruins.

Speculation about the close relationship between nature and culture in prehistory is not starry-eyed idealization, nor is it ahistorical fantasizing about a Golden Age. People living between earth and sky, with few human-made distractions, had to be far closer to natural forces and phenomena than people living on our crowded planet now. They were undoubtedly aware of their environment in ways lost to us. Obviously we do not relate to nature in the same way, but the reestablishment of a coherent relationship between nature and culture is a critical element in any progressive view of the future.

Contemporary artists tentatively resurrecting lost patterns are bringing into public view the images and actions unearthed from ancient art. Art in nature is open to all the confused longings and idealizations our culture lays over nature itself. Art outdoors—in streets, parks, gardens, or fields—is a particularly effective vehicle for communicating these discoveries. It can be more intimate and accessible, closer to people's lives, than art seen in brutally hierarchal buildings (museums look like courthouses, schools, or churches) or in elegant, exclusive settings (commer-

cial galleries look like rich people's living rooms). Nature on some level is still felt to belong to all of us. Art in nature or in the local community becomes more familiar, a part of daily life, simulating though not replicating the role of art in other times. Acknowledging their peripheral role in society, the artists in this book are to greater and lesser degrees repossessing the means of communication by going directly to their audiences. In doing so, they become not only decorators and object makers but image makers, shamans, interpreters, and teachers. At its most effective, their art helps us to understand how the ancient patterns apply to our own, to move toward a reintegration of the political and the cultural, the personal and the natural, and all the permutations thereof.

6.

6. *Dennis Oppenheim.* Star Skid. *1977. Project proposal for western United States. Cast concrete, broken glass. 30' diameter, 200' trench.*

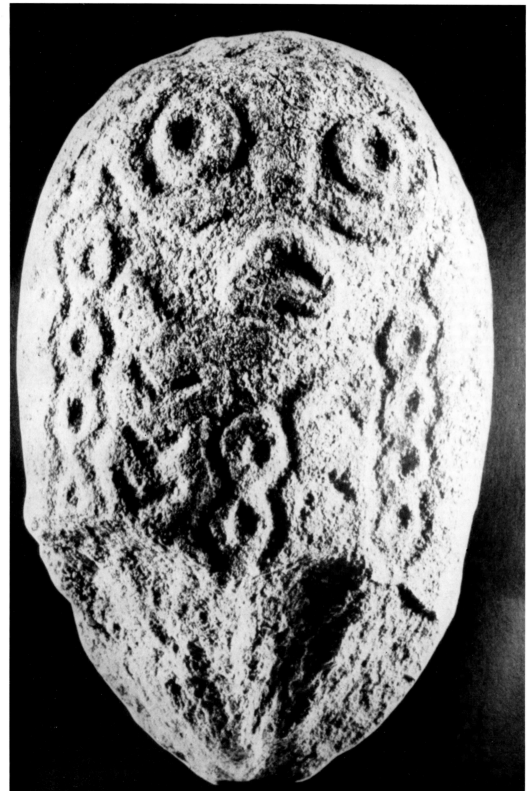

1A.

Stones

1B.

"Invulnerable and irreducible, the stone became the image and symbol of being."[1] Stones touch human beings because they suggest immortality, because they have so patently *survived*. Virtually every culture we know has attributed to pebbles and stones, rocks and boulders, magical powers of intense energy, luck, fertility, and healing. And in virtually every early culture the entire world was sexualized, "divided into male and female, incorporating the entire life force into all reality."[2] Earth and stone are two forms of the same material, symbolizing the same forces. Both are the sources of the world as we know it. The alchemical *petra genetrix,* or generative stone, is an incarnation of *prima materia* — the beginning, the bedrock, the Old European Great Goddess who was both earth and sky — "unmated mother" — sole creator of everything.

In our own urbanized culture the earth is rapidly being buried beneath metal and plastic. Gardeners, quarriers, stonemasons, builders, and sculptors are among the rare few to remain in touch with stone, the most basic and most mythic of materials. Artists in particular have continued to celebrate the central role of stone, consciously or unconsciously unearthing fragments of ancient beliefs, delighted when their own creations parallel those of cultures closer to nature. In order to follow the involvement of these artists and to understand the role ancient sources play as communicative bridges to the rest of us, I will begin with a glimpse of the breadth of ancient stone lore and with a summary of what we know about the various types of megalithic monuments to which artists often refer. This nonchronological but not quite random selection of stone connections will indicate the impossibility of doing justice to their depth in the present context. I also include it in the hope that it will inspire similar collections on your part, which will in turn tell you more than I can about the residual meanings of such beliefs in our own culture. The artists whose works end this chapter are among a far greater number all over the world who have intuited or consciously absorbed the evocative power of the stone as object or image.

I was stone: mysterious stone;
my breach was a violent one, my birth
like a wounding estrangement,
but now I should like to return
to that certainty,
to the peace of the center, the matrix
of mothering stone
 —Pablo Neruda, Skystones, XXIII

The lines of stone lead inward, bringing
the follower to the beginning
where all I knew
is new.
 —Ursula LeGuin

1A. *Egg-shaped, fish-faced water divinity from Lepenski Vir, northern Yugoslavia c. 6000 B.C. Sandstone. 16" high. (Collection: Belgrade University Museum; courtesy Marija Gimbutas.)*

1B. *Faith Wilding.* The Great Anatolian Egg-Temple, *from* Imago Femina *series. 1978. Watercolor. 10" × 12". (Photo: Everett C. Frost.)*

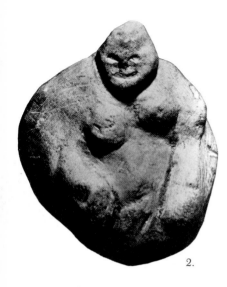

2.

2. *Chalk goddess found in Grimes Graves. c. 2850 B.C. It was probably placed in the flint mines to generate more stone. Also found were several chalk balls, small chalk "cups," and red deer antlers, all associated with fertility. (Courtesy The British Museum of Natural History.)*

3A. *Votive stone from Reiyosaki Shrine at Makiyama, Miyagi Prefecture, Japan. 1832. The shrine is patronized by fishermen and other seafarers. The phallic tradition of agricultural Japan is part of an ancient folk religion focused on sex and food, or fertility of the land and its people, without separation of nature and culture. It has since been absorbed by Shinto. The* Dosojin *statues and roadside shrines usually depict a symbolic couple embracing, and some are realistically shaped like male and female genitalia. Like the Greek phallic herms, they often marked crossroads and boundaries. The tradition originated as naturally shaped stones, chosen for their sexual forms and placed at the edges of fields to ensure fertility and protect the crops.*

3B. *Francesc Torres.* Culture Is Society's Erection. *1982. Charcoal on paper. 50″ × 38″. (Photo: Dan Hunstein, courtesy Elise Meyer Gallery.)*

Stones are the armatures and the markers of vaster monuments made of the earth itself. They focus the relationships of its own magnetic patterns to the patterns made beneath it by subterranean waters, and above it by sun, moon, and stars. From the beginning, mining appears to have been considered a sacred activity, accompanied by purification rites—the roots of alchemy and the philosopher's stone. Minerals have been seen as organic embryos growing in the belly of the earth according to a different, slower rhythm. Pebbles and minerals in suggestive shapes may have been the predecessors of the earliest human-made female figurines, like the *Venus of Willendorf,* and, millennia later, the similar effigy found in Grimes Graves, an ancient British flint mine. A related concept is illustrated by the custom of annually reburying stone and clay representations of fertile goddesses in the fields to encourage crops to grow.

Numinous sites of a preorganic life, which were experienced in *participation mystique* with the Great Mother, are mountain, cave, stone pillar and rock—including the childbearing rock—as throne, seat, dwelling place, and incarnation of the Great Mother. . . . It is no accident that "stones" are among the oldest symbols of the Great Mother goddess.[3]

Myths of people born from stones are common, and stones are ubiquitously associated with childbirth. In New Mexico the ancient Native American fertility shrines are called Mother Rocks; they are incised with vulva symbols, male and female figures, seeds, serpents, and rain symbols, and they contain natural holes in which stone scrapings were deposited. German women up to modern times stroked their breasts with "milk stones" to increase the flow; Peruvian women still swaddle stones like babies and leave them at the bases of specific boulders to cure barrenness. In Brittany, Ireland, and Cornwall, through the last century, women and couples desiring children would touch, caress, and worship the prehistoric standing stones and holed stones at auspicious times of month and year, in relation to lunar cycles and the cycles of their own bodies.

Stone pillars were the male connections between earth and sky. Phallic roadside standing stones in China and Japan are called the Heavenly Roots. In Gaelic Scotland "going to the stones" meant going to church, whereas to Iatmul shamans "raising a standing stone" meant making love. The Greek herms—busts of men with genitals isolated on the pillar bases—were also journey markers. The Greek messenger god Hermes and the word *herm* are related to the verb "to protect" and to the words for stone or rock.

In some cultures the sky was thought to be made of stone. Meteorites were seen as chips off the heavens, as "thunderstones" and "snakestones" (making another connection to water from sky and earth). When Neolithic stone axes were unearthed in nineteenth-century Europe, they were superstitiously regarded as thunderbolts. Striking a stone in both New Guinea and in ancient Scotland was thought to bring wind. Quartz crystals, full of light and spirally structured, were used as oracles and for initiation rites. The earth mound at the great tomb of New Grange (see p. 103) was once covered with quartz crystals, making this religious center a

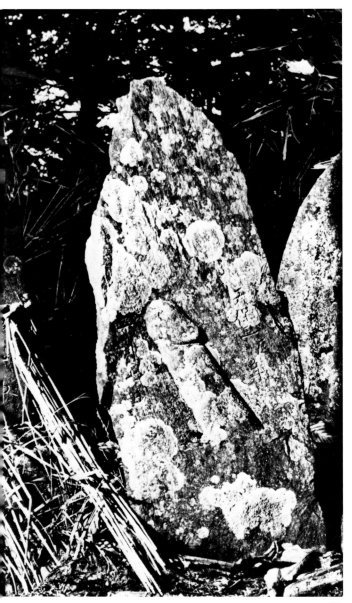 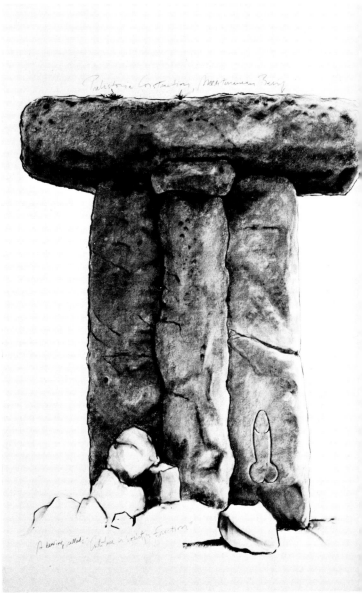

3A. 3B.

4.

glittering white cone, simultaneously solid earth and reflected sky.

The almost universal association of stones with water is fundamentally related to fertility beliefs uniting earth and sky. There are innumerable myths in the most diverse cultures linking serpents, wells, maidens, caves, and rocks. There are many British stories of standing stones going down to adjacent waters to drink at midnight. In the Temple of Jerusalem a huge rock outcrop, once used as a threshing floor (thus mixing the fertility metaphors), allegedly marks the place where the Deluge was sucked back into the earth. The sacred center of the Muslim world is the Kaaba at Mecca—a black stone cube.

Such images in turn serve as the collective macrocosm of the widespread belief that a stone stands for an individual. Abram Tertz has noted that a rough-hewn idol, "closer to unfashioned stone than to the image of a man," was in archaic times a repository for the soul rather than a representation of the body—intended not to offer a likeness but to evoke a mental projection of that image which lives within the stone.[4] The stone *represented* nothing; it *was* both spirit and spirit's dwelling place.

On Easter Island, Thor Heyerdahl discovered that some families had a secret underground chamber (the key hidden beneath a stone) which was the repository of a variety of objects ranging from natural stones to carved stone idols, some of which were connected to hunting magic. "These stones are a symbol of the Self; they represent the secret of eternity and uniqueness and the secret of the essence of life of the human being."[5] In Stone Age Switzerland holes were made in the ground for a cache of specially shaped stones; a person's nest was kept secret and was a symbol of individual secret power. Oddly shaped stones are found in shamans' graves. Crazy Horse wore a special stone behind his ear for luck. In the pre-Columbian Andes, *canopas* (stone household idols and unusually shaped pebbles) were thought to house ancestors; colored

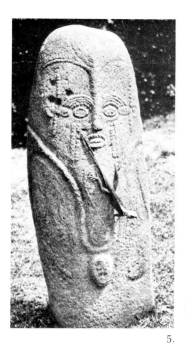

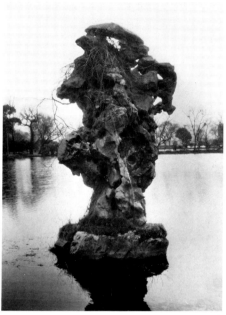

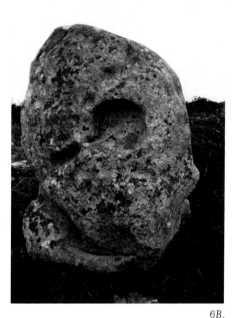

5.

6A.

6B.

5. African stone monument with image of ancient tribal chieftain. (Courtesy Nigerian National Museum.)

6A. Natural stone "sculpture" at the Summer Palace, near Beijing, China. (Photo: Lucy R. Lippard.)

6B. Natural stone from prehistoric rows at Kermario, near Carnac, Brittany. c. 2500–2000 B.C. (Photo: Lucy R. Lippard.)

stones were carried in pouches like figures of saints.

The notion of being personified by a stone appears in many old European rituals, especially at the Celtic Imbolc, Halloween, and Midsummer, where people marked stones in varying ways, threw them in the fire, and searched for them the next morning. If someone's stone was missing or damaged, it was an ill omen. Stones in fires were also used to determine who was to be sacrificed or, in later times, who was "fey" or "devoted" or the "fool." In many cultures a more casual manifestation of this belief is the cumulative construction of wayside cairns, or heaps of stones, on which every passer-by tosses a stone for luck. Among Native Americans, cairns were records of journeys, as are those accumulated beside the Greek herms. In Norway cairns were raised where something fearful had happened, such as a violent death. In Borneo piles of stones, or sticks, were called "liar's mounds" or "lying heaps," in memory of social disgraces.

Touchstones, or suggestively shaped stones, sexual or otherwise, were not always small-scale individual talismans. They played a similar role for the communal psyche in many cultures. The presence near Avebury in England of sarsens, or bridestones (after the Celtic goddess Bride, or Christianity's Saint Bridget), may be one of the reasons why that site was chosen for the extraordinary series of Stone and Bronze Age monuments extant today. These huge boulders, pitted and pocked into sensual visceral shapes, lend themselves to interpretation as living (or frozen) forces. In the People's Republic of China large "found sculptures" of even more exotically distorted limestone remain as the centerpieces of formal gardens, placed on ornately carved pedestals to honor the work of nature as artist.

Contemporary artists in the West have followed in this tradition (as well as that of Marcel Duchamp's *Readymades* and Henry Moore's, Con-

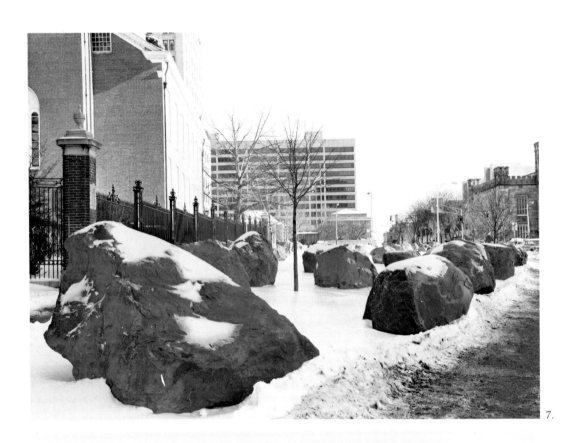

7.

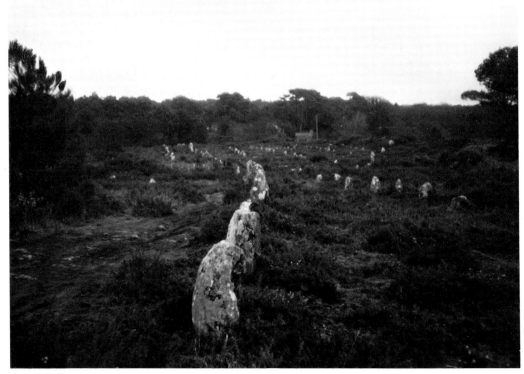

8.

stantin Brancusi's, and Isamu Noguchi's celebrations of natural form) by slightly altering and assembling boulders and slabs as sculpture. The best-known recent examples are Robert Morris' imitation megaliths at the 1977 Documenta in Kassel, Germany, and Carl Andre's controversial *Stone Field Sculpture* in Hartford, Connecticut. The former, on its green museum lawn, offers a domesticated version of the ancient sites, more formally and less symbolically complex. Like Moore's art and that of many others, it brings the ancient fertility image into the urban sculpture "garden." Andre's great rounded boulders are varied in rock type and also in size as they move down a gentle slope, the "field" thus acquiring a grander scale by artificial perspective. They stand next to an eighteenth-century churchyard with its own worn gravestones. Both are surrounded by slick stone skyscrapers, whose megalomaniacal scale is the modern counterpart of the ancient stones, typically distanced from the earth itself. Vestiges of the fertility image of death and rebirth can also be read into this triad of unintentional references to the history of vertical stone monuments. Paradoxically, Andre's sculpture—the newcomer—seems more permanent in its evocation of the origins of stone building than the churchstones and the skyscrapers. Come upon in the midst of a bustling city, his rows look as though they were there before anything else and will outlast everything else.

The megalithic monuments, inseparable from their sites and from their unknown but suggestive histories, include a multitude of varied and many-leveled forms, each ranging broadly in scale as well. A *menhir*, deriving from the Celtic word *men*, for stone, is a single standing stone. Menhirs come in an amazing range of stone type, shape, height, width, degree of worked surface, location, and association with other monuments. Menhirs are spires and stubs and massive blobs, as well as roughly anthropomorphized figures. They turn up alone in the most isolated areas, or as "outliers" connected with other stones and sites, in the centers of towns and even in churchyards, at crossroads and roadsides, in hedges (where they have been dumped by farmers because they interfered with plowing), or in fields (where one of many may have been retained as a "rubbing stone" for cattle). They may be pierced by holes, striated, pocked, carved with spirals or the enigmatic "cup-and-ring marks," Christianized with crosses, or cut into cross shapes; in Brittany there are low stone domes. The single standing stone is probably the most difficult prehistoric artifact to identify, since "long stones" have been put to use since time immemorial for endless different purposes—as gateposts, boundary markers, threshold steps, beacons, or fireplace walls. It is often impossible to tell whether they are ancient and in their original locations, or ancient and relocated or reworked, or whether they are relatively modern.

Stone rows, or rows of menhirs, are found only in specific areas of Britain and in Brittany. They too are highly diverse. On Dartmoor alone, there are single, double, triple, and quadruple lines. Some rows are little stubs of stone (intentionally so, or eroded); others are made of tall, elegantly spaced pillars. Sometimes every stone is a different size, shape, and height; sometimes they are arranged in straight lines, sometimes in magnificently meandering lines. Some rows are only a few yards long;

7. *Carl Andre.* Stone Field Sculpture. *1980. Hartford, Connecticut. Permanent installation of 36 glacial boulders. 290' × 53'. (Photo: courtesy Paula Cooper Gallery.)*

8. *Stone rows at Kermario, near Carnac, Brittany. c. 2500–2000 B.C. (Photo: Lucy R. Lippard.)*

9. *Long Stone, Shovel Down, Dartmoor, Bronze Age. 10'5" high. The Shovel Down complex consists of a fourfold retaining circle, two cairns, five rows, a menhir, and a kistvaen, spread irregularly over 2000 feet. (Photo: Lucy R. Lippard.)*

9.

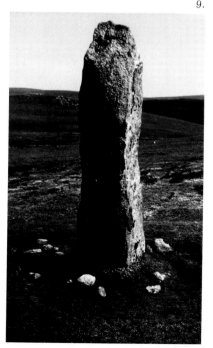

others, several miles. At Avebury the double stone rows form broad processional "avenues"; elsewhere, the stones are too close together to serve that function. Some rows seem to be connected to astronomical alignments. Near Carnac, in Brittany, there are immense fields of rows including over 3,000 stones, set in great fan-shapes.

Stone circles are even more varied and more complex in form. Alexander Thom's research on those in Britain and Brittany reveals several different geometric categories: the circle, the "flattened" circle, two kinds of "egg" shapes, the ellipse, the "composite" circle, and the "recumbent" circle (with one huge slab lying horizontally). There is a stone circle in Brittany constructed like a wall; there are circular retaining curbs that supported disappeared mounds, which are called cairn circles; and there are innumerable hut circles and drystone-walled animal pounds, on Dartmoor and elsewhere. Some circles are paired together; one large, one small near each other, or adjacent equal-sized circles in a figure eight. "The Hurlers" in Cornwall is the only known triple circle. Complex sites like Stonehenge may combine several of these features, and in western America and Canada there are the related spoked stone "medicine wheels." Aubrey Burl's *The Stone Circles of the British Isles*, though local, is the most thorough investigation of this form.

Then there are the endless varieties of stone tombs and chambers—*passage tombs, stall tombs, chambered tombs,* the French *allées couvertes*—with different celestial orientations and intricate carved inscriptions, sometimes still covered by earth mounds. The greatest of these (such as Maes Howe in Orkney, Scotland; Gavrinis in the Gulf of Morbihan, Brittany; New Grange, Dowth, and Knowth in Ireland; or Bryn Celli Dhu in Wales) have different internal architectures and functions, but their fundamental structure is similar—a huge central chamber with a slabbed or corbelled roof, led into by or branching out into other chambers and passages. Some tombs are cut out of cliffs or out-cropping rock.

The *dolmen* or *quoit* is a tablelike form of two or four giant slabs of stone topped by a still larger "capstone"; dolmens may have been tombs once covered by earth. A *cist* or *kistvaen* is a relatively small box, or buried stone slab coffin. A *cairn* (or Celtic *carn*) can be the relatively small and long-accumulated trail marker mentioned above or a monumental rock pile over 35 feet high and 200 feet in diameter, built as a monument in itself. Such cairns often cover graves, or contain a corridored complex of graves. A *cove* (and the related Scottish "four-poster") is a much rarer form—a three-sided, roofless box of huge uprights, found within British henges, perhaps a later imitation of the dolmen, connected to burial rites.

Serving the same function as the tombs and cairns in different times and cultures was the ubiquitous *tumulus* or *barrow*. "Disc barrows" (round, like an overturned bowl), "long barrows" (trapezoidal), or "conical barrows" are sometimes called mounts or *mounds*, though that term is usually reserved for very large cone-shaped, flat-topped, vaguely pyramidal, or even trapezoidal human-made hills. Whole necropolises of barrows are found in most European countries, as well as along the Mississippi Valley and in midwestern America, where "effigy mounds" are also found in the forms of animals (see Chapter VI). Barrow and mound

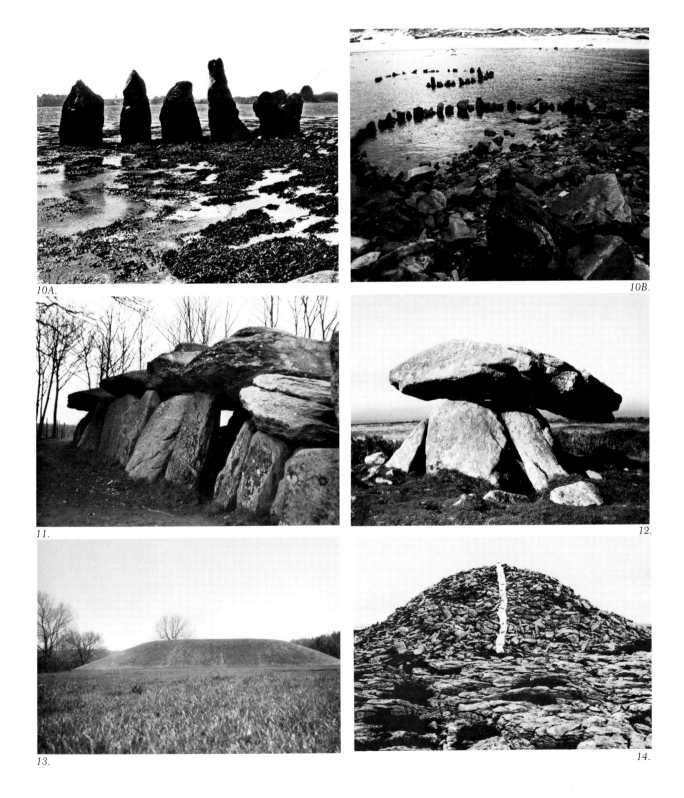

10A.

10B.

11.

12.

13.

14.

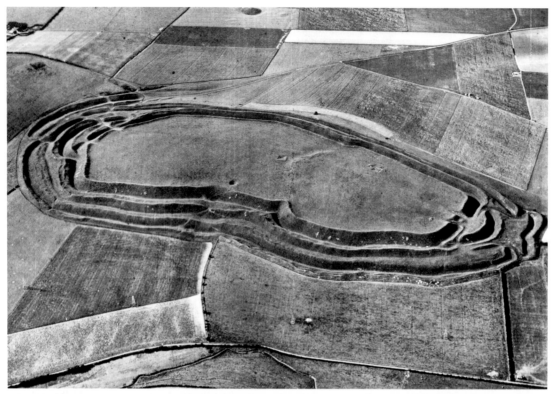

15.

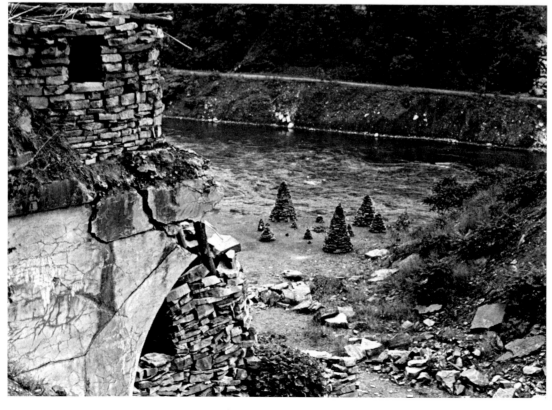

16.

15. *Aerial view of Maiden Castle, Dorset, England. Earliest construction c. 3000 B.C.; present configuration from 300 B.C.–70 A.D. 1½-mile circumference. The original Stone Age causewayed enclosure and ritual cursus were mostly obliterated by an Iron Age hill fort. The northern and southern entrances are complex labyrinthine forms. Thomas Hardy compared it to "an enormous many-limbed organism of an antediluvian time, lying lifeless, and covered with a thin green cloth, which hides its substance while revealing its contour." (Photo: Department of the Environment, London, Crown copyright.)*

16. *Charles Simonds.* Niagara Gorge: Excavated and Inhabited Railroad Tunnel Remains and Ritual Cairns. *1974. Artpark, Lewiston, New York. The work consists of five elements from different times: a natural cliff face, an arched ledge excavated by the artist from the vestiges of a 19th-century railway tunnel, a full-scale stone dwelling overlooking a series of ritual cairns that ranged in size from 8" to 10' and a miniature clay Little People's settlement nestled in the same cliff. Simonds' Little People are a migrating imaginary civilization whose settlements, landscapes, and ritual places are usually found in the nooks and crannies of deteriorating cities. The Iroquois Indians, local to northern New York State, where this piece was made, also tell stories of a Little People who formed these and other cliffs. The theme is excavation — both historical and psychological. Simonds performed his* Landscape↔Body↔Dwelling *ritual among the cairns. (Photo: Charles Simonds.)*

burials have been used in both hemispheres by consecutive social groups with different funerary styles. A single grave site may include evidence of cremation, individual and group burials, ritual dismemberment, scattered corpses and bones, corpses in fetal or stretched-out positions. Sometimes the bones or ashes are sheltered by remains of a wooden "house," embedded in strata of different kinds of clay and earth, circled by stones, bones, or ritual artifacts.

Earthworks are equally varied and ubiquitous. *Henges* —large circular enclosures, ditched and banked with any number of "gates"—were probably ceremonial places, meeting places, trading places. They may have been used in these ways simultaneously, or at different times of the year or of their histories. Some have been labeled animal pounds and forts (even when their architecture would clearly seem to make them useless for these functions). The henge is defined as a rough circle, but many are lopsided oval shapes. The term is also used for stone circles and similar sites are also called *causewayed camps, castles,* or *rings;* I have been unable to find any but arbitrary distinctions between them. Circumferences vary from a few hundred feet to several miles.

Huge walled earthworks are found both in Europe and in the Americas. Maiden Castle in Dorset, England, is an irregular, multiwalled oval covering 120 acres, with mysteriously labyrinthine entrances at east and west. Fort Ancient in Ohio is a walled hilltop with no discernible shape to its 100-acre enclosure. Archeologists believe that some henges—such as Woodhenge, near Stonehenge—were sites of huge wooden "round-houses," because of the mazes of post holes found within them. Other earthworks include often gigantic but fragmented *dykes, cursuses,* or *walls* —synonyms for equally mysterious sites. Suggested uses are processional or religious and secular racetracks, boundaries, and fortifications.

Included in the growing number of books about "ancient mysteries" are a number of enigmatic sites, some of which are from historic times, such as the Celtic *holy wells*, pits and mines and Scottish *weems*, Cornish *fogous* or *souterrains*, Scottish *brochs, clochans* or beehive huts, herringbone walls, clapper bridges, Irish "sweathouses," New England "root cellars," round towers and ritual caves—not to mention paths and roads and tracks on supposed "ley lines" (see Chapter IV).

Given their ubiquity even today, the mind boggles at how many such sites there must have been in the Iron Age, before agriculture expanded and before so many were hauled off for building materials. (After living near there for a year I still haven't seen all the hundreds of sites on Dartmoor—a misty, barren granite cap of rock and bog some 30 miles across that has escaped wholesale destruction, partly because no road crossed it until 200 years ago. Its heights were farmed only briefly, between the eleventh and fourteenth centuries, and today only the dedicated plunge into its interior.) Yet the majority of these prehistoric monuments are not well known in the British Isles, and certainly not in America, where a domesticated Stonehenge popularly stands for the whole megalithic past. Avebury, Callanish, and Carnac may sound familiar, but until recently there appeared to be little interest, outside expert circles, in the forms or significances of the Stones. Now a rash of books is beginning

to appear, based on the fieldwork of scholars in archeology, history, astronomy, and anthropology, and incorporating to varied degrees the speculations of writers whose fields are not directly related.

There are two main theories about how the megaliths came to be so omnipresent. The first is the diffusionist theory. It posits the spreading influence over the millennia of a single very ancient culture, through direct contact. This theory is harder and harder to prove archeologically, but is often made credible by the presence of identical images, myths, and symbols in disparate parts of the world. The second theory might be called "the ideas-in-the-air school." It holds that similar forms arose at different times in different places due to the fundamentally similar nature of people and natural phenomena. Thus any culture, given certain conditions and materials, might imitate mountains and make processional rows, dance circles, ceremonial enclosures, and underground tombs. Comparative mythologists, especially the Jungians, come up with some fascinating correspondences connecting, if not the actual objects, at least the underlying belief systems and psychologies of extremely diverse and distant cultures.

Although this line of thought, implying a "family" of humankind in terms of psyche and civilization, as well as biology, provides a general framework in which to understand identical symbols found in, say, Australia and Scotland, the coincidences are often so striking as to be almost incredible without a more specific connection. It is at this point that the pure archeologists firmly disagree with the methods of the "speculative" writers, who depend, as John Michell puts it, on "an educated use of the imagination" and on a synthesizing overview.[6] The traditional archeological approach to megalithic culture is grounded in excavations and datings; then the careful analysis of specific findings is subjected to generally known historical and sociological data. Speculation about belief and value systems is avoided, even viewed with some embarrassment. The geological approach is also little respected by traditional archeologists, but it raises interesting questions about possible connections between ancient sites and natural phenomena. Those open to nontraditional ideas (including very old and still mysterious ones such as dowsing) have found measurable centers of terrestrial magnetism, or "earth energies," at ancient sites and stones; they also record coincidences with geological faults, buried springs, and the crossing of underground streams. Tantalizing clues to the original functions of the stones are also found in local folklore, etymology, and place names. These in turn provide fuel for the "ley hunters," who are now the core of a popular industry in the United Kingdom. Tracing networks of straight-line tracks, or "ley lines," which they claim crisscrossed Britain in prehistoric times, the hunters incorporate a chaos of proven and unproven information. While they are considered fanatics and even lunatics by many academics and traditionalists, it is well to remember that those tracing astronomical connections with the Stones were also very recently considered beyond the scholarly pale (see Chapter III).

The anthropological approach coincides to some extent with that of the comparative religionists. In its illumination of the cultures and magical

17A.

17B.

17A. Margaret Hicks. Detail of Hicks Mandala. 1975. Corsicana, Texas. 32' diameter. Three concentric circles and a square, oak logs and red sandstones, with an altarlike tree trunk in the center, on which is set a boulder naturally marked with a cross (also readable as a yoni or female genital symbol). The piece was accompanied by an ongoing "Ritual of Giving," where each visitor brought some natural object to exchange, or left a small stone.

17B. Grace Bakst Wapner. 38 lbs. 1971. Painted Styrofoam. 15'9" × 13'8" × 6'5". Woodstock, NY.

beliefs for which stone and earth monuments all over the world were created, cultural history is invaluable for understanding, if not for establishing, facts. Directly applicable to specific sites or not, anthropology provides an inexhaustible suggestive source for contemporary artists as well as for scholars.

The mathematical approach is exemplified by the work of the Thom dynasty (Alexander Thom, his son Archibald Thom, and now his grandson Alexander Thom). They have established that megalithic people used a standard measure—the "megalithic yard" (2.72 feet)—which made possible a sophisticated geometry predating the Pythagorean theorem. What was initially seen as an unexpected level of astronomical, mathematical, and engineering expertise on the part of Neolithic and Bronze Age peoples seems, in retrospect, logical enough; the sites themselves and the astounding feat of their construction cannot be denied. The "barbarians-in-skins" image of these accomplished civilizations never made sense.

Among other things, Bronze Age people appear to have had cosmological knowledge not rediscovered until Copernicus and Tycho Brahe—the fact of the moon's "wobble" in declination. Thus the astronomical ap-

18. Chris Jennings. Castle Rigg, Cumbria (England). *1977. Photograph. The plan is based on a survey by Alexander Thom. Over the years, Jennings has photographed more than 500 stone sites, focusing on their surface markings and on the way "they seem to act as a focal point in the landscape, bringing together the sky, the horizon and the land." He is concerned to make people perceive the stones as works of art, whatever their disputed function, "not only because they are beautiful forms but because they direct and extend our vision beyond themselves. They emphasize man's proper relationship to the landscape."*

18.

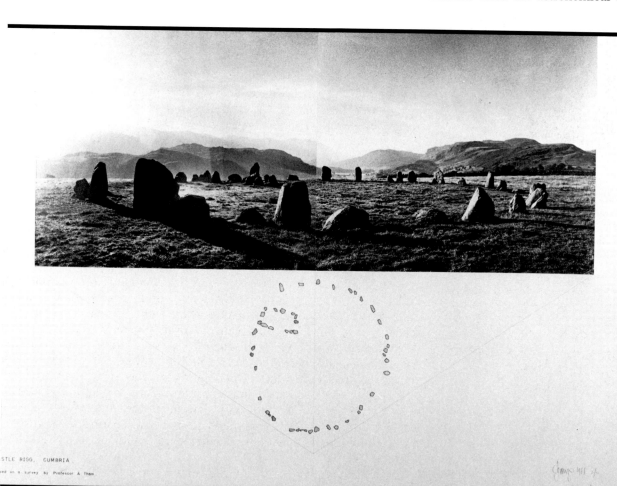

STLE RIGG, CUMBRIA
ed on a survey by Professor A Thom

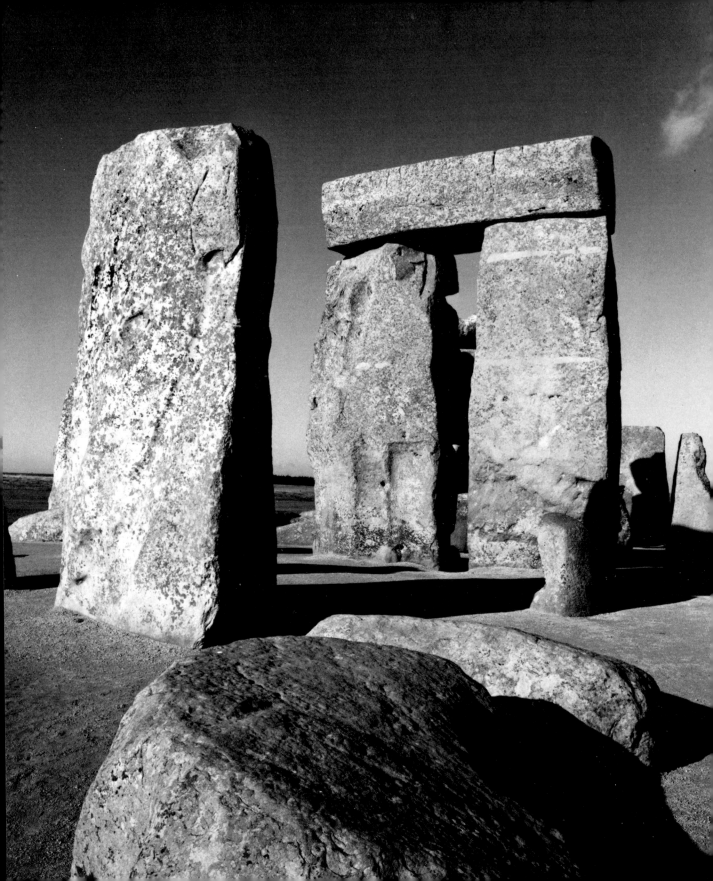

proach is the most seriously taken (at last) of these offshoots from traditional archeology. The Thoms' painstaking research was supported by Gerald Hawkins' popular book *Stonehenge Decoded*, in which, with the aid of a computer, he proved the premises of earlier British scholars that astronomical alignments of stones and horizons to solar, lunar, and stellar features were an integral element in megalithic construction.

Whether the approach is anthropological, archeological, geological, or astronomical, the relatively new field of prehistoric scholarship has two prime obstacles. The first is that absolute proof, based on datable artifacts, is very hard to come by, due to innumerable factors—notably time, acid soils, and still not entirely dependable dating techniques. Radiocarbon, or "tree-ring" dating, based on charcoal and wood remains, applies only where these are found. However, this dating method has revolutionized archeology, proving, for instance, that inspiration for the European megalithic cultures did not come from those "cradles of civilization"—the Aegean and the Near East. According to corrected radiocarbon dating, the magnificent New Grange chambered tomb in Ireland (see p. 103) was built in 3500 B.C., and there were no stone buildings in Egypt until 3000 B.C.

Second, only a minute percentage of the *known* sites have been excavated. Avebury itself is 94% untouched. Many of the extant excavations were perpetrated in the nineteenth century by heavy-handed clerical amateurs, who destroyed as much evidence as they unearthed. Funding is simply not available today for such detailed and "irrelevant" work. There are many thousands of known sites. Of those which have been investigated, only a few have turned up the museum-worthy artifacts that funders like to have found.

Yet it is not entirely disadvantageous that the perishable evidence of prehistory has been devoured by the earth and that much of the imperishable evidence has yet to surface. It leaves us with the stones—the hard skeletons to be collectively refleshed in a metaphor for interdisciplinary rebirth. Eminent prehistorian Jacquetta Hawkes has said that every era gets the Stonehenge it deserves and desires. And there is no more challenging arena for diggers, thinkers, and artists than this no one's land of prehistory—receptacle, like this book, for syntheses of science and speculation on which to model our own socio-esthetic visions.

Plotinus said about stone monuments already ancient in his day that the sages had "once understood that it is always easy to attract soul (or the universal essence) and particularly easy to keep it, by constructing an object fashioned so as to be influenced by it and to receive a share of it."[7] This is a good description of what many contemporary artists have been trying to do, often without permanent objects, focusing on immediate experience rather than cosmic knowledge.

By the mid-1960s rebellion against purist formalism ("Post-painterly Abstraction") and purist anti-formalism (the *tabula rasa* of Minimal Art) had led much of the New York avant-garde into a search for new ways to introduce content, to attract broader audiences than those in museums and galleries, and to combat the art market's increasing commodification of objects in favor of more directly communicative modes. "The world is

19. *Stonehenge, Wiltshire, England. c. 2600–1800 B.C. (Photo: Chris Jennings.)*

20. *Chris Jennings. Bronze Age #4. 1982. Pastel on paper. 22″ × 30″.*

20.

19.

21.

21. *Robert Smithson.* Slate Circles on
Flat Plain (2 circles). *1972 Pencil on
paper. 12″ × 24″. (Photo: Nathan Rabin,
courtesy John Weber Gallery.)*

22. *The N. E. Thing Co. (Iain Baxter).
Plate from* Piles, *artist's book of photos
of "process sculptures" found in the
landscape. 1968. University of British
Columbia, Vancouver.*

full of objects," wrote Conceptualist Douglas Huebler in 1969. "I do not wish to add any more."[8]

Process Art, Earth Art, Conceptual Art, and Performance Art shared a deemphasis on the final work and an emphasis on how it came to be. Sculptors—among them Carl Andre, Robert Morris, Iain Baxter, Richard Serra, Eva Hesse, and Dennis Oppenheim—explored gravity and random or naturally ordained activities like scattering, piling, leaning, breaking, by which matter and then shape are formed. Andre's influential formal solution was to use flexible unfixed units like bricks and other "particles" and to take his sculpture back to "ground level"—to the floor, or the earth—rejecting the pedestal and felling the traditionally anthropomorphic stance of heroic vertical sculpture by identifying with roads and journeys.

The idea was to open the gallery doors, to let in nature and daily life, while art (sometimes) escaped to the streets and fields. There it was to be welcomed by a populace hitherto intimidated by high art while simultaneously maintaining some foothold in the economics of the market. This enterprise was not entirely successful, but the whole tendency toward the "dematerialization of the object" did introduce a healthy number of new subjects and concerns into experimental art. Among them was a growing interest in geology, part of the preoccupation with natural process. When geologist Paul Leveson wrote that his task was "to interpret the earth to society, to bridge the gap between pattern and process,"[9] he might have been describing the goals of these artists. In addition, many of them had visited or read about the best-known British megalithic monuments. The hermetic quality of the awesome stones and mounds was compatible with Minimalism's obdurate silence. The combination of nature and monumental scale also characterized New York modernist sculpture at the time.

A key figure at this point in avant-garde history, when art and nature recombined on a new level, was Robert Smithson. His cantankerous intelligence and unlikely combinations of prehistory, science fiction, industry, nature, and art were particularly influential through his writings. A geology buff, his interest in crystallography, mining, and the formation and changes of the earth led in the late '60s to a series of "flows" or "pours," in which he investigated the speed and formal properties of different materials such as asphalt, mud, and glue moving down slopes of gravel pits or eroded cliffs in a metaphor for the molten beginnings of those same surfaces. Around the same time, Smithson was evolving his concept of "sites and nonsites"; in an art gallery he would juxtapose the map of an area with piles of materials—usually dirt or rocks—taken from that area. The result was a first-hand or physical (as opposed to second-hand or pictorial) experience of nature both as art and as independent from traditional art systems. It objectified the "sense of place" in an original way; it simultaneously "dematerialized" the object by reducing a landscape to a map and stressed the material side of art by exhibiting the raw materials of that landscape. The site-nonsite notion deeply affected the development of "site sculpture" (art made for specific outdoor locations) by making this leap between object and source, work of art and site and all surrounding views.

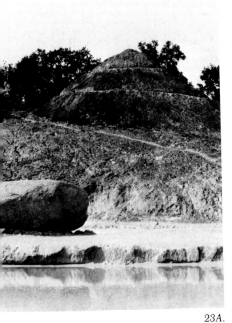

23A.

23B.

23A, B. Robert Smithson. Broken Circle/ Spiral Hill. 1971. Emmen, Holland. Circle c. 140' diameter; hill c. 75' at base. (Courtesy Estate of Robert Smithson.)

23C. "Hun's Bed." Drenthe province, Holland. Dated (with the 54 other Hunebedden that survive) between 3400 and 2300 B.C. (Photo: Lucy R. Lippard.)

23C.

Smithson's two major earthworks—Spiral Jetty (see p. 224) and Broken Circle/Spiral Hill—were both in a sense reclamations—of neglected land and of neglected symbols. The circle and hill were built in an abandoned quarry in Emmen, Holland, in 1971, under the auspices of the Sonsbeek outdoor art exhibition. It is Smithson's most complex piece. The circle itself is a double, or mirrored, or positive/negative semicircle, made half of land and half of water, half jetty and half canal. Its shape is defined by two arms—one embracing a section of green lake and the other cut into yellow sand with the band as the 140-foot diameter. The hill on top of the bank overlooking the circle is dark brown, its coiling ascent marked by a spiral of white sand. The "accidental center" of Broken Circle/Spiral Hill is a huge boulder that was too expensive to move out of the way. Smithson initially disliked the way its intrusion focused the piece, "blotted the circumference out"; he thought of the stone as a "cyclopean dilemma," impossible to escape "just as the earth cannot escape the sun." It became "a dark spot of exasperation, a geological gangrene on the sandy expanse. Apprehensions of the shadowy point spread through my memory of the work."[10]

Yet the center boulder in fact significantly expands the associative levels of this work because it offers a direct tie to prehistory. Such large rocks are rare in Holland, existing only along a glacial moraine that runs on a diagonal line through the country. In the Bronze Age they were used to make the huge dolmens and passage tombs the Dutch call Hunebedden ("Huns' Beds"). Once covered with earth mounds, their stone skeletons are now exposed on the flat landscape like lurking mastodons. Smithson passed a Hun's Bed each day on his way from town to the site, and it became important to him. He planned a film in which he would connect these ancient monuments to his own. He wanted to zoom into

24.

24. *Michelle Stuart. #28. 1974. Rocks, earth, graphite, muslin-mounted rag paper. 144″ × 62″.*

the surface of a Hun's Bed boulder and then pull back to see the rock surface of his own boulder to "link up the two boulders in a kind of cinematic parallel that would cover vast stretches of time." Similarly, the spiral hill is vertical where the circle is horizontal, and counterclockwise (winding back into the past) where the circle reads clockwise (moving into the future). The boulder might be seen as a seed, or an egg. Smithson once thought of burying it to get rid of it, which has a ritual flavor and also suggests the artist's ambivalence about competition from nature.

Smithson's view of nature was not your garden-variety idealization. He scorned pretty views and grand vistas, anything cozy and "finished," preferring swamps, barrens, deserts, and industrial wastelands—places where "remote pasts meet remote futures." He liked the substance of nature, not its looks, and always made clear that he did not separate humankind from nature. He would have identified with a description of the geologist, by René Dubos: "The geologist can't escape dedication to history, and this makes him the epitome of Western man, whose tragic sense of life comes from his awareness that he is not absolute and is going somewhere."[11]

A self-declared anti-romantic, Smithson nevertheless admitted "a tendency toward a primordial consciousness . . . our future tends to be prehistoric." Yet, after "digging through the histories," he did manage to avoid nostalgia. His interest in the prehistoric might be seen as a symptom of political pessimism, even cynicism, amid the ruins of the new world. Preoccupied with time, horizons, and lost continents, he often expressed himself in "archeological" terms. His description of "the illusory babel of language," which he saw as "covering rather than discovering," might have been a description of the trials of the megalithic prehistorian: "To intoxicate himself in dizzying syntaxes, unexpected echoes, unknown humors or voids of knowledge. . . . But this quest is risky, full of bottomless fictions and endless architectures and counterarchitectures." He called his own art "a quiet catastrophe of mind and matter," saw "no hope for logic," "nothing more corruptible than the truth," and was particularly fond of the concept of entropy, or energy drain.[12] He was attracted to what he saw as prehistory's gloomy, chaotic, death-obsessed character.

Smithson was killed in a small-plane crash in 1973 while surveying a new earthwork. The tragedy of his early death lies partly in the fact that he was virtually the only well-known artist of his esthetic generation to be vitally concerned with the fate of the earth and fully aware of the artist's political responsibility to it.

Michelle Stuart's work with geology and history is overtly romantic, sensuous, and subjective. Emotionally involved with the earth and its history since childhood, when she accompanied her father, a water inspector, through the wilds of southern California, she only began to focus her art on its substance around 1970. In a series of lyrical, near-abstract drawing-constructions of the moon, she used her professional experience as a cartographer. The drawn textures soon gave way to more naturally generated techniques. She pounds, rubs, and permeates vast expanses of muslin-backed rag papers with dust, dirt, stones, and other particles from

specific sites, chosen because of personal experiential or historical associations. The earth's chromatic span provides her with a rich and layered palette for the resulting scrolls, drawings, and environments. The microcosmic landscape of the paper's pocked relief surface reflects the macrocosmic landscape from which it came—the "spirit of the place."

All of Stuart's art is about digging—into the earth, into the past, into her personal history and psyche and those of native peoples. It is also about touch, about *embodying* the experience of time. After pounding rock and earth into the paper, she polishes the surface with her hands until it takes on a fleshy gloss, a skin—"the most delicate and warmest of surfaces." She insists on the bond between body and earth, as well as the bond between her repetitive actions and traditional women's work and rituals, such as the grinding of corn on a *metate,* or the Hopi Corn Dance, in which women dance their energy back into the earth after harvest. In the fragmented style of her ongoing photo-journal—*Return to the Silent Garden*—Stuart writes about rock as "bone under the flesh of soil in the body of the earth. . . . The earth lives as we do, elastic, plastic, vulnerable. . . . Stone is self. . . . All places are marked on us and we have a map of that place engraved on our soul."[13]

The sources of Stuart's imagery are often literary—obscure history and travel books, anthropology and mythology. She also makes books herself. Using old photographs and narrative, she becomes a visual-verbal collagist detailing the fantasies and histories of ordinary people and their lands. In her wordless *Rock Books,* she tells the "story of a place" by imprinting its layers on pages resembling geological strata, then sealing them with woven strings, grass, feathers, a bone or a stone. Stuart does not disdain nostalgia, and in fact most of her work is brushed by an atmosphere of melancholy; it is as much about absence as presence, as much about the sorrow of leaving as the joys of experiencing a place. An avid traveler, as are so many of these artists, she has focused particularly on North American Indians, pre-Columbian Central and South American civilizations (she lived in Mexico as a young artist), and the British Isles (her own ethnic background; her grandfather was a Scots mining engineer). Her subjects range from Tikal to Avebury, from Creek Indian mounds to Scandinavian ship burials. Through them she tries to understand the "spiritual involvement of people with land, in the fact that people have been in the place, chosen it for a particular reason."[14]

Since the late '70s, Stuart has incorporated her growing interest in photography into her abstractions, bordering or centering the earth-saturated paper with her own photos of its prehistoric sources, fusing the pictorially evocative power of photographs with the directly physical power of the earth itself. Photography has expanded the formal vocabulary with which she expresses the gap between prehistory and the present. Some works, such as an intaglio study of the shape permutations of ancient stone tools and a grid of color photos of wildflowers, minimize or omit altogether the earth/paper element. But, for the most part, Stuart's ability to bring the viewer into her multileveled world of touch and memory is based on the process of finding, grinding, and rubbing. Her "remembered" or "dreamed" information about ancient places augments that in the history books.

25. *Michelle Stuart.* Silbury Hill by Winterbourne Stream, Wiltshire, England. *1981. Earth from site, black and white photos on rag paper. 11¾″ × 12¼″. (Photo: D. James Dee © 1982.)*

26A, B. *Michelle Stuart.* Rock Books. *1975–80. Earth and natural objects on paper.*

Silbury Hill by Winterbourne Stream Wiltshire England. M. Stuart

25.

26A. 26B.

27A. *Robin Lasser.* Passage Grave Art, *from the series* Remnants of Those Left Behind. *1980. La Jolla Cove, California. Sepia-toned silver print, 16″ × 20″; construction of sand, stone, pigment, pine needles; nests 1′ to 3′ diameter, column 5′. Lasser records her intimate and ephemeral "archeological constructions." Made from natural materials, guarded by birds' nests, these private ethnographies occupy drainage tunnels, rooftops, vaults, or natural settings for only a day, telescoping time as "a combination of past and future." The rocks remain as the "sole fossilized trace of the original construct." She sees these works, modeled on Mayan and Native American sacred places, as tombs: "the image's role is to ensure the preservation of an idea."*

27B. *Marie Yates.* Fieldworking Paper IX. *June 18, 1972. Harford Moor, Dartmoor. Documentation: photos and texts. In her* Field Workings *series (1971–75), Yates used the prehistoric monuments of southern England, especially those on Dartmoor, as the cores of evocative photo-text pieces to stimulate perception of the stones with their natural surroundings as a whole. Sometimes she enacted private performances in which weather, sound, and touch played the leading roles. They were conceived as "models of experience," relayed to a larger audience by photo-texts in galleries, or by booklets, in an attempt to construct "a coherence of ecology, cosmology and mind; an assumption of an attitude of awareness of the basic components of our universe, mostly disregarded, unremembered and ignored."*

27A.

27C. 27D.

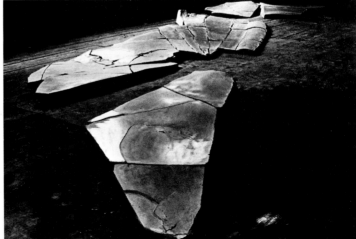

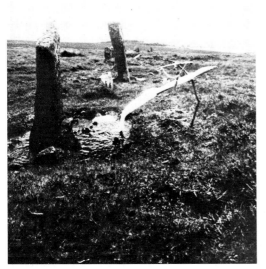

27B.

27C. *Cathey Billian.* Clay Phrases/Long Shadows. *1978–79. Installation of lava and earth samples embedded in high-fired clay. 37' wide. Billian's earlier work utilized rubbings of Southwest Indian petroglyphs. (Photo: Nathan Rabin.)*

27D. *Gillian Jagger. Detail of* Origins and Endings. *1979. Rockite cement. 22' × 12'. Jagger knows the British prehistoric sites well. Her cement castings are dissolved composites of the forms of natural rocks, her own body, and of animals, medieval rock-cut tombs and effigies, and a panoply of other ancient stone references. The result is a floor sculpture that is also a landscape—a "hill-and-vale motif," imitating "nature's process, not her products," her "facts of geometry and energy." Jagger uses stones as "a catalyst for merging with body parts." Inspired by the evocative frozen flow of an African volcano, she applies her studies of archeology and natural sciences by focusing on the ways things break and fit together, and on the resulting patterns that underlie all life structures—an Inca wall, the Burren cliff, a furrowed brow, an elephant skin; bits put together in different ways in different amounts making the whole."*

27E. *Bauduin.* Réalisation pour l'Aulnay, Loire Atlantique (44). *1978. Granite. Bauduin was raised near Carnac in Brittany, among the ubiquitous megaliths of that area, which deeply influenced his sculpture.*

27F. *David Harding.* Henge. *1972. Glenrothes, Scotland. Pre-cast concrete. 9' high. Harding was an initiator of the "town artist" program in the British Isles and was himself resident artist in the town of Glenrothes for some 10 years.* Henge *suggests ancient stone circles and Celtic decorative motifs, but these are combined with quotations from Gandhi, Dylan, the Beatles, and Martin Luther King. The external view is modern abstraction; the interior looks inward with sacred symbols. (Photo: Peter and Aase Goldsmith.)*

27E.

27F.

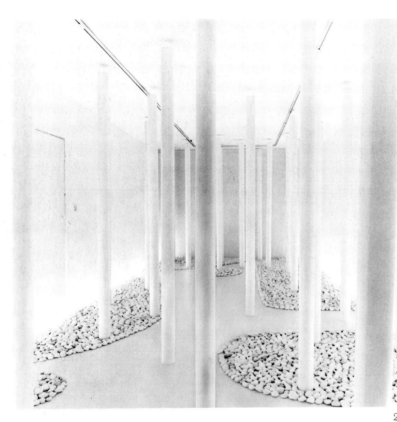

28A.

28A. *Vida Freeman.* Installation. *1981.*
ArtSpace Gallery, Los Angeles. White
PVC pipe, hand-formed porcelain and
stoneware stones, daylight fluorescent
lights. 35' × 12' × 8'. Freeman's
archeological experience helping
reconstruct a stone circle in Scotland
followed her photo-text works on Death
Valley and on land use in the town of
Northridge, California. This glowing,
all-white environment distills in
modernist form the stately pillars of
prehistoric circles. "It blows my mind,"
Freeman wrote in a letter, "to realize
that the bit of prehistoric pottery I can
hold in my hand today was made and
used by hands just like mine so many,
many years ago. How I wish I could
somehow, even for an instant, know
what life was like then."

28B. *Gisela Fischer.* Magic Circle. *1974.*
Sieved ashes and earth on paper with
pebbles and drawing. 30" × 22½". It
refers to the legend of Joseph's Circle; the
computer numbers might refer to the use
of computers to decode ancient
alignments, and the ashes might refer to
the fire rituals that took place within
many stone circles. Fischer concentrated
on the visual subtleties of natural
relationships in her gentle paper works
and temporary installations with stones
reeds, grasses, and photos of ancient
stone goddesses. Another work, Natural
Compass *of 1971, was inspired by a bent*
reed on a beach, which the wind had
helped to inscribe its own circle; she
reflected that perhaps this is the way
primal peoples discovered the compass.
(Photo: Daniel E. Quat.)

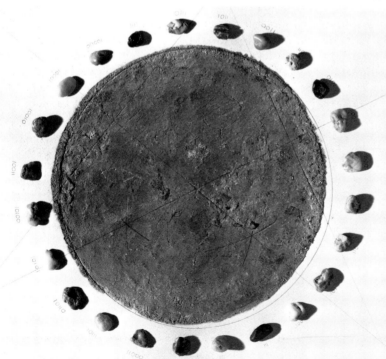

28B.

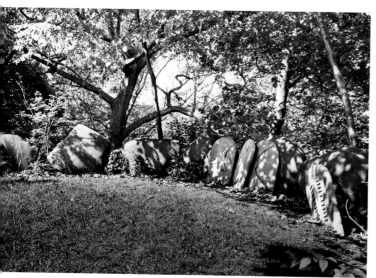 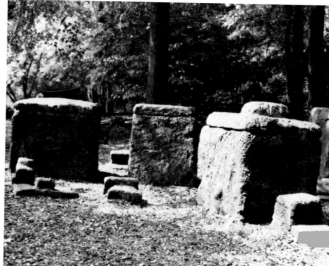

28C. 28D.

28C. *Donna Byars. Dream Stones. 1979. Wave Hill sculpture show. Cast cement. 40'; stones c. 33" × 19" × 3". Each stone tablet is marked with a symbolic form that emerged from the artist's dreams. She perceives the work as a kind of personal archeology, the viewer being forced to puzzle over and identify with the images as though discovering evidence of a lost civilization—a metaphor for the personal and collective unconscious.*

28D. *Beverly Buchanan. Ruins and Rituals. 1979. Museum of Arts and Sciences, Macon, Georgia. Stained concrete. 20" × 23½" × 4'7". This is the first, public part of a three-part work, the forms of which recall unburied tombs or giant reliquaries. The second part is private, hidden in the woods nearby and intended only for the searching audience. The third is still smaller, and totally personal; it was buried in a river by the artist. Buchanan's recent outdoor work* Marsh Ruins *lurks in the Georgia marshlands; it resembles the long-abandoned remains of some still more ancient monument made of untouched boulders. All of her works might be read as an archeology of the levels of consciousness.*

The illustrations above represent only a sampling of the large number of artists working with similar material. (A great number of others are working today with stone and rock motifs, though most relate only peripherally, if at all, to prehistoric cultures.) Their approaches to the "overlay" may vary immensely, but they share an interdisciplinary breadth that belies narrow definitions of art as decoration rather than visual information. They also share a desire to bring their audiences closer to their own intimate experiences of nature and of the past. One need not be a "soft primitivist" to admire the clarity with which the megalithic peoples collectively addressed themselves to the most profound questions about the earth, the cosmos, death and rebirth—human preoccupations then as now. They even did so within a relatively stable social framework. Malnutrition, human sacrifice, and a predictable amount of violence notwithstanding, there is little evidence of warfare through the Bronze Age in Britain. Some of the megalithic sites appear to have been used, improved, and reused continuously for over a thousand years, providing not only esthetic but enviable social models for our dangerously quibbling society with its mania for planned obsolescence. Stones, still symbols of permanence, add new meanings to the old in the midst of our cultural disjunctions while the ancient sites take on new functions when translated by these artists.

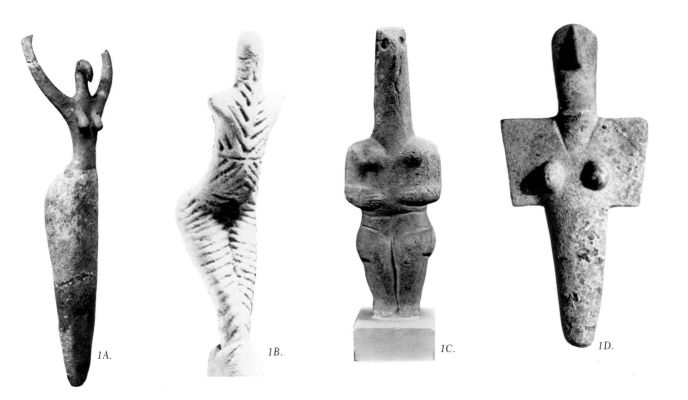

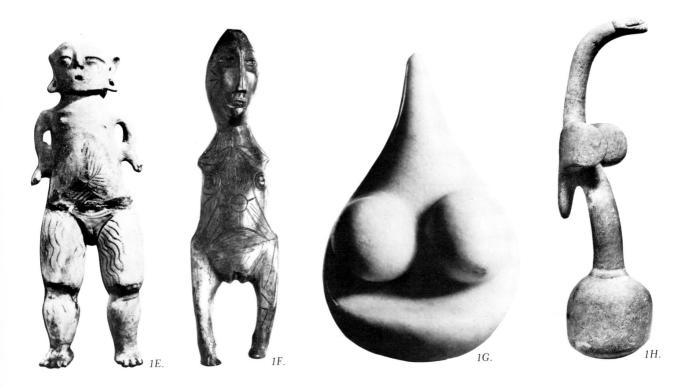

1A.

1B.

1C.

1D.

1E.

1F.

1G.

1H.

Feminism and Prehistory

Art itself must have begun as nature—not as imitation of nature, nor as formalized representation of it, but simply as the perception of relationships between humans and the natural world. Visual art, even today, even at its most ephemeral or neutralized, is rooted in matter. Transformation of and communication through matter—the primitive connection with the substance of life, or *prima materia*—is the rightful domain of all artists. Add to this the traditional, and ambivalent, connection between woman and nature, and there is a double bond for women artists.

Yet most of the art about nature we know historically is art by men. Horst Janson's standard textbook—*History of Art*—does not include a single woman. This absence of women from art history, added to emotional needs for gender affirmation, is one of the reasons feminist artists have taken the conventional history of art with a massive grain of salt. Searching for models of female experience, many have turned to prehistory (which has been colonized but not yet conquered by patriarchal scholarship); simultaneously women artists are reinserting themselves into history as a whole.

With the rise of the new feminism in the late 1960s, women's longing for a history and mythology of our own found an outlet in a revisionist view of prehistoric matriarchies. Despite cursory or downright absent information about women in the dominant literature, we began to find out that woman had once been seen as the omnipotent deity, source of all things, perhaps even earlier than 25,000 B.C.—the date given the *Venus of Willendorf*. Merlin Stone, in her book *When God Was a Woman*, brings to light female sun goddesses, Queens of Heaven, Ladies of Vision, goddesses credited with the discovery and sponsorship of language and writing, Goddesses of Intelligence and Knowledge. These heroic figures began to take their places beside the moon goddesses, household deities, and fertility cults of lesser stature to which the original Mother Goddess was relegated in the books most of us were raised on under the benevolent patriarchy. There is no proof of wholly matriarchal *governments*. But there seems little doubt that matriarchal *religions* existed in

In the beginning there was Isis: Oldest of the Old. She was the Goddess from whom all Becoming Arose. She was the Great Lady, Mistress of the two Lands of Egypt, Mistress of Shelter, Mistress of Heaven, Mistress of the House of Life, Mistress of the Word of God. She was the Unique. In all Her great and wonderful works She was a wiser magician and more excellent than any other God.
—Thebes, Egypt, fourteenth century B.C.

You ask me to plow the ground. Shall I take a knife and tear my mother's breast? Then when I die she will not take me to her bosom to rest. You ask me to dig for stone. Shall I dig under her skin for her bones? Then when I die I cannot enter her body to be born again. You ask me to cut grass and make hay and sell it and be rich like white men. But how dare I cut off my mother's hair?
—Smohalla, Nez Percé dreamer, c. 1850

He says that woman speaks with nature. That she hears voices from under the earth. That wind blows in her ears and trees whisper to her. But for him this dialogue is over. He says he is not part of this world, that he was set on this world as a stranger. He sets himself apart from woman and nature.
—Susan Griffin, 1978

1A. Egyptian female figure with bird's head from El Ma'mariya, 4th millennium B.C. Painted pottery. (Collection: Brooklyn Museum.) B. Bird-headed, water-striated goddess from Cucuteni, Romania. c. 4000 B.C. Incised terracotta. (Nam Bucharest.) C. Neolithic statuette from Eleusis. c. 2200–2000 B.C. (Photo: N. Stovnapas.) D. Prehistoric "Great Mother" figurine from Sardinia. Limestone. (Collection: Cagliari Museum.) E. Woman. Modeled and incised clay, remains of ornamental pigment. 18¼". (Mannil Collection, from Arte Prehispanico de Venezuela, fundacion Eugenio Mendoza.) F. Ovick figurine from Old Bering Sea culture. c. 3000 B.C. Ivory. (Photo: courtesy University of Alaska Museum.) G. Louise Bourgeois. Femme pieu (Stake Woman). c. 1970. Pink marble. 4½" high. (Private collection, New York.) H. Stone pestle in the form of a bird from N.E. Papua, New Guinea. (Collection: British Museum.)

every part of the world and dominated the most ancient cultures. Traces of the matriarchal tradition remain in the matrilineal and matrilocal customs of some primal societies today. Even the most muddled and misogynous scholarship on prehistory provides fuel for contemporary art around this theme.[1]

The earth was and often still is seen as a woman's body. This has, on one hand, provided a psychic history of female strength that remains, vestigially, even in urban societies. It is also the source of much debate among "cultural," "radical," and "socialist" feminists on issues of female stereotyping, submissiveness, and biological destiny. There is no question that the identification of woman with nature and man with culture has played a damaging role in the relegation of women to inferiority in male-dominated societies. Many theorists have pointed out that the essence of a culture can be found in the degree of its domination of, or independence from, nature. As Gina Blumenfeld has shown:

In order to undertake the conquest of external nature, man had to conquer his own internal nature, making woman the repository of all the qualities within him which he had come to fear and despise. This transformation amounted to nothing less than the transformation of human beings, male and female, as well as the rest of the natural world, into *means of production*. Today we stand at the end of this long process of internal and external subjugation . . . the antagonistic split between man and external nature as well as that between humanity and its own internal nature (which includes the polarization between woman and man) are of a whole cloth and *must be overcome together*.[2]

Women can, and do, identify the forms of our own bodies with the undulations of the earth—the hills and sacred mountains which were the first gardens and the first temples. Our menstrual periods are moon-determined, therefore related to the earth's magnetic energies and to the ocean's tides. Our genitalia recall caves, cleft rocks, river beds—the cozy and fearful abysses culturally associated with the nourishing and with the fearsome, with the maternal and sexual, the regenerative and deathly aspects of the Earth Mother.

To many of us, feminism has meant the discovery of a regrettably unfamiliar pride and pleasure in being a woman. My own attraction to prehistory, with its consistent female depictions, was prefaced by my personal experience of women's art and the ways in which it differs from men's. Beginning in 1970, I looked at the work of virtually thousands of women artists. By 1971, I could no longer deny, as I had before, that there is a uniquely female expression, although whether this is "innate" or the result of social conditioning is still a controversial question.[3] Either way, women's social, biological, and political experiences are different from those of men; art is born of those experiences and must be faithful to them to be authentic. Therefore, to deny the fact of a woman's art is to neutralize and falsify what women are learning from our new approach to history: that one of the roles of female culture has always been to reach out and integrate art and life, idea and sensation—or nature and culture.

With the realization of how men's domination of nature has often led to ecological disaster, to pollution, a disappearing water supply, world

2A. Dolmen, Kermario, Brittany. Probably before 2500 B.C. (Photo: Lucy R. Lippard.)

2B. Dowth mound, Boyne Valley, Ireland. One of three great Stone Age mounds built c. 2500 B.C., including Knowth and New Grange. (Photo: Nigel Rolfe, "West of West" exhibition.)

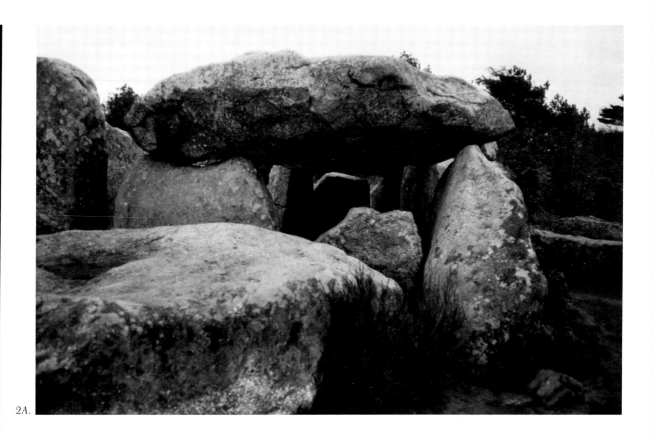

2A.

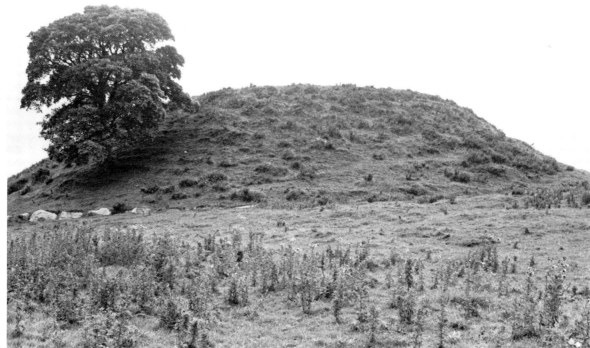

2B.

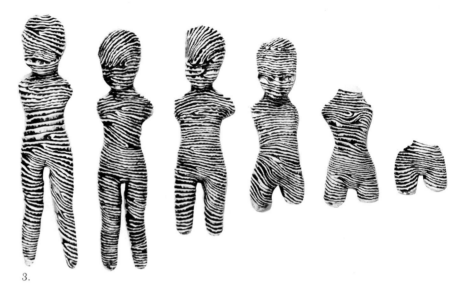

3.

hunger, overpopulation, nationalism, militarism, and greed, comes a real necessity to understand where the paths of nature and culture diverged.[4] Sherry Ortner's important 1972 essay "Is Female to Male as Nature Is to Culture?" acknowledges that the biological and psychic differences between men and women "only take on significance of superior/inferior within the framework of culturally defined value systems."[5] Yet even she proceeds to follow the conventional, male-conceived path by defining culture as the transformation and transcendence of nature, wherein woman's role as synthesizer, mediator, or simply fuser of nature and culture is destined to be "transcended" rather than valued in its own right.

I disagree with Ortner and with those feminists who insist that all uses of "primitivism" are retrograde, who deny all identification between women and nature because it encourages destructive stereotypes. While physical rapport with images and cycles in nature means a lot to many women artists, many others still become anxious and even angry when any link is suggested between women's art and women's biological and social experiences—and, by implication, between women's art and ancient matriarchal traditions. Yet feminism is about changing the negative impact of such notions, about controlling our own lives and products and public images, within a framework of social responsibility to all people.

Revolution means, among other things, retaining the individual political choice to change some things and keep others in one's personal life. Because women's social subordination has resulted largely from the unchangeable character of our bodies, some feminists believe that it is backward to perceive any part of that character as culturally affirmative or worth retaining. Others, myself included, see no reason why all distinctly female qualities should be discarded in the process of change, especially in favor of an unattainable, overrated (and undesirable) androgyny.

A related issue, which links stylistic "primitivism" to women's political identification with the earth, is the way such an identification parallels that of disenfranchised peoples in "underdeveloped" Third World countries. ("Underdeveloped" or "uncivilized" means remaining closer to nature.) We do not have to approve the historical reasons for this empathy

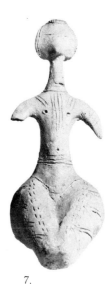

4. 5. 6. 7.

3. *Michele Oka Doner.* Descending
Torsos. *Clay. 16″ to 3″. (Collection:
Elizabeth M. Bank; photo: Dirk Bakker.)*

4. *Ana Mendieta.* Itiba Cahuba (Old
Mother Blood). *1981. Carved rock on
site, Jaruco, Cuba. Life-size. (Photo:
Ana Mendieta.)*

5. *Louise Bourgeois.* Fragile Goddess.
*c. 1970. Self-hardening clay, 10¼″ ×
5⅝″ × 5¾″. (Photo: David Sher.)*

6. *Jeanne Fabb.* La Revolutionnaire.
1979. Wood and roots, 6¼′ × 4′ × 1½′.

7. *Nubian fired-clay figure of a tattooed
woman. 1900–1550 B.C. (Collection:
Egyptian Museum, Cairo.)*

between women and the oppressed, but we should be questioning why
we are so often discouraged from thinking about this, why the "nature-
nurture" syndrome is anathema to the patriarchy as well as to some
feminists.

Artists can help change the dominant culture's view of women by
changing the context in which the deeply engrained connection between
women and nature is perceived. Examination of prehistoric matriarchal
religions can help place the symbolic content of contemporary artists'
work in critical relation to its general social framework. The debate about
the advantages, disadvantages, and sources of woman's identification
with nature is important to this book because of the profound influence of
prehistoric myth and imagery on contemporary women's art, due in part
to the convergence of the latest wave of feminism and the upsurge of
interest among avant-garde artists in "primitivism." This combination is
no coincidence. It testifies to a basic need, expressed by men as well as
women, to reevaluate the socio-esthetic structures and values of the soci-
ety in which we live.[6]

The contemporary artist's renewed interest in natural process can in part
be traced to a prevalent anxiety. Our civilization has placed cement be-
tween us and the earth, pollution between us and the sky, technology
between us and the seasons. We have lost our rural/matriarchal connec-
tion with natural phenomena, and its resurrection seems less and less
likely in an increasingly urbanized world. Robert Graves has noted that
the fundamental agrarian mother-son myth (in which the Great Goddess
bears, mates, and murders the waxing then waning Year King) "is so
closely linked to the natural year and its cycle of ever-recurring observed
events in the vegetable and animal queendoms that it makes little appeal
to the confirmed townsman, who is informed of the passage of the sea-
sons only by the fluctuations of his gas and electricity bills or by the
weight of his underclothes." However, Graves did not take into account
the possibility of the cultural impulse from "the distaff side" reforging
some of those bonds. His *White Goddess* is a classic combination of

woman-worship and misogyny: "Woman is not a poet, she is either a muse or she is nothing."[7] Not only is most of the art about nature we know art by men, but the theorizing about creativity is similarly one-sided. For instance, when Otto Rank says "the creative impulse . . . has something positively antisexual in its yearning for independence of organic conditions,"[8] he is talking only about the male creative impulse, and ignoring the sources of much women's art.

The abyss between nature and culture in the West seems to have been made historically official by the artless Judaic and artful Christian religions. With a deeply anti-natural bias and a brutal severing of spirit from matter, mind from body, they managed to replace or at least absorb and disguise "pagan" culture. (The word *pagan* comes from the Latin *pagus*, for country or village, i.e., rural and agricultural.) Due to the resulting skewed notions of nature and culture, women artists' attempt to restore a forceful female image is a complex enterprise. Replacing the headless and expressionless nudes, the flowery muses and femmes fatales and bovine comforters of "high art" history with a new active persona, or trying to imbue the old images with more positive content, is not an easy task, and it is only in its early stages. The assumption that woman's creativity is taken care of by her biological ability to bear children is nonsense, although many women artists do relate their cultural creativity to their natural creativity, and explicitly link their art and their bodies. As Tania Mouraud said, "Women, who create, know what creation is. I started to paint after bringing my daughter into the world. The male argument which sees the maternal sensibility as an obstacle to creation seems inverse. On the contrary, the male's fixation upon his sex, the fundamental fear which animates him of one day finding himself impotent, has completely falsified the very notion of art."[9]

Mouraud's assumptions are borne out by scholars like Géza Róheim, who says that men, when creating poems, feel like pregnant women; and that women, when pregnant, forget their art.[10] Similarly, if more sinister, artist Stanislao Pacus declares, "Woman annuls creativeness. She is the dualistic model of love-hate in which the artist loses himself and from which, with intellectual effort, he escapes."[11]

Another way female culture has been reassimilated into the fine arts is through the unconscious absorption of utilitarian elements. Divorced from "high" culture in the Renaissance, "crafts" or "decorative" and "minor" arts have made their way back into the mainstream largely through feminists' restoration of women's traditional images and techniques. But this reconciliation of high and low cultures is only partial; Navaho rugs are acknowledged to have influenced famous male geometric painters, but are never called women's art. "Low" or "useful" art "transcends itself" to become "useless" when it is appropriated by high culture—a process that is a major historical factor in the alienation of art from life and of makers from what they have made. Crafts are still derogatorily associated with women (who probably invented them along with architecture, medicine, and animal "husbandry"). Some women artists have welcomed this association with objects of daily necessity (both sacred and profane) and have worked individually and collectively to insist on it even while it is denigrated by the purists. Others continue to

reject the whole idea of "useful" art as part of a demeaning female stereotype.

Yet a volcanic layer of long-suppressed imagery has been surfacing in women's art about prehistory and nature, much of it anxious, angry, sexual, and painful—in the senses both of dealing with internalized pain and of being excruciatingly unfamiliar. The goal, however, is rarely narcissism or masochism (as some would have it), but transformation. The imagery is intended to dispel taboos and is part of an exorcizing and healing process. In fact, ancient healers found correlations between the rhythms of the body, nature, and the heavens. The development of a "higher," "objective" culture was possible only when the purely "subjective" factors (or individual relationships to natural cycles) could be overcome by more generalized control. Rank and others suggest that religio-art "progressed" from location in the belly/womb to eventual residence in the head (which, as in Zeus' case, absorbed the more ancient female functions of the belly).

In this view, contemporary art might be going back—or backwards, depending on your stance. As Jack Burnham has observed in his essay "The Artist as Shaman," "Art in its last stages constitutes a structural reversion to the infantile stages of human development," foregoing sublimation through object making and returning directly to our bodies and personal experiences. "It is precisely those artists involved in the most naked projections of their personalities who will contribute most to society's comprehension of itself," he declares. The shaman-artist has the potential to "draw people away from the substitute objects toward the ancient memories of life and productivity."[12] Like an archeologist, then, the viewer of contemporary art must collate residual information about the maker *and* about her or his own experience, in order fully to comprehend the work.

The paintings of the Mexican artist Frida Kahlo (1910–54) offer a rare fusion of personal physical sensations and a broader cosmic view. She was part Indian and part European, immersed in "that Mexican sense of solitude that Octavio Paz has called 'a form of orphanhood.' "[13] Kahlo's works are painful, powerful and direct—embarrassingly emotional and visceral (to an Anglo-Saxon culture), exuding a longing for connection with an anthropomorphized Earth Mother, or perhaps for death and release from the torture of her own numerous miscarriages and eventual invalidism.

The painting *Roots* (1943) is a self-portrait. The artist, in peasant dress, reclines on a barren, rocky plain; stemmed plants, or vines, grow from a cavity through her chest. From their leaves spreads a network of tiny red capillaries, bleeding back into the earth and binding her to it. In *La Flor de Vida* (1944), lightning, sun, pods, and fiery leaves firmly confuse body and plant, woman and cosmos. Childless herself, Kahlo repeatedly depicted what might be called mythological motherhood. In her 1949 *Portrait of Diego* (her husband, the artist Rivera), a giant goddess, half black, half white, holds in her lap a dark idol who holds Kahlo herself who holds in turn a small Diego. Growing from these concentric circles are animals, plants, and roots.

9A.

9B.

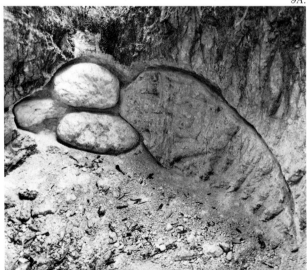

Kahlo's most extraordinary work on this theme is *My Nurse and I* (1937), in which a nude Indian woman with the calm, strong face of a stone pre-Columbian mask suckles an adult-faced Kahlo with a child's body. The breast is transparent and the lactating veins become tiny white flowers whose stems lead out through the nipple. Hayden Herrera, the artist's biographer, has remarked that "such masks were associated with [ancient Mexican] ceremonies in which women, children and captives were sacrificed to propitiate . . . [with] the idea that the sun must be fed human blood to sustain its life-giving powers."[14] (In a perfect example of the overlay of patriarchal on matriarchal values, the Aztec goddess Coatlicue—originally a benevolent serpent-skirted deity, like the Cretan snake goddess—was later transmogrified by bloodthirsty militarism into a fearsome mother of war gods.[15])

The early work of Ana Mendieta is marked by a similar preoccupation with blood, violence, and fertility, with images of skeletons, flowers, and the earth-as-body (characteristic of a Hispano-American fusion of "pagan" and Catholic religions). Sent from Cuba to the U.S. as a 13-year-old and raised, miserably, in an Iowa orphanage, Mendieta began to make art that might be seen as charms against the evils of her deracination. Since the early '70s, she has cut or demarcated her *Silueta* series into a great variety of natural materials and environments. The image is based on her own schematized figure, arms sometimes raised in an incantatory gesture. She has cut this form into the earth and set it on fire, leaving a black human-shaped pit of fertile ash. She has silhouetted it in flowers which she then floated down a river on a raft, as though on a journey to another world. She has outlined her body in candles like a shrine, and in fireworks against a night sky. She has made herself into a volcano with a gunpowder *silueta*, altered a ravine and a cave entrance to resemble her body, drawn her figure on the stone floor of a pre-Columbian temple. She has had herself filmed beneath the grass as a pulsing mound of turf, has erotically "breathed life into a skeleton" in another photo piece, and once painted her bone structure on her nude body in a literal *vanitas*. In a piece that recalls Kahlo's *Roots* and *My Nurse and I*, Mendieta was photographed nude in an ancient Mexican stone grave with a mass of tiny white flowers growing from her body.

Mendieta's art is not only a generalized expression of body-earth identification, but is specifically tied to her obsession with Cuba and her Latin heritage. Her subject is resurrection in a double sense—mythical/personal and historical/political. Her poetic use of her own body is paralleled by a revolutionary metaphor. After returning to her homeland to visit several times, Mendieta worked there in the summer of 1981. She carved her *siluetas* deep into the limestone caves of Jaruco—a mountainous area that has traditionally given shelter to Cuban rebels. The protective element is both concrete and mythical, or maternal. The images are stronger, cruder, more sexual and more abstract than the delicate earlier work, as though the artist had gained strength from direct contact with her native earth and the myths of its ancient peoples. Mendieta's *Rupestrian Sculptures* are both modern and primal in their ferociously female symbolism.

The double affinity with nature and with "primitive" culture is also

paramount in the work of Georgia O'Keeffe (1887–) and the Canadian Emily Carr (1871–1945). Although their medium, like Kahlo's, is traditional oil paint, their imagery reinforces an almost sculptural view of place, nature concretized, that appears peculiarly female. Carr worked among the Kwakiutl Indians of the Northwest, documenting their disappearing forest and river cultures and painting their environment as though she herself were part of it. The oval spaces of her rain forests seem to wrap themselves around the viewer like enormous cocoons. The individual trees disappear and the place is epitomized as a swooping, dipping parabolic curtain of organic matter, fearsome in its height, age, and claustrophobic stillness. She makes us understand why during the rise of Christianity the northern forest was considered the pagan stronghold; to enter it was to risk one's soul.

Carr's *Grey* (1931) shows a petrified forest whose triangular core is like rock, like a cave, or like a heart, as well as an eerie source of light. In her diaries she fantasized about becoming a hill, or a tree. When she painted the rounded limbs of the *Kitwancool Totem* (1928), she saw them growing like tree trunks or phalluses (or standing stones) out of sensuous green nests of earth and foliage. "The Indian has carved into his pole the same silences, mysteries, and excrescences as nature has in hers," wrote Doris Shadbolt. Carr "has grasped the Indian's intuitive creative process and in turn 'totemized' her own environmental experience."[16]

Georgia O'Keeffe, the lone woman to be included in most books and shows of modern "masters," has become almost a cult figure, especially for feminist artists, despite the fact that she is adamantly uninterested in making connections between her art and her female experience. She insists that the erotic imagery in her paintings of flowers and rhythmic hills has been "put there" by the viewers. Nevertheless, O'Keeffe's extremely realistic and at the same time highly abstract pictures of the New Mexican earth, where she has made her home for some 50 years, have a voluptuous spareness that unavoidably evokes a female body in contour and surface. She once wrote: "I am trying with all my skill to do a painting that is all of women, as well as all of me."[17] (Her public resistance to feminism is probably a reaction against critics like Willard Huntington Wright, who wrote, wrongly, "All these pictures say is 'I want to have a baby'."[18]) To "paint all women," she chose to picture the land and natural forms. In a lone black stone or the bleached aperture of a cow's pelvic bone or the harsh multicolored folds of dry mountains, she evokes what the earliest peoples once saw—the spirit of the object, its simultaneous past and future. "Nothing is less real than realism," she has said; and of her home in the Southwest: "Sometimes I think I'm half mad with love for this place. . . . My center does not come from my mind—it feels in me like a plot of warm moist well-tilled earth with the sun shining hot on it."[19] The Pedernal Mesa—a recurring image in her work—is believed by the Navahos to be the birthplace of their legendary Changing Woman (literally "A woman she becomes time and again"), who represents both earth and time.

Archaic societies believed that sanctity was incarnated in the earth itself. In *The Earth, the Temple and the Gods,* his eye-opening book about ancient Greek architecture in landscape, Vincent Scully says that in an-

10.

cient religious traditions, "the land was not a picture but a true force which physically embodied the powers that ruled the world." This sense of place as literal *birthplace* has been better recognized by artists than by art historians and classical archeologists. Scully complains that their bonds to a nineteenth-century model of esthetic reality make scholars unable to see landscape "in other than picturesque terms." Blind to its sculptural forms and insensitive to its iconography, he says an overview of its spiritual underpinnings is out of their reach.[20]

Most prehistoric peoples seem to have begun by worshipping nature generally, as the body and fluids of the All-Creative Mother who preceded the Indo-European split between Mother Earth and Father Sky. John Michell has suggested that the worship of specific parts of the earth's body in isolated land forms emerged from a nomadic life, and that only with agriculture was this custom formalized into a ritual retracing of the annual journey: "With settlement the primordial rhythm was lost. People no longer traveled by the stars and followed the veins of the earth to the old landmarks."[21] As culture became more separate from nature, people began to alter the natural forms and still later to imitate and abstract them into communally recognizable symbols. Michell surmises that religion itself emerged from guilt at abandoning the old natural ways. (Perhaps *this* was the original sin?)

Today, however, when all the arts are in danger of becoming "the

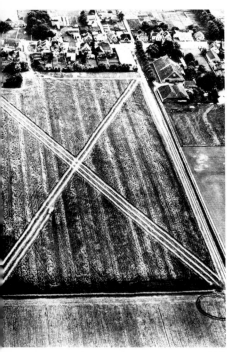

11A.

dance band on the Titanic,"[22] visual art is popularly put on the derogatory "nature" side of the status scale, although lip service is paid to it as "culture." Men who have chosen such a "feminate" vocation have had to protect their virile images with a competitive vengeance, which has been concentrated on separating themselves from female artists and from the female in themselves. Thus discrimination against women artists probably has its roots in thousands of years of discrimination against nature, and against the early matriarchal religions.

Due to the complexity of modern self-knowledge and the heightened awareness Marxism, feminism, and the ecology movement have brought to our perceptions of man's relationship to nature, the ways in which this issue is addressed in contemporary art are rooted in social and esthetic contradictions. The double need to become part of a nurturing nature and to master a threatening nature make man's relationship to the earth more ambivalent than woman's. On the one hand, there is the relatively gentle notion of seduction or colonization, as when Jackson Pollock (working on canvas rather than earth) declared, "I *am* Nature . . . I work from the inside out, like nature."[23] On the other hand, there is the survival of sentiments such as those expressed by Francis Bacon in the seventeenth century in an essay entitled "The Masculine Birth of Time": "I am come in very truth leading to you nature with all her children to bind her to your service and make her your slave."[24] A contemporary male artist told me, only half-jokingly, "Nature is my slave." And it is clearly a male image wryly evoked by Martha McWilliams Wright when she imagined the earthwork artist standing "alone in the desert or in the semi-rural art park, shaking his fist at the universe, with the bulldozer and dumptruck at his side."[25]

With this in mind, I find it interesting that an X across the earth has been a favorite motif for male earth artists. Robert Morris made a giant X across a hill as a public park/path in Grand Rapids, Michigan. Chris Burden made fiery X's on the land in the early '70s. Even the gentle Richard Long makes X's, treading them into the land, or, in a particularly ambivalent gesture, by decapitating the heads of daisies in a field. This might be seen as a reflection of Joseph Campbell's observation that "there is a subtle hint of death in the life-giving harvest," referring to the annual decapitation of the First Fruits, or of the Year King.[26] Women artists have emphasized the earth victimized or fighting back, paralleling Frankfurt School philosopher Max Horkheimer's concept of a cyclical "revolt of nature."[27] In 1972 Eunice Golden painted a huge woman horizontally crucified on and as the land. In her *Scarification Object Series (SOS)*, Hannah Wilke adorned her body with tiny pink vaginal forms, comparing the scars of nature's and modern woman's domination, and identifying with the earth's vulnerability. Muriel Magenta and Barbara Noah have focused on a constructively catalytic natural violence rather than on individual pain in their photomontaged and painted images of volcanos.

Although there has been a good deal of criticism of the anti-ecological aspect of huge-scale earthworks that gouge and alter the land in a para-industrial manner, large works are not inherently more domineering than small works. It is the attitude toward the land, the artist's sensitivity to the place that determines the effect of the imagery. Dennis Oppenheim has

11B.

11C.

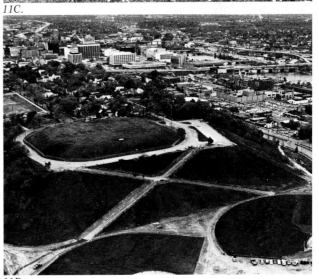

11D.

11A. *Dennis Oppenheim.* Directed Seeding; Cancelled Crop. *1969. Finsterwolde, Holland. "Procedure: the route from Finsterwolde (location of wheat field) to Niew Schans (location of storage silo) was reduced by a factor of 6X and plotted on a 508' × 221' field. The field was then seeded following this line. In September the field was harvested in the form of an X. The grain was isolated in its raw state; further processing was withheld. This project poses an interaction upon media during the early stages of processing. Planting and cultivating my own material is like mining one's own pigment (for paint). . . . In this case the material is planted and cultivated for the sole purpose of withholding it from a product-oriented system . . . the material's destiny is bred with its origin."*

11B. *Richard Long.* Two Lines Walked Through Dust-Covered Grass by the Roadside, *Kenya. 1969. (Photo: Richard Long.)*

11C. *Richard Long.* England. 1968. *Durham Downs, Bristol. (Photo: Richard Long.)*

11D. *Robert Morris.* Grand Rapids Project. *1974. Grand Rapids, Iowa. Asphalt, two ramps, each 18' across, cut into graded hillside; cross at central platform. (Photo: courtesy Leo Castelli Gallery.)*

11E. *Dennis Oppenheim.* Relocated Burial Ground. *1978. El Mirage Dry Lake, California. Black asphalt primer. 2000' square.*

11E.

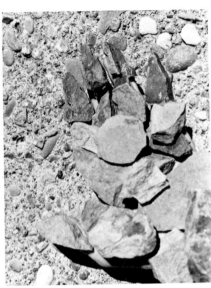

12.

12. *Dennis Oppenheim.* Rocked Hand.
*1970. Aspen, Colorado. Stills from 4-
minute 8mm color film.*

13A. *Michael McCafferty.* Body
Compass. *1976. McCafferty writes: "The
difference between artmaking and ritual
is one of efficacy; artmaking is one step
behind impact. Ritual solicits, elicits
impact by humbly building and tapering
off. . . . Artwork is social but more
personal in the making. Ritual is
social."*

13A.

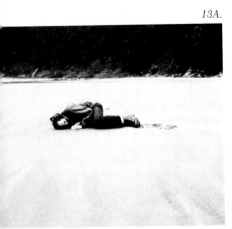

worked for years in an eccentric middle-ground between "male" and
"female" attitudes to the earth. He acknowledged the demands of a
materialist realism when he asked, "How can you justify working
abstractly on the land? Earth cannot be treated in the same way that
sculptors worked steel. One possibility that the earth movement did allow
for was the interaction with real-time structures, to tap into a dynamic
geophysical structure."[28] Oppenheim deals with ideas of identification/
dislocation, security/anxiety, in both physiological and psychological
terms, balancing precariously between the desire to succumb and fall or
to dominate and rise. In a work called *Two Jumps for Dead Dog Creek*
(1970), he jumped over a stream and noted "the place was now em-
bodied." In 1969 he branded a mountain, like the cattle grazing there, in
an overtly territorial gesture, noting that "branding the land and then its
cattle makes no distinctions in scale; cows graze on abstractions of their
own bodies."[29] In a true anti-fertility gesture, or a gesture of esthetic
power over "bread alone," he made *Cancelled Crop* (1969) in Holland, by
harvesting a field in a huge X. He also blew up a hunk of earth with
explosives in *Five Downward Blows,* or *Knuckle Marks* (1975).

In a series of Body Art pieces (1969–70), Oppenheim made himself
into a bridge between aspects of nature and aspects of self, punishment
and penance. In *Preliminary Test for a 65' Vertical Penetration* he slid
down a conical hill resembling the belly of Mother Earth; in *Wrist and
Land* he filmed morphological parallels between topography and a mus-
cle flexing; in *Parallel Stress* he lay in a cavity in the land and then as-
sumed the same position hanging painfully between two concrete walls;
in *Leafed Hand* and *Rocked Hand* his right hand rendered the left invisi-
ble by covering it with leaves and stones and reincorporating it into na-
ture; in *Reading Position for Second Degree Burn* he lay down and of-
fered himself as a captive (female) surface for the sun to penetrate
(though his "heart" was "protected" by a book on military tactics). His
body was thereby made into a painting: "My skin became pigment," he

said. "I could feel the act of becoming red. . . . It's like plugging into the solar system." In a related statement about his body-work, Oppenheim talked in an overtly sexual manner about merging with the earth: "Falling is probably the most profound experience an artist can have. . . . Essentially falling would be like presssing a traditional tool into a soft substance."[30]

Burnham's ideas about art as a "structural reversion to the infantile stages of human development" are poignantly borne out in Oppenheim's work and in that of many other male artists who seem to be testing out a primal individual relationship to the earth. For instance, Graham Metson did a photo piece showing the bearded artist himself curled naked into an oval crevasse in a rock. In 1969 in England, Keith Arnatt executed *Self Burial,* a photo series showing him slowly disappearing into the earth. In Seattle in 1976, Michael McCafferty lay in a fetal position on a beach and made himself into a *Body Compass* by "changing his spinal energy with the directions and wriggling into the land."[31] Michael Heizer, whose giant earthworks executed by machines in the western desert are seen by some as "drawings" on and in the earth, and by others as mother-rape, illuminated the quasi-incestuous relationship male artists often have with the earth when he said, "My personal associations with dirt are very real.

13B. Graham Metson. Rebirth. 1969. Colorado. From a series of works "toward meaningful ritual."

13B.

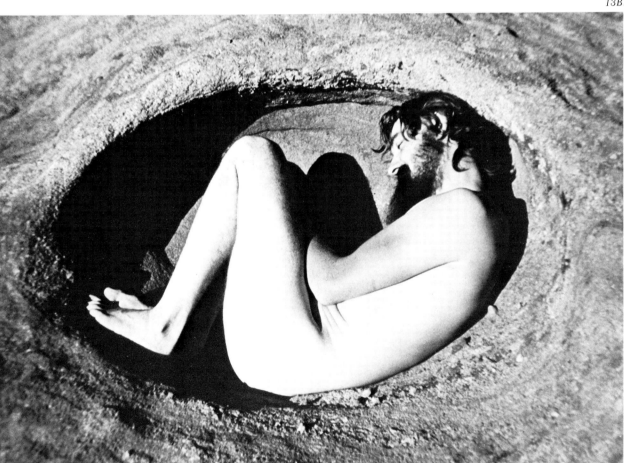

14A.

14B.

I really like to lie in the dirt. I don't feel close to it in the farmer's sense. . . . The work I'm doing with the earth satisfies some very basic desire."[32] (By calling attention to this, I may be falling into what Smithson called the "ecological Oedipal complex.")

Charles Simonds' concerns with people's cultural and psychobiological relationships to the earth are expressed on several levels, from personal fantasy to social metaphor. "I'm interested in the earth and in myself," he has said, "or my body and the earth, what happens when they become entangled with each other and all the things they include emblematically and metaphorically; like my body being everybody's body and the earth being where everybody lives."[33] The social and communal aspect of his art is best expressed in his imaginary civilization of (invisible) Little People, who migrate through the devastated inner-cities of New York and elsewhere. Simonds goes out into the streets with a pack of raw clay, builds a landscape in a niche in a broken wall, a vacant lot, a gutter, or other refuges provided by a deteriorating city; then he builds on it—ritual places, ruins, dwellings and settlements of tiny bricks. These dreamlike miniature places are ephemeral and timeless, but they also act as specific social metaphors, sparks for more permanent reconstructions of abandoned neighborhoods (see Chapter VI): "Like the Indians, the Little People's lives center around belief, attitudes toward nature, toward the land."

In his private rituals, the films and photo-works that parallel his street works, Simonds traces human evolution in personal microcosm. In *Birth* (1970), he buried himself in a clay landscape and in the film is seen emerging, or being born—horizontal and invisible at first, then slowly rising to a vertical, still covered with clay. In *Body/Landscape* (1974), he forms a mountainous landscape by writhing nude in a field of mud, creating the world. In *Landscape↔Body↔Dwelling* (1970, repeated almost yearly thereafter), he turns his own nude, clay-covered body into the earth by sculpting on it a clay landscape, which he then populates with the dwellings of the Little People. In another version (1971), he repeats the process of building on the clay-covered body of a nude woman. These androgynous rituals, in which Simonds is both born from and gives birth to the land, then populates it, constitute the rituals of his fantasy civilization. Their imagery is reflected in the strange, ambiguously sexual forms that rise from the miniature landscapes in his street and object sculptures.

Simonds sees clay as "a sexual material—symbolically as the earth and physically the way it behaves"; "the development of a personal/universal mythology" is a central concern, "as is the use of that mythology as an investigative tool to fracture the present." The Zuñi Indians in New Mexico consider clay to be the flesh of a female supernatural, and all work in clay, including brick making, is done by women. A thousand years ago, the great Anasazi "apartment buildings" of the Southwest, like Pueblo Bonito in Chaco Canyon, were built of stone and adobe by women; even today Pueblo women "plaster" the outside walls of adobe houses by smoothing the mud with their hands. Georgia O'Keeffe remodeled her house in Abiquiu, New Mexico, this way; "every inch was smoothed by a woman's hand," she noted proudly.[34] Recently the maga-

14A, B. Charles Simonds. Landscape↔Body↔Dwelling. 1970. A ritual of the Little People enacted by (and on) their creator. (Photos: Howard Nathanson.)

 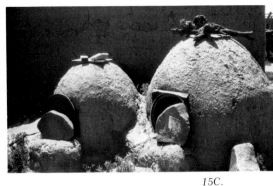

15A. 15B. 15C.

15A. Prehistoric dome, Kerlegat, near Plogonnec, Brittany. c. 2½′ high. One of several small domes moved from original sites to farmer's garden; circular pits on top surface. Similar domes have also been found in Colombia, South America. (Photo: Lucy R. Lippard.)

15B. Old European ritual oven from Great Goddess shrine at Sabatinivka, Soviet Moldavia. Mid-fifth millennium B.C. The oven was apparently used for sacred bread baking. Models of such shrines often were surmounted by horns and decorated by snake patterns prefiguring these motifs in Cretan art consecrated to the snake goddess. (Drawing after Marija Gimbutas.)

15C. Contemporary adobe ovens in Taos Pueblo, New Mexico. (Photo: Lucy R. Lippard.)

15D. Barbara Zucker. Dark Huts (50 Units). 1973. Outdoor installation at Sarah Lawrence College, Bronxville, New York. Hydrocal on cheesecloth, pigment. (Photo: Richard Nonas.)

16A. Marsha Bailey. Cleft Rock. 1977. Hand-tinted photograph. 11″ × 14″.

16B. Life-sized human figures engraved on a granite outcrop at Mt. Edgar Station, in the Pilbara region of northwestern Australia. They may represent spirit beings. (Photo: Bruce J. Wright.)

zine *Ms.* wrote about Anita Otilia Rodriguez, the last of the *enjarradoras*, or female adobe architects, who slip the walls with different hues of clay, make adobe furniture and fireplaces, and build beehive-shaped outdoor ovens.[35]

The conical dome form is found as far back as the mid-fifth millennium B.C. in clay goddess shrines from Russia, where fertility rites of sacred bread baking were practiced. It is also the form of the Navaho hogan, the Turkish yurt, and the Bedouin tent—all of which echo the contours of the land on which they stand, rather than interrupting it as angular houses do (see Chapter VI). In primal societies the house is not so much a decorated interior, a place to hide from nature, but a shelter, since the outdoors itself is home. As Simonds makes clear, a dwelling is a surrogate body, an intermediary between the macrocosmic earth body and the microcosmic human body. The form is often that of breast or belly; the reference is to darkness, dampness and nourishment, reinforcing the womb/tomb associations. The domed *kiva* and *sipapu* of the Southwest are similarly passages from and into the spirit world and the symbolic center of the universe—the *omphalos*, or navel of the earth.

The most illustrious example of the omphalos is the carved and cone-shaped stone dome of Delphi, the sanctuary of the ancient chthonic Earth Mother. It was guarded by the dragon/serpent Python, who was eventually vanquished by Apollo in a mythical reflection of the triumph of patriarchy over matriarchy, sun/sky over water/earth. The word *Delphi* meant uterus, and W. Roscher surmises that the original "navel" was the cleft in the rock from which the oracle drank the waters of wisdom;[36] the stone domes were markers, or "hills," raised over the underground springs. Such fissures in relation to domes and origins occur in various creation myths, such as the one from the North African Kabyles, in which all wild animals were said to have been born from a rock into which a bull ejaculated after losing his cow to her son. My favorite hymn as a child went: "Rock of Ages, cleft for me. Let me hide myself in thee." In researching this book, I was amused to rediscover its overt female references, and still more amused to find that the words were composed by a Reverend *Toplady*, while taking shelter from a storm in a cleft rock on a Somerset moor.

The navel of the earth is a world-wide symbol of centering for cities and civilizations. The name *Cuzco*—Peru's Inca capital—meant navel, and conical stone omphalloi inscribed with spirals are found at Celtic sites.

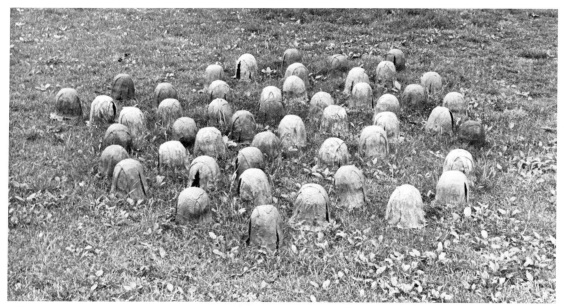

15D.

16A.

16B.

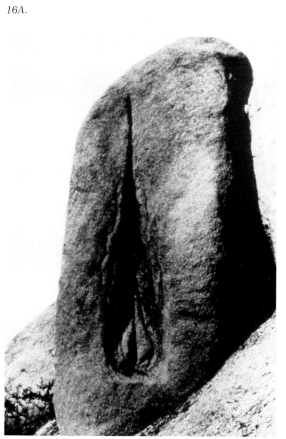

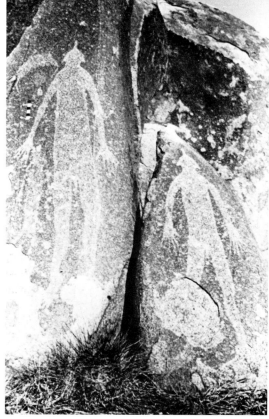

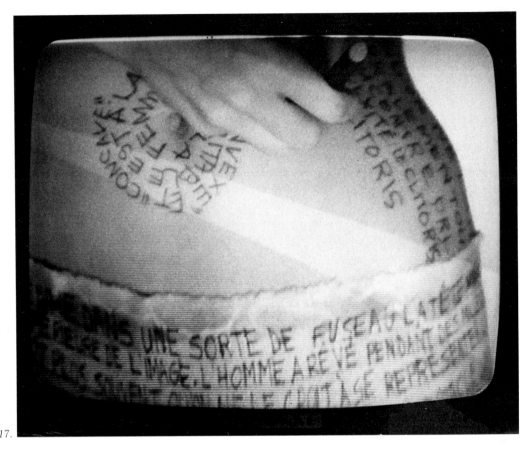

17.

17. *Nil Yalter*. The Headless Woman (or, Belly Dance). *1974. Videotape accompanying exhibition of "yurts" by Yalter, who is Turkish. In areas of the Middle East, belly dancing was performed as encouragement and entertainment during a woman's birth labor.*

18. *Bill Vazan. Sun Zone. 1977–78. York University, Downsview, Toronto. Chalk on turf and 13 blocks of granite. 26'5" × 458'9" × 244'3". Rocks are aligned to the main solstice and equinox sun points on the eastern and western horizons.*

The domed rock in the Temple of Jerusalem, holding down the floods of chaos beneath, is another omphalos; Jewish legend identifies it as the first solid thing created in the world, a sort of embryo. Sometimes the "navel" was inverted into a ritual pit, or *mundus*, closed with a round stone.

Omphalos, snake, spiral, primal waters, and labyrinth are all related to oracular customs of reading the entrails of sacrificial animals to predict and control the future. The labyrinth was known in several cultures as "the palace of the entrails" (see p. 147). Otto Rank sees the Cretan labyrinth as symbolizing the great transitional period when human creativity was freeing itself from its animal/monster/earthly nature, rising from "creature to creator . . . from religion to art."[37] The spiral, seen in all its elegance in Malta, Crete, and Ireland, recalls origins, just as the snake coiled on the mound to activate or fertilize it, a spiral on the goddess' belly, is a profound symbol of the interior exposed on the exterior, individual on collective origins and aspirations. In a probably unconscious and typically individualized modern rendering of this symbol, Dennis Oppenheim explained his *Stills from Stomach X-Ray* (1970) as releasing "sensations of what it feels like to be formed. I spiral with a closed system, making contact with myself."[38]

Of the reams of theories produced in the last century about ancient death and rebirth concepts, the one that, for me, most revealingly illumi-

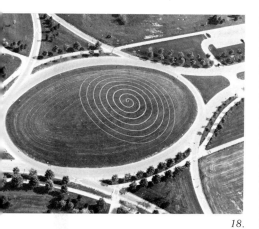

18.

nates the transition from "primitive" matriarchy to "civilized" patriarchy is that in Rank's elegant essay "Microcosm and Macrocosm." He traces the notion of immortality (and art as its concretizing factor) from an organic, earthbound animism and totemism, to a preoccupation with astronomy and divination, to the separation of matter and spirit characterizing our era. Like others, Ernst Cassirer in particular, he uses the human body as the microcosmic model, beginning in the belly, ending with the head. He begins with a world divided between "death-bringing" and "life-furnishing" objects—foreign to or identified with human biology. He moves toward a more detached interest in celestial phenomena—initially seen not as a means toward a practical calendar, but as a means by which to understand and then influence time through rituals designed to overcome or deal with death. Rank attributes the driving motive behind the human need to understand nature to a need to control and dominate nature.

In most cultures, the moon seems to have been the first vehicle for this development because its monthly waxing and waning recalled human biology. Because the lunar calendar was associated with the menstrual cycle, woman "played a greater part than that . . . allotted to her in the patriarchal organization of high cultures with their sun-cult."[39] "Art" was primarily devoted at this time to the disposal of the dead. Rank recapitulates Wilhelm Max Wundt's theory that the soul was originally conceived as residing in body fluids, which were pressed out of the corpse and retained until new life showed in them—i.e., until worms appeared. The soul symbol was soon transformed into the skin-shedding snake—an even more appropriate (and moon-related) symbol of umbilical cord, coiled intestines, and rebirth. In what can be seen as an amazing parallel to the theory of evolution, Rank traces the soul concept from worm

19. Susan Hiller. "Eight," detail of Ten Months. *1977–79. Artist's book and photo-sequence in 10 parts (with corresponding captions) of the artist's pregnant belly, showing its gradual growth, like the waxing of a moon, or the building of a ritual hill. Text for the eighth month: "She is the content of a mania she can observe. The object of the exercise, she must remain its subject, chaotic and tormented. ('Tormented' is not* too *strong a word, she decides later.) She knows she will never finish in time. And meanwhile, the photographs, like someone else's glance, gain significance through perseverance."*

19.

(liquid) to reptile (land) to bird to small animal and on to larger life forms, connecting this evolution to the custom of sewing a dead king's body into a "womb" made of the skin of a dangerous animal (the danger being mortality). The skins of bulls, elsewhere avatars of the Great Goddess, were used for the same purpose in one African tribe, their fast-growing horns associated with the moon and immortality. Rank considered Freud's concept of artmaking as fundamentally sexual to be merely an early, matriarchal phase in a cultural development that parallels the individual creative impulse—evolving from keeping/holding onto the soul, to collective regeneration of the soul, to the independent self-creation we have known since the Renaissance as art.

Since Rank wrote *Art and Artist*, excavations in the Balkans and Central Europe have detailed and clarified the culture of "Old Europe," which reaches back to the earliest agricultural periods (7000 B.C. to 3500 B.C.). In *The Gods and Goddesses of Old Europe*, Marija Gimbutas calls this the "product of hybridization of Mediterranean and Temperate Southeast-European peoples and cultures. . . . Almost all Neolithic goddesses are composite images with an accumulation of traits from the pre-agricultural and agricultural eras." It is possible that Old Europe was heir to Paleolithic goddess religions and was in turn the source of the British, West European, Scandinavian megalithic, and Celtic cultures as well as those of the Minoans and Mycenaeans; that this esthetically and symbolically sophisticated link gave birth to diverse offspring as it traveled west, south, and north. Gimbutas makes clear the complexity of this process:

In Old Europe the world of myth was not polarized into female and male as it was among the Indo-Europeans and many other nomadic and pastoral peoples of the steppes. Both principles were manifest side by side. . . . [The masculine world of the Indo-European] did not develop in Old Europe but was superimposed on it. Two entirely different sets of mythical images met. The study of mythical images provides some of the best proofs that the Old European world was not the proto-Indo-European world and that there was no direct and unobstructed line to the modern Europeans.[40]

The spiral, water meander, lozenge, zigzag, and bird, snake, and egg motifs of this goddess-centered Old European culture turn up in different guises until (and into) Christian times. Reptile-headed goddesses from 4000 to 3500 B.C. have been found in Sumer. The androgynous bird-snake goddesses of Old Europe, with their phallic heads and fertile bodies, were the predecessors of the Cycladic idols that inspired Constantin Brancusi (who was raised in Romania, in the heart of Old Europe) and Max Ernst, with his androgynous bird alter ego—Lop Lop.

The bird-snake goddesses regain their female content in the sculpture of Louise Bourgeois. Her work, developed in the '30s and '40s on the fringes of Cubism, Surrealism, and Abstract Expressionism, has always recalled "primitive" more than modern sources. Each period of Bourgeois' art corresponds to the hidden rhythms of her life at the time, yet like ancient animistic artists abstracting from nature, she transcends individual experience to communicate collective emotion through form.

20. *Louise Bourgeois.* Cumul I. *1969. Marble. 2' high × 4' wide. (Collection: Musée nationale d'art moderne, Centre Georges Pompidou, Paris.)*

20.

On the one hand, Bourgeois' subject is power—or power and power-lessness—and on the other, it is growth and germination.

Bourgeois' domed marbles, with their abstracted androgynous sexuality, suggest the Delphic omphalos. Her armless, legless, soft-centered *Stake Women* (c. 1970) resemble both the plump body and emphatic pudenda of the *Venus of Willendorf* and of the Old European "steatopygous" goddesses, whose exaggerated buttocks, often spiraled by snakes, resemble pottery designs of birds with large eggs inside them; their pointed heads represent aggression. If the ancient figures seem calm and powerful in their fertility, however, Bourgeois' modern counterparts are rooted in anxiety, becoming terrifyingly vulnerable and vulnerably terrifying. They embody, she says, "the polarity of woman, the destructive and the seductive. . . . A girl can be terrified of the world. She feels vulnerable because she can be wounded by the penis. So she tries to take on the weapon of the aggressor. But when a woman becomes aggressive, she becomes terribly afraid. If you are inhabited by needles, stakes, and knives, you are very handicapped to be a self-perceptive creature. . . . The battle is fought at the terror level which precedes anything sexual."[41]

"When religion became the principal symbolic means of integrating Neolithic communities, woman's role as healer was intimately related to that of religious practitioner and deity itself," write anthropologists Ruby Rohrlich and June Nash.[42] Some of the rare clues to prehistoric beliefs and rituals in Britain come from the great Celtic tradition of tales and oral history which survived in Ireland. The Celts are thought to have been there since the Bronze Age. Typical of their social arrangements was the high status of women, among them the warrior queens like Boadicea, and characteristic of their religion was the figure of a Great Goddess, often worshiped in triplicate as Maiden, Mother, and Hag. The legendary Queen Mab was probably originally a Great Goddess, as Saint Bridget was the Goddess Bride. All local Celtic tribes and gods were united under the Great Goddess Matrona.[43] Like the Old European, the Irish tradition links the bird with sexuality and the goddess, as well as with the horse.

21.

One curious Irish initiatory rite survived until the twelfth century. The king-elect had ritual intercourse with a mare, after which the animal was killed and he sat in a vessel with it, bathing in its broth and eating its flesh, so the fecundity of the mare was transferred to the king, and thereby to the whole tribe. (In a similar Hindu rite, the roles were reversed and the queen performed.) Some of these rites and myths appear to reflect the transition from matriarchy to patriarchy. For instance, it was said that Ireland was taken by the gods from three goddesses who fought the invaders with an army composed of sods of peat and mountain. Saint Patrick (originally a legendary king, whose excavation of tombs and raising of the dead from prehistoric graves ties him to ancient tales) suppressed serpents because of their importance to pagan, matriarchal worship.

Anne Ross, an acknowledged Celtic authority, states firmly that the powers of the female were very important to the Celts, to whom water was more sacred than the sun. The earliest of all goddesses, she says, "may not have received representational form, but her powers would be seen as

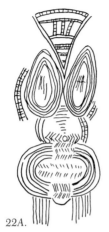

22A.

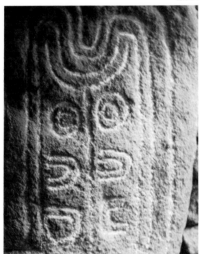

22B.

anything reflecting themselves in the rushing rivers and in the thrusting hills of the North" that embodied her powers.[44] The Celtic wells, some of which were receptacles for goddess figurines, were also absorbed into Christianity and remain today as "holy wells." As Erich Neumann has pointed out:

The female powers dwell not only in ponds, springs, streams and swamps, but also in the earth, in mountains, hills, cliffs and—along with the dead and the unborn—in the underworld. And above all, the mixture of the elements water and earth is primordially feminine; it is the swamp, the fertile muck, in whose uroboric nature the water may equally be experienced as male and engendering and as female and lifegiving.[45]

Given the fact that scholars like Neumann, J. J. Bachofen, Leo Frobenius, Sir James Frazer, Esther Harding, Mircea Eliade, Merlin Stone, Vincent Scully, and innumerable others in the fields of anthropology and comparative religion have readily accepted the worship of female forces, especially in agrarian societies, and given the strength of evidence for goddess worship among the Celts, it is all the more bizarre that archeologists—diggers into the earth by trade—have had such trouble with these concepts. One man, disgusted at finding only female figurines, decided there must have been a dominant male god who was so "ineffable" he could not be pictured. Others faced with the plethora of female figurines at various sites forgot to mention their sex, emphasized other rarer images, or categorized all females as "merely" objects of "household devotion" or "fertility," no matter what their attributes.[46] The usually thorough Aubrey Burl writes rather querulously:

In the past, some archeologists and art historians have been led, because of the profusion of female figurines, engraved plaques and carved stones, to talk of a mother goddess whose cult was widespread in Mediterranean countries and in western Europe. . . . What evidence there is for such a goddess seems limited to France, whereas in Ireland the megalithic carvings of the passage graves are better placed in a religion that involved the sun.[47]

22C. 22D. 22E.

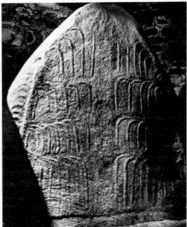

23.

This is not the place to argue the existence of goddess worship in various cultures, but such attitudes do cast some light on the way scholarship is molded by societal attitudes.

There is no way of knowing which prehistoric images were made by women and which by men. Anthropological evidence from contemporary primal societies suggests it was both. However, judging from the sparse remains we do have, much prehistoric art was made under a value system that equated woman with nature and endowed both with extensive powers over human life. Contemporary women artists have delved into this ancient imagery in every medium, sometimes simply promulgating new clichés, sometimes opening new avenues into and out of history.

One of the first to unleash the rich resources of specific goddess lore in her art was Carolee Schneemann. As a child she had a Scottish nurse who showed her the Great Mother in the moon and told her tales of the goddess. In a 1963 performance called *Eye Body*, Schneemann appeared nude with live snakes crawling on her belly and breasts in a graphic reflection of the goddess' dominion over the serpent—a universal symbol of rebirth and fertility connected with woman, water, and healing (see Chapter VI). Schneemann's *Divisions and Rubble* (1967) made subtle

interconnections between creation and destruction, birth and decay cycles, in a "discomforting labyrinth" related to America's wasteful invasion of Vietnam.

These and other early '60s Happenings predicted the whole notion of Performance Art in the '70s, in which Schneemann has also been an innovative figure. Her *Homerunmuse* (1977)—subtitled "The Muse was Serpent and Bird/water and fire/source of transformations/female birthing/the growth of mind in matter/guide to gesture and dance/the shape of the pot and the nourishment taken there"—was a slide and text performance in which she entwined current dreams about bulls, serpents, cats, and their ancient meanings in a semi-autobiographical narrative.

Schneemann's strategies were designed to free women from the bonds of male-defined pornography, to give women their own natural eroticism, which has been suppressed in America's puritan culture by disapproval at one extreme and witch-hunting at the other. "The life of the body is more variously expressive than a sex-negative society can admit," wrote Schneemann in 1968. "In some sense I made a gift of my body to other women: giving our bodies back to ourselves. The haunting images of the Cretan bull dancer—joyful, free, barebreasted women leaping precisely from danger to ascendancy, guided my imagination."[48]

Another of Schneemann's major concerns has been to release the body from modern confines. Her unexecuted *Parts of the Body House*, for instance, projected an interior installation simulating a biological landscape in which the viewer rediscovered sex, scatology, self, and release. In her proto-feminist work of the '60s Schneemann often appeared nude, attempting to prove that woman was not just a manipulable object but an image maker creating her own self-image. Jamake Highwater has observed that "without an *articulate body* . . . people cannot participate in their world or in their own emotional lives."[49] Schneemann's courageous stands in trying to present a "primitive" unselfconsciousness about the body, poorly rewarded by the "high art" world, function like that of the maid-figure Baubo in the Demeter myth; she allayed the goddess' sorrows through obscene jokes and dances and, as Nor Hall has put it, by "lifting her skirts, lifted her spirits."[50]

Judy Chicago's *Dinner Party* (1973–79)—a monumental table on a raised tile floor, dedicated to the buried history of women in Western civilization—arose from her conviction that "myth has to be challenged before economics or sociology will change," that women's "deep cultural hunger" for affirmative symbols is a key to the process of feminizing society.[51] This gigantic, cooperatively executed work, which took her and hundreds of others six years to make, begins with a series of oversized ceramic plates devoted to the prehistoric goddesses. The first of 39 settings belongs to the Primordial Goddess, whose plate shows the cleft in the rock and rests on an animal skin, cowrie shells, and spiral; then comes the Fertile Goddess of childbirth and rebirth, with her bulbous podlike forms; then Ishtar, the Babylonian Great Goddess, still in her early omnipotent incarnation, medium between all nature and humanity; then Kali, the fearful blood goddess, the destructive opposite of the generative powers; then the Cretan Snake Goddess, and later the

24.

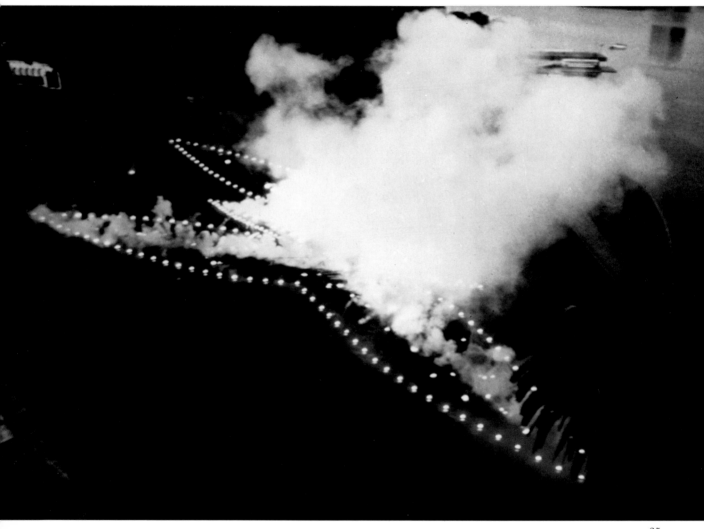

25. *Judy Chicago. Butterfly for Oakland. 1974. Fireworks. 400' × 200', 17 minutes. Commissioned by Oakland Museum. (Photo: Lloyd Hamrol.)*

Celts—Boadicea, with an image of a dolmen behind her spiraled helmet form, and Saint Bridget. The table itself is a glowing white inverted triangle—symbol of female power.

Chicago's personal/universal symbol since she became a feminist in 1969 has been the butterfly—"the witch's messenger"—which, sometimes in conjunction with a bull's or ox's horns, is an ancient symbol of female transformation and sexuality, of the goddess' epiphany. The crescent horn goes back to Paleolithic times as a symbol of the moon, and of animals like the stag whose horns are similarly "reborn." Antler headdresses and picks are found in ritual burials from Neolithic Europe and are probably part of a universal schamanic tradition going back to Paleolithic times. Peter Furst has observed survivals of that tradition among

the Huichol Indians of South America, which he traces back to the earliest hunting and gathering religions. Noting that the "overriding concept of male-female unity and qualitative equivalence of the sexes" are "the essential prerequisites for fertility and not only biological but cultural survival," he shows how the deer's antlers are gifts of the primordial female "owner" of the species: "The very symbols of the divine deer's maleness, then, are here seen as the gift of woman."[52]

The temple or palace of Knossos in Crete was apparently once crowned by hundreds of pairs of bull horns, suggesting both the goddess' raised arms and her fertile thighs. The one restored pair of horns visible today frames the suggestively notched Mount Jouctas in the distance. When I was there, notch and horns were coincidentally centered on a single tree, just like ancient images of horns embracing a plant or tree in Crete and elsewhere, including Native American cultures. Following G. R. Levy's research on "The Gate of Horn," Vincent Scully has made a fascinating case for the "horned" notched mountains and conical breast-and-belly-shaped hills as earth goddess attributes interacting with and augmenting the meaning of Cretan and Greek temple architecture.[53]

Labyrinth, bull horns, and birthing goddess also appear together as sculptures and carvings in the Mesopotamian temples of Catal Huyuk, from 5000 B.C., and in Egyptian mythology. Michael Dames finds English concurrences in the "horned" entrance to the West Kennet barrow at Avebury and in possible body forms at Windmill Hill; he suggests that the ox at Christ's birth was a survival of the Egyptian Goddess Hathor, the "cow who bore the bull."[54] I was struck by the same protective image in the Scottish "recumbent" stone circles, where the horizontal element is flanked by two tall pointed stones curving inward. (One such circle, at Midmar Kirk in Aberdeenshire, now stands within a churchyard, in a classic illustration of overlay.)

The American artist most deeply immersed in the study of the Great Goddess, resurrected from prehistory as a medium between nature and humanity, is Mary Beth Edelson. For over a decade she has combined a multiplicity of ingredients—Jungian psychology, feminism, dreams, fantasies, the collective unconscious, politics, and collaborative artmaking—into a body of work that spans many mediums and millennia. Her disregard for historical boundaries imposed by the patriarchy has led her to a belief system expressed in ancient images that hold their own unique power today. Her utterly serious (and equally humorous) battle cry has been "Your 5,000 Years Are Up!"

Edelson's prime form is ritual, which I will talk about in Chapter V, but she has also developed static forms that convey much of the flavor of her collective pieces. Using time-lapse photography, she documents her own private rituals in timeless landscapes by drawing paths of light in the air. Her gallery installations incorporate the personal hopes and fears of her audience. In an ongoing series of *Story Gathering Boxes*, begun in 1972, she invites her audience to contribute to her own tablets of "Old Myths/ New Myths," "Goddess Dreams," and "Blood Power Stories." Among the public contributions to the "Stone Stories" are: "When I was little I held stones up to my crotch to feel the coldness"; "In order to move mountains you've got to know what stones are about."

26. *Minoan gold votive double-axe. c. 1500 B.C. (Collection: Museum of Fine Arts, Boston.)*

27. *Nubian rock crystal ball with gold Hathor head. Napatan Period, late 8th century B.C. (Collection: Museum of Fine Arts, Boston.)*

28. *Reconstruction of the "horns of consecration" originally lining the walls of the Palace of Knossos, Crete, with the horned Mt. Jouctas in the background. Marija Gimbutas has raised the possibility that butterflies might have been centered on these horns, as was one on a miniature shrine from Knossos. (Photo: Lucy R. Lippard.)*

29. *"Horned" recumbent stone circle with internal ring cairn, Sunhoney, Aberdeen, Scotland. c. 1900 B.C. Eight deposits of burnt bone were found in the area, and some of the stones were fire marked, apparently from ritual use. (Photo: Chris Jennings.)*

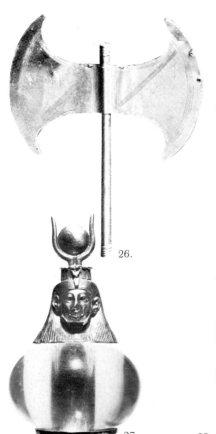

26.

27. 28.

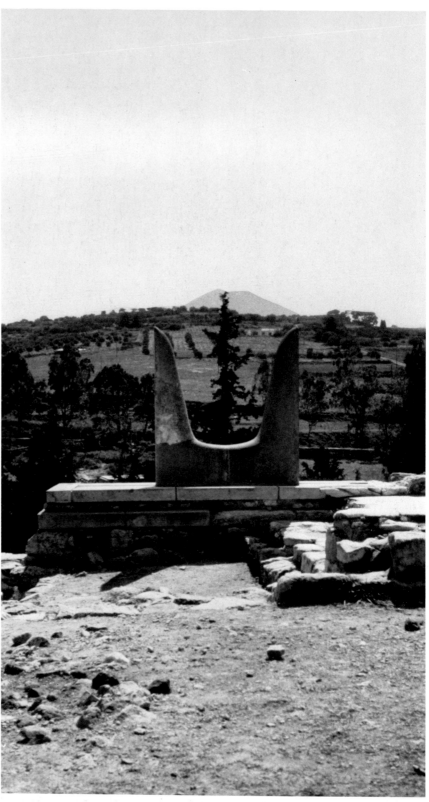

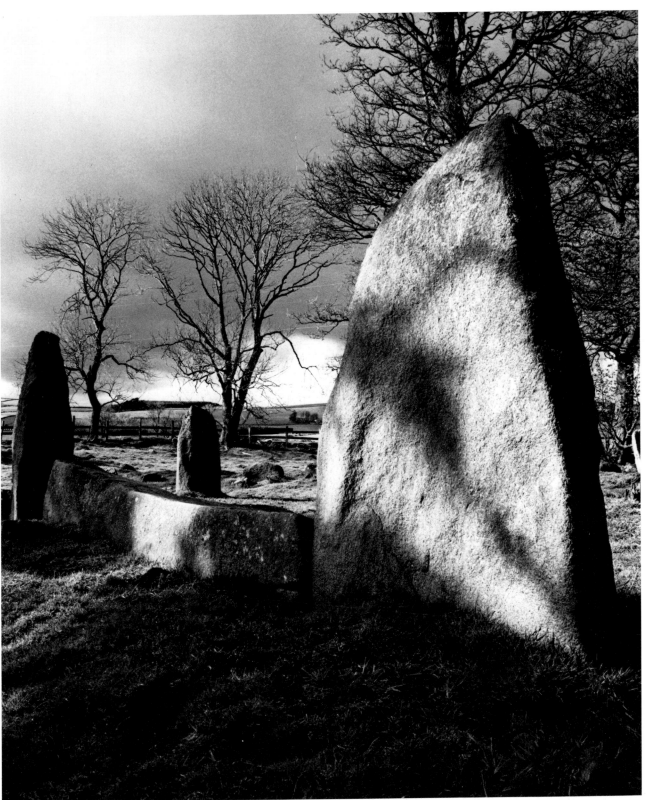

29.

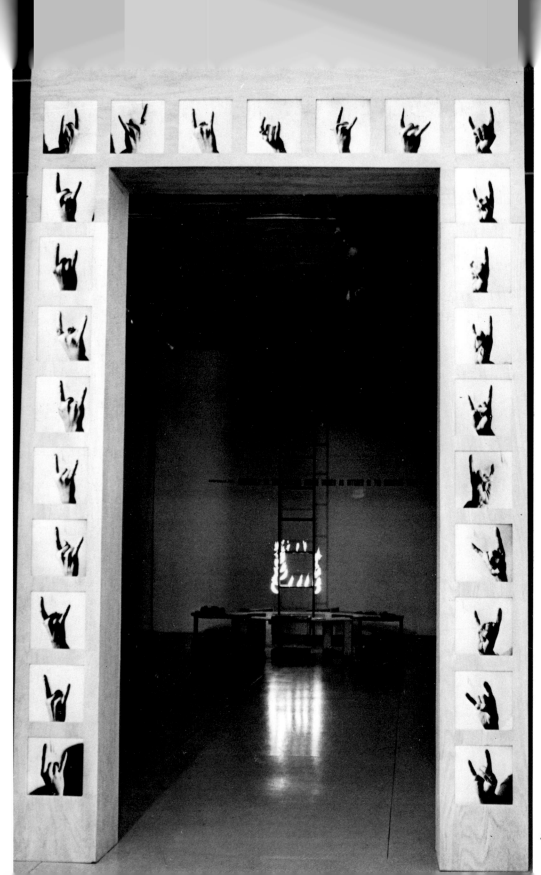

30.

One entered Edelson's 1977 show at A.I.R. in New York through a "Gate of Horn," toward an actually flaming ladder. The gate was a frame of photographs of different women's hands making the horned finger gestures *(mano cornuta)* and the "fig of triumph" *(mano en fica)*. Edelson was combining power and sexuality as a memorial to the "9,000,000 Women Burned as Witches in the Christian Era." On Halloween, adopted as the Woman's New Year, a public ritual took place in the gallery and then in the streets. In a 1980 show, *Toothless* (a black *sheela-na-gig* or vagina-non-dentata sculpture) doubled as a cave and throne, both for the viewers' imagination and for performers.

Edelson's esthetic talismans are stone and fire—the cool but reassuring colors of earth and stone, the warm but fearful colors of flames—echoed in the greys of photography and the warmth of human ritual interaction. Stone and fire are at the heart of the Great Goddess myths that she is adapting to contemporary needs. "Women need images to relate to that are strong and positive," she has said. "When I was active in the civil rights movement, I remember the power of the slogan 'Black is Beautiful,' understanding what that reassurance meant for people who had grown up without mainstream positive images of themselves. It is the same for women now. We need to overstate to realize our full confidence. . . . Naturally some of us are going to create our own symbols, our own myths, our own stories, our own rituals."[55]

By collecting everywoman's tales, Edelson is accumulating the fragments of a "new history." She wants her art to generate power as a consciousness-raiser and as a rallying point for women with many different experiences. Unwilling to separate social change from spiritual change, affirmative action from affirmative passion, she generally avoids the isolationism of artists who look to the past but forget to look around their present. In the process she and others offer open, developing ways of using ancient imagery to revivify rather than embalm contemporary culture.

31A.

31B.

31C.

31D.

31E.

31A. *Beverly Terwoman.* Magna Dea. *1979. Stone. 7″ × 10″ × 8″.*

31B. *Kalmia.* Knossos. *1976–78. Wood. 63½″ × 17″ × 1″. (Photo: Robert Bull.)*

31C. *Lynn Randolph.* Growth. *1975. Oil. 59″ × 47″. (Photo: Tony Santos.)*

31D. *Jeanne Fabb.* La Nuit de la pleine lune ("Night of the Full Moon"). *1977. Cowhide, caribou antler, moose hide, shells, copper, 9′ × 5′. (Collection: Jeanne Fabb, La Macaza, Quebec.)*

31E. *Chris Millon.* Totem. *1975. Mixed media. 12′ × 4′.*

31F. *Monica Sjoo.* The Goddess at Avebury. *1978. Oil on canvas. 4′ × 8′.*

31F.

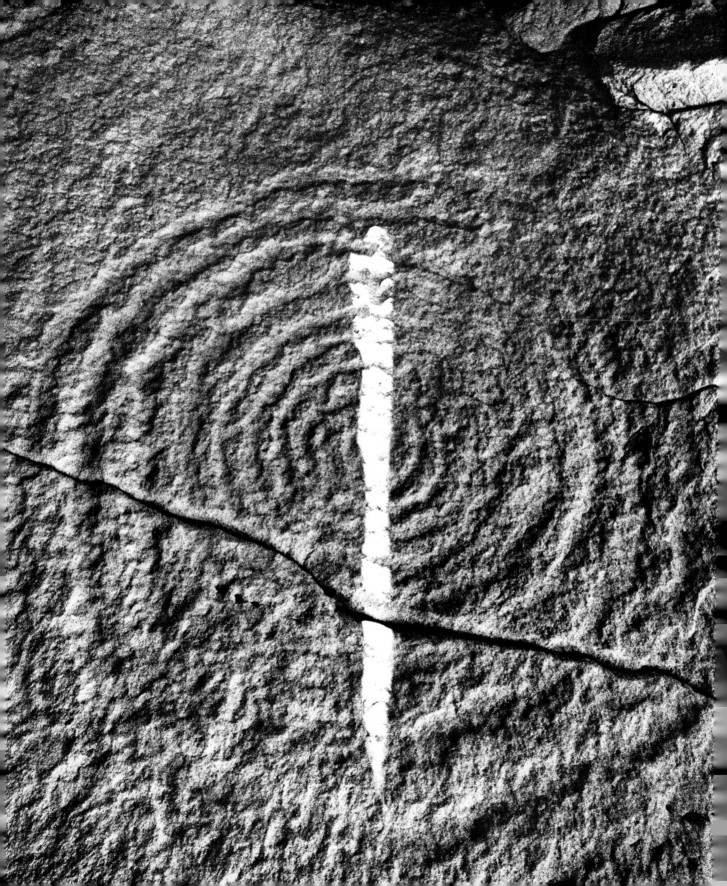

2.

The Forms of Time: Earth and Sky, Words and Numbers

Time, poised between the abstraction of distance and the concreteness of numbers, is in a sense the crux of this book, with its theme of forced synchronism. The origins of time and of counting seem in turn to lie somewhere between the cycles of the earth and the moon (with the human body as medium) and the lines of a journey, a life, toward change. If these were preoccupations of ancient peoples, they have periodically resurfaced in the history of art—most recently in the work of the Minimalists and Conceptualists of the 1960s and '70s. They rejected the excesses of Abstract Expressionism from the '50s, the contentless decoration of Post-Painterly Abstraction from the early '60s, not to mention the frenetic faddism of Pop, Op, and Photorealism.

Given the social upheavals of the '60s, it is interesting that a similar attempt at a *tabula rasa* also took place around the French Revolution, with the *primitifs* and the "Etruscans." As Robert Rosenblum has pointed out, the spirit of drastic reform often coincides with the return to extreme simplicity or a "therapeutic geometry."[1] The Minimalists' and Conceptualists' obsession with simple word and number systems, with basic geometry, with repetition, modules, measurement and mapping, laid the ground for "primitivizing" artists of the '70s to explore more complex areas of myth and history. This may sound odd to those familiar with the Minimalists' concerted effort to exclude all symbolic, metaphorical or referential aspects from their art; they hoped to create a concrete actuality, perceived within the "real time" of the immediate present. Yet while few stylistic connections can be made to the "mythicists," these disparate groups share an idealistic notion that art can become more democratic, more accessible to a wider audience, by becoming simpler.

The beginnings of what we in the West like to call civilization probably lay in a "morphological understanding" of life[2]—what the eighteenth-century philosopher Giovanni Battista Vico called "serious poetry," the origin of all knowledge. Its contemporary counterpart is a nonverbal communication distrusted by pedagogues because it suggests ways of expressing complex ideas without totally understanding them, or of under-

Who hath the measures thereof, if thou knowest? Or who hath stretched the line upon it?
—*Book of Job, Old Testament*

The deeper an artist sinks into the time stream the more it becomes oblivion; because of this he must remain close to the temporal surfaces. Many would like to forget time altogether, because it conceals the "death principle." . . . Floating in this temporal river are the remnants of art history, yet the "present" cannot support the cultures of Europe, or even the archaic or primitive civilizations; it must instead explore the pre- and post-historic mind; it must go into places where remote futures meet remote pasts.
—*Robert Smithson, 1968*

1. *Sun Dagger of Fajada Butte, Chaco Canyon, New Mexico; spiral cut through the center by dagger on summer solstice. (Photo: K. Kernberger.)*

2. The Black Square Room, *Ad Reinhardt exhibition, The Jewish Museum, New York, 1966–67.*

1.

standing them primarily through form. (The attitudinal poles are expressed by the Roman Cicero—"If something can't be said in words, it has no meaning"—and the contemporary Frithjof Schuon—"What a true symbol teaches is not subject to the limitations of verbal expression."[3])

In Western culture the visual arts continue to stand for the possibility of nonverbal communication of ideas. With hindsight, it seems that the Minimalists reached back to rescue the vestiges of "morphological understanding" with conscious paradox. Sol LeWitt wrote in 1969: "Conceptual artists are mystics rather than rationalists. They leap to conclusions that logic cannot reach. . . . Irrational thoughts should be followed absolutely and logically."[4] An ancient parallel is the way in which teachers like Pythagoras "set their pupils to practice the arts of dynamic geometry and numerology in order to exercise the faculty of intuition, through which may be apprehended the essential laws of cosmic motion."[5] Like their predecessor Ad Reinhardt (1913–67), with whom this brief history of mysticism couched as anti-mysticism must begin, the Minimalists were not entirely unaware that "the end is the beginning," that by steadfastly sticking to essentials (their work was called "primary structures" and "ABC art"), they were paving the way for a renewed esthetic complexity. They could not, of course, have known what direction it would take.

For the last six years of his life, Reinhardt made almost identical black, five-foot-square paintings which he called "timeless" and "ultimate." Despite his insistence that "art is art and everything else is everything else,"[6] these paintings have come to represent more than an obdurate abstraction. The first of many contradictions is that the "black" paintings are in fact very dark blue, red, and green. These "formless" and "idealess" canvases are trisected into a grid, forming a cross and four quarters, like an ancient world-picture—a fact Reinhardt deemphasized in his efforts to negate all "romantic" references either to individual or collective expression.

Reinhardt saw art as the anti-institutional heir to religion. He was a synthesizer, combining a respect for the past and for classical tradition with a healthy and inventive cynicism. ("There is nothing new under the sun," he protested as he proceeded to make his unexpected series of black squares.) As a scholar of Far Eastern and Islamic art, Reinhardt admired the former for its rejection of linear progress and the latter for its rejection of pictorial and relational composition—in other words, he admired both for their formal neutralization of time and space.

Reinhardt's black paintings incorporated an acute criticism of the commercial art world of which they were necessarily a part. The moral stance implicit in his work was antipathetic to the "evolutionary" treadmill on which American artists since Abstract Expressionism had been running in place. The goal of this linear "advance" was simply a painting that was totally "true to its nature as a painting"—that is, nothing but a flat surface covered with color. By asserting that he had reached that "ultimate" point with his black squares, Reinhardt suggested that painting, or art, should begin all over again. While he claimed to be aiming for emptiness, he in fact offered emptiness *as content:* the meaningful void rather than the logical dead end toward which many of his colleagues were recklessly careening. Like the mythical *tabula rasa*, Reinhardt's

3. Sol LeWitt. Serial Project #1, Set D. *1966. Painted steel. Small forms, 28" square; large, 81" square. It presents a complete and finite set of permutational relationships between two and three dimensions, containers and contained.*

enigmatic, invisibly full black surfaces, his determined "purism and negativism" held out renewed possibilities to a generation of artists who did not follow him so much as set out from their own beginnings.

By the mid-1960s there had emerged a group of artists, mostly sculptors, whose intentionally unevocative cubes, modules and grids, mathematical systems and permutations, diagrams, mechanical "working drawings," and inventories were based on yet another New Realism—"what you see is what you get." Their goal was "wholeness." Through literal conjunctions of number and language (and sometimes through a bewildering screen of theories derived from linguistics, perceptual psychology, and logical positivist philosophy), they reintroduced the fundamental concepts of seeing to a jaded, novelty-addicted audience. Their "cool," "dumb" forms had their own mystery. They conceived of art as thought, though not necessarily verbal. Hermeticism was paradoxically an element of their phenomenology, as it has been in much tribal art. Anthropologist Edmund Carpenter has written about tribes who spend their lives surrounded by hidden art which is seen and heard only on appropriate occasions by appropriate people, and yet at the same time is part of a shared social fabric and not owned by anyone.[7]

In 1967, when Conceptual Art was just developing, I wrote that the artists depended "on the eye being restored to a state of innocence." LeWitt, one of the major Minimalists, went further. He suggested that a

3.

blind man could make art and that artists could learn by working like blind men, that only by not worrying about how art looks could one eliminate "old-fashioned" compositional factors and invent new forms. His sculpture was regulated by measure, generated by systems, executed by industrial fabricators. It was as though the gods had taken over the arts again, guiding the hand of the artist—recalling what Ernst Cassirer said of number in the age of myth: that it did not possess abstract universality but was "always founded in some concrete individual intuition."[8] In a parallel tradition, from which alchemy developed, natural magic was once unlocked by the study of numbers, which in turn aided the increased domination of nature.

In the late '60s, time itself became an important ingredient for many Minimalists and Conceptualists, and with time, timelessness, and with timelessness, a new and self-conscious awareness of the history of history, and finally of prehistory. After decades of existential emphasis on the individual, on the self-referential constructs of modernism, they seemed to want to return to a more collective base. The more individualized a society, the more emphasis is laid on form without communicable content, and the Minimalists were seeking a new kind of nonrepresentational content. They were also looking back to the history of mathematics and thought. In 1972, the year he made a piece from hazelnuts and chalk called *Meditation on the Theorem of Pythagoras*, Mel Bochner told Ellen Johnson: "Numbers interested me because they're so available. Everybody counts things. Everybody measures things. It is our way of ordering the disorder around us. . . . It is all just there. I use it. Those numbers don't mean anything other than themselves. You could ask me what 'number' means, but I don't know."[9]

Several Minimalists—notably Tony Smith, Robert Morris, and Sol LeWitt—concentrated on the cube, which in Pythagorean doctrine was the perfect form.[10] Pythagoras (who flourished c. 539 B.C.) offers an interesting pivot for these overlays. His principle that numbers were the elements of things in nature was a significant component of myth and religion in ancient times. He himself was a mythical figure, with a thigh

4.

of gold. He was certainly heir to more ancient systems of knowledge, and is credited with the ideas of transmigration of souls and the harmony of the spheres, as well as his famous theorem. Many Minimalists compare their three-dimensional constructs to music, and they too might be seen as heirs to a hypothetical megalithic civilization from the Bay of Biscay to the Arctic Ocean—"a lost community who found numbers more interesting than words."[11]

In the 1940s, Alexander Thom revolutionized archeological history by confirming the existence of such a community. His painstaking research proved a hitherto unsuspected mathematical sophistication among the builders of the stone circles in the second millennium B.C. Thom showed that the six different geometric categories of stone circles were based on Pythagorean principles and on a standard measure of 2.72 feet—the megalithic yard. "One can almost say that megalithic man was obsessed by the desire to discover and record in stone as many triangles as possible which were right angles and had all three sides integers," he wrote.[12] "The ultimate polygon that every plane can be reduced to is a triangle;

5.

therefore we should look to the triangle for our essential sets of relationships," wrote Plato in the *Timaeus* dialogue, which may be the recapitulation of an ancient oral tradition.[13] Measures of three—the most elementary number system—predominate in Neolithic planning. Most cultures seemed to believe, with Lao Tzu: "Tao generates one. One generates two. Two generates three. Three generates all things."[14]

It seems to come as a surprise to some scholars that "primitive" peoples could have developed any degree of mathematical sophistication, as though this reflected unfavorably on their own scientific achievements. Yet the symbolic mathematics resulting from astronomical observation now seems to have begun some 17,000 years ago—sufficient time to amass and test a substantial amount of knowledge. Keith Critchlow suggests that the history of mathematics needs rewriting. Studying the enigmatic tetrahedral stone spheres found in Scottish Neolithic graves, he discovered that they illustrate the regular mathematical symmetries of all Platonic solids, "yet appear to be at least a thousand years before the time of either Pythagoras or Plato."[15] Like the circles and rows, these symbolic objects were made of stone for permanence. The more complex among them, like the one carved with intricate spiral and concentric patterns closely resembling those inscribed in the Breton tomb at Gavrinis (see p. 65), would have taken weeks to complete. The idea that number is always tied to the processes of nature evokes the Fibonacci spiral—the self-reproducing principle of proportionate growth which was discovered (or rediscovered) in the Middle Ages through examination of natural forms. Italian contemporary artist Mario Merz has based many years of work on the Fibonacci system, using natural and artificial materials— branches and neon. He, Mel Bochner, Agnes Denes, Dorothea Rockburne, and others working with mathematical and geometrical progressions in their art, belie John Michell's complaint that today's artists "have not cared to study the eternal gods of visual harmony, preferring the joys and delusions of free expression to the psychological certainties of the canon."[16]

Connecting the Scottish stone spheres to cosmological belief, Critchlow notes: "the study of the heavens is after all a spherical activity, needing an understanding of spherical coordinates. If the Neolithic inhabitants of Scotland had constructed [the elaborate corbeled chambered tomb of] Maes Howe, before the pyramids were built by the ancient Egyptians, why could they not be studying the laws of three-dimensional coordinates? Is it not more than a coincidence that Plato as well as Ptolemy, Kepler and al-Kindi attributed cosmic significance to these figures?"[17] Such a theory is supported by the fact that the Dogons in Africa are also " 'Platonists' . . . much given to diagrams, number play and geometry. Their cosmology is one of the most complicated ever to be recorded in print."[18]

Giorgio de Santillana and Hertha von Dechend, in their brilliant book *Hamlet's Mill*, have evolved a complex mythological/astronomical hypothesis based on the existence of an international preliterate code language of numbers, motions, and measures. This "archaic lingua franca," which covered the globe and consisted of "a huge framework on many levels," recalls Buckminster Fuller's concept of three-dimensional

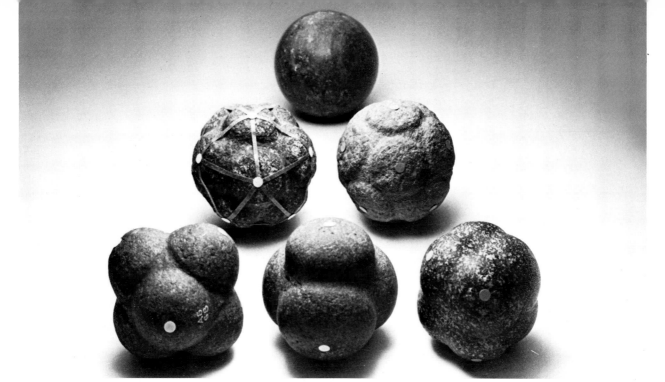

6. Plain sphere, plus full set of stone polyhedral spheres or Scottish Neolithic "Platonic solids," made a millennium before Plato's time. Keith Critchlow, who discovered the mathematical significance of these objects (set forth in his book Time Stands Still), *suggests that Plato's "Timaeus" dialogue was the exposition of an ancient oral tradition that reduced the essence of earth, water, air, and fire to symbolic geometric figures. (Photo: Graham Challifour.)*

space lattices. The authors hypothesize that it "ignored local beliefs and cults. It concentrated on numbers, motions, measures, overall frames, schemas, on the structure of numbers, on geometry. It did all this although its inventors had no experience to share with each other except the events of their daily lives and no imagery by which to communicate except their observations of natural lawfulness."[19] The code was revealed through colors, plants, forms, music, verse, and visual structures as well as through stars and numbers. It was surrounded by strict secrecy and could be passed down in everyday language even through people who did not fully understand the knowledge they transmitted. It could then be picked up again by initiates, generations later.

Santillana and von Dechend see archaic imagery as strictly oral because myth concerns time, not space. Pure number structures (the counting process) are "word pictures"—not diagrams, but a "matter of times and rhythms." And structure came before system, the authors say, because system cannot be orally transmitted; art came before analysis because "ordered expression comes before organized thought"—ideas obviously attractive to visual artists. Systematized numbers, on the other hand, cannot be told; they must be demonstrated. At some point gematria—the symbolic science of relating words to numbers—emerged.

Ask someone to describe a spiral staircase, and they will inevitably do so by gesture; I see no reason why gesture would not have been passed along with oral history. Certainly both literacy and numeracy had mutual origins in the human body. As language evolved from gesture, and knowledge was communicated "by heart," so writing began in pictures, then pictographs, and "degenerated" into ideographs which, once commonly understood, became "external characters," no longer parts of ourselves.

*7A, B, C, D. Engravings on kerbstone
and in tomb chambers at Dowth, Ireland
(c. 2500 B.C.) and back of kerbstone at
New Grange. (Drawings: Claire O'Kelly.)
E. Engraved stones on Ilkley Moor,
Yorkshire, England. (Photo: Tom Steele.)
F, G. The Stronach Stone, above Brodich,
Isle of Arran, Scotland. H. Cup-and-ring
mark on* Long Meg, *a red sandstone
outlier of a graystone circle in
Cumberland. I. Petroglyph, Frijoles
Canyon, New Mexico. (Photo: Charles
Simonds.)*

7A.

7B.

In *Hamlet's Mill*, writing is blamed for the human race's loss of memory, and with it the loss of that "strange hologram" that is archaic cosmology. Claude Lévi-Strauss suggests that writing deprived humanity of the fundamental "archaic capacity for explaining the world around us by establishing analogies between nature and human life."[20] John Michell adds that writing has "seriously distorted our sense of history," while Robert Morris surmises that "the past had to become object in order that the future might be controlled."[21] Eventually history became sequence—"just one damn thing after another"—and the simultaneity that some think enriched archaic life and could enrich our own, disappeared. Actual taboos on writing may have existed as long as the oral tradition survived. The British Druids, according to Caesar, considered it improper to commit their studies to writing.[22] The Incas are believed to have known about writing, but to have forbidden it; the Andean *quipus*—knotted mnemonic cords often identified as language/number systems—may have been only personal memory aids, illegible to others.

Because there is no individual authorship in oral history, it preserves collective values. Yet written language, too, may have evolved from collectively understood abstract symbols like the spiral, lozenge, concentric circle, or cup-and-ring mark. Otto Rank suggests that language did not originate as a form of communication but as *art*—as individual objectifications only later collectively formulated.[23] Certainly a large number of modern artists have been drawn to ancient pictographs as a means by which to invent their own new form language through an abstract notational style. The best known among them are Joan Miró, Joaquin

7C.

7D.

7E.

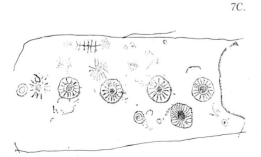

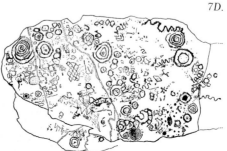

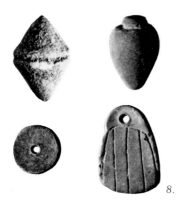

8. *Clay "tokens" from Susa, Iran. c. 3000 B.C. Some are simply rough shapes; others are marked or inscribed; some are perforated. The more complex shapes can be equated with early Sumerian ideographs. The "tokens" were often carried in rounded hollow clay "envelopes," also inscribed. Denise Schmandt-Besserat found other clay shapes 5,000 years older than these, which she suggests are their predecessors, used throughout western Asia. (Collection: Musée du Louvre, Paris.)*

Torres-Garcia, Adolph Gottlieb, Mark Tobey, and Jackson Pollock.

Ironically, the impetus for some of today's artists to reinvent number and word systems was accompanied by an anti-intellectual, nonverbal trend. This, and the subsequent "primitivizing" tendency, can also be related somewhat negatively to Chrisotopher Lasch's pessimistic ruminations about narcissism:

Formerly, religion, myth and fairy tale retained enough childlike elements to offer a convincing view of the world to a child. Science cannot take their place. Hence the widespread regression among young people to magical thinking of the most primitive kind; the fascination with witchcraft and the occult, the belief in extrasensory perception, the proliferation of primitive Christian cults.[24]

Written language may have had its origins in Middle Eastern counting and calculation systems that go back as far as the ninth millennium B.C., when geometric clay "tokens" or "counters" were used in trade. Eventually spheres, discs, biconoids, tetrahedrons, rectangles, ovoids, triangles, cylinders, and schematic animal forms were incised, then marked with signs. Denise Schmandt-Besserat's research suggests that these tokens were the origins of a three-dimensional alphabet; later they might have been strung together on strings (to be read like a rosary?). From them evolved the clay tablets of Uruk in Mesopotamia—generally accepted as the first known written texts.[25] This revolutionary recording system developed at the same time as farming. The Neolithic period was described by Lévi-Strauss as "consumed by symbolic ambition such as humanity has never again seen rivalled, a scrupulous attention directed entirely towards the concrete and the implicit conviction that these two attitudes are one."[26]

It was also in Neolithic "art" that collective abstraction or a symbolic visual vocabulary evolved from the highly naturalistic animal and plant images of the cave paintings; these in turn may have stood for phrases or attributes, such as "unshakeable dignity" (the mammoth) or "stormy drama" (the bison).[27] Marija Gimbutas suggests that during the same period in Old Europe the symbols used in the worship of the Great Goddess (many of which are the same as those found on tokens in the Middle East) also constituted the beginnings of an alphabet.[28]

The Chinese ideogram began in an oracular process of asking questions of celestial patterns. The Mayan writing system also began as part of a calendrical system. The making of significant connections between the

7F.

7G.

7H.

7I.

earthbound human body and celestial events was a turning point in human history. It has often been pinpointed as the moment of independence from the material world, of separation between the matriarchal belly and patriarchal head—a probably false distinction between "gut reaction" and superior intellectualism. Both the Babylonian and the ancient Mexican world-ages were based on a numerical conjunction between the year and the time a baby is nurtured in the womb. Each astrological sign is associated with a specific body part (as the astrological "house" is a body symbol too), and ancient healers found celestial/biological conjunctions in their magical anatomy studies.

The human being as the measure of all things is a crucial aspect of many origin myths, as reflected in the Old Testament: "God disposed of all things by number, weight and measure"; "I lifted up my eyes again and behold a man with a measuring line in his hand"; "Then I said, whither goest? And he said unto me, to measure Jerusalem, to see what is the breadth thereof and what is the length thereof." The "measurer's might" is equated with the Creator or Holy Shaper in the seventh-century *Caedmon's Hymn*, thought to be a late reflection of a pagan creation myth. In many cultures the Fates are measurers as well as spinners; the Egyptian god Heh is portrayed with two long measuring staves. (His female counterpart, Hehet—a uterine-shaped frog goddess of birth and resurrection—represents the other half of creation.) Alfred Watkins, discoverer—or inventor—of the British ley lines (see Chapter IV), believed that in ancient Britain there was a whole class of "dodmen" who carried the standard measure from one end of the country to the other and perhaps oversaw the construction of the stone monuments. It has been suggested that the first-century Hill Figure—the "Long Man of Wilmington," with his two long staffs—was a surveyor (and, less believably, that the cup-and-ring marks—concentric circles found on stones all over the world—might have been the imprints of surveying devices).

Theories of ancient measuring obsessions were given strong support in 1967, when Alexander Thom published the final statistics of his research on the megalithic yard. Its accuracy in England and France even suggested that there might have been a single "home" for the measure. Thom's opponents point to the likelihood that all ancient measures were simply based on body parts—the foot, the stride, the hand-span—just as the Old English "ell" was elbow to fingertip and the 28 letters of the fingers and joints of two hands relate to the lunar calendar.

The single-lined Ogham alphabet—ancient Celtic grooved writing—is found on Irish standing stones. There are many different kinds of Ogham, which was "part of a secret language by which different aspects, qualities and uses of trees could be repeated like nursery rhymes."[29] At some undetermined point in the past, Ogham shared roots with the ancient cryptic alphabet called the Beth-Luis-Nion, which was used as a seasonal calendar and related to body-finger gestures and to another complex language involving flowers and other plants. Robert Graves has created and partially unraveled a fascinating riddle involving all of these early natural alphabets. The body-part theories of the origins of writing do not contradict those of the megalithic yard. The argument is historical—about the point at which the measure was made precise and standard.

9. *Long Man of Wilmington, England. Hill figure cut into chalk. Possibly 1st century A.D., no later than 7th century. 231' high. A similar figure is found on the bronze plaques of Sutton Hoo. The figure was restored in 1874 and previously may have held a rake and a scythe, or perhaps spears.*

10. *Bill Vazan. Bord Ogam. 1979–80. Edge of L'Assomption River, Joliette, Quebec. Water-based paints on concrete wall. 15' × 150' × 400'. The piece refers to the possibility of Celt-Iberian visitors to Canada in the pre-Columbian period, and is one of several concerning ancient natural marks and languages.*

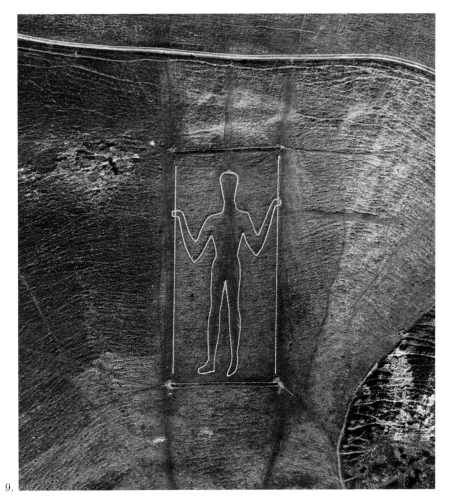

9.

10.

11A.

11B.

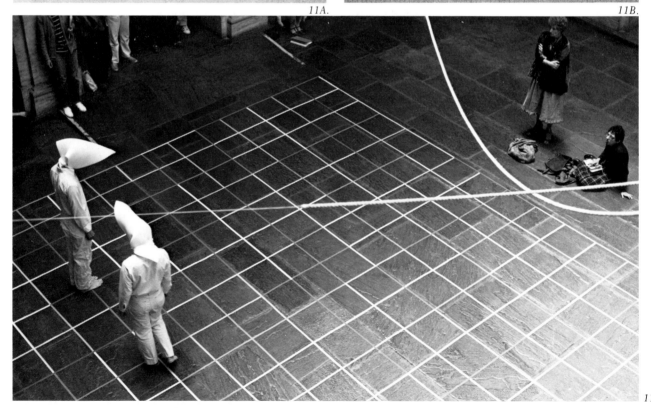

11C.

One contemporary artist who has incorporated these ideas within the modern Minimalist sensibility, without sacrificing their poetic aspects, was—not coincidentally—born in Ireland. By 1967 Patrick Ireland (Brian O'Doherty) was living in New York and seeking a way to combine ideas on language and seriality, influenced by Hans Richter's films and the experimental music of composer Morton Feldman. Recognizing the connections between Minimalism, Conceptualism, and ancient Irish culture, he introduced Ogham as a bridge between archaic and still evolving "alphabets."

Ogham is based on a system of one to five strokes and four permutations; vertical lines cross a horizontal plane or an edge/corner, or march above it or below it, or are slanted across it. Ireland used these lines to translate and mirror language, evolving a visualization of harmonics. He worked with "magic squares" of letters instead of numbers, conjoining, for instance, the words *one/oen/noe/neo/eon/eno* (one/wine/year/new/time/man). The vowel sounds became private performances or "primal screams," which later evolved into public performances on a floor grid.

Beginning with black and white drawings (based not on motifs, but on intervals), moving into colors applied to vowels—the primal breath—Ireland eventually developed Ogham's echoes and resonances into a double three-dimensionality. In *Babel,* a long vertical wall piece of polished aluminum, a series of equally-spaced lines across the edge could be read as any chosen vowel, depending on the viewer's perception while scanning them. With gleaming four-sided pillars, he mirrored (and unmirrored) his linear structures, arriving at a labyrinthine spiraling effect that could also be read like a musical score. Other "compositions" were based in a system of six reflections, which in turn related back to the "vowel drawings," and to Ogham.[29]

What Ireland had found was a virtually infinite system that looked minimal and abstract but had intricate meanings (especially to those who speak Gaelic, where the word for horizon means "edge of the sky"). Ogham interested him because of its construction of vowels and consonants, which allowed him to "get off on linguistic explorations, to play with phonemes and morphemes as clusters of line which mobilize another plane on top of that ordinarily given in speech or words."[30] Ireland's work is about nothing and everything, finity and infinity, symmetry and asymmetry, artist and history. His key code is rooted in the words *one now here*—the individual in the present place. He speaks of his art as "play" in the ancient sense—what Rank described as an act that diminishes fear of destiny and "liberates an energy which can ultimately express itself creatively."

Rank has suggested that astronomy was first used for prophecy rather than for calendar making; that in trying to predict personal/collective fate and to influence time in the search for immortality, people discovered measurement instead.[31] One theory even has the consonants being formed by the shape of the mouth to imitate the sun's course. Ernst Cassirer has observed that the sun and moon were intelligible only when "copied" in terms of the human body.[32] There are indications that the megalithic alignments were lunar before solar, as at Stonehenge (though John Edwin Wood disagrees, noting that we know of "no lunar New

11. *Patrick Ireland. From* Vowel Drawings *series, which could be "read in roars and grunts." (A)* One. *1967. Ink on paper. 22″ × 17″; (B)* One. *1967. Ink on paper. 22″ × 17″ (Photos: Jimmye Kimmey.)*

11C. *Patrick Ireland.* Vowel Grid, *1970. A "structural play" based on length of line rather than edge strokes; this performance at Fogg Art Museum, Cambridge, 1971.*

DAY 15—14 STONES

13A.

12. Three faces of engraved bone from Ishango, Congo. c. 6500 B.C. According to Alexander Marshack, this is a record of lunar markings.

13A. Mary Fish. Day 15—14 Stones. 1974. Pencil on paper. 8" × 10". From Twenty-Eight Days, *an artist's book documenting menstrual ritual performed daily on Doheny State Beach, California.*

13B. Mary Fish. Twenty-Eight Days. 1974. Doheny State Beach, California.

12.

Grange").[33] The moon may have been studied by early astronomers before the sun because its monthly cycles were more closely attuned to organic life and concurred with early matriarchal beliefs; its effect on the tides would also have been crucial to the early British and Scandinavians (and, to a lesser degree, to the Mediterranean peoples).

Today, all over the world, people are still closely attuned to the biological clocks of worms, fish, plants and animals on which they depend for survival.[34] A Japanese scientist's research into the relationships between eclipses, sunspots, the earth's magnetic field, and body chemistry suggests that "we may be on the threshold of discovering new biological responses that made eclipse prediction so important to the ancients."[35] The British philosopher John Addey has developed a harmonic theory of sex determination and birth dates according to lunar/menstrual cycles and has suggested that this was known in prehistory. If, as Alexander Marshack proposes, the repeated scratches and notches found on stones and bones from the Paleolithic era are "time-factored" and therefore the first calendars, there would have been several millennia for such knowledge to develop. Much more recent lunar calendar sticks have been found among the Pawnee and Biloxi Indians in North America. The Hopi ceremony *Márawu*, which occurs in October, is a fertility ritual in which

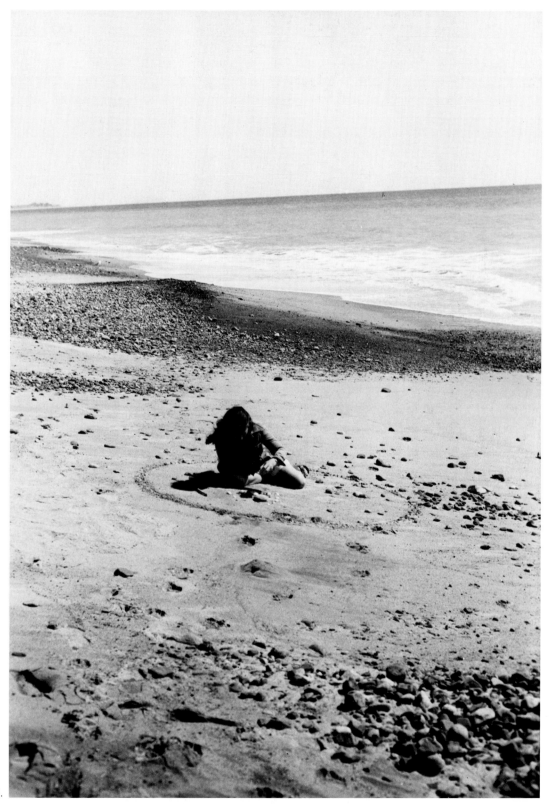

13B.

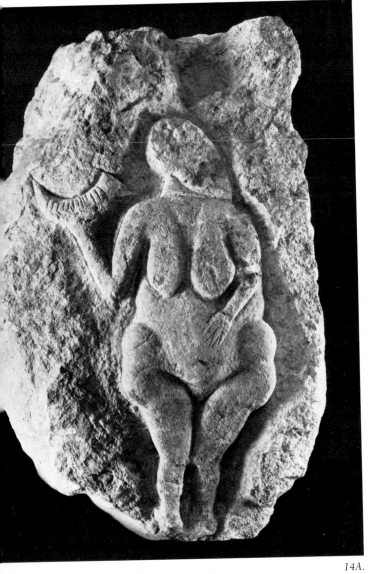

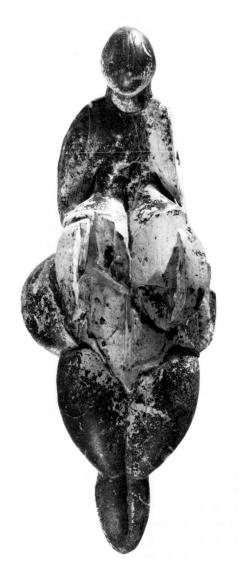

14A.

14B.

14A. *The* Venus of Laussel, *a relief carving from overhanging rock shelter in the Dordogne near Les Eyzies, France. Paleolithic, c. 6500 B.C. Limestone, ochred red. c. 17" high. Probably a "mistress of the animals," forerunner of the Neolithic agricultural goddesses, also associated with moon, snake, water, and seasonal and calendrical myths. (Photo: courtesy Musée de l'homme, Paris.)*

14B. *The* Venus of Lespugue. *Paleolithic. Ivory. 5" high. Bart Jordan has associated its silhouette with the Neolithic toad or uterine image, among other, more complicated, cosmic/mathematical associations. (Photo: courtesy Musée de l'homme, Paris.)*

15. *Medicine wheel, Big Horn Mountains, Wyoming. c. 1500–1765 A.D. 80' across, 245' circumference. Built by prehistoric Native Americans (restored by forest rangers in 1931–55), it may represent the sun, though its 28 spokes suggest lunar months. Its six cairns might stand for the planets; they are aligned to sunrise and sunset on the summer solstice and to the rising points of the stars Aldebaran, Rigel, and Sirius. The wheel may have signaled the proper day to begin the Sun Dance. The spokes of the Big Horn Wheel, like those of other medicine wheels on the Plains, nearly always point to other, distant wheels and cairns. Artifacts found at the Majorville Wheel in Alberta, Canada, establish its construction up to 5,000 years ago, while the Egyptian pyramids were under construction.*

15.

four vertical stripes drawn down the women's legs symbolize the beginning of menstrual periods as well as the four directions. The Hopi also used a horizon calendar and a sun-watcher kept track of time on a notched stick.

One of the most ancient lunar images, dating from 6500 B.C., is the stone *Venus of Laussel*—a wide-hipped nude woman holding a crescent-shaped bison horn with 13 notches, corresponding to the lunar months. The Pythagorean "complete" numbers (such as 7, 9, 12, and 28) reoccur throughout the old cosmologies, equated with the planets, the zodiac, and the lunar mansions. Bart Jordan has found the lunar number 28 on the *Venus of Laussel*, and interprets it as outlining the moon's journey.[36] He also notes that to the Sioux visionary Black Elk, the bison stood for 28 because it had 28 ribs. There are 28 feathers in the headdress and 28 poles in the lodge dedicated to the Sun Dance, representing the conjunction of the sacred numbers 4 and 7 and the number of the Sioux lunar months. The Big Horn Medicine Wheel has 28 spokes, and the number 28 recurs elsewhere in the most diverse societies. Its base, the number 7, is the "virgin" number because it is neither the product nor the factor of any other number; a mathematically perfect heptagon does not exist: "The geometry of seven is developed from no other system nor does it give birth to any."[37] It is the product of 3 (representing odd numbers) and 4 (representing balance), so it unifies the contradictions. Seven appears rarely in physical nature but often in references to temporal cycles and spiritual forces. The horse, a lunar and Great Goddess attribute,

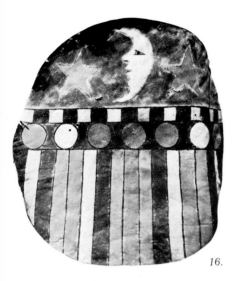

16.

16. *Portion of Jemez dance shield. c. 1920. Paint on rawhide. 19½" diameter. (Photo: Herbert Lotz, courtesy Museum of Navaho Ceremonial Art, Santa Fe, New Mexico.)*

17A, B. *Leandro Katz.* Lunar Alphabet *and* Lunar Typewriter. *1979. Katz photographed the faces of the moon throughout its cycle and made from it an alphabet that functions both visually and textually. (Photos: D. James Dee.)*

18. *Tina Girouard.* Pinwheel. *1977. New Orleans Museum of Art. Cyclical multimedia performance utilizing archaic symbols; about the four directions and the four seasons. (Photo: Richard Landry.)*

was traditionally shod with 7 nails on each hoof, becoming the transmitter of earth to sky, and vice versa.

Jordan has reconstructed a hypothetical lunar "alphabet" which visually "turns" as the week does. His analysis of another prehistoric goddess—the ivory *Venus of Lespugue*—involves a dizzying array of references to finger language, geometry, musical tones, chord systems, note names. By fusing the forms of egg, mandala, and uterine frog in overlapping ovals within her sculptural silhouette, he makes the figure into a mathematically evolved symbol of the universal goddess. He has also read the masklike features of other "Venus" figures (which in turn resemble the goggle-eyed Celtic goddesses) as numerical representations of movements of the planet Venus through the heavens.

Jordan is a musician, and his cultural deciphering of Paleolithic symbol constructions is embedded in the notion of permutation (also the base of Sol LeWitt's art). He works from the networks between natural, astronomical, physiological, spectral, musical, numerical, and linguistic systems in prehistory. After setting up a 20-semitone harmony wheel based on the human hand, and taking clues from sources as diverse as Plutarch and ancient Chinese thought, Jordan asked himself what the solstice and equinox and the seasons had to do with music—"and that's when I began to realize there must be a system older than this." His conclusions have the elegance of the most modern mathematical formulas and they appear to apply to virtually every prehistoric culture.

Combining an intuitive sense of form with meticulous research, Jordan attempts to *see* with the eyes of the ancients. Of particular interest to visual artists is his work with color (traces of pigment are found in Neolithic pictographs in Valmonica, Italy, and of course in the caves) and with body counting, which he says always began with the left hand. (There are still places in the world where women count with the 28 finger-and-joint system.) Jordan then ties all this into the magic squares of 9, adding up to 15. (The magic square is still a popular mathematical game; Ad Reinhart used a nine-square grid armature for his black paintings.) These magic squares may relate to the enigmatic "checkerboards" or calendar grids found in many ancient rock carvings on all continents.

Ernst Cassirer has also pointed out that mythical time is always conceived "both as the time of natural processes and of the events of natural life."[38] Thus the determinedly "simple" art of the Minimalists and Conceptualists can be related to basic survival, seen as a way of coping with the clutter of modern specialization and going back to learn for oneself how humankind learned—within "the terrible simplicity of the archaic frame."[39] If one distrusts the value systems of this society, where does one look for alternatives? Back to the beginnings. Thus in much art about elementary systems there is a certain longing for precision that is simultaneously anti-technological and anti-romantic.

In "Sentences on Conceptual Art" (1969), Sol LeWitt stated a simple premise that helped to spark the synthesizing third stream of visual art: "Ideas alone can be works of art; they are in a chain of development that may eventually find some form. All ideas may not be made physical. . . . If words are used and they proceed from ideas about art, then they are art and not literature; numbers are not mathematics."[40] Almost without ex-

ception, the most interesting, the most obsessive Conceptualists combine time and number in their work about perception separated from physical phenomena.

Douglas Huebler, whose mapped *Duration* pieces first appeared in 1968, expressed one of the political motivations behind such work when he said that rather than add more objects to the world, he preferred "simply to state the existence of things in terms of time and/or place."[41] Thus he returned, in a sense, to the archaic "word-pictures." He was accompanied in this endeavor by Robert Barry, Ian Wilson, Joseph Kosuth, Lawrence Weiner, Dan Graham, and others, all of whom used words to describe invisible sensorial experience and initiated a new kind of impermanent, "dematerialized" art. As Wilson suggested in 1970, the reason for this burgeoning use of language and number was "a more acute consciousness on the artist's part that he is really part of the world . . . the artist by his nature communicates."[42]

There was an element of puritanism as well as pragmatism in this anti-commodity Conceptual Art about number and time, and that may explain why so many American artists have been involved. They are inadvertently reflecting national myths—Do It Yourself, See How It Works, and Independence from Authority. Yet perhaps the two most quintessentially conceptual artists working with time and calendar making are Japanese and German. On Kawara and Hanne Darboven have compulsively recorded the times of their lives in art, as though hanging onto sanity by constantly locating themselves in the world.[43]

Kawara began his *I Met* and *I Went* notebooks in 1968, typing lists of everyone he met and mapping all his movements. Since 1966, he has made an almost daily series of *Date Paintings* which are just that—small monochrome canvases with the date stenciled on them, accompanied by a clipping from that day's newspaper. Other works include a longitude and latitude painting series and a continuing series of *I Got Up* postcards, documenting his rising hour and sent to friends all over the world from wherever he is (Kawara travels a great deal). His extraordinary *One Million Years* book in fact covers two million years, as it consists of two sections: "One Million Years—Past" (dedicated to "all those who have lived and died") and "One Million Years—Future" (dedicated to "the last one"). Each year is simply enumerated, as follows: ". . . 947096 BC 947095 BC 947094 BC 947093 BC. . . ." Another series stated in telegrams: "I am still alive."

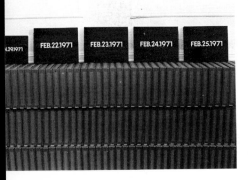

19A.

Darboven's art is more visually and mathematically complex. She began as a classical pianist and today is working again with musical scores. Her work focuses not so much on numbers (which are the vehicles or forms) as on the continuous process that is her true content. In her *Diaries* and *Year Books*, the numbers of the dates are permuted and "produced" by page after page of numerical or written-out numerical notations in her calligraphic hand. ("1 = 1 and 1 + 1 = 2 is 1 2—one is one and one plus one is two is one two—I write and don't describe and I do like to write and don't like to read," she explained in a drawn exposition of her motives.) *One Century in One Year* (1971) consists of 365 volumes of 100 handwritten pages, each continuing the obsessive web of numbers, suggesting still more expansive webs in their indices. One

volume a day was shown as she simultaneously executed the piece.

For Darboven, the calendar is merely a vehicle, with no other meaning for the work, but by permuting its sequences of order (and leap-yearly disorder) through endless cross-sums and progressions, she creates her own time. In this time she lives, and "writes" her art. The mathematical circles in her works can be macro- or microcosmic. The indices sometimes suggest works of such scope that they could never be accomplished. Her systems often double back on themselves "so I relearn where I came from," she says. She only uses numbers "because they are so steady, limited, artificial. The only thing that has ever been created is the number."[44]

Thus Darboven states her accomplishment in terms of survival and immortality: "Going on is the enormous thing I do." She is on a journey in her own head, while Kawara travels as obsessively in space. (At one time Darboven "wrote" 500 pages of Homer's *Odyssey:* "Time compensates time, time neutralizes time / No time at all / Time total.") She visualized a 42-volume system of her "real book" (which in 1973 had 15,000 pages) as a perfect diagonal S-curve: "The circle as symbol of infinity, everything, what is beginning, where? What is end, where?" She immerses herself in a flow of numbers and words as though acting out a metaphor for the ancient world-picture—the globe held in the circular river of time—Oceanus, the tail-eating serpent of waters, and the circular River Styx.

The zodiac snake, the Mexican serpent with a head at both ends of its body, the world snake of so many cultures, is the optimistic symbol of the oldest, circular time, modeled on the seasons and reinforced by observation of the heavens: "Nature is an infinite sphere whose center is everywhere and whose circumference is nowhere" (Pascal); "What is eternal is circular, and what is circular is eternal" (Aristotle); "Everything an Indian does is in a circle and that is because the power of the world always works in circles and everything tries to be round" (Black Elk).

Body-identified solar and lunar cycles are recalled by the "hands" and "faces" of the clock, although the clock itself reverses natural time by moving from "west" to "east," or anti-sunwise. The linear time a clock measures developed over the millennia with patriarchy and industry. In Aztec myth it appeared when the four directions battled to become the sun. Christian time is also linear and anti-natural; the world has a beginning and an end that lies "beyond" the daily or annual cycle. Ironically, Darwinian time is equally linear, with its insistence on the steady progress of evolution. Until the Renaissance, when public clocks were installed to regulate "the new social relations of production and the market,"[45] the clergy controlled the time in Europe by ringing the church bells. Today, in art, the "formalists" who are devoted to esthetic versions of progress and evolution might be said to espouse an ahistorical linear time (sequence rather than structure), while the "anti-formalists" devoted to form as a vehicle for content tend to look to the spiral, which incorporates both linear and circular forces.

The ancient Chinese understood that circular and linear time were not incompatible and reconciled them by having two time mandalas—one round and one square. They were twirled together for divination in a sacred marriage between heaven and earth, between "masculine" time and

19B.

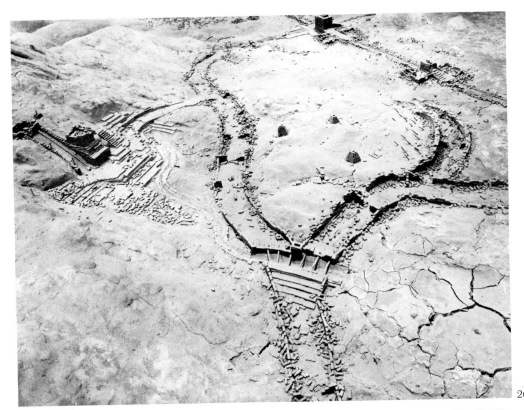

20A.

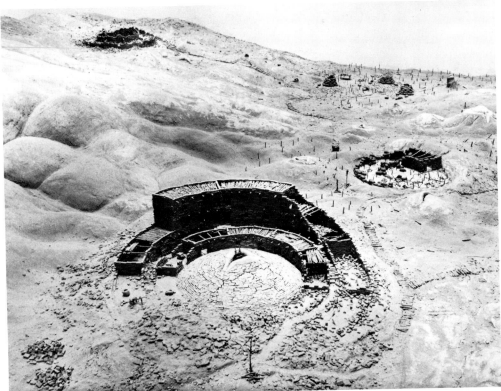

20B.

"feminine" space. (Stonehenge, like St. John's New Jerusalem, has been read as "the circle squared.") The swastika, in its positive, sunwise orientation, also fuses circle and square in its motion and outline. In a sense, Einsteinian physics has reintroduced something close to the primitive or cyclical notion. As Marie-Louise von Franz has observed, "It is a remarkable coincidence that at approximately the same time as physicists discovered the relativity of time in their field, C. G. Jung came across the same fact in his exploration of the human unconscious,"[46] with his theories of racial memory, the collective unconscious, and synchronism —another "twirling together," or basically anti- or ahistorical reconciliation of physical and psychic time. Also significant to contemporary art is Marshall McLuhan's fragmentation through mass media. By seeming to make all times contemporary with ours, it denies us the sense of history necessary to understand our own time.[47]

The simultaneity of Charles Simonds' "time landscapes," his superimposition of fantasy world on real world, and the curiously timely and timeless offspring of this union produce a more dynamic dislocation than the McLuhanesque model. When Simonds worked in the New York streets, the community watched his Little People go through a whole life-death cycle in one day. As he continued to build in the same neighborhood, month after month, a whole history and mythology unfolded, like a TV serial. The micro/macrocosmic creation and decline of the Little People's dwellings reflect both self and humanity to onlookers.

Simonds' *Three Peoples* is a narrative artist's book, unillustrated except for the symbols representing the Linear, Circular, and Spiral Peoples. It brings out three different civilizations, value systems, and attitudes to the earth, all of which are part of the Little People's vast and complicated history. The Linear People straggled across the land on roads that were also houses, leaving behind all their personal effects whenever they moved on, occasionally crossing paths with their pasts as they moved into a random future. Intersections formed cities that combined life with ruins with gardens/museums of personal histories—"a confusion of pasts" investigated by organized tours, mapping, and geneological projects. In this anti-chronological miasma, the Linear People traveled through a web of simultaneous times.

The Circular People, on the other hand, lived a life of great security, abandoning and rebuilding their "clock city" in a cycle of excavation and reconstruction that followed the seasons, confronting their past at regular, predictable intervals. Stories and memories unearthed during this progression were used to reconstitute the past, just as the old bricks were fitted into new dwellings. The year broke with an orgiastic winter solstice rite in the central dome.

The Spiral People, closest to our own civilization, "believed in a world entirely created by their own wills, in which nature's realities were of little concern." Gambling with their natural resources, relentlessly consuming material goods, building higher and higher into the sky with less and less people, their goal was "an ecstatic death . . . to achieve both the greatest height possible and to predict the very moment of collapse."[48]

Whether the calendar was a "scientific" breakthrough or a byproduct of the spiritual pursuit of immortality, its appearance represented the most

20. *Charles Simonds. Two details of* Picaresque Landscape. *1976. Room installation at the Museum of Modern Art, New York. Clay bricks, wood, earth. Showing (A) the Linear People, (B) the Circular People in foreground, Spiral People in background. The installation is a composite of the past, present, and future histories of these three branches of the Little People's civilization.*

21. *Sun Dagger of Fajada Butte, Chaco Canyon, New Mexico, made by the Anasazi Indians. c. 1000 A.D. (A) The butte. (B) The leaning slabs (6' to 9' high) forming the channel for sun- and moonlight and shadow. (C) The dagger on the large spiral at noon on summer solstice. (D) The daggers embracing the spiral at noon on winter solstice. The spiral is about 15½" wide. In similar phenomena, the vernal and autumn equinoxes are marked by a "serpent" of shadow descending the balustrade of the Great Pyramid of Kukulcan at the Mayan site of Chichen Itza, Yucatan, and the eyes of a horned shaman figure in a Baja California cave are cut by a band of light on summer solstice. (Photos: Anna Sofaer, Karl Kernberger, Jay Crotty; © The Solstice Project, Washington, D.C.)*

21A.

concrete, the most subtle appearance of number in life. The earliest clock—the gnomon, a vertical rod casting a shadow on a flat place (still used in some parts of the world today)—marks the center, the place time starts, the birthplace or navel of the earth. Like the primal peoples who raised the great standing stones that may be heirs to the gnomon, the visual artist is concerned with energies, light and shadow, as well as matter and substance. A classic bridge between ancient calendrical notation and contemporary art is offered by a solar calendar that was executed in Chaco Canyon, New Mexico, by the Anasazi Indians (950–1150 A.D.). Rediscovered in 1977 by artist Anna Sofaer, it has been reborn as a work of contemporary art through an overlay of its archeological significance, its current esthetic meaning, and an artist's interpretation.

Sofaer's own art at the time she found the Chaco marker consisted of "collages in space and time," photographs of stone ruins and monuments rearranged into new three-dimensional structures. The statement she wrote for a one-woman show in 1977 eerily predicted her Anasazi find (which she herself sees as "a kind of quest"): "The quality of light in photographs suggests a seeing through—a dream, an illusion—a walking into and beyond, an extra reality—a reality that exists as in film, bigger and more than the dense quality of 'real life.' Suggests communication, constant, unending *process* where content is ever-changing but the process is ceaseless."[49]

What Sofaer found on top of the almost inaccessible, 430-foot-high Fajada Butte in Chaco Canyon were two spiral petroglyphs—the only known calendrical markers using the noonday sun rather than the rising or setting sun. They are incised on the cliff face, sheltered by three leaning slabs of rock, arranged so that for a brief period at every midday, light passes through two slits between the slabs. At summer solstice, the larger, nine-ringed spiral (13″ × 16″) is pierced through the precise center by a dagger of light. At winter solstice, two daggers embrace either side, as though to protect it from further disappearance. The other, three-ringed spiral (3½″ × 5″) is centrally pierced at the autumn and spring equinoxes.

Sofaer and her team have now confirmed that a shadow passes through the center of the large spiral when the sun rises "at the position reached

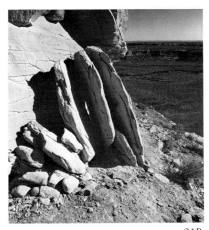

21B. 21C. 21D.

by the full moon once every 19 years, bisects the spiral's 19 rings (counting both 9's and center) and is aligned with a pecked groove from center to bottom left edge."[50] In addition, the researchers have found that the moon at its maximum extreme, also reached only once in 19 years, casts a shadow tangential to the far left edge of the spiral. In other words, the Indians were observing and marking on the same spiral, with both light and shadow, the minimum and maximum extremes of both sun and moon.

The intricacy of this arrangement, its translation of the celestial horizontal movement into a terrestrial vertical image, involves not only astronomical knowledge, but surveying skills and the physics of curved surfaces. Its discovery showed an amazed scientific community that the extent of Native American calendrical knowledge was far beyond anything previously imagined. Yet the Chaco civilization's advances in other areas were well known, from its architectural achievements to its refined masonry to its irrigation and huge, arrow-straight road systems. A 50-mile area is covered with sites. Skunk Springs, recently investigated, had 1,000 rooms and covered an area of 594,000 square yards—marks of a highly developed and confident culture. Before Sofaer made her discovery, scientists in the new interdisciplinary field of archeoastronomy (as it is called in the U.S.) or astroarcheology (as it is called in England) had found that the primary design elements of the 800-room, multistory Pueblo Bonito in Chaco Canyon were precisely aligned to the rising and setting of the equinoctial sun and to the daily passage of the noon sun. Alignments had also been recorded in the nearby Casa Rinconada.

As a layperson, Sofaer did not find it easy to convince the scientific community of the facts. In order to do so, she tested her theories with scientific investigation. For example, she hired a geologist, who subsequently proved that the slabs had been placed by humans rather than conveniently falling in just the right positions. Sofaer has noted wryly that "the last people to be impressed by the Indians are those who study most closely the originators of the sites." She suggests that the calendrical spirals come as a surprise "because we have put away the North American Indian heritage, buried it . . . to cancel our painful past." Sofaer is also active in calling attention to the fact that innumerable sites

22A, B. Engravings on kerbstones at
New Grange, County Meath, Ireland.
c. 2500 B.C. (Drawings: Claire O'Kelly.)

23A, B. New Grange mound, passage
grave, and temple, in Boyne Valley,
County Meath, Ireland. c. 3400 B.C. The
earth-covered mound (262' wide × 33'
high) was fronted by gleaming white
quartz crystals so it sparkled from a
distance. The kerbstones, intricately
carved with spirals, lozenges, and
concentric circles, welcome the visitor
into the 62' passage leading to a
spacious corbel-roofed chamber with
three stone niches. At sunrise on the
winter solstice, and for one or two days
around it, the rising sun shines through
a horizontal slit over the entrance (closed
at other times of the year) and
illuminates the triple-spiral carving deep
in the chamber. Before it was
"discovered" by scholars in 1968, a
longstanding local tradition testified to
this event. The mound is surrounded by
the remains of a circle of standing
stones, one of the oldest of over 900
circles in the British Isles. The rock
carvings (c. 2500 B.C.) resemble those
on passage graves in Brittany and Malta,
which are roughly contemporary. New
Grange was probably the center of
midwinter ceremonies, perhaps opened
annually to encourage the sun's return
and for performance of fertility rites of
rebirth. (Photos: Charles Simonds, Nigel
Rolfe.)

22A.

22B.

are now under siege by the corporate energy interests. Something like
one-sixth of the world's known uranium supplies are within 150 miles of
Chaco Canyon. Private developers (and now sometimes the U.S. De-
partment of the Interior itself) would sacrifice the land, the history, and
these irreplaceable works of art to their own greed for temporary wealth
and power.

The Fajada Butte site would accommodate only two or three people at
most; any ceremony there would not have been a large public one, but
was probably used by "priests" who "told time" for the whole community.
Even today, the various Pueblo tribes continued to keep strict secrecy
among themselves about their sacred rites. Sofaer was given some indica-
tion of such rituals by two Zuñi Indians. Andrew Napatcha, the tribal
historian, told her about a large rock slab that told the sun priest the times
of the year by cast shadows. A young painter active in traditional culture
told her his grandmother had spoken of a place where the sun priest went
to see "shadows come on a spiral to tell the time of year," but no one knew
where it was.

Though billed as the "American Stonehenge," Fajada is, on the con-
trary, the subtlest of monuments, testimony to the Anasazis' detailed yet
tender knowledge of natural processes. "A work of art like this," says
Sofaer, "grows out of a tradition of meditation and intense mind training,
perhaps a tradition that develops certain qualities and capabilities known
to only a few western people, such as creative scientists, artists and mys-
tics. And it grows out of a culture with certain cosmic beliefs. Among the
Hopi there are no words for past or future; shadow has as much meaning
as light; process is as important as product; matrilineal societies have a
special connection with the earth."

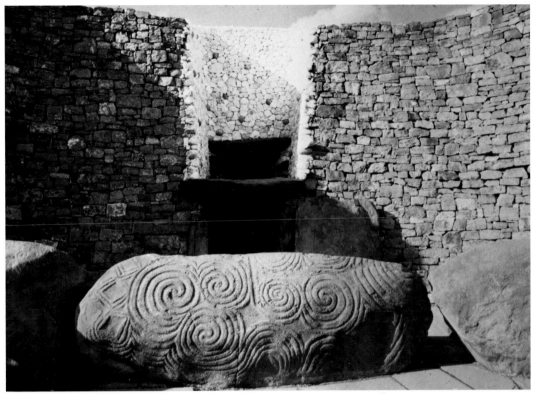

23A.

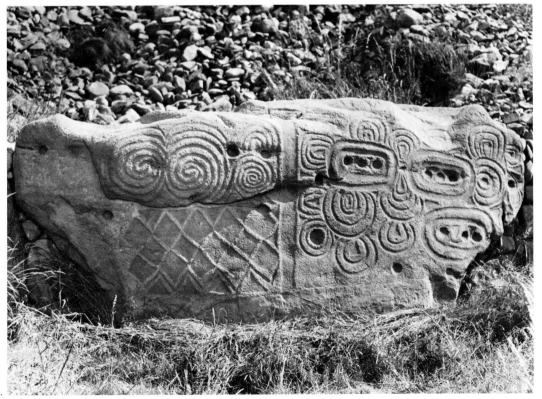

23B.

24A.

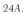

24B.

24C.

Another artist who has moved back and forth between art and science is Charles Ross. His film on the 1972 solar eclipse represented the New York Hayden Planetarium's coverage of the event. Ross works with huge prisms which light up public architectural spaces and transform them into containers for constantly changing rainbows. In galleries he shows his calendrical solar burns (*Sunlight Convergence/Solar Burn: The Year Shape*), executed beneath a large lens on his New York studio roof. Each day the passing sun burns a curve—"the day's signature"—into a wooden panel. The resulting forms are widely varied but sequentially related, and when shown together they look like brown-on-white paintings. When the burns are placed end to end, following their actual curvature, they form a double spiral—an ancient year-symbol that reverses its direction from winter to summer and is a migration symbol among Southwest Indians—time and space unified.

What Ross has made with modern technology is a primitive map-calendar that is no longer socially necessary, so it becomes art. On the other hand, he sees the burns as looking "beyond the notion of art as a closed system to propose art as a point of contact with the universe energy matrix." The burns "are not information *about* but rather a point of contact with their source," bearing out his image of the artist as catalyst "precipitating form without interference or interpretation." Like Sofaer, Ross sees the double spiral year-shape he discovered through his burns as a "treasure at the end of a quest."[51] Steve Katz has remarked that the double spiral is "a complex configuration resonating with allusions to the infinity sign, the double helix, the analemma, the figure eight. That the sun spends every year making that drawing on the various inches of this planet occurs to me as an ironic footnote to the story of fine art."[52] It is tempting to think this is how the prehistoric peoples who constructed New Grange were thinking.

Knowledgeable about ancient astronomical myth as well as modern astronomy, Ross has also worked with the stars. His cut-out *Star Maps* chart the universe as "a conceptual system bridging the ages of history." The core of each map (essentially photos of the heavenly spheres flattened out) is the Milky Way. "Each map," Ross says, "includes the stars above your head and the stars beneath your feet, no matter what your position on earth."[53] Since 1974 he has also been planning and constructing a still unfinished earthwork called *Star Axis*—a concrete cylinder in the side of a mesa, 100 miles east of Albuquerque. Aligned with the earth's rotational axis, it points to the north celestial pole. The top will be lined with drystone walls and will loom about 50 feet over the mesa. As one climbs the stairs inside the tower, one will see increasingly larger circles of sky; these will each describe a circumpolar orbit of Polaris at a different point in history. The shadows will describe the earth's rotation in terms of huge time spans and minute ones—from eons to seasons to minutes. The viewer will move back and forth through time, following the pattern of the 26,000-year cycle of the "wobble" in the earth's axis.

As John Beardsley has written, *Star Axis* will render time "less anthropocentric, less automatic, as we see ourselves relative to the cycles of a far greater duration and permanence than our own."[54] An analogous function is no doubt served by the Navaho "star panels" on cliff faces in

24A. Charles Ross. Sunlight Convergence/Solar Burn: The Year Shape. 1972. Photo construction. 36″ × 96″. Such double spirals are found in Native American petroglyphs (sometimes squared) as a year or migration symbol of time and space unified.

24B. Charles Ross. Point Source/Star Space/Sun Center. 1975. Acrylic, paper, ink on canvas. 8′ 10″ × 24′9½″.

24C. Navaho star chart (part of a large planetarium panel in Cottonwood Canyon, Canyon de Chelly, Arizona). After 1775 to the present. A Navaho living in the area knows of 32 such planetaria in Canyon de Chelly. The shapes may have been stamped on the ceilings of the rock shelters with wooden patterns mounted on long poles. In other New Mexico locations, colors and figures are also introduced to planetaria. These are sacred sites, starlore being important to Navaho religion. (Photo: Campbell Grant, courtesy University of Arizona Press.)

Canyon de Chelly, which seem to be unique in North American Indian art. They show how much astronomy the Navahos knew and the special importance of the Pleiades, which marked the time to start the Night and Mountain Chant ceremonies. "The shamans sought to relate the stars to the human condition, especially in matters of long life," and they still visit these planetarium sites for ritual reasons.[55]

In the early '70s, Nancy Holt concentrated on urban or landscape spaces as seen through holes in tunnels, pipes, and other devices that made the viewer consider both outside and inside, perceptual and physiological sensations. In *Sun Tunnels* (1973–76), an ambitious work constructed in Utah's Great Basin Desert, Holt again bound sky and earth and again tapped a lyrical vein within steadfastly "objective" forms (see p. 64). *Sun Tunnels* consists of four huge concrete pipes (18′ long and 9′2½″ in diameter, with walls 7¼″ thick). They face each other in pairs across a central void and are oriented to the summer and winter solstices. For about 10 days around the winter solstice, the sun rises in the pipe facing southeast and can also be seen through the northwest pipe. At and around the summer solstice, the sunrise and sunset are aligned to the northeast/southwest and northwest/southeast pipes.

In addition, holes of eight to ten inches in diameter drilled in the walls of the pipe reflect the configurations of Capricorn, Draco, Perseus, and Columba. During the day, these constellations are contained in the interiors of the tunnels, through starlike points of light on the concave walls. During the night, moon- or starlight penetrates the darkness within, sometimes in the form of moonlike crescents, and the shapes vary constantly, depending on the angle of light. Thus "an inversion of the sky takes place; Stars are cast down to Earth, spots of warmth in cool tunnels."[56] (This use of roof holes as stars was prefigured by the French Revolutionary architect Etienne-Louis Boulleé in his domed *Cenotaph to Newton*.)

The *Sun Tunnels* both expose and protect. Though the great cylinders are the same grey color and material as the earth of the site, they offer only abstracted points of identification with the human body. The round holes in the walls, however, offer micro/macrocosmic parallels between the human eye (looking in, looking out), the form of the earth itself, the form of the planets they bring down to earth, and the motion of sun and planets.

The desert is the traditional geography of revelation—simultaneously empty and full. Holt writes:

"Time" is not just a mental concept of a mathematical concept in the desert. The rocks in the distance are ageless; they have been deposited in layers over hundreds of thousands of years. "Time" takes on a physical presence. Only 10 miles south of *Sun Tunnels* are the Bonneville Salt Flats, one of the few areas in the world where you can actually see the curvature of the earth. Being part of that kind of landscape and walking on earth that has surely never been walked on before evokes a sense of being on this planet, rotating in space, in universal time.

25. *Nancy Holt. Annual Ring. 1980–81. Federal Building, Saginaw, Michigan. Steel bars, concrete and steel footings. 30′ diameter, 14′3″ high. There are four circular openings in the barred dome, with diameters from 6′ to 10′. The top and east-west holes frame the rising and setting sun on the equinoxes; the north hole frames the North Star. On the ground there is a steel ring, 10′ in diameter. In conjunction with the aperture above, it frames a circle of sunlight to mark the yearly solar zenith—noon (actually 1:36 P.M.) on the summer solstice. At Xochichalco, Mexico, a perfectly round shadow is cast into a shaft in the Great Pyramid at the sun's zenith. (Photo: Nancy Holt.)*

26A, B. *Nancy Holt. Sun Tunnels. 1973–76. Great Basin Desert, Utah. 86′ overall. (Photo: Nancy Holt.)*

25.

26A.

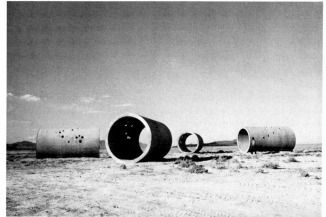

26B.

27. *Athena Tacha.* Crossings of the Ecliptic with Horizon at 41° Latitude. 1975. *Study for room-size, blue-on-white chalk drawing/sculpture executed at Oberlin College, Ohio. Ink on vellum. 24″ × 33″. The heavens were probably first studied from a hole in the ground, a concept Tacha modernized in this work by focusing on the dynamic and changing angles of the earth's movements. The result was an impressive abstract drawing in space which made the viewer the center of a daily circle that registered nature's grander patterns.*

28. *Keiko Prince.* Shelter: Sun Water Dial. 1972–73. *Model with water, light, mirror, projected for the Charles River, Cambridge, Massachusetts. Hovering like a horizontal cave or half-open clam shell between the reflecting water of the river and a shimmering ceiling of prismatic light, the sun water dial would have multiple functions. It is a shelter for natural forces, rather than for people, who view it from the outside, publicly sharing the common experience of cyclical time. The river acts as a conductor of austere luminescence and information between nature and observers. The ceiling receives the movement of sun and water from the water itself and from a thin curving mirror along its projecting lip of land. The roof of the structure is a year clock, with 120 prisms making each hour of daylight each month and sending a spectrum of colored light through the roof in reverse proportion to the actual light duration; at the summer solstice, when the sun is highest, only a single prism will shine at noon; in December, at winter solstice sunset, all of them will be alight, directly contradicting the darkness of this day, and confirming the return of the sun. The shelter is based on the* Tsuko Mi—*the Japanese moon-viewing ritual. Prince's goal is to redevelop confidence in human communication through this common bond to the "grand motions of nature." As in her other projects—a water maze and a tidally controlled light piece for Boston Harbor—she proposes a unique fusion of public and private, of infinitely repetitive process and ephemeral, unrepeatable experience. (Photo: Nishan Bichajian.)*

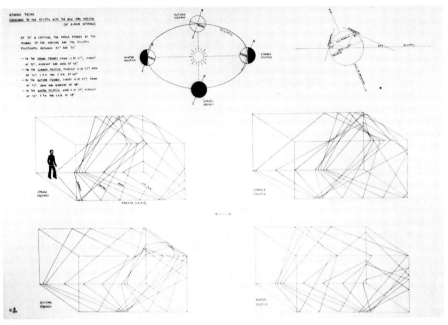

27.

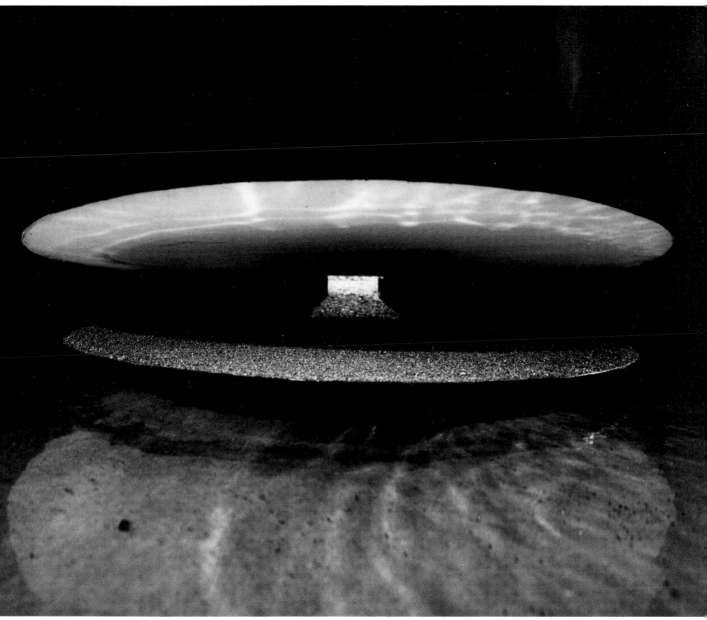

28.

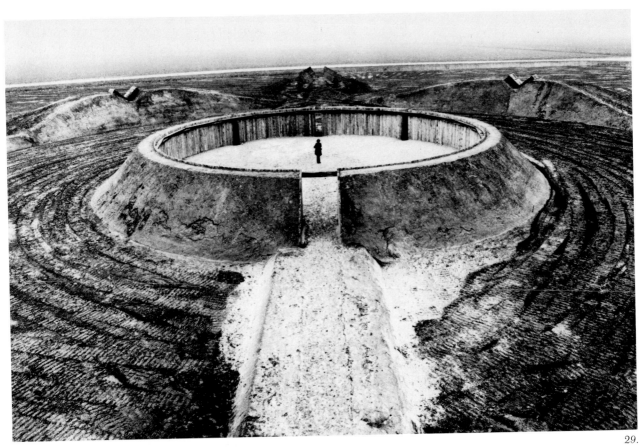

29.

29. *Robert Morris. Observatory. 1970–*
77. Permanent installation at Oostelijk,
Flevoland, Holland. Earth, wood, granite.
298½' diameter. This Observatory was
preceded by the unbuilt Ottawa Project
of 1970, a concrete and earth mound
spiraling to a 20'-high center, with slits
cut in the directions of solstices,
equinoxes, and moonrise. Observatory
has two earth rings; the inner one (9'
high × 14' wide and almost 300' in
diameter), consists of five sections—
two canals and three banks; it has four
notches, lined with granite boulders,
twice corresponding to two V-shaped
notches in the outer ring which are
oriented to the sunrises at winter and
summer solstices; the other two
apertures are equinoctial. (Photo:
courtesy Leo Castelli Gallery.)

Robert Morris' *Observatory* (first built in 1971 at the Sonsbeek outdoor sculpture exhibition, then destroyed and reconstructed at another site in Holland in 1977) is a massively confrontational fusion of archaic science and sophisticated modern perceptual theory. Morris has consistently been concerned with "how things are made." In *Observatory,* for instance, the two steel plates used for the equinoctial notches were dragged along the ground by bulldozers to their final resting places, leaving deep grooves in the ground as a record of their passage—ironically little effort, compared with the achievements of prehistoric engineers. Of course Morris was not trying to reproduce an ancient temple; he was making a sculpture that gained a dimension by *referring* to the past from his own point in history, just as he did in the untitled stone piece at Documenta (see p. 7). He is equally interested in "scanning"—in ways of seeing available to people with advanced surveying equipment and/or airplanes. Though *Observatory* connects human behavior and perception to the annual round, it is more concerned with time as a concretized abstraction than as a vehicle for cosmic meaning. Edward Fry has described its base as a "dialectical synthesis between historical consciousness and astronomical time. . . . Its real function is the symbolic negation of cumulative knowledge, historical and scientific, through Morris' choice of a model that we recognize as prehistoric . . . the negation only confirms that which is negated."[57]

In June of 1979, with some 3,400 rocks, Michelle Stuart built *Stone Alignments/Solstice Cairns* on the Rowena Plateau overlooking the Columbia River Gorge in Oregon (see plate 6). The piece was "a rite of passage, about time and place, so people could come up and contemplate the transitions from spring to summer, darkness to light, and from mountain to river."[58] A wheel of boulders in modulated lines "like a drawing," irregularly punctuated by four stone cairns, it accurately marked the summer solstice, with the sun rising over the beehive-shaped central cairn and setting over the peripheral conical cairn. The topography of the land determined the final form. Stuart found three natural mounds and a concave hollow, which, by coincidence, measured perfectly in her scheme and were added as a "Moon Aura" and a "Moon Crater." Artist Paul Sutinen, who helped build *Stone Alignments*, wrote that it was "like a lens gathering many things into focus."[59] Stuart herself said, "When the solstice sun came up over the cairn, I felt that I was sharing an experience with humankind of all times."

Several elements in the work elaborated on this motif of connection. To begin with, the Indians called Rowena Plateau "the place where the sun meets the rain." In order to contrast with the indigenous dark basalt rocks, Stuart had boulders brought from Mount Hood, some 30 miles away; they were light-colored and rounded by glaciers and water from the Hood River, which flows into the Columbia. Thus stones from the water's source met stones from the water's outlet. When the piece was complete, Stuart found to her surprise that the sunset cairn also aligned with an island in the river below; it had once been an Indian burial ground and Lewis and Clark had found a circle of horses' skulls there. (Horses' skulls were also found mounted on menhirs at Mané Lud, a 2500 B.C. dolmen in Brittany.)

Following another Native American custom—that of burying records under cairns—Stuart interred small stones beneath her central cairn, as mementos of other places she had worked, including Guatemala, New Jersey, the Southwest, Scandinavia, and England. With them she placed a poem by Rudyard Kipling to Mithras the Sun God (whom she later learned was born from a rock) and a T'ang Dynasty poem by Han Shan

30A, B. *Michelle Stuart*. Stone Alignments/Solstice Cairns. *1979 Rowena Plateau, Columbia River Gorge, Oregon. Views from opposite directions (see also color plate). (Photos: Michelle Stuart and Maryanne Caruthers-Akin.)*

30A.

30B.

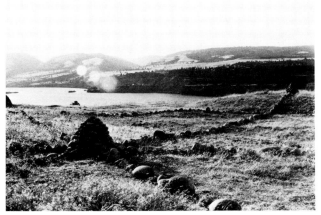

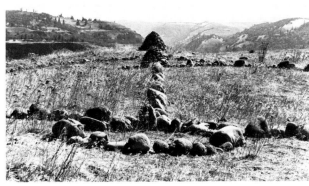

31A.

31B.

called "Cold Mountain." In other words, the artist observed gleefully, "East and West *did* meet."

Still another coincidence in this context: not far away, across the river, is the hideous American replica of Stonehenge. Stonehenge itself was also an observatory, for which the bluestones were transported many miles from Wales for unknown reasons. This is the case with many prehistoric monuments, which adds to their mystery. Perhaps the superhuman effort of dragging the megaliths many miles was an overlay in itself, a means of importing the magic properties of one place to another, doubling the powers of an important ceremonial site; it makes sense put in Stuart's context of symbolic "meetings."

I'll end this chapter with a very brief overview of astroarcheology, since it too is an overlay of time on time, "eternity" on history.[60] The field is a new one, and still somewhat of a mongrel science, bringing together teams of astronomers, anthropologists, archeologists, physicists, photographers, engineers, comparative mythologists, and even artists.

The origins of astroarcheology lie in 1740, when William Stukeley noted that Stonehenge was oriented to the northeast, "whereabouts the sun rises when the days are longest." Although in those days Stonehenge was considered Roman, Stukeley was aware of its relationship to the outlying ancient barrows. His contemporary, architect John Wood, noted the geometry of the stone circles at Stanton Drew and connected it with a Pythagorean model of the universe. He concluded that the seven hills of Bath were part of a model of the planetary system—an idea reborn in this century with the notion of a giant Glastonbury Zodiac, sculpted in all the outlying land forms. Yet Wood made very accurate plans of Stonehenge and related it to lunar and calendrical cycles. In Devon, later in the century, William Chapple began, but never finished, his grand study of the astronomical and geometrical surroundings of Spinster's Rock at Drewsteignton on the edge of Dartmoor.

By 1846, the Reverend E. Duke could assume that "astronomy, as a science, took an early precedence, and those, whom at this day we account barbarians, possessed a knowledge, at which we ought worthily to wonder and admire." Toward the end of the nineteenth century, A. L. Lewis worked out astronomical relationships between 26 British stone circles and their outliers. In the same period, such hypotheses gained credibility when Sir J. Norman Lockyer—a renowned astronomer and director of the Solar Physics Laboratory—took up the cause, having already established the solar and stellar orientations of the Pyramids and of Greek temples. He introduced the notion that the megalithic sites were aligned not just to the sun and moon, but to certain stars as well, and though he was handicapped by imprecise dating techniques and occasional overenthusiasm, he has frequently been proved accurate when his dates have been checked by radiocarbon.

In the 1920s, Admiral Boyle T. Somerville, though rejecting Lockyer's more imaginative forays into the past, was converted to his general ideas when he found astronomical connections in almost every megalithic site he studied, beginning in Ireland. He became the first to realize how precise the ancient builders had been. Most significantly, his survey of the

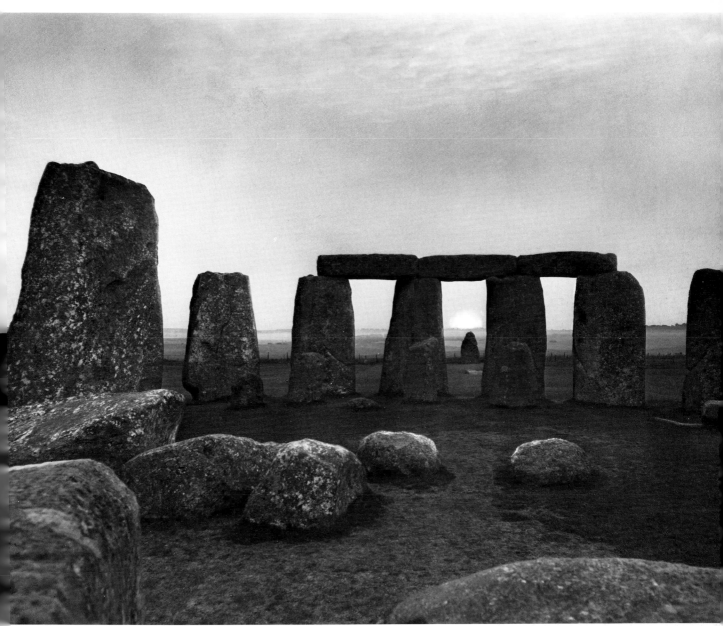

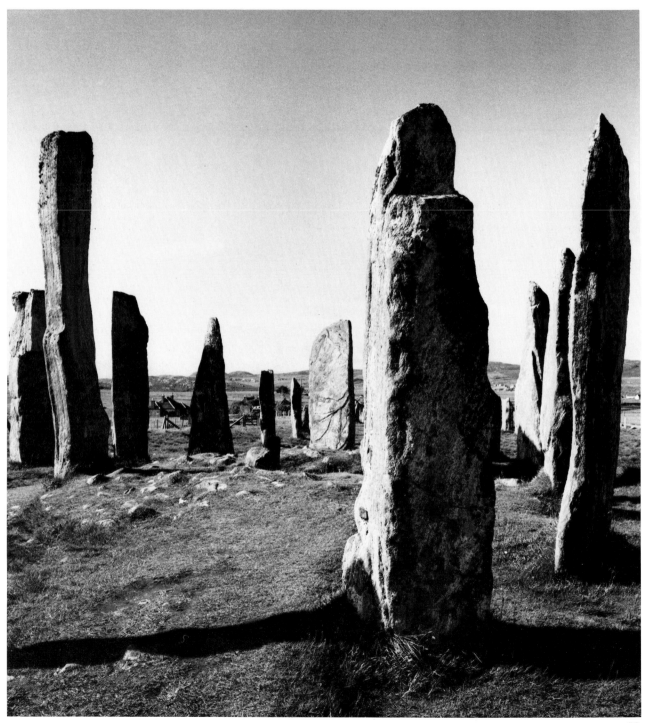

Clava passage graves near Balnuarin, Scotland, showed that the summer solstice sunset ran right down the line of tombs to the center. Somerville also began work on Callanish, on the Isle of Lewis off the west coast of Scotland—the most charismatic of the Scottish sites, with its small spired ring, chambered tomb, avenues and rows.

It was also at Callanish that Alexander Thom was first struck by the prehistoric stones. He was a professor of Engineering Science at Oxford when in 1934 he was forced by rough weather to put in his sailboat at a harbor near Callanish. Gazing at the needlelike pillars in the moonlight, he noticed their precise north-south alignment. "It fascinated me," he wrote later, "because I knew that in those times there was no pole star— its constellation hadn't reached today's position. So what I wanted to find out was whether this had happened by accident and whether it happened at other sites."[61]

Some 20 years and 600 sites later, Thom was convinced it was no accident. He published his findings in 1954 and his first book in 1967, establishing as fact that the "barbarians" of the late Stone Age and early Bronze Age not only knew proto-Pythagorean geometry and used a megalithic yard, but were also aware of the complex variations in the lunar ecliptic (the lunar "wobble" not "rediscovered" until the sixteenth century). The early Bronze Age (c. 1850 B.C.) was an apogee of astronomical activity. According to the present-day scholar John Edwin Wood, it was "a most sensitive and intellectual period in human history," which declined after 1700 B.C., when weather conditions changed for the worse: "The heyday of Bronze Age astronomy was over long before Babylonian astronomy reached its peak. Megalithic astronomy was an independent development; it owes nothing to ideas from the civilizations of the east."[62] By the Iron Age, when the Druids reigned, this knowledge was probably already lost, though the observatories were still in use as temples. It may be that the enigmatic Scottish *brochs*—stone "watchtowers"—functioned as later observatories.

Thom's theories have not been popular with most professional archeologists. As late as 1971, Professor Stuart Piggott, an authority on the Druids, announced on television that "only professional archeologists have the right to put forward new ideas on archeology." Yet this kind of rigid and counterproductive compartmentalization has been breaking down. The eminent archeologist R. J. C. Atkinson, initially a fervent opponent, has been converted to the general notion of astroarcheology and there is an increasing number of scholars who share Wood's convictions. By the time Thom's first book was published in 1967, the archeological establishment was already reeling from another blow. Gerald Hawkins published two articles in the prestigious British magazine *Nature* (October 26, 1963, and June 27, 1964), proving that Stonehenge was a solar and lunar observatory. Dramatically entitled "Stonehenge Decoded" and "Stonehenge: A Neolithic Computer," they raised a furor, partly because they came from an astronomer, not an archeologist, working in America, not Britain, and were based on detailed measurements and calculations backed up by "one minute of time on the Smithsonian-Harvard electric computer," as Hawkins explained.[63]

Hawkins discovered a pattern of sun and moon turning points on the

33. *Callanish I, the main circle, Isle of Lewis, Scotland. c. 3250–1500 B.C. The Callanish site consists of a small circle, a 270' avenue, and three rows (unfinished avenues) coming together in a rough cross shape with the circle at the center; the tallest stone, almost in the center of the ring, is over 15' high. Inside the circle is a chambered tomb and there are other monuments in the environs. Callanish I–V (as Thom has designated the various parts of the site) was definitely a lunar (and solar) observatory; the midsummer sunrise was precisely marked as well as equinoxes and the movements of various stars. A local legend has it that the circle was built by a great priest king dressed in mallard-feather robes; this has been related to the healing powers of various waterbird goddesses and to the cult of water itself, associated with so many stone circles. (Photo: Chris Jennings.)*

horizon that were marked by the stones and archways. It took $18\frac{2}{3}$ years for the moon to go through the pattern, and three cycles, he suggested, could be counted off using the 56 marks called the "Aubrey holes." The builders could use the marks to predict the turning of the moon and the danger of eclipses. He also suggested that Stonehenge's outer sarsen circle represented the lunar month, and its inner bluestone horseshoe referred to the approximately 19-year lunar nodal revolutions within that cycle, perhaps cited by Diodorus of Sicily in 150 B.C. in his *History of the Ancient World:* "The god visits the island every 19 years." In 1965, Hawkins went on to propose Callanish as an equally accurate but less advanced "observatory."[64] This implies that the builders of the megaliths knew the world was round, and transmitted that knowledge down through the generations.

In Thom's second book, published in 1971, he crossed the channel to provide a detailed geometrical/astronomical analysis of the megalithic monuments of Brittany, an area where menhirs, dolmens, passage graves, and cairns are so ubiquitous that they are being neglected and destroyed. Some, however, are unavoidably overwhelming in size and extent. The stone rows around Carnac include over 3,000 great stones— 1,169 at Menec alone, 70 of them forming an oval ring and the rest filing across the gently rolling countryside in 11 lines, about 328 by 3,828 feet, decreasing in size as they fan out in a curve. Virtually next door are the Kermario alignments—1,029 menhirs in 10 lines—and at nearby Kerzehro, 1,129 stones in 10 lines remain.

Thom concentrated on the Carnac rows and on a gigantic series of monuments on the Gulf of Morbihan around Locmariaquer, notably *La Table des Marchands* dolmen with its immense capstone and carved interior slab, and the menhir Er Grah, or *Le Grand Brisé*, which once stood almost 70 feet high and would have been visible nine miles away. Thom's findings indicate that the great menhir and the Carnac alignments were part of an astounding lunar calendar that measured declination and calculated eclipses. He has identified eight lunar observing stations—stones or mounds—whose sight lines tie into the huge marker. At nearby Crucuno, he found a rectangular arrangement of stones which seems to merge the four directions, a Pythagorean triangle, and a symmetrical relationship between solar observatories that can only be found at the latitude of Carnac.[65] He also suggests that the fan-shaped alignments (similar to those found at Mid Clyth in northern Scotland) provided a grid by which to check data and solve extrapolation problems, suggesting the possibility of communication between the two areas.

The unarguable expenditure of incredible physical labor and the time required to find the right locations for these monuments addresses a question which applies to all the astronomically precise megaliths: Were their builders "trying to discover the *exact* day of the solstice, in order to maintain an accurate calendar? Or were they simply directing attention in a general way to movements of the sun and moon which were important to them, mainly for symbolic or religious reasons?"[66] Yet the two functions need not be mutually exclusive. Where Thom believes that the megalithic observatories were intended for pure scientific investigation and tends to ignore the ever-present spiritual dimension, Wood makes a

34.

more reasonable distinction between "ritual" and "observational" orientations, based on whether there are accurate sight lines attached.[67]

The subject of astroarcheology burst into public view in 1976 with the publication of Barry Fell's *America B.C.* A marine biologist at Harvard whose hobby is epigraphy—decoding ancient languages—Fell announced that long before Columbus, Celtic, Phoenician, and Iberian settlers had left behind a vast network of inscriptions, standing stones, stone slab shelters, balanced stones, and walls all over the U.S. He and Salvatore Marc Trento (an archeologist, once director of a prehistoric museum in Minorca, whose *Search for Lost America* was published in 1978) have concentrated on the profusion of stone sites in the Northeast, particularly in New York, Connecticut, Vermont, and New Hampshire. Both postulate more than can be proved as yet and as such have been fair game for traditional archeologists. At the same time, they raise a whole new batch of questions that are hard to dismiss.

The best-known "pre-Columbian" site is a curious conglomeration of ruins near North Salem, New Hampshire, called Mystery Hill. Inevitably touted as another "American Stonehenge," it is dated 2000 B.C. in the tourist brochures; Fell puts it at 800–600 B.C., and an improbable radiocarbon dating has put it at 3000 B.C. Mystery Hill is at the very least a provocative and entertaining tourist attraction, a sort of prehistoric Disneyland. The brochure offers such highlights as Sacrificial Table, Oracle Chamber, Tomb of Lost Souls, Well of the Crystals, Winter Sunrise Monolith (and more disappointingly, Undetermined Structure and Strange Cut-Out). Attributed by Fell to Bronze Age travelers worshiping an array of gods from Bel to Astarte, Mystery Hill offers an embarrassment of real or imagined riches. Fell's finds include "Druidic mathematical and religious charts," "Celtic herms," cup marks, a bison sculpture, and a statue of the nude Great Goddess. There are also a plethora of triangular stones and some apparently valid lunar alignments, as well as an unexplained quarry.

The most heated archeological conflict around the New England sites is focused on the innumerable stone chambers with huge dolmenlike capstones, identified by some as Colonial root cellars and by others as megalithic tombs, astronomical observatories, or temples to sun gods and moon goddesses (see p. 199). These distinctive slab-roofed and corbeled structures are either free-standing or built into hillsides. Archeologist Giovanna Neudorfer has made a strong case that their solar orientation, huge size, and ambitious construction is logical for Colonial farmers' root cellars, and has written her own meticulously field- and library-researched book.[68] Much of the argument revolves around what is the proper context in which to study these sites. "The conclusion that the stone chambers are ancient structures should be independently verifiable," Neudorfer writes, "and should not ride coattail to inscriptions or other purportedly ancient evidence." Her opponents insist that study of such beehives and dolmens cannot be pursued *out* of its ancient context.

Legends persist in both North and South America about lost tribes of whites who appeared, scattered the benefits of their superior civilizations, and then either disappeared or were eliminated by native peoples who became conscious of where all this was leading. There is no doubt an

element of white chauvinism in our historians' eagerness to accept such stories, which will only be validated should the "Phoenician, Celtic, and Iberian" inscriptions prove real. In the Midwest, the effigy and geometric mounds and the astronomical alignments at Cahokia are still attributed to Native Americans, but the grasping at foreign straws continues, largely because the scientific motives or knowledge necessary for such engineering feats are denied "nomadic" and "primitive" tribes.

Yet no one has satisfactorily explained the oversized stone wall fragments in New England, the ancient copper mines in Michigan and Wisconsin, those stones finely worked into rounded "phallic" forms reminiscent of the Breton menhirs, the huge boulders neatly placed on conical uprights "by glaciers," complex sites like the 30 conical cairns of the "Lifting Rocks" group in New York State, the "Turtle Mound" outside Andover, Massachusetts—and any number of other phenomena. All over the U.S., amateurs and professionals are photographing petroglyphs, deciphering inscriptions, recording sites, tracking alignments, and (alas) digging into mounds without proper training. The New England Antiquities Research Association (NEARA, founded in 1964) and Trento's Middletown Archeological Research Center (MARC, founded in 1976) and other groups are accumulating a vast store of information that awaits detailed study.[69] Some of the theories being offered are no wilder than astroarcheology itself first appeared to be. We are at the very beginning of understanding our own prehistory.

35. *"Watch House," Mystery Hill, North Salem, New Hampshire. Date unknown. Constructed like a megalithic dolmen, this may have been a root cellar, a tomb, or a shrine; it is part of a complex of chambers, passageways, walls, standing stones, large triangular stones, and inscriptions that cover more than 150 acres. (Photo: Lucy R. Lippard.)*

35.

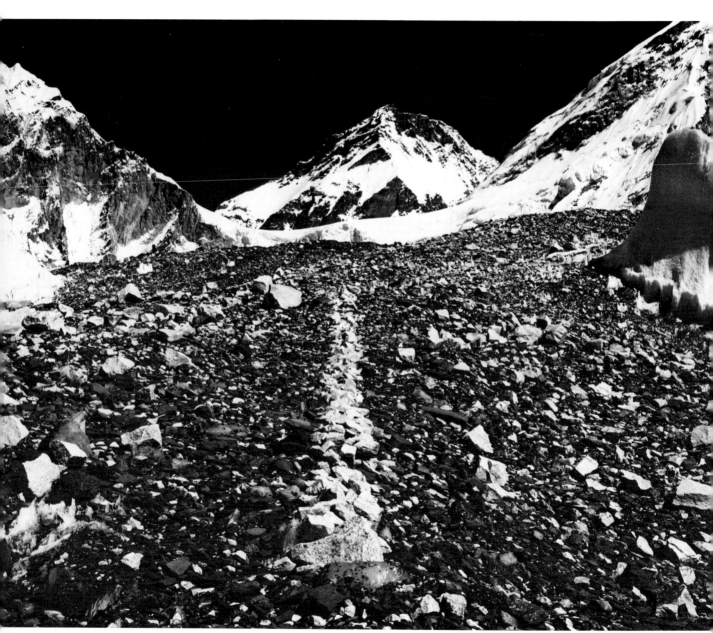

1.

Time and Again: Maps and Places and Journeys

Implicit in the work discussed in the last chapter is the notion of the journey—sacred or profane. The restless artist's preoccupation with travel, navigation, and mapping is often an attempt to address and reconcile the mythic relationship between the daily round and the road to spiritual achievement. Time may be finally inseparable from place, even when it is symbolized as an abstraction or independence from place/body, but the historical conjunction of the two has come to mean possession or domination of nature. Time as a line and space as a circle have been interpreted as male and female. "Territorial establishment and maintenance is closely related to sexuality and to other socializing processes. Love of one another is linked to love of place. . . . Relationships between men and women partly determine how people use their environment."[1]

Maps mark distance in space as calendars mark distance in time. The great popularity of the map in contemporary art began with the Minimalists' concern for number, time, and measurement. Conceptual artists conditioned by the American modernist's adoration of huge scale, but unwilling to fill the world with more objects or to "rape the land"—adopted the map and the photograph as evocative substitutes for first-hand experience. The sensuous connection with matter necessary to all visual art, no matter how dematerialized, was not ruptured; it was simply abstracted. "Land that is not mapped is not possessed. Expert tracing of contours is not unlike lovemaking," says geologist Paul Leveson.[2] The contour lines of a geological map resemble the human fingerprint. We read maps with our fingers, demonstrating our journeys. Mapping and map-reading are intimate processes.

In the late 1960s and '70s, the map also became the vehicle of the new landscape artists—painters and sculptors as well as Conceptualists. Its compactness offered a more effective embrace of vast space than did constructed earthworks, which were usually so inaccessible that they were primarily seen in photographs anyway. The most ordinary map has an inherent formal beauty as a drawing and it satisfies a basic longing for order by offering a syntax, a language through which to appreciate, with-

The world as a work of art is an idea that has been with me for a long time, the idea of the vast configuration, art that could never be seen all at once, and that would be understood only by very sensitive, intelligent people with good memories and a good sense of history, geography and so on.

—Patricia Johanson

1. *Richard Long.* A Line in the Himalayas. *1975. (Photo: Richard Long.)*

out depicting, landscape. It is a way of modernizing the whole notion of art about space.

Maps are graphic notations of remembered experience. Polynesian tribes make small bamboo and shell "stick charts" that define the prevailing directions of swells and winds. To map the almost featureless deserts of central Australia, Aboriginal tribes made sand (and later canvas-board) paintings which resemble modern pointillist abstraction. They overlay places and events and tie the tribal past to the present. To the inhabitant of that particular territory, the "abstract" picture is immediately recognizable in its depiction of hillocks, snakelike watercourses, or water holes represented by spiral springs. The formal vocabulary of these "maps" resembles the religious symbols found on the Aboriginal *churinga* (sacred carved tablets) or in the cave paintings. One Australian tribe made small carved sticks called *toas* to indicate directions to those coming after them on a trail, but also to commemorate natural episodes (such as a shooting star, a snake aroused, an emu sleeping) which are recounted in legends about the supernatural Mura-Mura, who were born from the earth and gave places their names in Dreamtime.

Nancy Graves' paintings, sculpture, and films in the early '70s were an overlay of natural, anthropological, and astronomical systems from "primitive" insights to satellite data from NASA, especially as represented on maps. She has written about the wooden pocket maps whittled by Eskimo fishermen: "It is simply their shapes—the feel of them—that makes them maps. . . . A good map has mastered the complexities of nature and idea and resolved them so as to form a necessary—utilitarian—design."[3] The map, and map-derived art, is in itself fundamentally an overlay—simultaneously a place, a journey, and a mental concept; abstract and figurative; remote and intimate. Maps are like "stills" of voyages, stasis laid on motion. Our current fascination with them may have something to do with our need for a meaningful overview, for a way to oversee and understand our location. The results can be disorienting or reassuring—the former expressed by Robert Smithson: "The sense of the earth as a map undergoing disruption leads the artist to the realization that nothing is certain or formal"; the latter containing an element of nostalgia for "the good old days" when, as John Michell has it, humans "kept moving" like birds, animals, stars and earth, according to natural rhythms with which we have since lost touch.[4]

Today the need to travel—especially to places unfamiliar and even unpleasant—motivates much of the art discussed here and can be seen as part of a general social anxiety. Some artists are inspired by what they see and return home to develop from it; others work while they travel; others, like Richard Long, make travel their work. The impulse toward constant movement is one more confrontation of that tension, inherent in modern life and in art, between the ephemeral and the permanent—or life and death.

One of the most influential bodies of work in the mid-1960s was Carl Andre's "sculpture as place," made from standard units of material, based on composite ("convenient") or prime ("inconvenient") numbers, and

2.

2. *Tim Leura Tjapaltjara*. Possum Dreaming (Mudjuna). *From the Warlpiri tribe. Acrylic on canvas. 5′7½″ × 5′8¼″. (Photo: Diana Catcher, courtesy Aboriginal Artists Agency, Ltd., Sydney, Australia.)*

superimposed on the irregular grades and surfaces of nature. Andre proposed that the only "engaged" position for sculpture was the horizontal. He and other sculptors began to look down and then out again—to the floor of the gallery and to the surface of the earth, away from the anthropomorphic vertical with which the "statue" (or status quo) is traditionally associated. Andre said he was merely "putting Brancusi's *Endless Column* on the ground instead of in the air."[5] But there were also political ramifications to such a decision for "low profile." "When you build high, you become unstable," said Andre. "When you build low you remain stable all through." The vertical came to be associated with the macho formalist art establishment, with the skyscraper in a time of urban decay, and with the military in a time of unjust war (this was during the peak of the American involvement in Vietnam). The horizontal was associated with the oppressed, the feminine, the earth element.

As a young artist in New York, Andre worked on the railroad, "taking long trains of cars that had come in from another city and drilling them. . . . It was essentially filing cars, a matter of moving largely identical particles from one place to another; then there was the whole terrain-following business which I like very much in my work. A band of cars segments and follows a terrain: it's not rigid." He also did indexes for a textbook publisher, and what he learned in both jobs "on the line" was

3A.

3B.

incorporated into his sculpture. Andre also acknowledges the early influence of Stonehenge and other prehistoric sites in southern England, of the Ohio Indian mounds, of Japanese gardens and Taoist principles. He feels that:

. . . abstraction arose in Neolithic times, after Paleolithic representation, for the same reason that we are doing it now. The culture requires significant blankness because the emblems, symbols and signs which were adequate for the former method of organizing production are no longer efficient in carrying out the cultural roles that we assign to them. You just need some *tabula rasa*, or a sense that there is a space to add significance. . . . Perhaps abstract art has occurred in human history every time there has been a total technological change in the organization of society.

Andre's *Lever* (1966) was a single straight line of bricks laid sideways which moved through a doorway from one room to another, thus incorporating not only place but motion. *Joint* (1968) took the idea outdoors. A 580-foot line of 183 untied hay bales, it led out of a wooded area into an open field in Windham, Vermont, again bridging, or traveling through two different spaces. *Water Void* (1975) reversed the process; nature moved instead of the sculpture; a rectangular aluminum plate placed in a rapid stream was "blurred" by the water's motion. *Secant* (1977) was a line of 100 timbers of Douglas fir which followed the contours of a hill and disappeared over it. (It was *Secant* that flashed through my mind when I tripped over my first stone row on Dartmoor that same year.) "My idea of a piece of sculpture is a road," Andre wrote. "That is, a road doesn't reveal itself at any particular point or from any particular point. Roads appear and disappear. . . . We don't have a single point of view for a road at all, except a moving one, moving along it."

By incorporating an oriental notion of multiple viewpoints, and both implied movement and direct intervention in the landscape, Andre set the scene for a subgenre of dematerialized sculpture which is simply, and not so simply, *walking*. For many reasons (among them those that led me to conceive of this book in England), the leading practitioners of this form live in the British Isles. The English landscape, with its network of old lanes and tracks and public footpaths, and the English culture itself, encourage walking and the tempo of walking as North America's spaces and paces do not. Ian McHarg has pointed out that the English landscape is almost fully human-molded: "Never has any society accomplished such a beneficent transformation of an entire landscape. It is the greatest creation of perception and art of the Western world and it is a lesson still largely unlearned."[6]

The English landscape retains a communal accessibility which is related to the country's overall scale. Behavorial scientists say that mental and physical attitudes are determined by the landscape one is surrounded by. There is something revelatory about walking daily in a familiar place. Each view, each detail is constantly renewed by changing light, seasons, personal moods, becoming increasingly tangible, until that specificity doubles back into generality, then back, and forth, with the rhythms of walking, day after day. The profound simplicity of Georgia

3A. Carl Andre. Joint. *1968. Windham College, Putney, Vermont. Common baled hay. 183 units, 14″ × 18″ × 36″ each; total length 580′.*

3B. Carl Andre. Secant. *1977. Nassau County Center for the Fine Arts, New York. Douglas fir timbers. 12″ × 12″ × 300′. (Photo: courtesy Paula Cooper Gallery.)*

O'Keeffe's responses to space and form, for instance, can probably be attributed to 80 years of such walks through the places she has in every sense inhabited. She has talked about the "feeling of infinity on the horizon line or just over the next hill . . . the distance has always been calling me."[7]

"Look the ground in the eye," says Richard Long. In 1967, still in a London art school, he began to make geometric forms in the landscape (concentric circles of paper laid out on grass; concentric squares of cut turf in a lawn). He soon began to work exclusively with natural materials, and his low-profile sculptures became not so much objects in the landscape as integral parts of the landscape. For instance, in 1968 he made a piece in which stones on a stone beach were almost imperceptibly rearranged in a rectangular frame—a landscapist's version of *White on White*. In 1969, around the time Sol LeWitt wrote, "for each work of art that becomes physical, there are many variations that do not,"[8] Long made a walk on Dartmoor into a sculpture, photographing the process for a book that did not document but *was* the sculpture. By this simple statement (involuntarily heir to Marcel Duchamp's *Readymades* and Robert Rauschenberg's famous telegram, "This is art if I say it is"), Long made what the art world fondly calls a "breakthrough" in landscape art or sculpture as place.[9]

Since then, Long has walked/made art on every continent and in the most remote, exotic, uninhabited parts of the world, as well as continuing to work in England, especially on Dartmoor. Along with sculptures shown in galleries (which cramp his style), Long has made a great number of sculptures in the landscape, including a stone line in the Himalayas, a stone circle in the Andes, an X trodden into dusty grass in Africa, a spiral of rockweed on a beach, and a pile of ashes in a campfire. His works are documented by books, by striking photographs of the landscape he passes through, or by naturalist observations along the way. The emphasis may be on time, place, or experience. Long has climbed spirally around instead of straight up mountains, used riverbeds as footpaths, walked along the ancient Nazca lines in Peru, walked "in place" for miles. One piece involved meeting another walker, but that is rare. For the most part, Long walks alone along the land.

Between his actual "sculptures" and his totally immaterial evocations of physical experiences lies a series of works that take the form of horizontal or vertical "cairns." The vertical cairn is the common one—the very seed of the domination of nature, used by humans since the beginning of time to assure safety, accrue luck, mark celestial events, make paths and then boundaries. On one walk, Long added a thousand stones to a vertical footpath marker. On other walks, he stretched "horizontal cairns" over whole journeys, as in *A line of 164 stones/A walk of 164 miles; Roisin Dubh,* "a thousand stones moved one step forward along a 74-mile walk in County Clare"; or *Milestones,* "a 300-mile walk from Tipperary to Sligo / Placing 5 piles of stones along the way," in which he notes that "the walking, the places and the stones all have equal importance."

Long prefers to let his work stand for itself, but in a rare statement about it, he wrote in 1980:

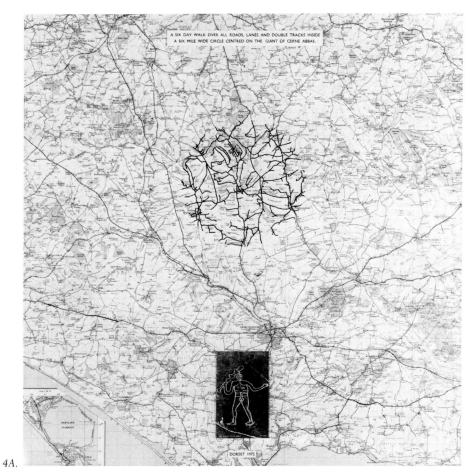

4A.

4B.

4C.

I like simple, practical, emotional, quiet, vigorous art. I like the simplicity of walking, the simplicity of stones. . . . I like the idea that stones are what the world is made of. . . . I like sensibility without technique. . . . I like to use the symmetry of patterns between time, places and time, between distance and time, between stones and distance, between time and stones. I choose lines and circles because they do the job. . . . A walk expresses space and freedom and the knowledge of it can live in the imagination of anyone, and that is another space too. . . . A walk traces the surface of the land, it follows an idea, it follows the day and the night. A road is the site of many journeys. The place of a walk is there before the walk and after it. [10]

Walking in England is always a history lesson and the Ordnance Survey maps are tantalizingly embellished with a whole vocabulary of historical symbols. Long does not deny this aspect: "A walk is just one more layer, a mark, laid upon the thousands of other layers of human and geographic history on the surface of the land. Maps help to show this." He has made pieces that emphasize the historical aspects literally moving through time, such as the 1980 *Power Line Walk: From a Water Wheel to a Nuclear Power Station,* or his walk from Windmill Hill (habitation of the oldest known English people to make permanent changes in the landscape) to Coalbrookdale, where the Industrial Revolution was born. These works take a logical place in an art conceived as "the laying down of modern ideas in the only practical places to take them. The natural world sustains the industrial world."

Although he has noted the "almost ritualized" process involved in walking some circles, spirals, or zigzags, Long takes pains to distinguish himself from any "primitivizing tendency." It is true that while his pieces in the land may closely resemble prehistoric remains (with which, of course, he is very familiar), they would never be mistaken for the real ruins or sites by anyone who was familiar with the megaliths. Nevertheless, he has often made works that focus on specific prehistoric sites. There are at least two pieces about Silbury Hill. He has done a six-day walk around the Cerne Abbas Giant (1975) and another *Day's Walk past the Standing Stones of Penwith Peninsula* in Cornwall (1979). His 1971 sculpture in Connemara reproduces exactly a seven-ringed "Cretan-type" labyrinth (or "Troy Town") on the Scilly Islands (see p. 155). [11]

Long's outdoor work is moving precisely because of its evocation of the past within a highly specific present. He has managed to make a "dematerialized" and occasionally democratized form of sculpture that remains highly pictorial (or picturesque), an art that is both physical and poetic. Its apparent innocence and lack of arrogance may be deceptive; this is the "outgoing" art of a loner: "My work is about my senses, my instinct, my own scale and my own physical commitment." I, for one, envy the intensity with which Long has brought together art and pleasure, in part because this book has a similar origin; it arose from walking as "pleasure" and committed me to more of the same as "research."

Walking has been recognized as a means of concretizing and releasing emotions in many cultures, not least among them our own repressive twentieth-century Anglo-Saxon one. An Eskimo custom offers an angry person release by walking the emotion out of his or her system in a

straight line across the landscape; the point at which the anger is conquered is marked with a stick, bearing witness to the strength or length of the rage. Cairns are also built up as expressions of emotions and the obsessive and repetitive quality of much Minimal Art suggests such an emotional source. The Eskimo story was told to me by Lawrence Weiner, who in the early '60s made sculptures in woods and fields as he hiked or bummed around the country, leaving them to be found, or not, by chance "receivers."[12]

Such ideas connecting concrete spaces and ephemeral experience were very much "in the air" in the later '60s and were institutionalized in Process Art. As part of the rebellious, anti-precious-object syndrome, the process by which a work is made and material from which it is made became as important as the final product. The whole notion of process in art can be interpreted as a search for the origins of creation, transforming a work into its own history. Robert Morris' *Box with the Sounds of Its Own Making* (1965), a cube containing a tape recording of hammering and sawing, was the key artifact, and Morris was also a major theorist of this trend. In his influential 1968 article "Anti-Form," he traced the concept back to Jackson Pollock's ability to "recover process and hold onto it as part of the endform of the work." "Matter and gravity . . . chance and indeterminacy" were seen as instruments of a "refusal to continue estheticizing form by dealing with it as a prescribed end."[13]

While British artists concerned with process and lines across the landscape tend, like Long, to modest scale, most Americans work big. Michael Heizer's 1968–70 geometric loops, tracks, and lines cut into or dyed onto the Nevada desert (where he leased a dry lake bed as his drawing pad) were conceived as "negative forms" so as to "create without creating a thing." However, their scale, like that of all his work, was enormous. *Double Negative* (1969–70) displaced 240,000 tons of earth, and by 1972 Heizer was building above ground one of the biggest objects an artist has ever erected—*Complex One/City.* Made of concrete, steel, and earth, its axes are the horizontal of the land and the vertical of human aspiration. *Complex* is planned to be part of a still larger city complex, a microcosm of ancient Aztec and modern megalomaniacal architectures. Heizer's father was a well-known archeologist, with whom he traveled as a boy to Egypt and the Yucatan. He sees his own work as an extension of those civilizations. "Man will never create anything really large in relation to the world," he has written, "only in relation to himself and his size. The most formidable objects that man has touched are the earth and the moon. The greatest scale he understands is the distance between them, and this is nothing to what he suspects to exist. . . . What if an artist is so confused by his society that he reflects other cultures in his work? Perhaps the indication is that . . . time warps and does not extend indefinitely."[14]

In 1968, Walter de Maria drew two parallel mile-long chalk lines and three circles in the Mojave Desert. His *Lightning Field* in New Mexico (1977) consists of 400 steel poles in straight lines over almost a mile square; these are activated only "3 to 30" times a year by thunderstorms. In 1976 Christo's famous 18-foot-high fabric *Running Fence* ran temporarily for 24 miles across hilly California farmland, and in 1977–78 he covered all the walkways in a Kansas City park in orange cloth, turning a

5.

6A.

6B.

6C.

walk into a visual memory. In 1978 Elyn Zimmerman paralleled the
Niagara River at Artpark with a gleaming grey 150-foot line of polished
granite; Keiko Prince's *Sentimental Journey* (1975) employed rocks,
grass, water, and weather conditions along 5,000 feet of abandoned air-
port runway at Floyd Bennet Field, Brooklyn, to align Japanese letters
and Arabic numbers into words. Patricia Johanson's *Stephen Long* (1968)
was also less an object than a path or road in itself. A 1,600-foot wooden
trail painted in gradated pastels and laid out along an abandoned railroad
track in Buskirk, New York, it was intended to take color and light beyond
traditional impressionism by adding the elements of distance and time
taken to perceive it.

The person who has done most to conceptualize the connections be-
tween such contemporary lines on the land, ritual art, and the ancient
notion of the journey is Richard Demarco, a Scottish artist turned arts
administrator/organizer/spiritual tour guide. An indefatigable traveler
and proselytizer who cares deeply about the soul of contemporary culture,
Demarco began his "Edinburgh Arts Journey" in 1976, though he had
been sowing ideas about ancient/modern connections for several years
before that. The annual voyage with artists, students, and interested par-
ticipants explores sites in Sardinia, Malta, France, Italy, Spain, Portugal,
the Azores, and the British Isles, and is itself Demarco's work of art about
these connections.

He describes it as "a 7,500-mile journey into the origins of European
culture, to the developing contemporary art language of the twentieth
century." Demarco is concerned with survival, with our "overliterate
educational systems," the need to return to direct experience, to reclaim
the "spirit of the place," and the earth's female principles. The Journey
"seeks to relate spiritual dimensions to those of time and place." It in-
volves not only ruins, places, and artifacts, but the travelers and everyone
they meet along the way. The Journey's markers are not only ancient
sites but the "energy points" provided by the work made by the itinerant
artists. Demarco's talisman is Lugh, "the many crafted one"—Celtic sun
god and "personification of the artist explorer." He sees the Celt as "the
perfect representative of all the peripheral and rejected cultures provided
by the European experience. For the Celt is the best-known European
equivalent of the Hopi, the Apache . . . the best-known of the peripheral
European cultures threatened by the twentieth century."[15]

6C. *Tom Taylor, Pattie Pate, Tim Taylor.* Covey Intaglios: Seven Birds. *1977. Aerial view of land drawings. 1300' × 100'. (Photo: Jack Higbee, © Taylor Bros. & Pate Prods., 1977.)*

7. *Patricia Johanson.* Stephen Long. *1968. Acrylic on plywood. 2' × ½ × 1600'.*

In a number of ancient cultures, the significant journey is seen as a straight line. Most of us would probably associate the winding, twisting path with the "primitive" and the straight line with "civilization." Yet there is a certain amount of evidence to show that the "straight and narrow" encouraged by the Bible held specific meanings for far older peoples, just as height itself was worshiped in the Andes and elsewhere. "Make straight in the desert a highway for our God," commanded Isaiah (40:3). The Cree Indians said that white men's roads were crooked, where Indian tracks were straight. In Peru the straight paths led to holy places (often directly up mountains) and demons awaited those who strayed from them. During Tony Morrison's arduous cross-country research on the Nazca lines in Peru, an engineer companion told him there wasn't anything so amazing about the lines' straightness, because "it's the shortest distance between two points." "All right then," replied Morrison, "so why are you walking around this rock instead of over the top? The old path goes straight over it."[16]

The mystery of straightness in prehistory is only now being confronted through the astronomical investigations of the Thoms and others. It is the substance of a fascinating (if perhaps totally apocryphal) book called *The Old Straight Track,* first published in 1925 by Alfred Watkins, a brewer's representative from Hereford, England. At the age of 65, while riding across a familiar landscape, he had a sudden vision of a glowing network

7.

8. Ley Line from Radnor Vale to Eastern End. *Fig. 20 from Alfred Watkins,* The Old Straight Track. *The ley runs from New Radnor Castle to Old Radnor Church through New Radnor Mound.*

RADNOR VALE — EASTERN END

MOUND ◯ STONE ◠ CHURCH ◯ CROSS ROAD ◌ INITIAL POINT ◯ 8.

of lines across the country, intersecting at traditionally "holy" places like prehistoric mounds, churches, wells, stones, mountains, and so forth. He named these networks of sighted tracks the "ley system" (after an old word for clearing in the woods) and devoted the rest of his life to proving his vision. Most archeologists, have rejected the theory of ley lines, though Thom has given it some tentative support and John Michell is convinced that the ley system is the next heresy to be proven valid, just as the astronomical and mathematical theories were.

If the leys don't exist, then Alfred Watkins was a very good conceptual artist. If nothing else, the "ley lines" have provided a framework through which a great number of people have learned to look at their local environments. Poised over one-mile-to-one-inch Ordnance Survey maps, checking their alignments, seeking markers in the field (and occasionally finding prehistoric remains unmarked on the maps), "ley hunters" have provided a new British national pastime unequaled for raising popular consciousness of history and ecology. As Watkins himself said, "it is detective rather than surveying work in the field." A benign substitute for amateur excavation, ley hunting also brings into play the etymological study of place names and folklore as clues. A ley may lead some two to twenty miles from a natural topographical feature, to a place whose name suggests it was a landmark or site of a beacon fire, to a notched hill, to a prehistoric stone, to a Roman ruin, to a medieval church, to a pond used as a light-reflecting "flasher" marker. For Watkins, the "sighted track" was not merely a road system, but a prehistoric belief and value system, incorporating all aspects of ancient life, extended through history and into the present by the fragments of lost knowledge.

Another theory connecting natural features and the ancient monuments was concocted by Guy Underwood, a dowser (or "water diviner"), geneologist, and electrician who spent some 20 years following up his

9. Robert Smithson. Double Nonsite,
California and Nevada. *1968. Map (A)
and sculpture (B); steel, obsidian, lava.
12" × 71" × 71". (Private collection;
photo: courtesy John Weber Gallery.)*

9A.

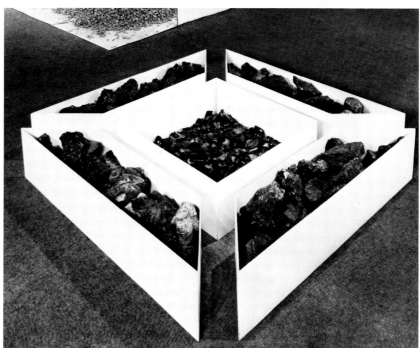

9B.

10A.

10A. *The White Horse of Uffington, after Guy Underwood: (1) Existing "dragon" form; (2) pattern of aquastats on site; (3) existing figure superimposed on aquastats. Underwood goes on to demonstrate that both dragon and horse were outlined by water patterns — aquastats and geodetic lines; that both were outlined at alternate periods, both being sacred; that to initiates one was always hidden in the other. The eye of the horse and the Dragon's Hill are marked with blind springs, respectively "left- and right-handed" spirals. (Diagrams: courtesy Pitman Books Ltd., London.)*

10B. *The White Horse of Uffington, Berkshire, England. Late Iron Age (Celtic) Hill Figure. 365' long. The White Horse was once ritually scoured every 7th year. Below the horse is a large circular mound known as Dragon's Hill, where grass has never grown on the bare patch. The horse races once held here may have been vestiges of a horse cult. It has been suggested that this curious "bird-headed" horse was originally a dragon. It may also have originally been ridden by a phallus, and legends connect it with Saint George. The White Horse is carved on a hill fort and resembles designs on Belgic coins and metalwork. (Copyright: Aerofilms, Ltd.)*

11. *Half-maze, Nazca Plains, Peru. c. 400 B.C.–900 A.D. This figure is locally called "the ear." (Photo: Marilyn Bridges.)*

own vision. Departing from the suggestions of two scholars of the Stone Age, he located the sources of virtually all prehistoric remains—stone and earth—in subterranean geodetic phenomena such as spiraling "blind springs," underground streams, lunar-reactive water movements with negative and positive energies that also influence the growth, lives, and movements of plants and animals. One of his most striking proposals was that the Iron Age Hill Figures, such as the White Horse of Uffington and the Cerne Giant (see p. 220), were drawn by tracing the patterns of underground waters. In his posthumously published *Patterns of the Past,* Underwood suggested that these principles also applied to medieval sacred architecture and had been carried through the ages via Freemasonry. To quote from Isaiah again: "Even by the springs of water shall he guide them. And I will make all my mountains a way and my highways shall be exalted."[17]

Tom Graves has compared Underwood's track lines (acquastats) to "place memories"—"interactions between person and place stored like holograms or video-recordings at that place" and retrieved by dowsers or other sensitives.[18] Francis Hitching, among others, has enthusiastically espoused in his book *Earth Magic* the notion of "divining the past" not only through dowsing but through measuring telluric (earth) magnetism. Though still unexplained, dowsing is broadly, if uneasily, accepted and is universally used for practical purposes. Dowsers can not only locate water but can often specify how much, how deep, and other topographical factors. Some can detect metals; others have dated and answered questions about prehistory by consulting a dowsing pendulum; others even dowse by remote control, using maps. It has been suggested that this capacity too is a vestige of lost knowledge, and that megalithic peoples took dowsing for granted.

Michell has written at length about the connection between divining and the Chinese geomancers of *Feng Shui*—a kind of acupuncture of the earth that plugs into positive forces with menhirs as stone needles.[19] In Wales, Bill Lewis, a retired electrical engineer, has offered some startling scientific evidence of the bonds between the megaliths and earth energies. He "sensed" that a 12-foot menhir emitted a spiral force that periodically waxed and waned. When measured with a gaussometer by a physicist, its static magnetic field registered far higher than predicted.[20] All of this implies, in however unorthodox a manner, that some kind of alignment between prehistoric sites does exist, since it appears so persistently no matter which method is used to detect it; and that these straight lines and other patterns had more than accidental significance for the megalithic peoples.

The reasons for the unrelenting straightness and giant scale of the extraordinary Andean lines in Peru, Chile, and Bolivia—the best known of which are those on the plains of the Nazca Valley in Peru—are still unknown. A bewildering network, these intersecting lines, triangles, and rectangles sometimes go straight up the sides of steep hills. They are sometimes superimposed on what appear to be older schematic animal drawings (a spider, monkey, condor, fox, and "whale"), on images of flowers, hands, "wheels," and over 100 types of spirals. The lines range from a few feet to 600 feet. They were drawn by the simple method of

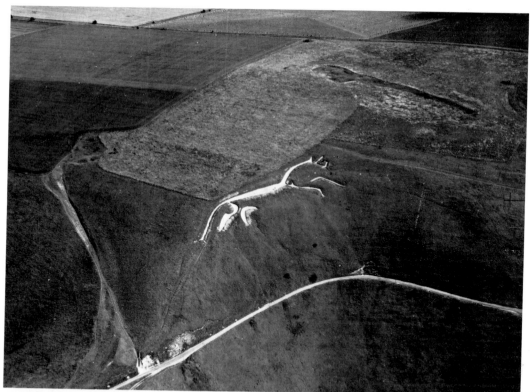

10B.

11.

12A, B. Parallel Lines to the Horizon
and Big Bird, *respectively*, Nazca Plains,
Peru. *(Photos: Alice Weston.)*

12A.

12B.

sweeping away the top layer of the desert, apparently with some sort of broom, which might have doubled as a siting pole. The climate is so dry that until recently the lines were in pristine condition; they had survived around a thousand years. Now their delicate ecological balance is threatened by vehicle tracks and tourism.

The sites were settled between 8,000 and 11,000 years ago, and the Nazca culture has been dated roughly between 800 B.C. and 900 A.D. The lines themselves are thought to have been drawn in the first millenium A.D., but the dates are still in question, as is almost every other fact about them except for their visual impact when seen from above. (From ground level they can be almost invisible at first, and while the straight lines do eventually reveal themselves as paths, their conjunctions and the images are impressive primarily when seen from a small plane, and through aerial photography.) Following the lead of Paul Kosok, who began the modern investigation of the lines, Maria Reiche—"the Mother of the Lines"—has spent over 40 years working on the site, trying to prove that they were part of a calendrical system. She believes that some of the lines mark the movement of the shadow of an important hill across the pampa on solstice day, though she has yet to publish the supporting data. When Gerald Hawkins applied his computer method to the lines, he found little support for astronomical theories. The animal figures, disappointingly, do not reflect the constellations with which their images might be associated. Nevertheless, seasonal agricultural connections have been made to certain constellations—especially the Pleiades, or "Seven Sisters," which figure prominently in prehistoric astronomy the world over; in Peru they were said to be guardians of the seed. It has been suggested that if the lines were oriented to stars, they would have had to have been made at night, using bonfires for sighting, perhaps as part of a midwinter festival.

Among other functions suggested for the Nazca lines are boundaries, highways, kinship connectors between the graves of clan members, racetracks, ritual dance grounds, water indicators, UFO landing strips, and, more convincingly, processional ways, or *ceques*. Tony Morrison believes that the lines had something to do with ancestor worship and the nearby burial mounds, that they were "paths between the living and dead, forming a vast two-dimensional temple."[21] The rare artifacts and other features offer few clues. Single wooden posts and sometimes whole forests of posts are occasionally found along the lines, as are stone and conical cairns ranging in size from a few inches to one foot wide. Some have depressions in the tops, indicating that they might have held posts. The piles were possibly counting devices, or had some other numerical significance. Stones are still added to these cairns, or *apacitas*, by Indians who believe that evil awaits anyone stepping off the paths.

Coca leaves, bulls, and other offerings are also still made to various *huacas*—the ceremonial shrines set or found as stations along the *ceques*. Of the 333 different *huacas* (or spirits of the place) listed by Father Bernabe Cobo in seventeenth-century Cuzco, over 80 were stones; over 90 were springs and fountains; 50 were hills; 50 were caves, gullies, and quarries. A *huaca* can also be a root or a tree, a mummy in the Inca Temple of the Sun, or anything decreed personally or commun-

ally sacred. Churches have been built over *huacas,* just as in Europe so many of the ancient sites have been Christianized or simply adopted. The *ceques,* connecting the *huacas,* offer obvious parallels with the British ley lines. Another connection to European prehistory is the presence of shells, intentionally broken pottery ("killed" objects), and signs of child sacrifice. String and balls of thread have been found in nearby graves— perhaps part of a pole-and-string measuring device by which the lines were executed. One of the older earth drawings seems to be a spindle and a ball of wool; a zigzag connects it to a spiral, relating it to the labyrinthine cup-and-ring marks, to the Spinning Fates, the World Spindle, and other European symbols.

The word *ceque* is also used for furrows, for lines of animals or objects, for rows (rather than paths). Not always straight, *ceques* seem to have been important not only in themselves, but for incorporating the intervals between them and the spaces around them. It is this aspect that has particularly attracted contemporary Conceptual artists. In 1975 Robert Morris, writing about the lines in *Artforum,* said they were made by a culture obsessed with "space as a palpable emptiness." He looked at the lines within the context of Minimal Art and its attempt to mediate between the "flatness" of notational systems and real space:

Assuming that the lines point to power points in the Sierra (as well as the literal sources of water) we then have both terms: the flat and the spatial, line and mountain, the abstract figure and the concrete existent. Here the artifact-symbol functions to channel the powers of nature into human design. Nature's power flows through the artist's marks. . . . Analogically the actual life-giving substance, water, flows through the erect penis of the Checan water pot which has further analogy to the biological function of the life force of male-conceived sexuality. The site of Nazca . . . [differs] from other ancient monumental art which confronted and dominated people by one form or another of gigantic verticality imposed on the flatness of the earth. In spite of the distances involved in the lines at Nazca, there is something intimate and unimposing, even off-hand, about the work. The lines were constructed by a process of removal. They do not impress by indicating superhuman efforts or staggering feats of engineering. Rather it is the maker's care and economy and insight into the nature of a particular landscape that impresses.[22]

Cesar Paternosto, an Argentine-American abstract painter, has studied the possible symbolism of the Nazca lines in relation to the stone sculpture of the Incas, and to the mysterious "landscapes" carved from single rocks embedded in the real landscape, to the *Intihuatana* or "sun hitching post" at Machu Picchu (probably built for a winter solstice ritual), and especially to the enigmatic asymmetrical lumps or bumps found on stone slab walls at the Temple of the Sun at Ollantaytambo, Saqsaywaman, Cuzco, and elsewhere.

Paternosto's research led him into Inca geometry, which differs from the Western concept in its sense of space and accents. (In an unpublished book manuscript, he quotes Ernst Cassirer on "the fundamental mythical accent, the division between the sacred and the profane."[23]) When he first scrutinized the Temple of the Sun, with its strange asym-

13. Bill Vazan. Detail of Regina Life Lines—9 Mind Mappings. *1980–81. Tractor tire impressions, negative print. 5000' × 3000'.*

13.

14A. 14B.

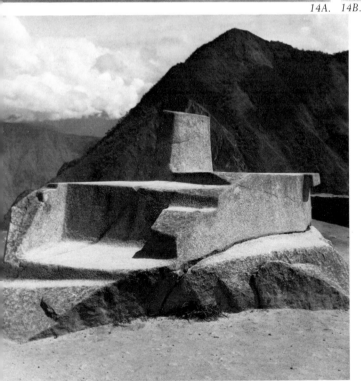
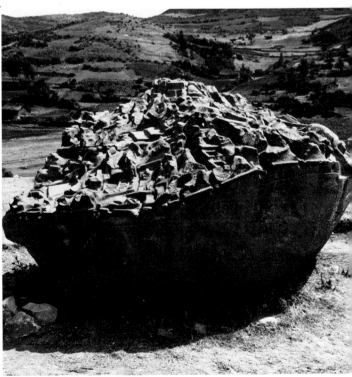

15A. 15B.

16.

metrical knobs set in an isochronous rhythm, he "intuited" a visual system of signs in which space is as important as form; this was later corroborated by examples found on walls in Cuzco, on the gateway at Rummicola, and elsewhere. He has related these asymmetrical knobs and niches to the grain forms which Larco Hoyle discovered on marked "glyphic" beans of pre-Inca cultures (Mochica, Paracas, Nazca). (These also correspond to the ancient Near Eastern "tokens" mentioned in Chapter III.) Their sprouting spots, probably fertility symbols, recall the possibility that the entrails of Inca leaders were buried at the foot of the Ollantaytambo temple, whose "sprouting stones," as Paternosto calls them, might reflect the same seed-and-rebirth metaphor, and recall the oracular meaning of the "immortal" entrails. (The shape of the *Intihuatana* at Machu Picchu resembles, perhaps coincidentally, the oracular stone liver-models from the Near East.)

Paternosto's own work consists of monochromatic abstract paintings in dense, glowing earth colors, which incorporate some of the principles and geometric symbols (notably the stepped inverted pyramid) of the pre-Columbian sites with which he is intellectually obsessed. What interests him in the ideographic systems of Inca stone sculpture is their "visual-tactile semiotic nature." This tectonic vocabulary is reflected in his own art. He perceives a bond between these signs and the Incas' mnemonic *quipus*—knotted strings (or information retrieval systems) which recorded verses, narrative and liturgical material, as well as numbers (in abacus fashion); they were also "read" like rosary beads. Other scholars have in turn related the *quipus* to the *huacas* on the *ceque* lines. Like the glyphic beans, these can then be related to the Inca logographic signs discovered in the textile *tocapus* by Victoria de la Jara. (Among them are the stepped pyramids by which the Andeans worshiped height; it is tempting to think that the Nazca lines offered a horizontal counterpart for the worship of distance.)

In applying this emergent historical data on ancient Andean civilizations to the culminative Inca sculpture and architecture, Paternosto hopes for a "holistic, integrative evaluation" of these forms within a non-Western context. He insists that the stone reliefs are not mere decoration, but geometrical intensifications and permutations of organic models. The free-standing, carved rock sculptures, or "altars" or stepped "sacrificial platforms," are also fascinating to speculate about in terms of their relationship to the surrounding landscape and to contemporary land art. It seems possible that the level of Inca abstraction derived in part from the fact that the "frame" in which the forms were perceived was in fact nature itself on a grand scale, just as the megalithic monuments expand when seen in relation to their surroundings. The sculpture appears to have been carved permanently on natural outcrops to refer to specific sacred mountains visible from it and to enhance the sacred character of the place as opposed to the profane space surrounding it. Discussing the degree to which sculpture as place alters the site, Carl Andre defined place as "an area within an environment, which has been altered in such a way as to make the general environment more conspicuous."[24]

When sculptor Athena Tacha visited the Pyramids in Egypt, she saw them as "a great lesson on what scale does to form. They are not at all

'Minimal' shapes. They are landscape. Like mountains and valleys. Tellingly, the ancient Egyptians called them 'the horizon of Cheops or Chephren,' etc. They modify the horizon."[25] Another sculptor, Gillian Jagger, has noticed how humans alone among living creatures do not "fit into the landscape." When she was casting the forms of horses and geological structures (see p. 36), she found it easy to "dissolve" the two into each other.:

A horse in a field is seen as part of the field, a man in a field is not. The horse is stretched out on four legs, its neck, shoulder and back have a hill and vale sloping, it fits in with the landscape. (Interesting to me that they use a man as a scarecrow.). . . Those ninth-century sculptural effigies achieved this fitting in . . . by laying their bodies flat on the ground and using concave and convex for their heads and shoulders. This is how they kept the kind of perspective between body and stone I am after. We see ourselves without backgrounds: cameos, Florentine style, and then of course suffer from that awful feeling of disconnection. The price I suppose of narcissism which leads in turn to that inevitable fear of death.[26]

The absence of landscape art in ancient Greece is attributed by Vincent Scully to "the fact that the archaic and classic Greeks experienced the landscape only as it was, at full scale."[27] Perhaps for similar homo-centric reasons, the obsession with giant scale in the American art world of the '60s and '70s can often be interpreted as an extension of the self, to the point of occasional megalomania. Dennis Oppenheim has attributed this to alienation, to "the self trying to become communal." He sees the connections he makes between his own body surface and the land surface as a means of "activating" the earth and at the same time being activated by it. It is this same exchange of energies that Richard Long seeks when he walks. Oppenheim's three-mile *Time Line*, cut in the frozen St. John River to eliminate the U.S.-Canadian border in 1968, and the accompanying *Time Pocket* (an island truncated by this line and by the International Date Line), superimposed a human line on a natural line—the river— and physical space on the concept of time.

The notion of "scanning" as a way of seeing large-scale art, introduced by Morris and Andre in the mid-1960s, was important in its new emphasis on horizontality, distance, and accents in the landscape. Oppenheim recalls that in 1966–67 "there was an almost magnetic attraction to horizontal scanning within the context of place as opposed to isolated objects, it was almost a gravitational pull."[28] Gaston Bachelard has written about this sensation on a more universal scale in his *Poetics of Space*—a bible for many of these artists: "every object invested with intimate space becomes the center of all space. For each object, distance is present, the horizon exists as much as the center."[29] Jack Burnham has connected Oppenheim's sensation of falling to the shamanistic function which "magnifies every human gesture until it assumes archetypal or collective importance."[30] Michael Dames adds another dimension to this idea, applicable to cultures as diverse as Avebury and the Dogon, when he cites "the familiar urge to create a structure capable of being simultaneously perceived as all possible sizes—a speck of dust, an egg, a human belly, a mountain, the world, and the universe."[31]

17. *Dennis Oppenheim.* Time Line. *1968. 1' × 3' × 3 miles. Time 3:15 P.M. U.S.; 4:15 P.M. Canada. Cut by snowmobile straddling time zone on boundary between U.S. and Canada at St. John River, Fort Kent, Maine.*

17.

18A. 18B.

*18A. Isamu Noguchi. Sculpture to Be
Seen from Mars. 1947. Model in sand;
destroyed. (Photo: Soichi Sunami.)*

*18B. James Pierce, Earthwoman.
1976–77. Pratt Farm, Clinton, Maine.
Earthwork. Pierce has made his own
roadside "historical park," or folly, at
his summer home overlooking the
Kennebec River in Clinton, Maine. He
calls his collection of picturesque
earthworks a "garden of history." It
includes a circular and a triangular
redoubt, the stone outline of a Viking
longship burial, a turf maze, a motte, a
burial mound, a tree burial, and a Kiva.
Pierce is an expert on the midwestern
Indian mounds. In his own work he
alludes both to the history of art and to
the history of this area of Maine. He
describes his park as "a relatively
harmless means of satisfying desires for
control, security, and immortality while
reliving the history of the race and
discovering one's humanity in physical
union with nature." (Photo: James Pierce.)*

It has actually been proposed that shamans once knew how to fly in-
stead of just dreaming about it.[32] Such an explanation for the Nazca lines,
the British "topographical deities" embodied in natural landscape forms,
the Hill Figures, North American effigy mounds, and the giant figures
drawn copulating on the earth along the California-Mexico border is un-
necessary. Since these forms were so large, and almost incomprehensible
from the ground, they are assumed to have been intended for the hover-
ing spirits alone. However, it seems obvious that people did comprehend
them, whether or not they could get an "overview." They probably did so
through the fundamental concept of mapping. Just as maps are fusions of
the real and the abstract, so are such para-visual monuments. These
shapes were undoubtedly known to the people who built them as well as
the shapes of their own bodies, and were as recognizable as the Christian
Church's reflection of the cross and Christ's body, or the prehistoric tem-
ples shaped like the Great Goddess' body in Malta, Skara Brae in Orkney,
and elsewhere.[33] The possibility has also been raised that numerical and
alphabetical codes were hidden in landscape forms as well as in other
natural phenomena. The same forms that were macrocosmically en-
graved in the land were probably also found in the textiles and pottery of
each culture (as is true of the Nazca animals) and perhaps directly on the
bodies of the makers at ceremonial times.

The expenditure of time and energy it took to make images on this

18C. John Latham. "The Niddrie Woman." Found hill sculpture in West Lothian, Scotland. Latham might have been picking up on the idea that prehistoric peoples "saw" the earth's body in unaltered land forms when he perceived "The Niddrie Woman" in a Venus-of-Willendorf-like shape, formed accidentally of shale waste near a Scottish mine. "The Niddrie Woman" is part of an elaborate conceptual scheme for ecological consciousness-raising and reclamation, and the artist has used her as a pun on female earth, rebirth, modern society's treatment of women's bodies as castoffs, and so forth. She is the contemporary counterpart of Silbury Hill—and the comparison is as devastating as it should be. At present, the artist is trying to save her from destruction. (Photo: John Latham.)

19. Temples shaped like goddesses: (A) Model of Ggantija, Gozo, Malta. 3rd millennium B.C. (B)Skara Brae, Orkney, Scotland. 3100–2450 B.C. The temple is set outside the village. (Crown copyright; courtesy the Dept. of the Environment, Edinburgh.)

scale might be explained by a notion of ritual that related time to size— that is, one that offered a slowing down of time in direct proportion to the difference between "human size" and "nature (or god) size." Robert Morris projected a similar experience in 1966 when he wrote about the viewer "sensing" rather than "seeing" the configuration of his *Earth Ring*. (Michael Dames' related speculations on the micro/macrocosmic goddess at Avebury are covered in the next two chapters.) A recent story about the Aymara Indians at Lake Titicaca bears out the possibility that internalized knowledge affects actual physiological experience. A *National Geographic* reporter in Peru knew that the word *Titicaca* meant puma to the Aymaras and was connected to early religious cults. When he produced a NASA photo of the lake made from 170 miles above the earth, his boatman said immediately, " 'Look. The Puma!' " He stared: "The outline of the main lake startlingly resembled a leaping puma, with outstretched claws and open mouth, about to seize a fleeing rabbit."[34]

Patricia Johanson has concentrated on this notion since her early length-and-line works. Her concern is to "mediate between human scale and the undifferentiated vastness of nature."[35] In 1970 she embarked on *Cyrus Field*—an ambitious "landscape-sculpture-park-path" which wound its way a mile and a half through the woods in three sections made of marble, redwood, and cement block. During the next three years she traveled to Mexico, Guatemala, Honduras, and Peru, becoming increasingly involved with principles directly related to ancient architecture and attitudes toward nature, and with the notion of "aerial" form. She began to take courses in civil engineering and architecture, and in 1977 received an architecture degree from City College in New York.

During this period Johanson made a (still-unexecuted) design for the sidewalks in and around a college complex at Yale University. Rather

18C.

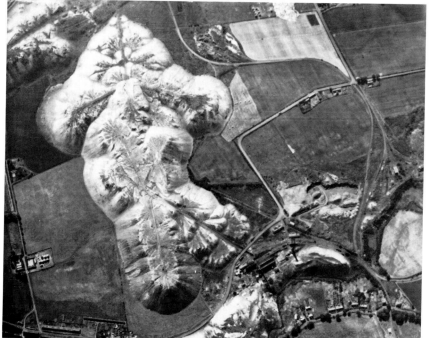

19A.

19B.

20A. *Patricia Johanson.* Venus
Maidenhair Fern/Staircase/Ramp/
Sculpture. *1974. Ink and charcoal on
vellum. 24" square. (Photo: Eric
Pollitzer.)*

20B. *Patricia Johanson.* Butterfly
Orchid Garden. *1974. Ink and charcoal
on vellum. 51" × 30". (Photo: Eric
Pollitzer.)*

21A. *Labyrinth with oculiform face, rock
carving, Valmonica, Italy. c. 4000–
2800 B.C.*

21B. *The Babylonian Palace of the
Intestine, deriving from divination by
entrails. (From Otto Rank,* Art and
Artist, *p. 149.)*

21C. *Coin from Knossos, Crete. An
identically formed labyrinth is carved on
a rock at Tintagel, Cornwall.*

21D. *Engravings on back of kerbstone,
New Grange. c. 2500 B.C. (Drawing:
Claire O'Kelly.)*

21E. *Turf Maze, Wing, Rutland,
England. The remaining turf mazes are
usually found near prehistoric
earthworks.*

than "build up," she chose to make a flat sculpture, describing in the
pavement the mysterious and graceful curves of glyphs and ideograms
from ancient languages, all of which have a snake or dragon reference.
(One of the buildings in the complex is the foreign language laboratory
and Johanson teased the experts by using a glyph from a still-
undeciphered ancient language.) Rather like flat effigy mounds, these
forms will reveal themselves as one sees them from progressively higher
windows; thus they are a series of fragments that can be "improvised"
into a whole by the spectator.

After the birth of her first child, in the early '70s, Johanson found her-
self getting interested in plants. She made a group of linear "rock draw-
ings" of plant forms. One of these, *Nostoc,* described an algae once
thought to be "an emanation from the stars"—perhaps a bow to her
father, to whom she was very close as a child; he was an engineer for
celestial guidance systems. These works then led to the designs for a
series of "Line Gardens, Vanishing Point Gardens, Artificial Gardens, Il-
lusory Gardens, Water Gardens, Gardens for Highways, Garden Cities"
(all of which is the title of an unpublished manuscript). With one of her
small sons Johanson has also designed a geological museum and earth-
work. Her gardens are often macrocosmic projections in stone and
earth of very small organisms—bacteria, lichens, leaves, blossoms, ferns,
and lizards. Like the ancient monuments, they are figurative forms per-
ceived as abstractions. For public commissions, during the '70s, she de-
signed parks up to 80 acres in size, combining meandering paths and
landscape architecture with "aerial" images of a snake, a bird, an African
mask, in direct homage to the midwestern effigy mounds.

Johanson has also worked with visceral forms in her "stone drawings,"
recalling the cosmic/visceral labyrinth, an image found world-wide, dat-
ing back to the third millennium B.C. and best known in the "Cretan"
incarnation, as it appeared on a coin from Knossos. The identically
seven-ringed, round or square, lobed labyrinth has been found in the
Mediterranean, Scandinavia, India, the Balkans, Britain, Java, and the
southwestern U.S. Everywhere it symbolizes initiation and birth, death
and rebirth—the return to the center, or womb. The true labyrinth (also
related to the double axe or labrys of the Great Goddess) has a single path
to the center that traces every ring, moving away from the center before
reaching it. The labyrinth walker swings back and forth from left
(clockwise, against the sun, death) to right (sunwise, life), which is one
reason why mazes are often called Troy Towns or Troy games (*troy*
means "turning"). The word *Troy* also relates the labyrinth to the found-
ing or birth of cities (Jericho as well). The enigmatic "cup-and-ring
marks" (which might be its earliest form) and the spiral are also related;
the mythical Spiral Castle was the home of the Goddess Ceridwen and is
supposed to have been a Labyrinth Hill. As Hermann Kern has pointed
out, the labyrinth's center "signifies the place and opportunity for a per-
ception so fundamental that it demands a basic change in direction. To
get out of the labyrinth one must turn around . . . a change of direction
of 180° means the greatest possible dissociation from the past."[36] By the
Middle Ages the labyrinth had been Christianized, had 11 rings, and
stood for pilgrimage, penance and redemption, as well as protection and

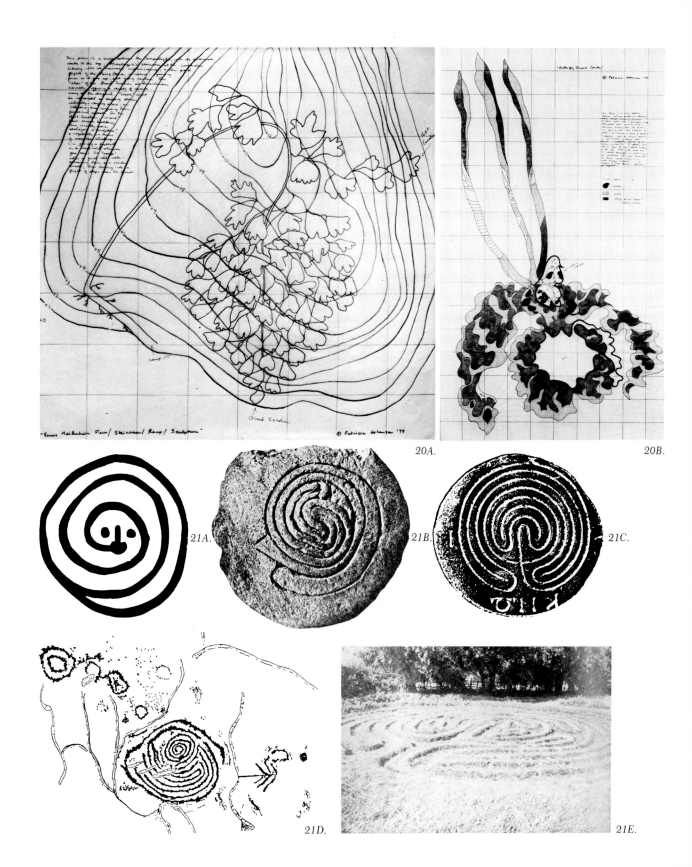

20A.

20B.

21A.

21B.

21C.

21D.

21E.

 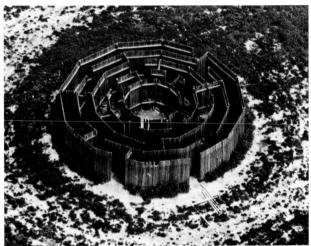

22A. 22B.

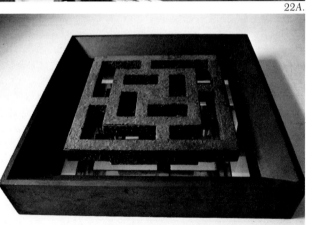 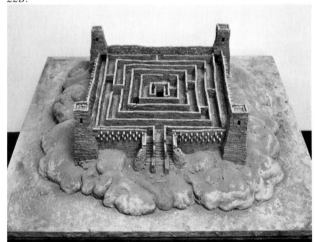

22C. 22D.

secrecy; the best-known example is the mosaic labyrinth on the floor of Chartres Cathedral. Mazes were the sites of European "heaven and hell" games and were also secular features in the gardens of some nineteenth-century utopian communities. A few turf mazes still remain in Britain and a number of labyrinths drawn in stone lines on the earth survive there and elsewhere.

The labyrinth seems to have served as a dance floor, a ritual place, sometimes a racecourse (the horse was a year-symbol with its 36 ribs and 28-nailed hooves). It is also a "weaving" or spinning image, referring to a woman's capacity to weave a child in the fabric of her body—thus it is connected to the Spider Woman and Ariadne traditions. A Hindu birth ritual involves sketching the labyrinth in saffron on a bronze plate, washing it off with water, which is then fed to the pregnant woman; she thereby permits her child to move easily through the labyrinth's seven uterine "rooms." Here, as in the Hopi Mother Earth symbol, the line of beginning to center (Ariadne's thread) represents the umbilical cord.

The maze is an adaptation of the labyrinth featuring tangled paths, dead ends, and varying degrees of confusion rather than the rhythmic single path to the center. For the most part, contemporary mazes are a disappointment if one knows anything about their antecedents—fraught with significance and mysteries fundamental to spiritual life. Today the maze tends to be a detached decorative device rather than a concrete vessel for archetypal experience. It has, however, attracted a large number of contemporary artists, some of whom are combatting the process of desacralization that isolates images from the reality they represent. In the '60s, for instance, Tony Smith made a black, formal labyrinth sculpture and also an outdoor water maze. Charles Simonds' miniature clay square *Labyrinth* (1973) is an erotic metaphor, leading to a soft inner chamber padded with moss. Alice Aycock's tall-walled wooden *Maze* (1972), like all her work, introduces the element of psychological frustration inherent in the maze form. Robert Morris made a composite of the conventional labyrinth as a walled indoor sculpture, and in England Greg Bright made so many variations on the form that he dubbed himself "The Maze King." Dennis Oppenheim's field *Maze* (1970) of hay bales in Wisconsin was a cow-sized enlargement of the laboratory rat maze; cattle were herded through it to find food, which they then "digested," along with the physiological information they received by moving through it—a kind of perversion of the funereal games that may have been played in labyrinths in ancient times. Carolee Thea's wood and stone *Hellgate Maze* (1981) on Wards Island in New York City and a collaboratively constructed steel *Forest Maze* (1981) in a South Bronx schoolyard, which was centered on a tree in that hellish landscape, introduce other ironic associations. Patrick Ireland's 1967 mirrored labyrinth allowed no entrance at all; he has also conceived of a "labyrinth as a straight line," an intriguing notion "perceived only when the formula is understood by the viewer" in whose mind it occurs.[37] Ireland's maze designs are derived from the rectangular, revolving pattern of the swastikalike Saint Bride's Cross (see p. 215), recalling a suggestion that the square was "discovered" through weaving—the right angles of woven reeds in turn recalling cat's cradle games with string and hands, which also have ancient origins.

22A. *Terry Fox.* Plaster Labyrinth. 1972. *7" diameter. After the Labyrinth of Chartres Cathedral. In a 1972 videotape,* Incision, *the labyrinth's path was followed with a magnifying glass for 20 minutes. Plants at left and right are "resurrection plants." (Photo: Terry Fox.)*

22B. *Alice Aycock.* Maze. 1972. *Gibney Farm, Kingston, Pennsylvania. Wood; a 12-sided structure of five concentric dodecagonal rings broken by 19 points of entry and 17 barriers. 32' diameter × 6' high.*

22C. *Patrick Ireland.* Labyrinth. 1967. *Mixed media. 35½″ × 35½″ × 6⅝″.*

22D. *Charles Simonds.* Labyrinth. 1973. *Clay bricks and moss; bricks ½″ long. (Collection: Harry Torczyner; photo: eeva-inkeri.)*

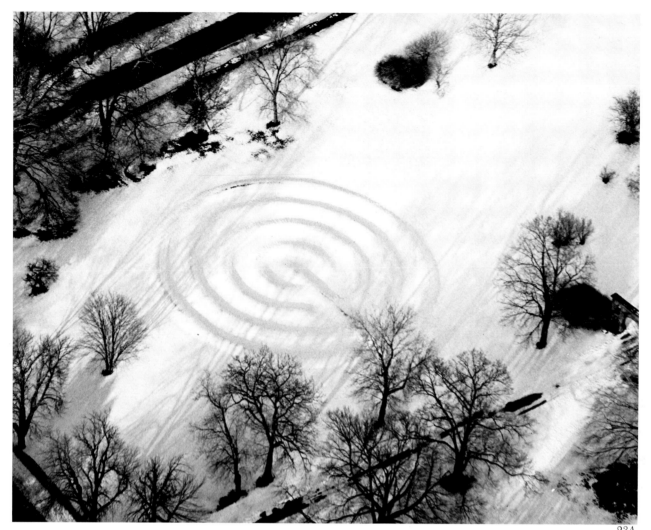

23A. *Richard Fleischner.* Sod Maze.
1974. Château-sur-Mer, Newport,
Rhode Island. Sod over earth. 18' high,
142' diameter.

Four recent artists in particular have concentrated on elaborations of the labyrinth or maze form—John Willenbecher, Richard Fleischner, Hera, and Terry Fox. Willenbecher's intellectually involved work is primarily in painting, drawing, and relief. He explores the labyrinth's geometric transformations through the centuries in a spirit closer to classical times and eighteenth-century scientism than to the prehistoric roots. In 1975 he made one full-scale, very simple but sculpturally innovative maze that seems to mark the height of his comprehension of the form. Fleischner has made mazes from tufa stone, corridors of Sudan grass and piled hay bales. He made a *Sod Maze* (actually a cup-and-ring mark—four concentric circles with the "hanging cord") in low turf relief in Newport, Rhode Island. In 1978 he built *Chain Link Maze* at the University of Massachusetts in Amherst, which exposed the transparent layers of the image and the symbol. Fleischner's sources include prehistoric henges, the Etruscan and Egyptian tombs, but his work for the most part underplays the maze's organic associations and is, like Willenbecher's, coolly formal.

23B. *Richard Fleischner. Chain-Link Maze. 1978. University of Massachusetts, Amherst. 8' × 61' × 61'. (Photo: Gene Dwiggins.)*

23C. *Richard Fleischner. Zig Zag. 1972. Temporary installation, Rehoboth, Massachusetts. Planted Sudan grass. 8' × 49' × 370'.*

23D. *Dennis Oppenheim. Maze. 1970. Whitewater, Wisconsin. Hay, straw, corn, cattle. 600' × 1000'. "Schema taken from laboratory maze, transferred to a seeded alfalfa field, and cattle stampeded through to corn." The site was selected for its peculiar surface, resembling the spotted hides of cattle; the concern was "the flow of moving bodies through an imposed structure," and the transfer of food from outside to inside of animals.*

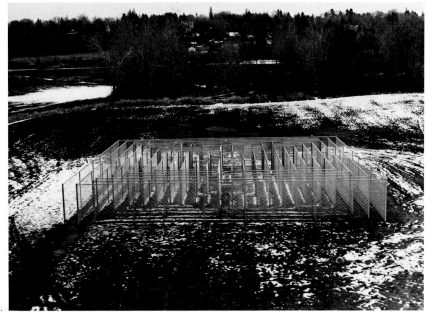

23B.

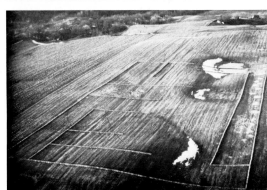

23D.

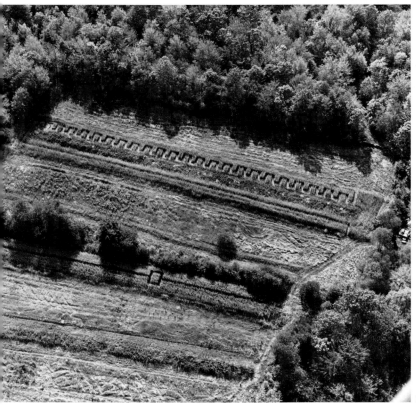

23C.

Hera's first labyrinth was a meander maze made in Texas in 1973; in 1977 she made a complicated "maze of four potential passageways" as part of an installation and ritual performance called *Lifeways* in Boston (see Chapter V). Then she branched out, using hedges and plants outdoors. Her high-walled hedge mazes echo the maze as year-symbol: the cyclical outer form is visible, but the internal events are unpredictable. "It is important to me to construct art through which people move," she has said—"the viewer-participant is 'in' the work, not just looking at it."[38] *Bear Paw Maze* (1979), projected for the Hudson River Museum, changes color as the seasons change, and refers to American Indian myth. *Floribunda* (1980), at Creedmoor Psychiatric Hospital in Queens, combines privet hedge and flowering shrubs in a form that suggests an abstracted goddess figure, a vaginal cleft, or a flower and its leaves. In 1979 Hera made the spiral *Snail Shell Maze* in Boxford, Massachusetts —double-entranced interlocking spirals made of privet, lilac, forsythia, and spiraea that will grow to a height of around eight feet. Located on the grounds of an elementary school, it is a "running maze" designed for both beauty and physical fitness. (Hermann Kern has recently rediscovered an eighteenth-century design for a "jogging maze.")

Terry Fox's mazes were begun in 1972, after he had recovered from a labyrinthine life experience—a long and serious illness. He has made a

24A. 24B.

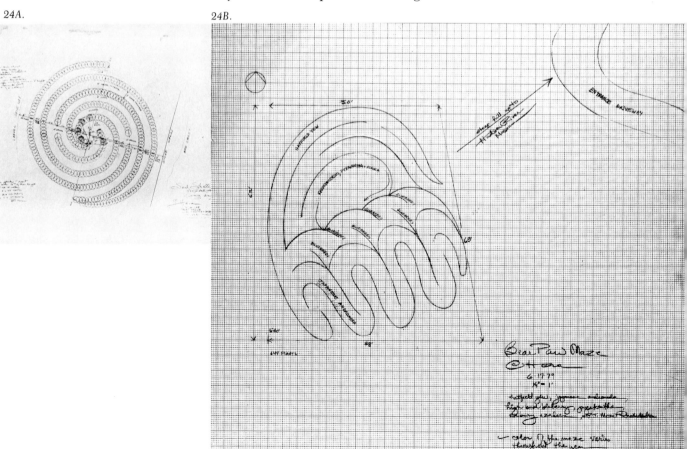

24A. Hera. Snail Shell Maze. 1979. Box-ford, Massachusetts. Privet hedge, lilac, forsythia, and spiraea. Eventually 8′ high. While constructing this maze, Hera found a local precedent in the "snail-shell houses" of late Archaic Indians 5,000 years ago. B. Hera. Bear Paw Maze. 1979. Proposal for Hudson River Museum, Yonkers, New York. 8′ × 68′ × 52′. (Photos: Hera.)

24C. Hera. Floribunda. 1980. Creedmoor Psychiatric Hospital, Queens, New York Flowering shrubs. 2′ × 86′ × 69′. D. Hera Storm Flower. 1980. Project for University of New Orleans. Flowering hedgerow of azaleas and sweet olive. 160′ × 25′. (Photos: Hera.)

series of *Works from the Labyrinth* in different media, including music, performance, ritual, and videotape, as well as objects. Their source is the medieval labyrinth set into the pavement of Chartres Cathedral, marking a subterranean spring. In order to understand Fox's 1977 *Labyrinth Object,* made of two wooden stools, a string, and a stone, the artist recommends a complex imaginative exercise:

In order to grasp the object, you need to make a few visual adjustments. Imagine the lower stool to be half embedded in the earth and pretend an underground river flows along the floor and through the center of the stool. A well rises from the river along the string to ground level, half way up the stool. This well is covered by a dolmen made of large stones. Its vertical stone walls support a single massive stone as roof, under such tremendous pressure that it is taut and resonant. This dolmen is in turn covered by an enormous mound of earth whose apex lies under the object at the center of the string.[39]

Fox completed his labyrinth series by installing a paving stone in a public square in Middleberg, Holland; the labyrinth was cut into it by a local tombstone carver and the exact location was determined by a dowser, so that it too marked moving underground water.

24C.

24D.

In 1973–74 Canadian Bill Vazan walked *Snow Maze/Digital Whorl* into the snow, suggesting the conjunction between maze and fingerprint (referring to the Indian belief that there are "eyes" in the fingertips). In 1975–76 he made *Stone Maze,* 180 feet wide, as part of the Olympic Games celebration in Montreal. He intended it as "an island refuge from the city's traffic, being a rock garden; a social meeting center; . . . a sun calendar with foresight stones aligned to the solstice sun risings and sunsets; and all with the symbol for issue from the earth-mother's vulva and the beginnings of the city."[40] The maze was destroyed by Montreal's mayor, who saw it as "uncontrollable pollution" and "designless devil's potatoes."[41] So long as the work survived, children ran through it, unconsciously reenacting ancient games. In 1979 Vazan used the brick maze on Rome's Palatine Hill as the subject of one of his "global photographs" (multi-viewpoint composites made through a scanning process in a circular grid).

"A work of art is not only the residue of an event but is its own signal, directly moving other makers to repeat or improve its solution," wrote George Kubler in *The Shape of Time.*[42] Vazan is one of the artists who has most thoroughly pulled together the focuses of this and the last chapter—semiotics, the time-and-space or sky-and-earth overlay, the notion of wholeness and rebirth connected to a local and national consciousness. Vazan's work consists primarily of large-scale drawings on the land. "My projects," he writes, "often offer configurations or formal structures destined to change over a relatively long period of time which forces us to reflect on the cyclical nature of time . . . each end being a new beginning."[43] Vazan not only draws *on* the earth, but he has drawn the vestiges of prehistory *out* of the earth (and, I suspect, energies *from* the earth). Well-informed about ancient sites and about the theories of current prehistoric scholars (though as an artist he is not confined by them), Vazan has become a self-appointed national prehistorian of eastern Canada—a truly public artist who draws local history into the land for all to learn from.

Form and content in Vazan's work are enmeshed. He makes lines on the earth (either with stones or with harmless water-based paint) and his subject is lines drawn by natural or cultural forces. For instance, he has enlarged the marks made by glaciers in *Ghostings* (Toronto, about 800 feet long, 1978–79) and the marks left on rocks at portage places by early visitors—pre-Viking and Amerindian—in *Plane Talk* (Ottawa, 4,920 feet long, 1979–80). He has dealt with early writing, first in *Rock Language* (1970, taped lines on naturally dispersed rocks) and recently in *Bord Ogam* (see p. 87). He has made walking pieces, solar calendars, a "medicine wheel." In a series of three spiral pieces he has overlaid archeological, geological, and astronomical phenomena. One of these, *Pressure/Presence* (1979–80, 1,312 feet long, on the Plains of Abraham, Quebec), forms a layered complex of meanings through alternating spirals and circles. It is about the continuing movement of the earth in the St. Lawrence River Valley and its rebounding from the pressure of the last Ice Age. *Pressure/Presence* is also about the present French/English cultural frictions, and was made on the battlefield where British forces defeated the French in the eighteenth century, to take over North America.

25A. Richard Long. Connemara Sculpture. *1971. Ireland. (Photo: Richard Long.)*

25B. Bill Vazan. Stone Maze. *1975–76. Olympic Games, Montreal; destroyed. 250 stones, 250 tons. 120' × 180'.*

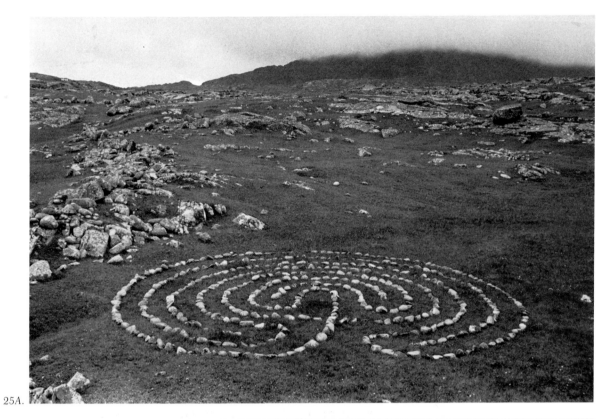

25A.

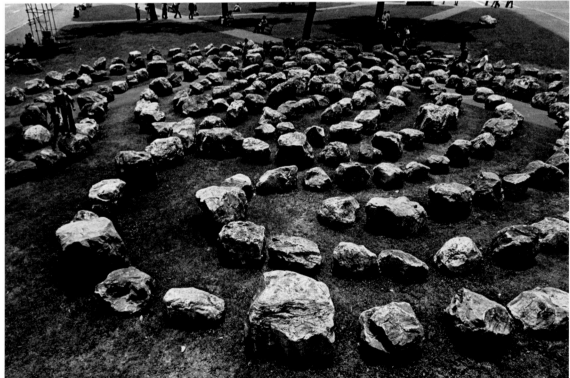

25B.

26. *Bill Vazan.* Diffusionists' Flights; Callanish, Scotland, and Hagar Qim, Malta. *1980–81. Photo-panels.*

27. *Bill Vazan.* Outlikan Meskina. *1979–80. Chicoutimi, Canada. 230' × 290'.*

Two of Vazan's recent works are wholly concerned with archeology, and are in part inspired by relatively recent aerial photography techniques used to perceive the faintest traces of ancient sites in the shadowing early morning or late afternoon light. *Cité du Havre Digs* (1978–79) juxtaposes the plans of early Celtic temple-forts, Algonquin longhouses, and the remains of Expo '67. *Outlikan Meskina* (1979–80, in the city park of Chicoutimi, Quebec, 230' × 290') is a meandering pattern of 340 granite boulders. The title comes from a Montagnais Indian divination ritual—the reading of cracks in a heated caribou shoulder bone for hunting magic. It is set in a public park, and people camping there use the rocks as an obstacle course, fulfilling Vazan's vision of the work as "a Montagnais rock garden, a social gathering place." The viewer, or "modern hunter," running, climbing, sliding through these paths (the piece lies on a hillside) becomes an unknowing participant in this ancient custom. Within the central area of the piece there are solstitial and earth-axial alignments, but they are "positioned askew so as to reflect a 'becoming' phase of evolution. The Montagnais were semi-nomadic and had not as yet reached that stage where sedentary people could develop sun-time devices."[44]

Vazan is a collagist—making a new reality from "unrelated" times and places. "Instead of encouraging the fragmentation of life and thought that largely characterizes contemporary society, my work reconnects individual, society and nature. . . . I guess you could say man is nature, yet you would need to complete the description by saying man is apart *from* nature rather than man is part *of* nature. Interestingly, this 'apartness' impels man to seek fusion with his sources."[45] His colleague Paul Heyer has called him a "cosmographer" (this is his collective identity), and Diane Nemiroff has seen his works as "entries in a diary" (this is his individual identity).[46] Bridging the two is the kinesthetic experience he shares with his audience—important to him as a means of communicating to others the meanings of his work. The incomprehensibility of these huge forms to the average park visitor reflects the fact that, like the British chalk-cut Hill Figures or the Nazca lines, they *are* mysterious. Our knowledge of them *is* incomplete and can only be sensed intuitively, rather than known scientifically.

26.

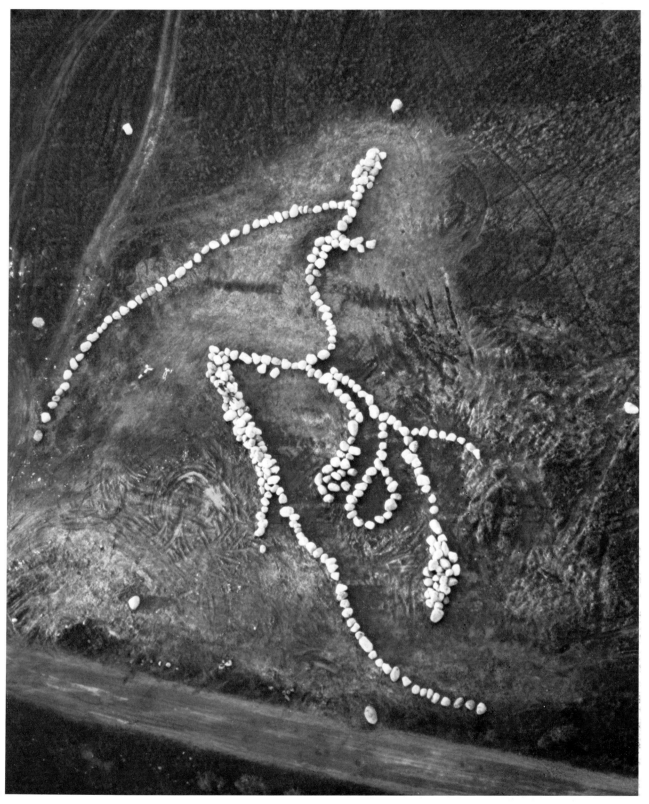

27.

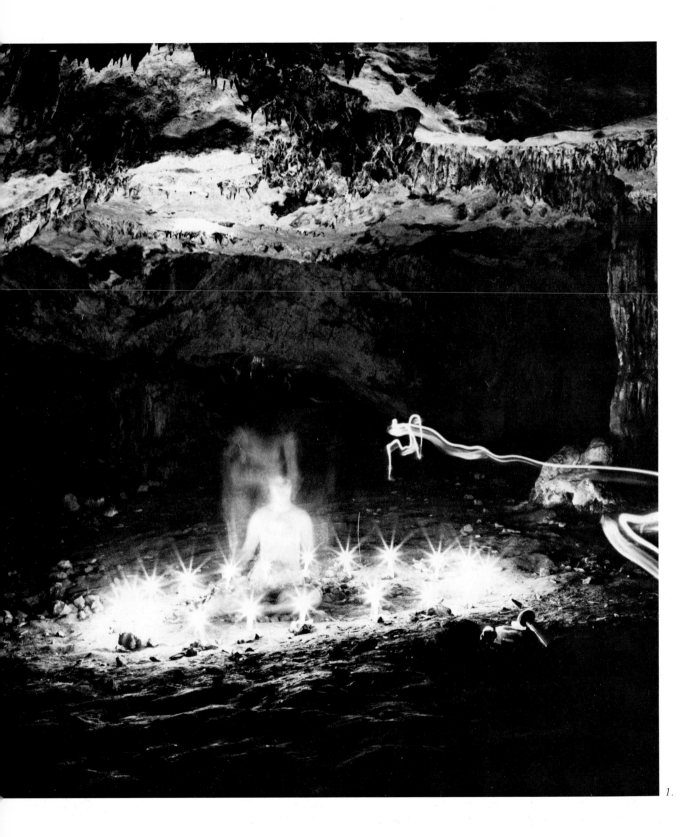

1.

Ritual

Discussing or even exploring the prehistoric sites today is like visiting a museum, or peering around a church as a tourist. For all the formal beauties that are accessible, the essence of life is elusive. Contemporary artists are looking to ancient forms both to restore that breath and also to take it for themselves. The animating element is often ritual—private or public, newly created or recreated through research and imagination (in itself a breath of life). Artmaking is a ritual, perhaps the most valid—if elitist—one left to this society. It is, however, in danger of becoming as disengaged as institutionalized religion. Émile Durkheim's conclusion that "religion is something eminently social" should also apply to art. "Collective representations accumulated over vast spans of space and time are results of a special intellectual activity . . . which is infinitely richer and more complex than that of the individual."[1]

The dominant alienation of maker from what is made, and the alienation of art and work from life, has led some contemporary artists to a conscious restoration of severed connections. Over the last 15 to 20 years there has been a move to reconnect "medium and message," "subject and object," in the course of which some artists have become quite literally *closer* to their art. They have become more necessary to its perception—not only as the actors in Body Art or Performance Art, but also as the major protagonists of their individual esthetic ideas in lectures and writing. The result has been an increased dialogue between them and their specialized art audiences. Too often, however, a broader audience remains out of reach, even to those artists most resistant to the erosion of art's communicative functions, because available forms are not easily understood.

Immateriality and impermanence, for instance, though sometimes valid strategies against commodification, have often backfired, leading to the same kind of isolation and inaccessibility the artists hoped to overcome. Although the form has changed—for example, from expensive steel to inexpensive xerox, or from object to action—the content is still meaningless to many people. In an ambivalent antidote to this situation,

The sacred principle is nothing more nor less than society transfigured and personified. . . . Howsoever little importance the religious ceremonies may have, they put the group into action.

—*Emile Durkheim*

Art need no longer be an account of past sensations. It can become the direct organization of more highly evolved sensations. It is a question of producing ourselves, not things that enslave us.

—*Guy Debord*

When ye pray use no vaine repetition as the heathen.

—*Saint Matthew*

1. Mary Beth Edelson. See for Yourself: Pilgrimage to a Neolithic Cave. 1977. *Private ritual in Grapčeva Cave, Hvar Island, Yugoslavia. (Photo: Mary Beth Edelson.)*

2. Emilie Conrad-Da'oud and the Continuum group. Black and White Dance. 1975. *Dry lake near Palmdale, California. Performed at sunrise, the theme was the birth of a new energy from stark, barren ground; the black and white motif representing the counterplay of opposites. (Photo: courtesy Meg Harlam.)*

many artists have found themselves drawn more directly into all aspects of making, explaining and distributing, even promoting and selling their art. In the process, they become public figures and their art, almost accidentally, has to become more public too. For some this syndrome is irrelevant, part of one "movement" or another, or "making it"; for others it has been an eye-opener, a consciousness-raiser, a way for the audience and its life concerns to enter and directly affect the art being made.

Of those who have tried to replace society's passive expectations of art with a more active model, many have chosen to call their activities "rituals." The word is used very broadly, but its use indicates a concern with that balance between individual and collective, theory and practice, object and action that is at the core of any belief system. Durkheim's division of religious phenomena into beliefs and rites is applicable to esthetics. "The first," he says, "are states or opinions and consist in representations; the second are determined modes of action."[2]

Any discussion of ritual in recent art raises the important question of the relationship of belief to the forms that convey it, or at least suggest its structure in a general way. Images and activities borrowed from ancient or foreign cultures are useful as talismans for self-development, as containers. But they become ritual in the true sense only when filled by a communal impulse that connects the past (the last time we performed this act) and the present (the ritual we are performing now) and the future (will we ever perform it again?).

When a ritual doesn't work, it becomes an empty, self-conscious act, an exclusive object involving only the performer, and it is often embarrassing for anyone else to witness. When a ritual does work, it is inclusive, and leaves the viewer with a need to participate again. At this point, ritual becomes propaganda in the religious sense in which the word originated—the sense that evolved from the rituals of the Catholic Church, the sense of "spreading the word" (or the seed, as in propagation). Today, as Dennis Oppenheim has put it, "ritual is an injected ingredient. . . . It's an objectively placed idiom necessary to move the work away from certain kinds of sterility."[3] But the concept of knowing through doing and communicating through participating continues, whether it is applied to daily routines or mystical states of enlightenment.

The active, or formal, element of repetition which characterizes so much and such diverse American art from the last three decades can be seen as an acknowledgment of the need for ritual. Art that is called ritual but is never repeated is finally an isolated gesture rather than a communal process. Repetition is necessary to ritual, and repetition was a major component of the work of those artists in the late 1960s who were adapting a deadpan Minimal style to an often sensually obsessive content. (Freud compared culture to neurosis, equating philosophy with paranoia, religion or ritual with compulsion, and art with hysteria.) It seems probable that in the New Stone Age, ritualization of tasks and "learning by heart" were the prime manner of perpetuating belief and history. Eventually oral history was handed down only by traveling bards and minstrels, who were "homeless," as artists are in this society. Eva Hesse said she used repetition in her sculpture because it recalled "the absurdity of life": "If something is absurd, it's much more exaggerated, more

3A. Houston Conwill. Passages: Earth/Space H-3. *1980. Nexus Art Gallery, Atlanta, Georgia. Earth and wooden ritual objects. 9' × 9' × 9'.*

3B. Susan Hiller. Dream Mapping. *1974. Collaborative performance, Purdies Farm, England. For three summer nights, six people slept out in a field among natural "fairy circles" (which have been said to form energy patterns); their dreams, and their interactions with the place and with each other, were diagrammed and compared. Hiller has noted that this piece was not intended to yield scientific results, but was an experiential structure aimed at intensified subjective experience and dream sharing as a definition of community. (Photo: Susan Hiller.)*

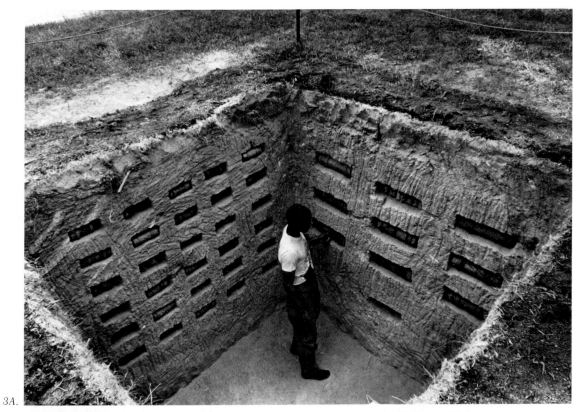

3A.

3B.

absurd if it's repeated. . . . Repetition does enlarge or increase or exaggerate an idea or purpose in a statement."[4] Yvonne Rainer has said of her choreography: "If something is complex, repetition gives people more time to take it in."[5]

The feminist development of ritual in art came in response to a genuine need on both the personal level (for identity) and the communal level (for a revised history and a broader framework in which to make art). Mary Beth Edelson, who sees herself as creating a "liturgy" for the feminist movement, introduced the function of ritual to her children in the early '70s:

I was setting aside a particular time, saying to them, "This activity that we do now is special. This time and these gestures I hope will make a lasting impression on you. So we are going to act it out. We are going to ritualize our behavior and document ourselves with photographs. The photographs will stand as a record of the unity and wonder that we experienced."[6]

At the same time, women noticed correspondences with traditional female work and arts. Artists began to see utilitarian activities with esthetic eyes, sometimes as the counterparts of mantras—social formulas for coping with oppression, for surviving. "The cumulative power of infinite repetition" was manifested, for instance, in the masonry techniques of the women who built the immense Pueblo Bonito in Chaco Canyon, a complex layering of small stone fragments. Vincent Scully has remarked how the ritual dances there were performed "tight up against the buildings . . . and the beat of those dances is built into the architecture, which thus dances too."[7] Artist Judith Todd has observed how the pueblo was laid out in clusters resembling matrilocal living patterns, and how the concentric arrangement and obsessive layering of the *kivas*, or domed underground chambers, also symbolized protection, the way the earth enfolds the soul, in a labyrinthine pattern.[8]

The rituals of modern artists evoke primitive rituals, especially those of the agrarian cycle of the birth, growth, sacrifice, and rebirth of the year god; the circle dance encouraging sun and moon to turn; the Troy dances of life and death. Michelle Stuart has written about her earth-on-paper scrolls (see Chapter I): "Move the body repeatedly and you will start knowing yourself because you no longer know anything at all. When I pound rocks or rub over layers and layers of dirt or move my body in dance, I don't want to stop. . . . Destroying to create a new state of being. It's like a murder—the destructiveness of creating."[9] Yet the forms do not survive without the beliefs, as Jamake Highwater, a Blackfoot/Cherokee who is both a participant in and articulate critic of avant-garde culture, says in his book *Dance: Rituals of Experience*. Describing the labyrinthine patterns of the farandole in southern France—a snakelike winding dance which is still executed but has lost its significance—he observes that when expressive form is abandoned, "what remains is neither art nor ritual but something else . . . decorative entertainment."[10]

In the 1960s, experimental dance broke away from the theatre world and became more closely associated with the visual arts, influencing them, in turn, to incorporate body and movement. Repetition suggests

4.

not only eroticism, but action and "revolution." Process and Performance and Ritual Art are all to a degree restless oppositions to the status quo. Visual artists' interest in dance coincided with the political need to "dematerialize" art objects. Dance is also experience ritualized, and Mircea Eliade has observed that "reality is acquired solely through repetition or participation."[11] "No form of dance is permanent," wrote critic John Martin. "Only the basic principle of dance is enduring, and out of it, like the cycle of nature itself, rises an endless succession of new springs out of old winters."[12]

Dance is considered the oldest art, and certainly the most socialized. With singing and music, it is the art most rooted in a continuing present: "Myths are things which never happen but always are."[13] Ritual takes place in the temporal framework of myth, in that Celtic "time between times" of twilights, mists, and hybrids which John Sharkey has compared to the "entrelacs" of Celtic visual arts, the intertwining knots and puns and curves—repetitive images arising from tasks set the contemplative mind.[14]

Although Jesus was worshiped as "the dancers' master" (and the mosaic labyrinths set in the floors of medieval churches were surely vestiges of dances as well as pilgrimage metaphors), "Christianity has lost its dances"[15] and consequently its spiral, growing motion, the natural circling around the spindle/axis. All that remains is the linear procession. A sixth-century Gnostic hymn warned: "Who danceth not, knoweth not what cometh to pass." A more recent version is Emma Goldman's "If there's no dancing at the revolution, I'm not coming." (A revolution is, by definition, a circle dance.) In contemporary art, ritual is not just a passive repetition but the acting out of collective needs.

Many of the megalithic circles are associated with dance through surviving local folklore, which calls them Trippe Stones, Merry Maidens, Long Meg and her Lovers, or a wedding party. Christian superstition assumed the revelers were turned into stones for dancing on the Sabbath. The stones are also said to bleed—like the spiral-inscribed, red sandstone Long Meg in northern England—connecting them with sacrifice; people turned to stone are returned to the earth. The megaliths are constantly associated with witches' dances and with the horned god become devil,

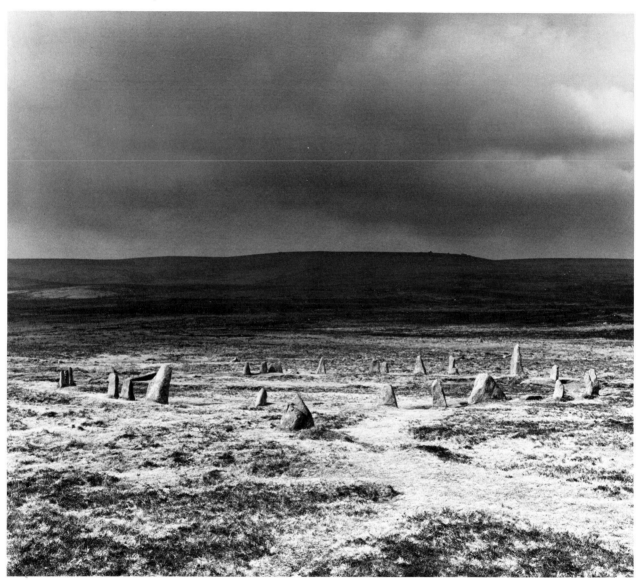

5.

6.

and with the general wickedness of woman. Witness the awful tradition associated with the Scorhill and Grey Wethers circles on Dartmoor. Faithless wives and fickle maids were forced to wash in the dismal Cranmere Pool, to run three times around Scorhill; they were driven down to the banks of the Teign to pass through a holed stone, and then to Grey Wethers, where they prayed for forgiveness. If not forgiven, they would be crushed by one of the stones, which were also said to turn on their bases at sunrise each day.

The game of tag has been called a survivor of rites going back to the labyrinth, to the scapegoat fool or sacrifice—"buck passing," quite literally, since the person who is "It" in games in some parts of England is still called Bull, Stag, or Old Horney. Francis Huxley points out that tag (or tig) is an "endless game" that circulates the touch—a kind of infectiousness, reflected in a similar game in Madagascar where the chaser is called "the leper." He says that children who end the day as It "seem genuinely ill at ease," as though some racial memory of sacrifical victims operated.[16]

Performance Art grew in the 1970s out of a double and contradictory source—first, the extremely individualized, even narcissistic, development of a fragmented Video and Body Art influenced by dance and based on personal, often virtually incommunicable sensations; and second, the politicized streetworks or "guerrilla actions" influenced by the anarchic Happenings of the early '60s and by radical theatre groups like the Bread and Puppet Theatre, the San Francisco Mime Troupe, and Teatro Campesino. Since 1980, having incorporated an increasing amount of textual and narrative components in the '70s, Performance Art has come full circle and is approaching "theatre" again. In the intervening decade, it engendered an interest in publicizing the private ritual or inventing new public rituals. These were an integral part of the whole "primitivizing" tendency of the recent avant-garde.

Some artists, like Charles Simonds in his private rituals (see Chapter II), chose to maintain a formal isolation while communicating, through

film, a communal content. Others, like Betsy Damon in her *7,000-Year-Old Woman*, projected their private rituals into the communal realm—the streets—in person. Drawing a circle or spiral of powdered pigment on the pavement, she created "a female space in the hostile city" and within it slowly divested herself of "the burden of time" in the form of hundreds of small bags of pigment which made up her costume. These she took from her body in a slow, repetitive motion, and distributed to onlookers, so they could make something of their own. (She found that generally girls treasured the little bags and boys threw them at each other.) In this feminist giving process, Damon hoped to rediscover the part of herself she did not know—her "woman line"—and simultaneously to communicate it to others. In subsequent works, in galleries and workshops and more public domains, she has used the same colorful little sacks to exchange gifts and messages with her audience. In her *Blind Beggarwoman* series, she collected stories and secrets orally, making herself a repository of a new female history.

A number of contemporary artists travel to ancient sites to reenact their own versions of ancient rituals. Bruce Lacey and Jill Bruce, in England, have made this the core of their work. Though they are aware of the different theories of prehistory, as artists they do not feel bound to support any single one of them. Their method is quasi-mystical. In costume, they build impermanent ritual sculptures on the ancient sites and perform around them. Assuming that prehistoric art was created not for esthetic reasons, but for a specific purpose—"to make something happen"— Bruce and Lacey are convinced that rituals worked through contact with energies since lost to "evolving" humans. In the mid-'70s, they set out to reestablish that contact, and have sometimes been mysteriously effective.

8.

7. *Betsy Damon*. 7,000-Year-Old Woman. 1977. *Street performance, New York City. (Photo: Su Friedrich.)*

8. *Bruce Lacey and Jill Bruce*. Dawn Ritual. 1978. *Tregeseal Stone Circle, Cornwall, England. (Photo: Bruce Lacey and Jill Bruce.)*

9A. *Peter Kiddle and Public Works. To Hunt the Cutty Wren. 1981. Public performance at Stonehouse, Plymouth, England. The Bird of Air and Bird of Water are dancing here. (Photo: Graham Green.)*

9B. *Peter Kiddle and Public Works. The Stones and the Share. 1979. A Beltane rite performed annually overnight until sunrise on May 1st at Down Tor circle and row, Dartmoor. This recreated (imaginary) ritual involves the personae of various Guardians, the Feast-Givers, the Acolytes of Sun and Wind, the Keeper of the Talisman, and the Harvest Lord. Performed with "anxiety and awe," it is a composite story of quest and initiation, of the death and miraculous rebirth of John Barleycorn, who was killed and sowed into the earth: "They let him lie for a long time then / till the rain from heaven did fall / then Little John sprang up again / and he did amaze them all." The piece was written and directed by Peter Kiddle; designed by Roger Bourke. (Photo: Cathy Kiddle.)*

Lacey and Bruce learned to dowse and found themselves "getting into some sort of communication with animals." In 1976 they began to go to the "medieval festivals" the English love. At their first, they did a rain-making piece that resulted in a violent thunderstorm, ending a drought. They did "a successful fertility ritual" at the Cerne Giant in 1977. The night they went to Avebury to do a dawn ritual turned out to be the night of the Perseus meteor shower. ("There were suddenly golden embers of light falling down to the earth. We thought what the hell is that.") In September 1977 they made "a journey of personal discovery" around the so-called Glastonbury Zodiac—a rather vague composite of topographical features, aerially readable as the signs of the zodiac, set around the ancient spiral hill.[17] At each site they performed a different ritual to combine aspects of its sign: A corn dolly was made at Virgo, relating to the early August "First Fruits" festivals (see Chapter VI); a fire was made for Leo on the "lion's groin" at the top of Green Down; the autumn equinox was observed from Libra, on the bank of the river Brue; "leaf-fish" barges were launched for Pisces and a bull's skull was placed in the center of a maze for Taurus.

Bruce and Lacey believe their rituals to be transmitters of "a form of communication developed before language," once used by animals and humans. "We are still the same animal as ancient man. We haven't changed at all genetically. . . . The incredibly exciting thing is that we still have this ability and can still use it." Their enthusiasm is contagious; their seriousness is not lugubrious. When asked by an interviewer if they felt their rituals were as "hilarious" as he did, they answered:

Yes, we enjoy them. But they're very serious for us when we're doing them. We saw a lovely film on television about a primitive tribe somewhere doing a whole ritual on stilts . . . as they fell off, everyone roared with laughter. So-called serious rituals operate on all sorts of levels. . . . England is a very inhibited country and if you do what we do you're looked on as masturbating in public, very self-indulgent. So artists have to pretend they're not doing things about themselves . . . a lot of artists are doing it, but they keep it quiet. With us it's a whole lifestyle, everything blended together—art, life, music, poetry, holidays, hobbies. We don't see how you can split these things up. . . . We're doing it like children. It's all for real.[18]

Also in England, Peter Kiddle, collaborator/leader of the "Public Works" group, produces a larger-scaled and many-leveled combination of myth, archetype, theatre, and populist entertainment. Working with colleagues and students at Dartington College of Arts in Devon, his scripted rituals take place with a few people on Dartmoor or other rural sites, or with much larger numbers in an urban festival context. The larger pieces always involve the people who live or work in the locale: "We take on the forms of ritual, ceremony, and spectacle in an attempt to share in and with the possibilities of the people's relationship to themselves, their geographic and social landscape and the active and imaginative world within which these relationships are contained."[19] Their pieces are cross-cultural and cross-disciplinary—modern visual spectacles with a traditional moral.

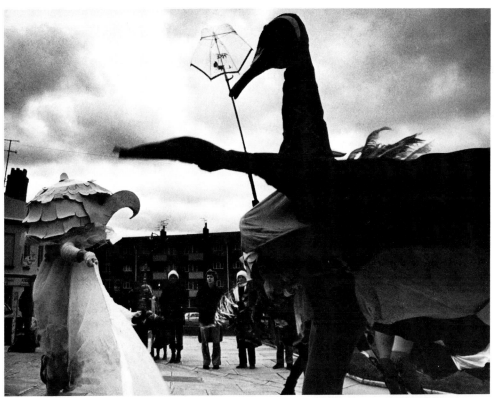

9A.

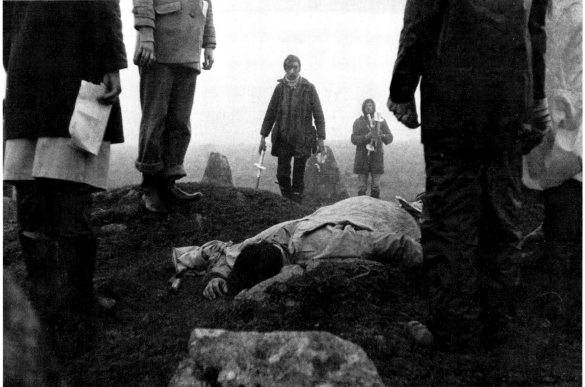

9B.

10.

10. *Christine Oatman.* Tree Ferns. *1977. Slide-text piece, Yosemite, California. Frozen ropes, resembling giant prehistoric fiddlehead ferns, rise ghostlike from the snow, bringing the past to the present through their natural spiral growth form. (Photo: Iris Laudig.)*

11. *Judy Varga.* Table of Noon/Mat of the Moon (I planted gardens of fire/ confederations of fire). *May 30, 1981. Wards Island, New York. Concrete, light-colored beach sand, aluminum sheeting, white candles in aluminum rings. Total dimensions: 50' × 30' × 9½". Made in an abandoned concrete foundation nestled in a grove of trees on the grounds of a psychiatric hospital, the piece was activated by a processional performance in which the candles were lit consecutively through the mazelike path. This "rite of passage" was performed at twilight, which the artist associates with alchemical transformation, when "solar light/energy gives over to lunar light/ energy," with the body as its vehicle. Synthesizer music by John Watts accompanied the ritual. (Photo: Ron Berlin.)*

Both Kiddle's small participatory poetic pieces and his festival work and parades are narrative and participatory, but the latter are more accessible to the general public—enlivened by wonderful costumes and visual effects, such as huge-winged birds, masks, headdresses, fire, and music that alternates between avant-garde experimentalism and marching bands. Incorporating topography, local customs, folklore, and images everyone is familiar with, their central theme is always the struggle between good and evil. In the 1978 "street opera" *WinterShip*, Spring arrived and after a good deal of horseplay banished the Winter King and burned his Longboat on the River Dart. In the 1979 *SpringWake*, the Winter King was expelled from the Norman ruins of the Totnes castle. *RainDough* took place in the spring of 1978 in the little stone village of Harbertonford. A zany and complex tale of a sleepy witch and white "Chromosol" allies from outer space bringing a celestial bread recipe coveted by a vile black water monster, its melodrama and broad humor did not confuse its ritual content. The crowds responded enthusiastically as the episodic procession made its way through the village. The water monster, escorted by wet-suited, goggle-masked cohorts with flame throwers, emerged from the stream that cuts through town. Later, brilliantly colored kites floated up from surrounding hills at a signal from the banner-swinging witch atop her trapezoidal tower (see plate 7).

In the summer of 1979, Public Works did one of its most political pieces—*The Travels of Peggy MacFail*—which dealt with the housing problems in the inner city of Plymouth, where the performance took place. The dour heroine, mythical Peggy, pushing a pram containing all her worldly goods, led her family through a white, painted 150-foot maze cleared on a gravel railroad siding and viewed from above by the audience. In the center was a Maypole with radiating colored strings. The performance culminated an all-day parade around the neighborhood and commented with good humor and a tinge of despair on what happens when you are "caught in the coils of democracy." Unlike most of Kiddle's works, this one had no happy ending. The maze's ends were blocked and the family was simply left there, trying to find its way out.

Kiddle's work brings ancient memories to modern country people, rural images to inner-city dwellers. He and his writer wife Catherine, who works with the Gypsies in Devon, lived in a caravan for several years as part of the "Welfare State" traveling theatre. He sees his major theme as the journey—seasonal, social, or individual. The performances are not private art enlarged for public consumption, but are engendered by the needs and involvement of the community in collaboration with artists. Costumes and props are all made on the spot from found materials, and although the story is preconceived, it is usually so archetypal that it adapts itself by association to local conditions. Although the audience for ephemeral streetworks like these is necessarily smaller than that for a permanent bank plaza monument, the ratio of emotional intensity is proportionately larger because of the intimacy of the form. The best chance for an effective public art may lie in just this intimacy, in providing an oasis of communication within the vastness and impersonality of public contexts.

Since 1970 Christine Oatman has also been working in both very pri-

vate and communal modes. She brings to her art a "childlike" (but not childish) delight in tales and images and in making things and places with mythical meaning—such as sand castles and mandalas and mud-pies and earth drawings. She makes her own fragile "landscape fantasies" (documented in series of color slides), as well as making fantasy objects with children in schools and in parks. There is a touching interplay between the two kinds of work. Making art this way "seems like the most natural thing in the world," she says, "and it's just what I did when I was a little kid."[20]

Oatman's ephemeral sculptures and images in nature evoke a mixture of joy and melancholy that I also associate with fleeting experiences of natural beauty itself. She works on the seashore and in the hills around San Diego, among the flora and fauna in which she grew up. Her works are triggered by a fusion of the history of the area, her own dreams and fantasies, and things she reads, especially fairy tales—those of Hans Christian Anderson, in particular, because "nature always speaks to his heroines, and helps them find their ways out of the forest."

Oatman has woven webs in trees and bound their limbs (as has Donna Henes, though their styles are very different; see below). She made a wildflower flying carpet on the desert floor, and three years later "her children" made "sand carpets" of shells and colored sands on the beach. *Stone Wave* (1978) froze a wave in gray, white, and black pebbles. *Snail Trails* (1976) was made with glowing bits of multicolored litter on a dark street, and she has had children make mandalas ("worlds within worlds") from twigs and bits of trash, simultaneously cleaning the parks and making art. (See also plate 1.) In *Tree Ferns* (1977), she recreated the giant spiral-headed plants of prehistory, inspired by Dylan Thomas' lines from "Fern Hill": "So it must have been after the birth/of the simple light/In the first spinning place."

Dennis Oppenheim's film *Whirlpool: Eye of the Storm* (1973) (see plate 5), aerially drawn in smoke over the desert, as though to draw rain, recalls the web of symbols woven by various mythologists between the spiral whirlpool or "turning mill" that is the center of the world, the world tree or axis pole on which it turns; between the tornado, the nebula, celestial patterns (especially that of Saturn) and the pole star, and the origins of fire by friction between firesticks (the Cronus and Prometheus myths); and the dialectical conjunction of fire and water—"burning

11.

water"—wells and stones and stars. This is the elaborate metaphor of Giorgio de Santillana and Hertha von Dechend's *Hamlet's Mill* (see Chapter III), which gleefully makes the whole world into a cosmological riddle revolving around this central image.

Many of the ancient monuments, considered here in isolation, were only parts of a whole we can barely imagine. They might have belonged to a network of alignments or may have been markers for journeys or ritual courses. Some were fire—beacons, or "beckoning" points to the traveler. Fires were an attribute of Mercury (Hermes), god of journeys and markers. Like labyrinths, fires also marked turning points in the year's journey, or, later, those in a nation's history. In England, fires are still lit on the ancient beacon hills to mark annual festivals and great events. The night before the royal wedding of Charles and Diana, while a huge fireworks display lit London, "bonfires blazed on 101 hilltops across the kingdom in joyous prelude," burbled the *New York Times* (July 29, 1981); a still greater cross-country pyrotechnical display was mounted for the Queen's Jubilee. Perhaps the most impressive fire line across the earth and across time is an ode to eternity as well as to cycles. It is a Brahmin chant, a fire fertility ritual that has been sung over the land in India continuously for over 3,000 years. Any village can simply "plug into" it and release its timeless sparks in that particular place and time.

Evidence of ancient fires has been found in many stone circles, implying either fertility or funerary rituals, or, more likely, a synthesis of the two. All over the world, burning torches were used symbolically to fertilize fields and orchards ("Firebrand burn. Every branch a basketful!"). Singed wreaths were brought back from midsummer fires and carefully preserved for a year. Girls watched the fires through garlands of flowers to strengthen their eyes. Animals were purified by smoke and driven through fires to protect them from disease. In Greece people jumped over fires on St. John's Eve, holding stones on their heads; later they threw the stones into the flames, made crosses on their legs, and bathed in the sea. In Europe, couples held hands and leapt over the fire; the higher they leapt, the higher the flax would grow.[21] (I leapt over a fire at the summer Hood Fair in Devon before I knew what it meant; despite my ignorance, there was a sense of liberation in the gesture itself.)

In the Brahmin *Vedas*, the four elements are contained in wood until the wood is "dismembered" by fire, a mystery reenacted every time fire is made with sticks. First the wood is divided in two; then the female half is laid on the earth and the male vertical is twirled upon it until flame ensues. In India this may have evolved into the appalling custom of suttee; in Christian times a misogynous reversal against "pagan beliefs" resulted in the Church's pruriently puritanical habit of burning witches at the stake, from Joan of Arc to the women of Salem. Francis Huxley suggests that the name *Prometheus* comes from the Sanskrit for firesticks, and that fire was indeed "stolen from the experience of sexual intercourse."[22] Robert Graves observes that the bed and the hearth were both altars; that Hestia, the hearth goddess, was first worshipped as a mound of glowing ashes—the burning omphalos or the birthplace of the earth, later translated into stone.

Another complex tradition called the "Need Fire" survived into historic

12.

13A.

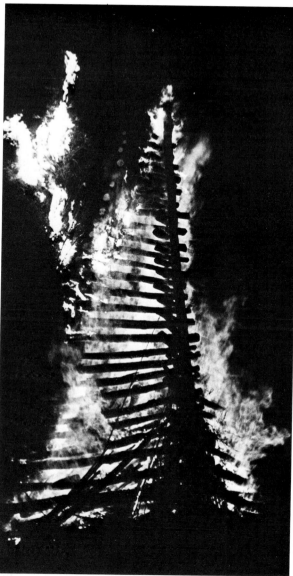

13C.

"THIS SHOULD BE A GOOD YEAR. I COUNTED MORE THAN 100 BETWEEN HERE AND GRAND POINT. SOME OF THEM ARE MORE THAN 30 FEET TALL, MOST AT LEAST 20 FEET, AND THERE IS ONE AT RESERVE THAT'S ALMOST 50....THE ORIGINS OF THE TRADITION ARE LOST. LOCAL HISTORIANS FIGURE IT HAS BEEN AN ANNUAL EVENT FOR NEARLY 150 YEARS. SOME SAY IT WAS A CUSTOM BROUGHT HERE BY FRENCH PRIESTS IN THE 1750'S, OTHERS SAY IT WAS IMPORTED BY THE GERMANS WHO SETTLED IN LUTCHER IN THE EARLY 1800'S. THE CUSTOM IS SAID TO HAVE STARTED IN THE CONVENT-LUTCHER AREA AND SPREAD UP AND DOWN-RIVER FROM THERE....TRADITIONALLY, THE BUILDERS TOUCH THEM OFF ON THEIR WAY TO MIDNIGHT MASS....WHEREVER THE ORIGINAL IDEA CAME FROM, THE IDEA NOWADAYS IS TO BUILD A BIGGER BONFIRE AND THROW A BETTER PARTY THAN THE PEOPLE IN THE NEXT TOWN."

RICK WEIDMAN,
LUTCHER, LOUISIANA

"CERTAIN IT IS THAT THE WINTER SOLSTICE, WHICH THE ANCIENTS ERRONEOUSLY ASSIGNED TO THE TWENTY-FIFTH OF DECEMBER, WAS CELEBRATED IN ANTIQUITY AS THE BIRTHDAY OF THE SUN, AND THAT FESTAL LIGHTS OR FIRES WERE KINDLED ON THIS JOYFUL OCCASION. OUR CHRISTMAS FESTIVAL IS NOTHING BUT A CONTINUATION UNDER A CHRISTIAN NAME OF THIS OLD SOLAR FESTIVITY; FOR THE ECCLESIASTICAL AUTHORITIES SAW FIT, ABOUT THE END OF THE THIRD OR THE BEGINNING OF THE FOURTH CENTURY, TO ARBITRARILY TO TRANSFER THE NATIVITY OF CHRIST FROM THE SIXTH OF JANUARY TO THE TWENTY-FIFTH OF DECEMBER, FOR THE PURPOSE OF DIVERTING TO THEIR LORD THE WORSHIP WHICH THE HEATHEN HAD HITHERTO PAID ON THAT DAY TO THE SUN."

SIR JAMES G. FRAZER,
THE GOLDEN BOUGH, P.611

13B.

14. 15.

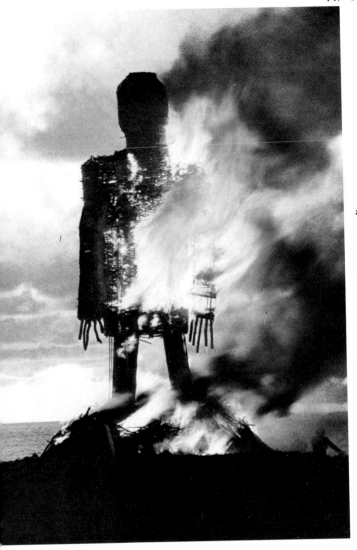

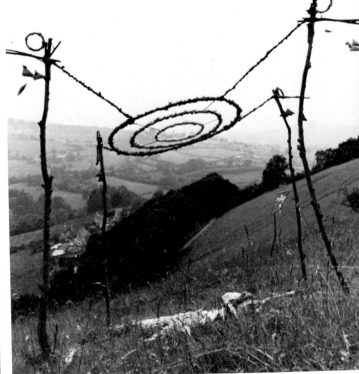

14. Still from the film Wicker Man, *written by Anthony Schaffer, directed by Robin Hardy. 1973. According to Julius Caesar, the Druids burned their sacrifices en masse in colossal wicker figures, though the veracity of this is now doubted. (Photo: British Lion Films.)*

15. Sylvia Scott. The Centre in the Midst of Conditions. *July 7, 1974. Ceremonial sculpture executed at Bowl Hill, Woochester, Gloucester, England. A ring and banners of fire built in the center of a natural ring on top of a hill radiated energy to the spectators in the valley; from four corners, four bearers ignited the structure's outer rings. For the asbestos-costumed figure lying at the center, "reality was, for an instant, a dark sky and three rings of fire, burning until spent." (Photo: T. E. Moore.)*

Europe A ritual unattached to the calendar but instigated when calamity struck, the fire was made by friction of wood (usually oak), sometimes with a pole and wheel, sometimes kindled by a naked boy and girl in a dark room, or by an old couple, or by naked men. The "fool," or victim, was chosen by having everyone place a stone in the Need Fire; its markings or disappearance the next morning determined the owner's fate. Europe, Russia, Mexico, Africa and China, Greece and Inca Peru all had annual customs in which every fire was extinguished for a period of time (usually in spring) until a "new fire" had been ritually delivered to each house. In Africa old flames were put out and new ones begun after the death of the king, to show his successor's ability to "make fire," to "create." According to a medieval legend, the new fires were first obtained from a woman's genitals, without male aid. The Prometheus myth and "new fire" tradition might also indicate a transition between matriarchy and patriarchy. Heat and fire were originally maternal elements, and fire was "stolen from nature." Among the Celts, it was Halloween, or Samhain, when the "new fire" was kindled and the souls of the dead returned. The Mexican Day of the Dead in early November is still a fire festival. The other great Celtic fire ceremony was Beltane, the first of May; in Germany that is *Walpurgisnacht*, or Witching Night—also a favored time to burn witches in the Middle Ages.

Fire is a boundary—between health/luck/fecundity and illness/bad fortune/barrenness; between light and dark, or between life and death. It is the universal symbol of transformation, of soul escaping from body, and it has always been associated with sacrifice—human and animal. The victim was often the most beloved, since it was an honor to be chosen as the means of ensuring the community's continuing life in these microcosmic death and rebirth rituals. At the tradition's most primal, it includes totemic cannibalism—rebirth through communal identification with the dead one's powers by consumption, which was later adapted to the Christian Mass. Eating oneself in the flesh of another is "a metaphysical idea of great subtlety," in which the part becomes the figure for the whole.[23] There are a number of recorded customs involving the ritual burning of effigies, of people, of huge wicker figures filled with people, of snakes or animals, and winter ceremonies like one in Lincolnshire, England, where a "fool" with blackened face and stripped paper costume was set alight.

Among both the Aztecs and the Tupi Indians in Brazil, there was a sacrificial ritual in which the honored victim was tied with a rope that represented the umbilical cord as well as the death knell, symbolizing the connections between "the horror of parturition" and "the horror of death."[24] In medieval Europe the various midsummer burnings of the Green Man or Vegetation King were undoubtedly vestiges of more drastic ancient rites touching on the primal agrarian cycle. This is the sacrifice of the king, the divine child, the tree god, the year god, or the grain (known as John Barleycorn, the Wild Man, the Leaf Man, Dionysus and Triptolemus, Adonis, Tammuz, Osiris). Born of Mother Earth, he grows from horizontal germination to verticality, becomes her lover, and is finally "decapitated" by his subjects so he can be ground between stones, consumed again, returned to the mother to be reborn and keep the cycle

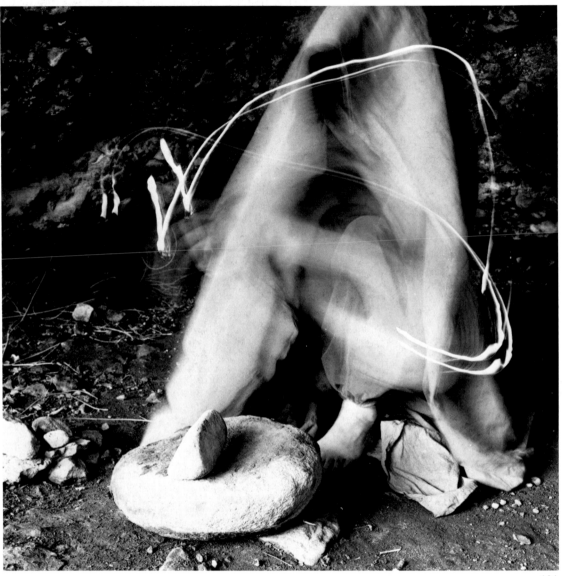

16A.

16A. *Mary Beth Edelson*. Fire Flights in
Deep Space. 1977. *Private ritual in
Indian cave, Chico Mountains,
California, with grinding stones.*

16B. *Mary Beth Edelson*. Where Is Our
Fire? 1979. *Public ritual with hanging
fire spiral. The performers drew in the
air with torches and developed a visual,
collective meditation at the "Feminist
Visions of the Future" conference at
Chico. (Photo: Mary Beth Edelson.)*

turning. "The king is dead, Long live the king, Hail Mary!" Thus ends
The Golden Bough—Sir James Frazer's stupefying compendium of re-
lated myths.

Mary Beth Edelson's theme of restoring "a living mythology that cuts
across many areas"—political and spiritual—takes a Jungian approach
to this central agrarian myth. Private and public ritual performances are
her prime vehicles. The private pieces she performs alone in some mean-
ingful place, using time-lapse photography to release the images that ex-
press her sense of the timeless landscape. In Yugoslavia, Iceland, and
elsewhere, she has gravitated to sites where collective energies have been
important in the past. She seeks out spectacular places—isolated caves,
ruins, beaches, and barrens—the way traditional landscapists do, in
order to make her connections to them tangible to those who are not

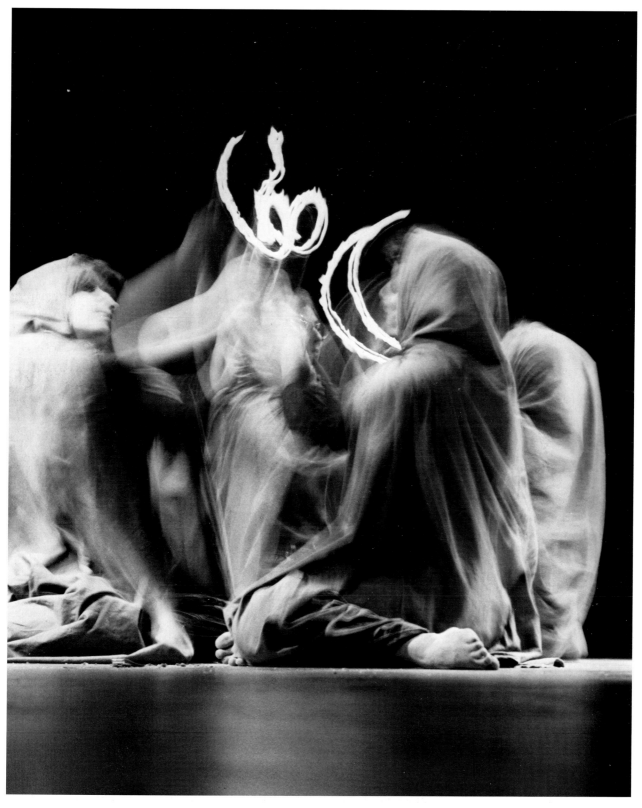

16B.

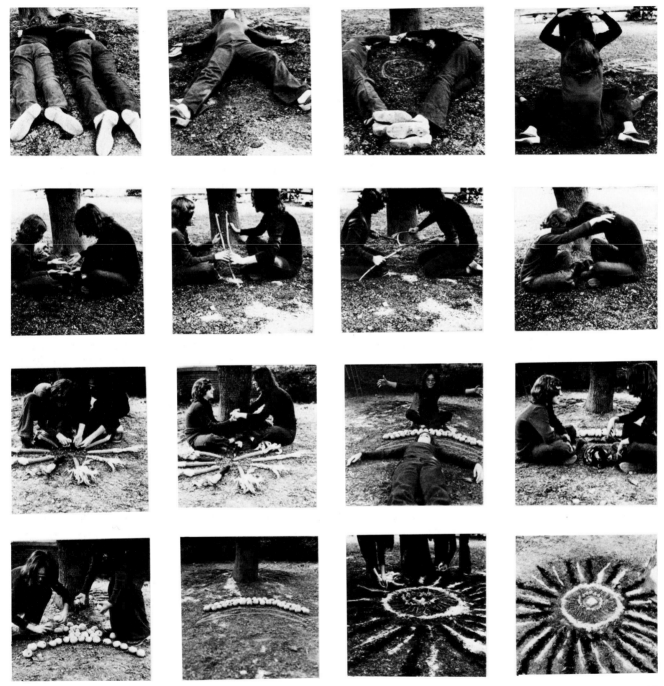

17.

there. Sometimes she disappears into the place, becoming a stone pillar, painting her body, becoming a female-shaped blur wielding a line of light, a ghostly entity crossing barriers (see p. 18). She often deanthropomorphizes herself in order to become part of a broader image of nature. In these photographic pieces, the viewer can identify, but not participate — an appropriate response to any strong emotion in the television age.

In her workshops and public, participatory rituals, however, Edelson insists on a more challenging collaboration. These works take place indoors and out. She has burned spirals in the cornfields of Iowa, read from Susan Griffin's *Woman and Nature: The Roaring Inside Her* while enthroned in a vaginal cave-sculpture *(Toothless)*, invoked the spirits of past and future through the personal experiences of her audience/collaborators. She uses stone and fire, light and dark, as her basic elements, and amorphous black robes which, when worn by women in rapid movement, take on lives of their own. Edelson is gradually evolving a communal vocabulary of gesture and image based on the symbolic treasury of matriarchal myth: egg, shell, spiral, moon, horns, mandala, mound, and uroboros — the tail-eating snake. Her works insist on the function of art as a generator of emotions, ideas, and actions, though not without a leaven of humor that intentionally undermines the potential pretentiousness of her serious goals.

The myth that is central to Edelson's rituals is that of Demeter and Persephone, commemorated by the Eleusinian mysteries which, like her art, were "mimetic of a journey to the other world to claim back from death the daughter of the Grain Mother Demeter, whose sorrow for her lost maiden could be assuaged only through the mystery of rebirth."[25] It is particularly meaningful to Edelson because she was denied custody of her young daughter after a divorce and spent years thereafter trying to confront and transcend her loss. In doing so, she discovered (and is still discovering) the complexities of the Demeter/Persephone and Divine Son myths, which she has applied to private rituals with her children.

Persephone and Demeter probably originated as parts of the same whole — the maiden and the mother/hag, three aspects of the original Earth Goddess who conceived her son in a "thrice-plowed field." Until they were smothered by Christianity in the fourth century A.D., the Eleusinian mysteries took place in September, at autumn sowing. At their height, up to 30,000 initiates would prepare for six months and then take the pilgrimage along the Sacred Road from Athens to Eleusis; its landmarks included a grove, a bridge over the "other world" (where masked men obscenely insulted the pilgrims), to the fertile plain where barley (the first cultivated grain) was grown, to the Maiden's Well, or Well of Flowers, and then to the temple in which the mysteries took place. The defamation of nature by "culture" is grotesquely illustrated by Eleusis today, its ruins trapped in the industrial wasteland that has replaced the fertile plain.

The British prehistoric monument most integrally concerned with this central cycle of birth, death, and rebirth, or death and fertility, is the great earth and stone complex at Avebury in Wiltshire, near the smaller and later Stonehenge. Since I can only touch on its forms and meanings here,

17. Mary Beth Edelson. Centering; Ritual with My Daughter. 1974. Photographs. 32″ × 32″.

18.

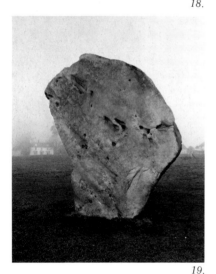

19.

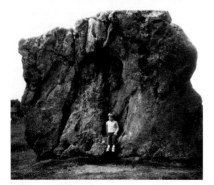

I recommend two very different views. They may seem to represent the poles and perils of academic and speculative treatments, but in fact they complement each other, bringing Stone Age culture to life. The two authors are Aubrey Burl and Michael Dames. Burl is a traditional field archeologist and sworn enemy of the "speculators." Dames is a geographer/archeologist/art historian, and, significantly, a visual artist in his own right, whose "narrative" approach defies the conventional injunction of silence on "matters of faith and religion" with "no written evidence to back it up."[26] Their books are Burl's *The Stone Circles of the British Isles* and *Prehistoric Avebury* and Dames' *The Silbury Treasure* and *The Avebury Cycle*.

The Avebury complex is dated from 3250 to 2600 B.C. It consists of the following six elements: the *Sanctuary*—now only post-hole remains indicating the presence of an often-replaced, wooden, circular building, probably roofed, and a stone circle that was recorded in historic times, since destroyed; the curved *Kennet Avenue*, lined by a double row of giant stones, which leads from the Sanctuary to the Henge; The *Henge*, a grassy circle about 1,200 feet in diameter, banked and ditched to a depth of 50 feet, topped by a stone circle dated 2660 B.C., and containing two smaller stone circles and a "cove"; the now totally lost *Beckhampton Avenue* of standing stones, continuing on the other side of the Henge; *Silbury Hill* (dated c. 2600 B.C.), a 130-foot-high conical mound with a 532-foot diameter (the largest known in Europe), made of earth over a round, tiered pyramid of chalk blocks (see Chapter VI); and the *West Kennet Long Barrow* (c. 3250 B.C., with a forecourt added c. 2600 B.C.), a passage tomb with transepted chamber covered by an earth mound 340 feet long. (The whole Avebury area is also covered with barrows from different periods; Burl does not consider West Kennet as part of the complex in his book.)

Much of Avebury has been destroyed within historic memory in the name of two false idols—profit and puritanism (or property and Christianity, or ignorant greed and ignorant fear). Burl and Dames both detail the appalling story, providing a cautionary fable for our own equally ahistorical time. What we know of Avebury today is largely due to the detailed plans and research of John Aubrey in the seventeenth century and William Stukeley in the eighteenth, as well as to the excavations and restorations of Alexander Keiller in the 1930s, documented by Dr. Isobel Smith. In the 1950s, the site, including much of the village that had been built inside the Henge, was donated to the National Trust through private contributions.

The visible Avebury was built of earth and of 600 giant sarsen stones, reputedly weighing up to 90 tons. The sarsens are sandstone slabs found on the surrounding downs, naturally multicolored, pocked and eroded into extraordinary shapes. Sarsens (supposedly from Saracen or infidel) are also known as Bridestones, perhaps referring to the Celtic goddess Bride, associated with rivers and water, as is Avebury itself, lying at the conjunction of the rivers Kennet and Winterbourne, near Swallowhead Spring. The shapes of the sarsens have led to a variety of imaginative "namings" of Avebury components over the centuries, such as the Diamond Stone and the Devil's Throne. These may or may not reflect

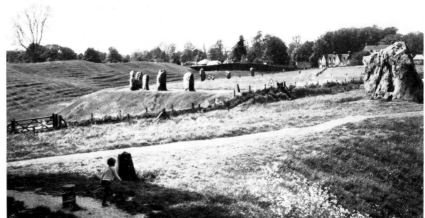

20A.

20B.

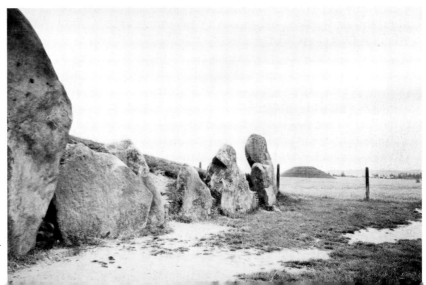

20C.

prehistoric functions. It has been surmised that the pairs of facing "wide-hipped" diamonds and thinner, flat-topped stones in Kennet Avenue were female and male symbols. (Dames sees both as female—the goddess in her fertile and deathly aspects.) A now-destroyed holed stone has also led to innumerable hypotheses about sexual and astronomical rituals.

It is generally accepted that Avebury was primarily a ritual complex, though how it was used is much debated. Excavation has barely begun, but present data offer no evidence that the Henge and Silbury Hill were cemeteries. Isolated jaw, leg, arm, and skull bones of humans; deer and ox bones, and deer antlers have been found there, as have a few human skeletons at the feet of stones—probably sacrifices. The barrows in the surrounding countryside also seem to have been "shrines and temples" rather than tombs, due to their lack of grave goods, the small amount of space alotted to chamber and the large amount to mound, and alignments to sunrises and moonrises. Burl surmises that they were designed to "catch" sun or moon "as an act of symbolism" rather than for any scientific purpose. (It should be noted here that Burl is not an aficionado of Alexander Thom's or any other astronomical theories; see Chapter III.)

The monuments of Avebury are the largest of their kind in England. For instance, Burl notes that "15 Stonehenges could have fitted comfortably into the North Circle."[27] The nearby "causewayed camp" at Windmill Hill is the largest in the world. In 1911 it took four weeks to reerect one 31-ton stone with modern machinery. The Henge itself has been estimated to have taken about 1,500,000 human hours, or 10 to 20 years, *before* the stones were erected. The whole endeavor must have lasted over 100 years. "Avebury itself was built by a people driven by megalomania to create a colossal centre where their leaders lived and which would be used by everyone for their communal ceremonies. It was the center of their private world."[28]

Half-hearted proposals by Burl and others that the Henge was intended for defense don't make sense; it took too long to build and he himself says that by the time the last quadrants of the great circle were completed, the steep-sided earlier ditches had already filled in. Nor do Thom's astronomical and mathematical hypotheses prove out here. Nor are the avenues truly curved to make two serpents coupling in the Henge, as Stukeley and Dames would have it. They may have been a processional device determined by the meaning of the central ritual that took place there. Mircea Eliade suggests that funerary cults generally influenced and absorbed fertility cults, turning agrarian rites into ancestor worship.[29] Giorgio de Santillana and Hertha von Dechend suggest that the whole agrarian cycle was preceded by the celestial cycle.[30]

Jacquetta and Christopher Hawkes posit Avebury as a transitional point, not only between Stone and Bronze Ages, but between matriarchal and patriarchal cultures: "The earth goddesses of phallic fertility rites which preoccupied the mind of Neolithic man . . . lost their hold. There was a shift of interest from the earth and the womb upwards to the sun and the heavens—well symbolized by the change from the dark, closed tomb to the open, sun-orientated temple."[31]

Burl and others draw "remarkable parallels" between Avebury's society

21.

21. *Horned figure from* Busó *procession, Mohacs, Hungary. 1968. This ceremony is probably traceable to the pagan rituals of the winter solstice; it is always held on the seventh Sunday before Easter. That night a huge fire is built on the town's main square "to consume the miseries caused by winter." In the past, masked figures symbolically ploughed up yards, pursued women across gardens with sticks, and made "movements unmistakably resembling those of the magic rites of fertility." (Photo: Peter Korniss, from his book* Heaven's Bridegroom, *courtesy Corvina Press, Budapest, 1975.)*

and rituals and those known among the North American Woodland Indians, the midwestern Adenas, the Hopewell and Mississippian mound builders. Excarnation—the "defleshing" of corpses left on platforms to dry so the soul could escape—was common in prehistoric Britain. Sometimes the bones were dried by fire (thus "bonefires") and important bones were apparently removed for ritual use. Burl sees "growing late Neolithic preferences for round houses and for rituals of the dead associated with water," conjecturing that there was once a charnel house on top of Silbury Hill (as on North and Meso-American mounds) and that the Sanctuary was a mortuary where bodies were stored until buried, since many bones have been excavated nearby. He finally, but "very hesitantly," pictures ceremonies taking place at Avebury at autumn, midwinter, and spring, "led by antlered medicine men or witch-doctors, the people dancing out the themes of death and rebirth, giving offerings, using human bones, and engaging in rituals of sex to bring back the warmth and richness of the summer soil."[32] Like many scholars, Burl traces the antlers from the Celtic horned god Cernunnos to today's remaining European horn dancers, noting that stags lost their antlers at the time of spring sowing and were symbols of regeneration, though he ignores their association with the Great Goddess and the Virgin Mary, just as he disregards the "female" lozenge symbols carved on bones found at Avebury.

Burl ends his book on Avebury with Stukeley's tribute to these "last monuments of the patriarchal religion." He states unequivocally that he finds no British evidence for a Mother Goddess religion even in Ireland. Burl stands firm, so to speak, for a solar cult and a death-and-fertility cult which oddly omits the goddess from her necessary role therein. At the same time, however, he does acknowledge the Sacred Marriage rituals, the custom of maidens marking the first furrows; he sees the pitted hollows in Kennet Avenue and the enigmatic pits filled with rich earth as offerings to the earth; he suggests that young girls were sacrificed at the Sanctuary and at Woodhenge "to give potency to the circles," that the antler picks were carefully buried in the Henge ditch as offerings because they were employed in "desecrating her," and that the perforated ox footbones found in West Kennet might have been symbolic figures of "Death herself."[33]

Reading Burl after Dames (I recommend the reverse process), I kept wondering how anyone so deeply involved in his subject as Burl could resist giving it more life. I kept wanting to pat him on the back and say, "Go ahead, man, live it up. *Speculate* a little!" However, his understandable dependence on those "remarkable parallels" between Neolithic/Bronze Age and Native American monuments, and occasional grudging references to Eliade or Frazer, emerged more fully fleshed in his new book—*Rites of the Gods*—where scholarship and cautious imagination are felicitously merged.

The appropriately named Dames, on the other hand—whose earlier book on Silbury Hill is subtitled "The Great Goddess Rediscovered"—begins his book on Avebury with the assertion that the entire complex reflects the symbolic seasonal cycle of the Great or Triple Goddess, "a body architecture . . . to be viewed as aspects of a supernatural metabolism."[34]

This is the crux of his differences with Burl. In his own evocative if un-provable reconstruction of an agrarian death and renewal cycle, Dames refuses to disregard all the data Burl mistrusts or downright disbelieves, such as clues from etymology, place names and folklore, as well as megalithic mathematics, science, and astronomy. As an unashamed romantic, Dames does not sound awkward and embarrassed when he offers poetic speculation. His compelling network of interrelationships is (perhaps dangerously) welcome amidst the dry denials of any imagination that characterize so much of the archeological literature.

In brief, Dames sees the Sanctuary as the site of puberty rites for girls in springtime; the Henge as a summer "wedding ring" (Kennet Avenue from the Sanctuary being the girls' processional row and Beckhampton Avenue the boys'); Silbury Hill as the pregnant vegetation goddess giving birth at Lammas in early August (when the hill's construction began); and the West Kennet Long Barrow as the hag—the death or "long," "winter," or "bone" goddess—where the bones/seeds germinate before rebirth begins the cycle again. Referring to topography and mythology as well as to archeological evidence, Dames integrates symbol, ritual, and myth with every natural feature of the area and with its human-made counterparts. No clue is ignored; no intuition, however far-fetched, is discarded. In the process he makes a convincing, if generalized, case for the resemblance of the hill and the barrow to the forms of Old European Neolithic goddesses, and in each phase of the cycle he introduces a wealth of natural phenomena to support his reconstruction of each calen-drical ritual.

Dames says Avebury was chosen as the site for this major temple to the "ever-changing Goddess" because "there the deity was seen to function through the fortuitous alignment of two river confluences with sunrise and moonset positions at the summer quarter days . . . interpreted as a divine exhibition of harmony between underworld, terrestrial plane, and sky."[35] Water—its conjunction with the eye goddess and the eye-womb goddess (who is presumably pictured in the Brittany tomb engravings) and its seasonal appearance and disappearance in the Avebury rivers—is central to Dames' thesis. Flowers, shells, the wavelike masonry in the West Kennet Long Barrow, perforated ox bones and meanders on pottery from Avebury, artifacts and anthropology of other cultures are brought in to weave a fabric of associations. He ties the feast of Saint Martin to the ox (mart), to the moon and horns and goddess motifs; he shows folk customs connecting "snail stones" (ringed cylinders of blue glass which cured sore eyes) with the spiral snail shells found in the Sanctuary with the maze or Troy dances that might have taken place there, and with the universal vocabulary of the snake as androgynous fertility symbol, playing with the conjunction of head and genitals (male and female, seed and vulva) in many cultures.

This connection, in turn, Dames relates to the Silbury spring—Swallowhead—to the Celtic worship of water before sun and the elabo-rate Celtic mythology of the head, the fact that like the snake, "the Great Goddess and her river Kennet runs into the ground in late autumn and re-emerges in the spring."[36] He throws an etymological curve with the derivation of *Kennet* from *cunt* (cunning, ken, cunicle, cunctipotent,

22.

23.

22. *Judith Todd.* Hill Reclamation Ritual. *1978. San Francisco.*

23. *"Clooties," County Leix, Ireland. Rag offerings to holy wells or natural water sources. (Photo: M. Andrain-Arthaud.)*

cunabula)[37] and marks alignments not only between significant geographical and stone features in the landscape, relating their proportions and measurements, but offers the imagery described by these lines as part of the whole symbolic vocabulary of Neolithic cultures.

Dames' is a *visual* theory, which is probably why I am so taken by it. He ends with a triumphal 33-mile aerially perceptible image of the "composite goddess" as a micro/macrocosmic life symbol, at which point I suspect his insights finally run away with him. Nevertheless, the pictures he evokes are firmly based in what little we know of Neolithic belief. As such they can be seen as a kind of parallel myth for contemporary perceptions of prehistory. His view of a collaboration between natural and human-made land forms is partly supported by Vincent Scully's studies of the Greek temples and Rio Grande pueblos; also by Francis Huxley's innumerable examples, such as the Aboriginal interpretation of the entire surface, detail, and features of Ayers Rock in central Australia as a composite mythical history of the race, even though to an uninitiated eye many of the figures, scenes, and animals would be invisible. Citing such examples, Dames recommends that English archeologists who deny the validity of such material "should watch more television . . . to hear the living voices of prehistoric people in the Sudan, New Guinea and Amazonia saying aloud and clear, as a statement of fact: 'this low-lying swamp is our Mother's groin; this dry upland her head.'"[38]

The Hopis in Arizona say of the twin San Francisco peaks there that they are "our mother; we nurse from these peaks for religious survival." On sunrise of November 1, 1978 (Celtic New Year and now the feminist New Year), Judith Todd related this and a mass of other information about hills sacred to the Mother Goddess to her own *Twin Peaks Ritual* as part of a "hill reclamation" series in San Francisco, California. Over 200 people participated in this public event; many others participated elsewhere by sending rituals and artifacts to be used, and by starting their own hill rituals at sunrise the same day. "Our web of rituals symbolically reclaimed this whole continent," Todd wrote, "one huge mountain, as the body of the Great Goddess."[39] The procession up the hills formed a figure eight or infinity sign—"a unique kind of spiral form which is at once divided into two halves, yet whole and never ending," recalling ancient labyrinthine dances. At its culmination, the participants bound themselves to each other with knotted cords and chanted artist Donna Henes' *Amulet Mandala*: "tying a knot is making magic./making magic is making love./making love is typing a knot./tying a knot is making a connection./making a connection is making love."

Henes, who calls herself "Spider Woman," has for years been making public rituals designed to "make connections." She sees her sculptural webs in urban and natural settings as "true maps of my unconscious. . . . Now I know it isn't circles and holes that are feminine, but the very compulsion to build webs. Web building is the most basic female instinct. Webs are what hold the world together."[40] One of her earliest public works—*The Brooklyn Bridge Event* of 1974—involved making plaster face masks of passers-by, who then stayed to make a mask of the next person, forging a sensuous and communal "bridge" between individuals and between Manhattan and Brooklyn.

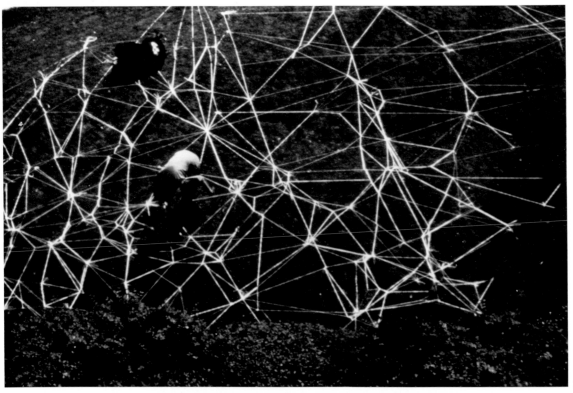

24A.

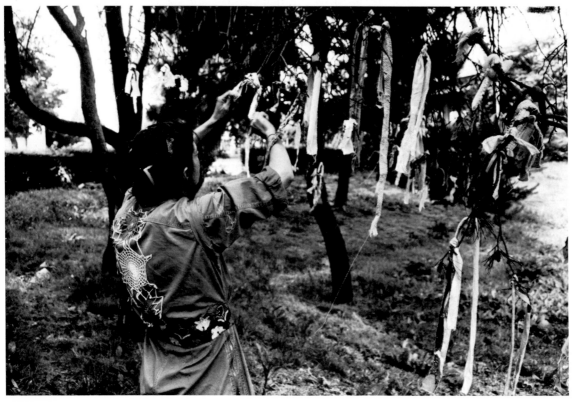

24B.

24A. *Donna Henes.* Spider Woman's Web. *1975. New York City. Public sculpture.*

24B. *Donna Henes.* Dressing Our Wounds in Warm Clothes. *1980. Wards Island, New York. (Photo: Sarah Jenkins.)*

25. *Donna Henes.* Great Lakes Great Circle. *1978. Ritual.*

25.

Henes then began to make actual webs and cocoons as sculptures, drawing random participants into the building process. This led her into studies of the Great Goddess. On the winter solstice of 1975, "the darkest day of the year," she lit a fire on a New York beach and led a dance to "invoke the female forces of the universe present in all people." The announcement (used yearly since) spirals a text over a photo of a single breast. On the spring equinox, Henes annually performs her most popular public ritual—*Eggs on End, Standing on Ceremony*—in which at just the right magnetic moment, she (and everyone) can make eggs stand on their ends, possible only at this moment. Widely reported by television and newspapers, this ritual is on its way to becoming a "folk custom."

Another ancient custom Henes has revived is that of tying "clooties," as the Irish call them, or bits of rag or clothing, to trees (or by wells and stones associated with fertility). She collects clothes from her friends, tears them into strips, and ties them on grasses, bushes, or trees in parks and other public places. Continuing the winding, wrapping, swaddling process that has characterized the work of many women abstract sculptors, Henes uses line to transform landscape, trees, herself, and others. In the 1978 *Great Lakes Great Circle* traveling ceremony performed at lakes and Indian mounds in the Midwest, Henes did a chanting, "head-wrapping" ritual from which she emerged a "source-erer, knot tier, web weaver, shaman, dreamer, dancer, *bruja,* witch (which means woman), macro/micro cosmic traveller." The chant ends "200 years ago I would have been burnt."

Perhaps Henes' most moving accretion of healing, webs, and knots was her 1980 *Dressing Our Wounds in Warm Clothes*, executed over almost a month's time at a psychiatric hospital on Wards Island in New York City.[41] Using donated rags, permeated with others' lives, she tied 4,159 knots on the hospital grounds, interacting all the while with patients, staff, and onlookers; performing ceremonies; thinking of women and war as she tore her bandagelike strips; chanting for peace; making a new language that confuses the sick and the well, a language of knots recalling *quipus,* worry beads, rosaries, and other such repetitive devices for health and transformation.

In California in 1978, as part of a series in which he identifies with plants, Stephen Whisler "dressed" the limbs of a line of trees in black "habits for the Winter Solstice"—mourning for their leaves, their protection against the winter. In 1976 Rosemary Wright made an artist's book about binding herself to a beech tree, as though being grafted back into nature. Henes was wrapping branches with red cloth long before she found out that it was a grave-marking custom of the Iroquois. In a cave on Crete, sacred to the goddess of childbearing, bits of cloth and pins were found in association with a large phallic stalactite. Strips of paper and cloth at shrines are also common to Denmark, North Africa, Tibet, and the Orient, especially the Japanese female-oriented Shinto religion. Into the nineteenth century, in Central Europe, a barren woman placed a new chemise on a fruitful tree on the eve of St. George's Day, and the next morning, if she found any living creature on it, she put it on and her wish was fulfilled. Similar birth and healing traditions are attached to holed trees and holed stones, with their obvious birth imagery.

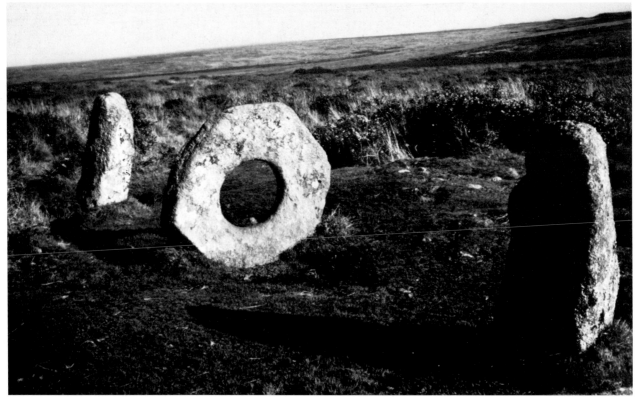

26.

26. Men-an-tol ("Holed Stone"). Bronze Age, c. 16th century B.C. Cornwall, England. Uprights, 4½' high, holed slab 4' across. There appear to have been four stones, one now fallen; those three still standing were once arranged in a triangle, but the original placement and use are unknown. Holed stones are associated with healing and may be the remnants of "portholed" entrances to tombs, thereby associated with the birth passage and rebirth rites. Naked children were once passed three times through the hole of men-an-tol and then drawn along the grass three times toward the east to cure rickets and scrofula. Prophetic qualities were also attributed to the stone; in the 19th century, if two brass pins were laid on the stone it would make them move and answer questions "through some unknown agency." (Photo: Lucy R. Lippard.)

27–28. Ree Morton. To the Maids of the Mist. 1976. Artpark, Lewiston, New York. (Photos: courtesy Max Protetch Gallery.)

The best-known modern depiction of these traditions is Arshile Gorky's painting *Garden in Sochi* (1942), recalling a similar well and rag-tree in his native Armenia.

For some artists, the notion of ritual is used to provide a flavor of ambiguity or an implied solemnity; it is in other words a formal component. For a rare few, art has become a personal counterpart of religion. For others, the "ritual gesture," although never to be repeated, has the therapeutic value of an exorcism both for artist and participants. Ree Morton, in the summer of 1976 at Artpark on the Niagara River, knit past and present, self, history and natural forces in a piece called *To the Maids of the Mist*. It was sparked by a local Indian legend about the annual sacrifice of a "bride of the river," who was sent over Niagara Falls in a canoe filled with flowers and fruits. Morton dedicated her piece to these women and called it "a symbolic rescue," a "gesture toward being female." She decorated a ladder and two life preservers with modeled ribbons and roses. The ladder was placed between the cliffs and the river; one of the "wreaths" was tied to the shore and floated nearby; the other was connected by a 70-foot rope to the artist's waist and was carried away by the strong current. When the rope was taut, Morton cut it loose, and the wreath floated free: "The rescue has become a memorial event." It was only after the piece's completion that she (a mother of teenage children) recognized its associations with the umbilical cord and the weaning process.

28.

27.

29.

30.

Adrienne Rich has suggested that an aspect of the feminist identification with the Great Goddess is related to a lack of mothering in one's own life.[42] Yet it has also been employed by Edelson and many other women artists to understand more fully maternal ties with their own children, to universalize and redignify the denigrated roles of childbearing and childrearing. This intention seems best communicated when acted out, in time, in photo sequences, or in repeated performances. Hera's *Lifeways*, performed in Boston in 1977, followed a black-garbed "hag" as she resurrected (gave birth to) a nude young woman from an elliptical tomb, and led her through a maze and a series of ritual actions.

In 1972 in Germany, Ulrike Rosenbach bound together her own and her daughter's bodies with a very long bandage of transparent gauze; the rhythm of the wrapping, embracing motion was echoed in sounds of deep breathing. This might have been seen as a reverse birth piece, retying the umbilical cord, grafting her child back to her self. Rosenbach's video and performance work varies in subject but almost always refers to mythical or historical women's power. Mirrors and headdresses are her central props. In *Mon Petit Chou* (1973) she attached layers of cabbage leaves around her own head by wrapping them round and round with thread, making herself "the heart" and "the center," part of nature, as well as playing off the French term of endearment which makes the object of affection into an object of nature. She repeatedly interprets woman as the magnetic center of energy and, conversely, as a prisoner in a cage of her own image. In *Projectkinem* (1974), Rosenbach used the mandala form, borrowed in this case from the Sioux Indians, replacing their central tree with a turning video monitor. She might have departed from a passage of *Black Elk Speaks:* "In the old days, when we were a strong and happy

29. *Hera.* Lifeways. *1977. Performance at Institute of Contemporary Art, Boston.*

30. *Ulrike Rosenbach.* Entwicklung mit Julia. *1972. Videotape.*

31A. *Geoffrey Hendricks*. Body/Hair, *May 15, 1971. A purification performance in which he shaved off all body hair while leaving the hair on his head, as "a shedding of skin," and return to puberty. (Photo: Valerie Heroovis.)*

31B. *Stephen Whisler*. Plant Work #2. *1977. 3 photographs. 20" × 24". From a series of works about "a concrete and metaphorical union between man and plants, man's need to appropriate the means of life from them, to take the energy of the plant and transform it into his own." Here Whisler expresses the classic nature/culture split by inflicting damage on a "crotched" tree and then "sharing the pain" by bleeding into it.*

31C. *Dennis Evans*. Instrument Case for Wind, Rain and Percussion. *1976. Porcelain, wood, thread. 36" × 28" × 26".*

31D. *Nigel Rolfe*. Markings. *1978. Black dust, white dust, light, sound. Performance based on the stone inscriptions at the Irish Boyne Valley passage graves (New Grange, Dowth, Knowth). Moving in the dust marked with prehistoric motifs, the artist uses his own body to make "a landscape of dust, an echo of an idea which is both memory and intention," while the audience thinks of the ancient spaces — "the peace there, the wind and the earth, the past and the future."*

people, all our power came to us from the sacred hoop of the nation, and so long as the hoop was unbroken, the people flourished. The flowering tree was the living center of the hoop, and the circle of the four quarters nourished it."[43]

"On its most integral level, ritual is the interface between Nature and Culture."[44] It is not, however, incompatible with political struggle. The best modern model is the way the Native American people have derived communal strength from resurrecting lost or disappearing beliefs. Jamake Highwater, distinguishing between ritual ("an unselfconscious act without deliberate 'esthetic concerns'") and art ("the creation of an exceptional individual who transforms his experience into a metaphoric idiom"), observes that art is unnecessary in tribal life so unified that communication is part of life. It is "only when the uniformity of social values in a group begins to shatter that meaning in the arts comes into existence. . . . Both white and non-white dancers have something in common: they're both aliens standing outside the value systems of the dominant culture."[45]

31A.

31B.

31C.

31D.

32A.

32B.

Miriam Sharon's various *Desert Projects* (since 1975) combine several such elements—a ritual process intended to reestablish bonds between people (especially women) and nature, the relationships of nomadic tents and dwellings to the land, and the political struggle of the Bedouins in the Israeli desert to maintain a way of life that is under attack by modern bureaucracy. With workers on the Tel Aviv waterfront, wearing "prehistoric" earth-covered costumes, she performed participatory rituals deriving from her work with Bedouin women in the desert. Sharon was attempting to communicate to urban Israelis the plight and beliefs of the Desert People, whose rituals are being diluted and forgotten as they are forced to abandon their traditional nomadic way of life and are herded into cement compounds. Workers wearing the desert costume found themselves taking on the "skins" of their culturally distant compatriots. Sharon's art, in the desert, or in city factories and public places, reinforces Bedouin beliefs without imitating them. She brings the notion of ritual and play into the lives of people to whom "high" art is unfamiliar. Ashdoda Harbor, where the Tel Aviv waterfront performance took place in 1978, is named after the Great Goddess of the Sea People in the Canaanite period. Sharon also recalls the history of the desert oasis ruins and their resident female deities in an ongoing piece called *Black Earth—A Tour Project*. She sees her contribution as the "transmission of earth energies into a dying civilization."[46]

Many of the feminist rituals I've mentioned here have also been inspired by the political structures of the Women's Liberation Movement, such as the leaderless meeting, consciousness-raising, going around the circle, and criticism/self-criticism. The responsive and respectful circle of private to public to private is offered in a spirit of intimacy as a means to strengthen the feeble bond between artist and viewer in a society where "uniformity of social values" has indeed shattered. These collectively generated rituals expand contemporary art by creating their own audiences and by acknowledging the importance of *exchange* between artist and audience.

32. *Miriam Sharon*. The Desert People. *(A) At Ashdoda Harbor, Tel Aviv. 1978. (B) In Bedouin village in the desert.*

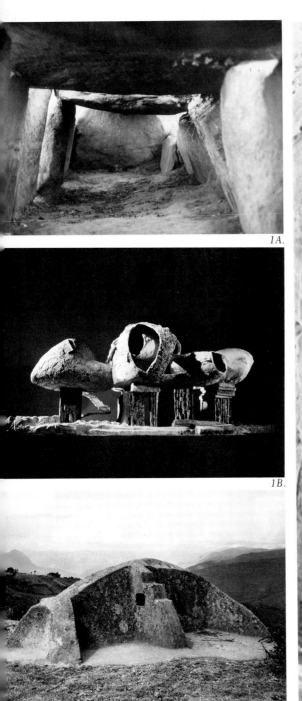

1A.

1B.

1C.

1D.

Homes and Graves and Gardens

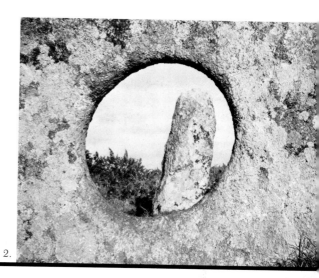

2.

The move toward biomorphic, body-related "architectural sculpture" in the last decade—especially work influenced by ancient monuments or sensitive to the site in nature—seems to have been a reaction against disengaged art objects that can be moved from place to place, but rarely "belong" to any place. The word *ecology* was coined by Ellen Swallow Richards from the Greek word for home, and much "ecological art" reflects a related need to "return." At the same time, our social restlessness demands a sense of movement. This gives rise to impermanence as a sculptural strategy well-suited to natural environments, allowing many different objects to enjoy a brief but relatively unobtrusive public existence.

Frederick Kiesler saw his lifelong project for an *Endless House* as a journey, "a living organism with a very sensitive nervous system." Its trail of rough-walled, egg-shaped rooms recalls the organic origins of architecture—from caves and animal burrows to wasps' and swallows' nests—while its basic form recalls the world-egg of innumerable origin myths. Kiesler described the *Endless House* as a temporal and spatial continuum, to be inhabited by two or three generations at once: "There is no beginning and no end to it. The Endless is rather sensuous, more like the female body in contrast to sharp-angled male architecture."[1]

The dwelling, the interior space, is the classic symbol of the female body. Architecture is called "the mother of the arts" and may well have been invented by women. Its history runs from the cave/womb to the skyscraper/erection, paralleling the relationship of female to male, matriarchal to patriarchal values. Take, for instance, the "conquest of nature"—consistently couched in terms of blatant sexual aggression. "Heroes" in every mythology are preoccupied with breaking into caves and tombs, killing the serpent dragon associated with paganism and goddesses, and getting away with The Treasure.

The earth-covered dolmen, the passage and chambered tombs no doubt evolved from imitating caves and holes in the earth. The cave is the archetypal shelter for both living and dead. In many cultures it was con-

Mary, Mary, quite contrary,
How does your garden grow?
With silver bells and cockle shells
And pretty maids all in a row?
—Nursery rhyme

Without communication with the dead, a fully human life is not possible.
—W. H. Auden

1A. Interior of La Roche aux fées *dolmen, Ile er Vilaine, c. 3000 B.C. (Photo: Lucy R. Lippard.)*

1B. Frederick Kiesler. The Endless House. Cement over wire mesh. 38″ × 96″ × 42″. (Photo: courtesy André Emmerich Gallery.)

1C. Third ceremonial stone at Sawite near Abancay, Peru. Probably early 16th century. (Photo: Cesar Paternosto.)

1D. Louise Bourgeois. Inside view of Hanging Lair. 1963. Plaster. 47″ high. (Collection: The Museum of Modern Art, New York; photo: Peter Moore.)

2. Men-an-tol ("Holed Stone"). Bronze Age, c. 16th century B.C. Upright, 4½′ high, holed slab, 4′ across. Cornwall, England. (Photo: Lucy R. Lippard.)

3A, B. Alice Aycock. Williams College Project. 1974. Williamstown, Massachusetts. Earth over concrete-block chamber. Interior 4' × 6' × 2'; entrance 14" × 28"; mound 15' diameter. One enters the mound "head first crawling down at an angle, dragging the rest of one's body inside, and ends up lying prone, face down," in a metaphor for the position of a corpse in the ancient tombs on which the piece was modeled. Aycock also sees her mound as "an entrance into the mountain," or into the other world. Its form echoes that of a mountain visible in the distance behind it, reflecting Vincent Scully's theories about the sacred use of landscape forms in ancient Greece.

3C. "Root cellar" or "ancient temple" at "Calendar II site," Windsor County, Vermont. Oriented southeast, made of nine slabs (the largest of which weighs almost 3 tons) and vented at the roof. c. 19½' × 9¾' × 6½. This is one of the largest slab-roofed chambers found in New England. These curious structures are at the core of the controversies around "America B.C." On the one hand they are offered as evidence of calendrical research and ritual by megalithic visitors long before Columbus; on the other hand they are presumed to date from Colonial times. (This one is dated c. 433 B.C. and late 18th century.) In either case, the visual resemblance of these stone chambers to megalithic tombs is striking; some have even been used for family burial vaults. (Photo: Lucy R. Lippard.)

4. Jody Pinto. Detail of Spotted Bundle Enclosure. 1976. Mixed media. 18' deep, 6' wide.

sidered to have been the home of earth spirits before it was inhabited by people. Caves are unique spaces; they are all entrance and interior. The psychological image of cave is a double one, incorporating the threat of absorption and the fear of violation, as well as the hope for germination and growth. Caves were also places of protection and divination; long after people had begun to build free-standing dwellings, they returned to caves for rituals of fertility and childbirth.

Alice Aycock's early work—structurally modern but emotionally primitivizing—combines the cave's fearful and hopeful aspects. After her early, germination images, like the Williamstown mound and a sod-roofed stone house, she made primarily subterranean passages, wells, towers, and shelters—massive "dead ends" which, when entered, gave way to contradictory signals of frustration and ambiguity, claustrophobia and imbalance. Time and memory—individual and collective—are important elements in Aycock's work. She brings into her pieces an amazing number of cross-references, incongruously literary in such monumental sculpture. For instance, in the fortificationlike cinder-block *Project for a Simple Network of Underground Wells and Tunnels* (1975), the functional appearance was belied by spatial ambiguities. The brave "viewer" crawled through dark passages from one light source to another. This experience of "a solid mass pocketed with empty spaces" is amplified by written notes accompanying the project. They include references to Gaston Bachelard's *The Poetics of Space,* to "underground maneuvers" of various military types, to light-well courtyards built 30 feet into the earth as dwellings in China, to pit-dwellings in Tunisia and Egypt, to the Hopi and Pueblo *kivas,* Edgar Allan Poe, fictional vampires and troglodytes and autobiographical episodes. In the text and structure composites, technological rationality is subverted by a paranoid wit or wiliness.

The intellectualizing bent that led Aycock to an arsenal of historical sources also led her to insights from perceptual and behavioral psychology. Her structures mix terror and enticement, punishment and indulgence. Her earlier shelters often turned out not to be sanctuaries after all; entrances led to coldly bunkerlike tunnels, ambivalent crawl spaces, and other nightmarish spatial surprises. Warmth became rejection; a welcoming staircase led to a precipitous ledge or a dank passage, a cozy space gave way to a dangerous one. Eventually, Aycock abandoned even the illusory simplicity of the single-image pieces in favor of a fantastic gigantism in which Rube Goldbergian engineering feats vie with an insane and quasi-utopian logic. Sometimes she seems to be building Piranesi's prisons.

Jody Pinto is another artist whose work is engendered by fear of death and darkness, dismemberment and painful initiation, though these elements are mitigated by a strong attraction to the earth's nourishing substance. She too introduces occasional autobiographical motifs in texts or titles to her architectural forms and overtly anthropological sources. Her *Spotted Bundle Enclosures* of the mid-1970s were small "archeological" environments placed at the bottom of old brick wells (or cisterns) in vacant lots in Philadelphia. Pinto excavated them herself. The remains of

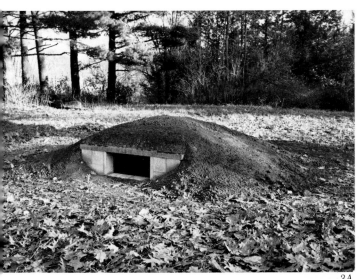

3A. 3B.

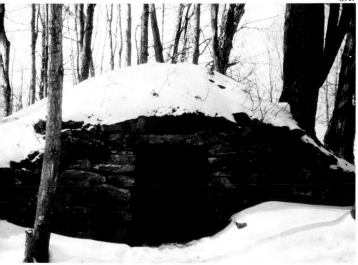

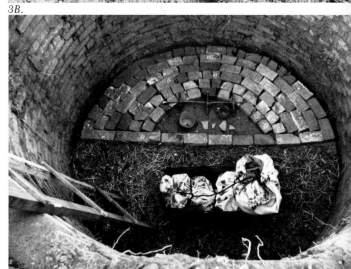

3C. 4.

a hearth, the bundle itself (resembling a corpse wrapped in an animal skin), a few shards and artifacts, evoke an ancient burial place, or the prehistoric pits filled with imported earth or votive offerings, or Celtic holy wells. She saw her wells as "time-bomb containers" of her own feelings and experiences.

Digging deep in the earth to make her sculptures, Pinto says she is being lured toward the center: "Twelve feet into the earth, and I can't tell where that hot, sweet damp smell is coming from."[2] There is something of a recreated self-rape in her imagery, an aura of ritual violence transmitted through the repeated motif of a disembodied limb or organ, which she attributes to a number of autobiographical factors, such as being present as a child when a dismembered body floated up on a beach, and her Catholic upbringing with its martyrs and bleeding hearts. In her notes, she recalls "you sitting in my room asking if religion has anything to do with my work and me answering very quickly 'no.' But it's 'yes' isn't it?"

C. G. Jung has offered the clearest modern metaphor of the house as image of the self and its development within the history of a collective unconscious. In a now famous dream, he explored a house that represented his own psyche as well as a passage back in time—from a "conscious" elegant and "inhabited" living room *down* to the "unconscious" cavelike cellar where he found the remains of a primitive civilization. Later in life he built himself a "spirit house"; it evolved in reverse—from a simple hut to a four-room dwelling-tower centered on a "maternal hearth" where he always experienced "an intense feeling of repose and renewal."[3] Descent into a well symbolically suggests both self-annihilation and potential rebirth; Pinto's "animal skins" suggest the unconscious. Her triple-lobed well of 1976, with ladders leading down into the earth, can also be read as a silhouetted female body, like those of the ancient goddess temples.

Yet if Pinto's structures refer to rebirth, it is a painful labor. *Five Black Ovals* (1975)—a series of travoislike frames leaning against a cliff—was destroyed by a storm and then immediately reconstituted as *Twelve Bleed Pockets*, which, when it rained, bled red earth. The artist's pain at the destruction of her creation had been used for a new creation—a true metaphor for immortality. Blood and stone and hay and earth are central elements in many of her shelters; they often house dismembered body parts representing the whole, such as *Hospitable Structures for the Wounded Body, Cave for a Split Tongue, Heart Chamber for H.C.,* and *Death Hut* (all 1978). The latter was an under-life-size portable shelter of dented, painted paper, grotesque and fascinating in its double reference to dead skin and wilting flesh or to menstrual isolation huts and other seasonal shelters culled from the artist's studies of prehistory and anthropology.

Pinto passionately anthropomorphizes her sculptures. They bleed and pulse. Her wells and chambers are "closed mouths slowly opening, drawing in new breath and exhaling experience." Her notion of "the body as hero" recalls the myths of dismemberment, and her use of blood recalls ancient body painting. Red ochre and hematite (named after blood in Greek) have been used in many cultures to smear corpses and bones with a renewing force. The oldest known mining operation in the world—

5. *Suzanne Harris.* Locus Up One.
1976. Battery Park Landfill, New York
City. Wood, concrete, sand. Circle 21'
diameter, 9' high; cube, 15' × 9'; tunnel,
4' × 8' × 20'.

5.

43,000 years ago in Swaziland—tried to recover this blood stone from the earth for ritual purposes. Mary Douglas has reported on the surviving Zambian symbolism of black bile, red blood, and white milk in both body and nature, part of "a complex representation of male and female spheres, and destructive and nourishing powers." She points out, "Art and the humanities are not sullied by blood and tissues, but given life."[4]

Judy Chicago's china-painted reliefs from the mid-1970s trace the prehistory of womankind in a series of images of caves, blood rivers, flowers, crevasses, and vaginal forms that share the imagery of her major opus—*The Dinner Party.* I own a tiny relief of rich browns titled, around its circumference, *The Rock Cunt as a Portal, a Passage, as a House of Darkness* (1974). Chicago had predicted this imagery in 1969–70 in her "abstract" *Atmospheres*—pyrotechnic environmental pieces in which puffs of colored smoke rose from abysses in the earth like a re-creation of oracular rituals.

Michelle Stuart's unexecuted cave project is a metaphor of an intellectual repository. She would like the viewer to enter "nude, vulnerable, new" for an encounter with its contents—her *Rock Books*, or the children of her head and hands. Their wordless, topographically pocked pages, thong-tied and feather-locked, form a bond between sense and intellect, representing all of history and knowledge—"The Idea."

There are few contemporary "primitivizing" works derived from ancient caves and tombs that do not imply rebirth as well as death. Colette's cavelike boudoirs (even the most baroque renditions), though not strictly prehistoric in inspiration, make the body-earth connection clear: "I create my own landscape and then become one with it," she says, chameleonlike.[5] In *Persephone's Bedroom* (1974), she built a subterranean chamber for the germinating seed with layers of luxurious tattered satins of soft pink, green, and grey, mirrors and sounds. Breast- or udder-like stalactites hung from the ceiling. The artist was photographed nestling nude in the soft furrows of her self/lair.

Suzanne Harris' *Locus Up One,* executed on the sandy landfill along the Hudson River in New York City in 1976, was a typically modernist adaptation of abstract form and allegorical implications. As one ap-

proached it across the "desert," it appeared to be a mound with a truncated triangular entranceway, but one entered an open-roofed polygonal corridor around a central cube plastered in white. It was like being under the earth and under the sky at the same time. The combination of enclosure and brilliant light, coolness and heat, fullness and void reduced to geometric simplicity evoked the following response from fellow artist Poppy Johnson:

A saint approaching death. . . . She walks slowly in the sandy desert and the horizon melts away as the sand rises symmetrically on either side of her progress. She won't look back which is the only way to see the world and people and life she is leaving behind. She looks straight ahead at a narrow dark doorway cut into the mound of sand ahead. Inside is a cool, dark but short passageway that immediately opens into a bright round limited space. In the center . . . is an implacable white cube. The saint looks up into the blue sky above. She has left everything else behind and entered into her own metaphor for her soul, hermetic and infinite. She is not afraid.[6]

This image took on an added and tragic mystery when Harris died a few years later in her late thirties.

In a series of "tombs" conceived in 1979–80 (shown as inscribed onyx plaques in a gallery), Robert Morris offered a group of chilling narrative projects, including Project for a Tomb—The Towers of Silence: "a five-acre space completely bounded by eight-foot-high masonry walls" with square stone towers and small continuous internal stairways, where bodies are placed by cranes from outside the walls. "The perpetual sound of tap dancing emanates from somewhere within the compound which is not, however, without a certain form of life, for the area within the walls is teeming with local poisonous snakes." Morris' text for Tomb for a Dismembered Body begins:

The Torso is said to repose beneath this lacy white trellis. And that rockery or grotto over there? I was told it marks the resting place of the pelvis. But I am not sure; nothing is marked. Beyond those trees are two small pools, just visible there to the left. Yes, for the feet. Who laid out these gravel paths? I was not told that. Yes: this is the maze you heard about. Don't ask me why it was covered with mirrors. Or why that mist from the top keeps them wet, I would prefer if you did not enter. I can't be responsible. No, the head is not visible at the center. It is deep in the ground beneath one of the walls. So I have been told.

The biological identification between body and house/temple and its connection to the land and to the structures of social life are nowhere so clear as in the dwellings and village plans of primal peoples, both nomadic and agrarian. The African Dogon, for instance, consciously model their houses and villages on the human body, from house to house posts to the arrangement of houses and fields in a complex macro/microcosmic system. Seen from above, the village looks like a field of cultivated hillocks. The Dogons believe that the world developed in a spiral, and the fields represent the world in miniature. Cochiti Pueblos also plant their fields in spirals.

6A. 6B.

7. *Alan Saret*. First Solar Chthonic Wall
Temple. *1975. Cone-shaped aperture in
the wall of a New York loft which
registered weather and time from outside
to interior. Saret called it an "apotheosis
of universal sexuality, fusing cosmic
opposites."*

7.

Cave and mound became hut and house in an organic chain of forms
related to the body. Joseph Rykwert traces this evolution of the dwelling
as model of the universe (with the occupant at navel or center) in his
memorable book *On Adam's House in Paradise*. He gives his "original
hut" a double parentage—the "found volume" of the cave and the "made
volume" of the tent or bower.[7] (This is interesting in view of recent re-
search showing that little girls in play "modify the space in imagination
rather than in actuality—a bush becomes a wall; whereas boys *build*
walls, windows, roofs."[8])

In a "cultural interpretation" of the North American tipi, Terry Straus
has outlined the intricate symbolism by which the Plains Indians de-
signed, located, and lived in their dwellings. The living arrangements
were a microcosmic echo of the macrocosmic religion (with young people
sleeping to the east, the new; and the old people sleeping to the north);
they reflected the four quarters, the seasons, and human life. The tipi
itself was seen as a human body—usually female, and sometimes read as
"a woman in the native position for childbirth, her arms outstretched to
clutch two upright poles, her dress covering her squatting body, the new
life emerging through the entrance." (The contemporary Cheyenne artist
Richard West, however, is quoted as identifying the form as "the figure of
a man, arms outstretched in prayer.") The plan of the camp itself echoed
the ground plan of the individual tipi. Strauss shows how inextricably
entwined was the circular design of dwelling and camp and world with
the lifespan of the tribe, and traces the decline of Native American cul-
ture through the awkward foreign living spaces imposed on them by col-
onization. In a Western house, the native culture crumbled, because
"there was no way to create a center, a focus to hold them together and
provide direction and security to individual members." "In times of trou-
ble even now, families will all sleep together in the main room, no matter
how crowded or uncomfortable."[9]

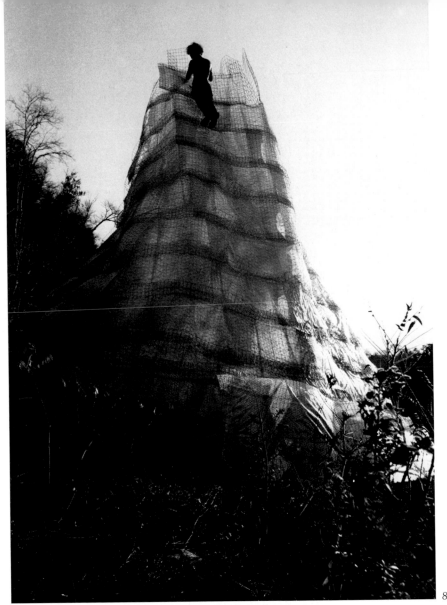

8.

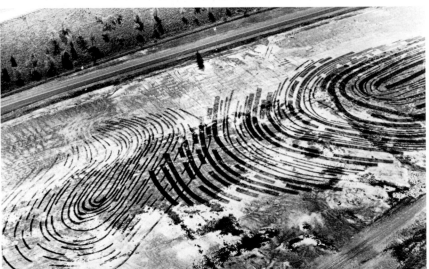

9.

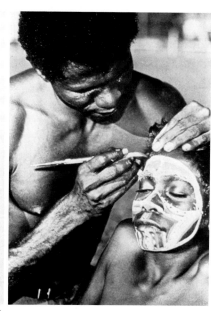

10.

11.

8. *Alan Saret.* Ghosthouse. *1976. Galvanized steel. A shimmering, transparent pyramid made of Saret's invented "@el units" of double mesh, with a cable armature strong enough to climb on and view both interior and surrounding environment from unexpected vantage points. Ghosthouse was intended as an ethereal emblem of a life "where technology bows to the spirit of the natural world from which it derives its materials and inspiration." Saret lived in the structure as it was built, simultaneously exposing lifestyle and creative process to the Artpark audience. It underwent continuing change during the summer and fall, acquiring a final nylon covering for its "winter phase." At all stages it raised the issue of private and public art, the separation between subject and object, intention and product, art and religion, art and life, while the artist acted out his role as exemplary shaman to society.*

9. *Dennis Oppenheim.* Identity Stretch. *1976. Artpark, Lewiston, New York. Hot sprayed tar. 300' × 1000'. Procedure: right thumbs of Dennis and son Erik Oppenheim printed on elastic, stretched to maximum and photographed; then enlarged and drawn slightly overlapping on the earth, where the tar surprisingly acted as a fertilizer for the grass.*

10. *Dennis Oppenheim.* A Feedback Situation. *1971. Photo-text. "I originate the movement which my son Erik translates and returns to me."*

11. *Australian Aboriginal painting the face of a boy for* pukumani *funerary ritual at Bathurst Island. The designs represent totemic creatures. (Australian Society for Education Through the Arts.)*

Many of the artists reproduced here employ two kinds of overlay. One is abstract and the other concrete—the former seeks "timelessness" and the latter a "timely" physical and even sexual "covering" to produce a hybrid image or reality. Dennis Oppenheim's "transplant" and "overlay" pieces of the 1960s quite literally "covered" the land in a private esthetic fertility ritual that found more overt forms in his later works about generation and family. At first he exchanged a rectangular patch of turf from a mountainside with one from a wooded valley, or drew the full-scale floorplan of a museum in a field (a classic illustration of culture imposed on nature). Later he worked with his father and with his children. Oppenheim and his son copied blindly on each other's backs a figure both were looking at. After his father's death, Oppenheim drew his "last lines" on the earth in huge flares, as a blazing memorial.

Several of these themes came together in *Identity Transfers* (1970–76), recalling at the same time a number of primal rituals about death and fertility, the transfer of power from ancestors to present generations. In various ways, Oppenheim overlaid the thumbprints of his father, his daughter, his son, and himself. "It's a linear regression," he said, "going back through the members of a family until an impasse is reached." In the attempt to reintegrate his individual experience with a collective one, Oppenheim was trying to "carry out activities that related to me but in a different chronology." At Artpark, his own and his son's thumbprints were made in blood and ended in the earth, as though "staying in touch": "Using material that is contained in the thumb is such a beautiful way to make contact with a material, to leave an impression."[10]

Oppenheim's ambivalent fusion of morbidity and energy gives the viewer a choice as to which aspect to focus on. I have interpreted his *Cancelled Crop* (see Chapter II), for instance, as a kind of *coitus interruptus*, a perverse interference with agriculture, the male counterpart of Mistress

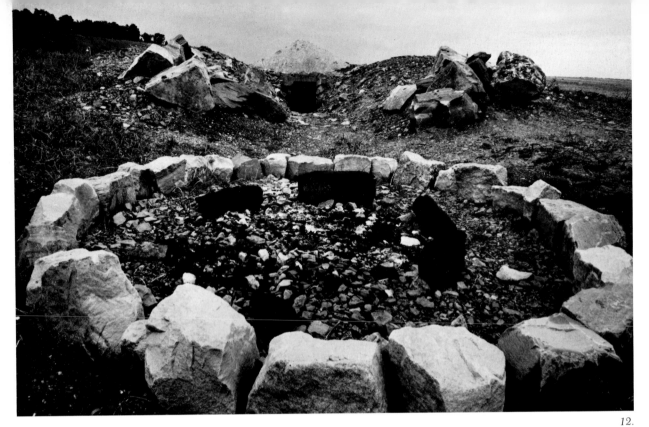

12.

Mary's "contrariness." On the other hand, the Hopi plant their corn in an X to encourage fertilizing by the Morning Star, and an X on an egg or oval is an Old European symbol for fertility, like the snake on the mound. And neither of these readings acknowledges the original political gesture of commodity destruction.

Working on the model of the New Mexican *penitentes'* caves, Tim Whiten put together several ancient concepts about death in his *Morada,* of which he wrote: "All religions talk about a change in awareness and that's what I'm concerned with: a change in awareness. The skulls and bones, human and animal, don't denote death but mark a stage in the state of life. I don't believe that there are two entities, one called life and the other death; it's all one unit, just a change in it." *Morada* was an ambitious three-part stone and earth work executed at Artpark in 1977. To experience it one followed a ritual series of stations: the "threshold" (a ring of boulders encircling a hearth with chunks of burned logs), a 60-foot path/trench, and a seven-foot cube chamber inside a conical earth mound flanked by two rounder mounds and more boulders. The mud and wooden chamber was whitewashed within as a setting for human skulls in the walls, with a garland of cedar and roses, burning copal, and a pine-needle floor. Branded into the ceiling were the signs of Cancer and Capricorn—ascent and descent.

Aware of current prehistoric research, Whiten measured, aligned, and oriented the elements of his chamber to correspond to an unseen aerial view of the alchemical sign for sulphur—the purest element, the ultimate change. The entrance faced east. At the completion of the work,

12. *Tim Whiten.* Morada. *1977. Oak and maple beams, human skulls, cedar, roses, pine needles, copal, rock, iron gate. c. 80' long; chamber 7' × 7' × 7'.*

13. *Dwarfie Stane, Isle of Hoy, Orkney, Scotland. Date unknown. Sandstone. 28' long. The only rock-cut tomb in the British Isles; chamber with bed or shelf on either side of entrance, which was blocked by huge chunk of stone. (Photo: Lucy R. Lippard.)*

Whiten invited the public to participate in a candlelight procession ending at the firepit, where everyone was offered roast corn, a symbol of life and fertility.[11]

Such a complicated synthesis of symbols combines the biological and the spiritual. The fact that so many megalithic excavations have yielded no evidence of burial suggests similar interpretations for the ancient tombs. For instance, the Dwarfie Stane on the Isle of Hoy in the Scottish Orkneys is a unique rock-cut "tomb," not in a cliff but in a rectangular free-standing boulder that lies in a field. It has been suggested that this was not a burial place at all, that chambered and passage tombs might also have been observatories of some sort, or shelters for priests or hermits during contemplative or communal energy-producing rituals. The Dwarfie Stane's double chamber and the immense square-cut stone that served as a door indicate that the tomb interpretation is correct, though it has been speculated that a rebirth ritual could have taken place there, consisting of "burying" a representative of the whole tribe and then resurrecting her or him at a propitious moment.

The vulnerability of the seed, and by extension its end product—human bones, also buried to be reborn—demands the insurance of immortality. Old European goddess figures were inscribed with a variety of graphic markings toward this end: Lozenges, the inverted triangles of female power, meanders or snakelike waves in turn protected the egg where life germinated. Seeds or eggs as future bones offer an apt metaphor for all these ancient images being reborn in contemporary art. Fiona Brown in England, for instance, makes fat little goddess figurines of clay that resemble the lumpy Paleolithic goddesses found in Old

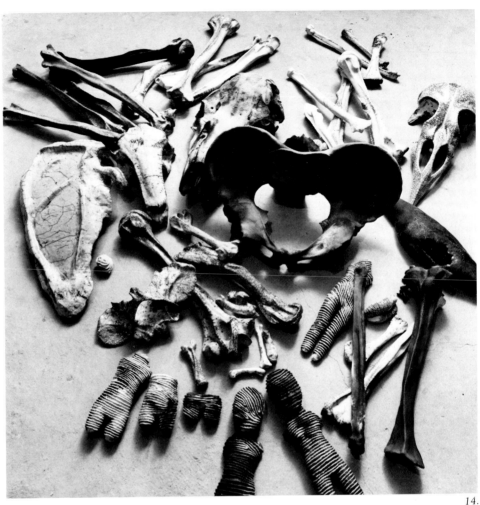

14.

14. *Michele Oka Doner. Burial Pieces. 1974–75. Clay. Various natural sizes. (Photo: Dirk Bakker; collections include Detroit Institute of Arts.)*

15A. *Louise Bourgeois. Torsos. 1969. Marble. Each 8″ high. (Photo: Peter Moore.)*

15B. *Bowl, Mochica culture. Peru. Vaginal orifice is perhaps for watering crops.*

15C. *The White Goddess of Harvest, with sheaf head, from Whalton, Northumberland, England, 1901. (From Michael Dames, The Silbury Treasure.)*

Europe, classified by the anti-matriarchal archeologists as "indeterminate or ambiguous objects."[12]

In Detroit in the late '60s, Michele Oka Doner made a series of "seeded" and striated ceramic dolls. She saw them as "fertility dolls," but they were also interpreted as napalm victims of the Vietnam war. Now, coming full circle, they look to me like the similarly marked Neolithic bird-snake goddesses of Old Europe. The reasons for which these appear to have been made are very close to Doner's. She recalls that the first thing she saw in a college art history course was the *Venus of Willendorf*, which, despite its small scale, was "one of the most powerful images I had ever seen." Her sources, or passions, are natural history, anthropology, and archeology. In the early '70s she began to make pods, bones, seeds, and fossils of clay (some were later cast in bronze). In a major 1974–75 work called *Burial Pieces*, she spread them all out on the floor in an apparently random "vocabulary" of form, later developed into a series of glyphs or "squishes" that she connects to the origins of writing. Combining animal, vegetable, and mineral, Doner's work is pervaded by a sense of the dead (the past), the living (the present), and the germinating (the

15A.

15B.

15C.

future). Her fossils recall the fossilized sea urchins found in prehistoric graves, once interpreted as magical snakes' eggs. She has worked with animal skulls and with the pelvic bone of the tortoise ("because it was a vessel, a cradle of civilization. The Latin word for pelvis is basin. It was a life, it contained life, it contained the seed").

Doner sees her seeds and pods and bones as "a kind of psychological compost heap." Her interest in the ruins of prehistory lies in "more than the art . . . it's how the people lived, what they were like, what remained after they left." Similarly, she erects few boundaries between her art and her life, noting that her work "is just an extension of what I do every day. I cut vegetables for dinner and I notice the structure and I notice the seeds, baking bread is like wedging clay," soup bones suggest the bone sculptures. Yet she also sees her seeds as "karmic seeds . . . seeds of thought" (there is even an etymological relation between *speech* and *semen*). In 1980 Doner spent some time on a dig in Israel, disinterring artifacts that closely resembled her own art, as well as recalling her own ancestral past. She wrote in her journal: "We find the bottom of a pot with a 'belly button' on it. Bob says there are samples of this thumb-print going back to Early Bronze times. . . . I put my thumb in it, discovering the link to an unknown brother or sister."[13]

The micro/macrocosmic concept of *pars pro toto*—the part standing for the whole—is prevalent in the work of several of the artists discussed here. It recalls yet again the "bleeding god," the dismemberment-reconstruction symbol of the seasonal cycles. Sacrifices of self and of deity, and of parts of deity as self and as parts of the whole community, provide a parallel to the modern notion of the "culture hero," of individually "giving oneself to" or "burying oneself in" one's art. Both are images of destruction/creation with which artists tend to associate their esthetic motives. One of the earliest manifestations of the sacrificial ritual was the ubiquitous, cross-cultural custom of burying with the crop objects, blood, flowers, water, female figurines (and probably in the beginning actual bodies and body parts) to act as particularly powerful seeds. Prehistoric fields shaped as symbols and pictures may have had a similar meaning.

For instance, when the Egyptian god Osiris was symbolically killed (his seed scattered), he was thrown into the Nile, or else water was poured over his body so it would sprout. In Devon, a related custom called "crying the neck" survived into the nineteenth century. It involved a circle dance around a sheaf of the finest grain, a strange primitive yell, and a sexual ritual wherein a youth ran with the "neck" to a girl's house and tried to enter before she drenched him with water—a vestige of ancient rain charms. In some areas of Central Europe, the last sheaf of the harvest was dressed as a woman and called the Corn Queen or the Harvest Queen. The figure was either thrown into the river to assure rain for the next crop, or burned and its ashes scattered over the fields. Such customs continue today. On October 14, 1979, the *New York Times* reported that, confronted by the worst drought in 40 years, farmers in India's Uttar Pradesh sent nude women into the fields at night to till the soil, as this was the only way to placate the rain god Varuna.

The burial of precious things to propagate precious things, or for luck, appears to explain the beautifully carved bone hands holding a gridded

15D.

15E.

15D. English corn dolly, "Mother Earth" type. Made by Mrs. G. Henley, Wiltshire. (From Michael Dames, The Silbury Treasure.)

15E. Eunice Golden. "Vegetable Salad" (or the male as cornucopia), still from 16mm film Blue Bananas and Other Meats. 1973.

15F. Meg Harlam, Feeding Series, Female Roles, "Earth Mother." 1973. Performance in Los Angeles. Another part showed woman as devourer of rather than giver of the cornucopia.

15G. "Female" and "male" corn dollies from Avebury. 8" and 10" high. (Photo: Jerry Kearns.)

15H. Jayme Curley. Aunt Ruth Cookie Jar. 1970. This ceramic pot with a nourishing and anthropomorphized landscape on it is a modern counterpart of pots like that from Mochica reproduced above.

object (a calendar or an ear of corn), which have been unearthed in Peru. Stone axes were ritually buried in ancient Britain. The notion of sacrifice, or giving away as part of gaining, is beautifully expressed in this story told by a contemporary Maori craftsman in New Zealand:

When I was nine I made . . . a clay model and it won a competition. . . . I brought it home. . . . And gave it to [my grandfather]. . . . He praised me. Then he got up, went outside and buried it in the garden. . . . I only questioned my mother about it when I was thirty. . . . "Your grandfather was giving back to God what is his." That figure was the first thing I created. . . . The Maori believes that if you are unable to give away the first thing, you will learn nothing.

The European tradition of the "corn dolly" (corn being the generic British word for grains, not maize; and dolly deriving from idol) is poetic and sensuous, rich in elements of joy, menace, and eroticism. The female effigy was variously called Rice Woman, Wheat Bride, Corn Mother, Ivy Girl (though her head is sheaves of grain), Hag, Baba, Witch. She survives in the U.S. in Appalachian cornhusk dolls. In Scotland and elsewhere her form varied according to the age of the crop. If the corn was cut before Halloween, the dolly was called the Maiden; afterwards, it was the Old Woman (and if cut after sunset, it was the Witch). In Malaysia there was a Rice Mother and Rice Child, and in Brittany a Mother Sheaf contained a smaller dolly inside it. There seem to be vestiges of the old Triple Goddess—maiden, bride, and hag—to whom Avebury may be dedicated. In The Golden Bough, Frazer saw them as a reflection of Demeter and Persephone, originally the same generalized force, with the Persephone (seed) of one year becoming the Demeter (grain) of the next. Sometimes the corn dolly combines male and female forces. The Hopi male and female páho are red willow sticks with pollen, honey, and cornhusk bound together by a string and feather (represent-

15F.

15G.

15H.

15I.

15I. *Faith Wilding. Seed Work. Summer 1980. International ritual for Copenhagen. Seeds were sent out to women all over the world from an earlier spring equinox ritual where a wax body filled with vegetation was burned to represent an end to oppression, winter, and "our old selves"; women leaped over the flames; the destroyed body was filled with earth and planted with new seeds.*

ing the breath of life). At Avebury today, one can buy two "abstract" versions of the corn dolly—one an elongated, twisting spiral and the other a familiarly pubic image, the fringed triangle. Like the stone pairs in Kennet Avenue, these can be interpreted as male and female fertility symbols, or as two aspects of the goddess: long barrow and spiral hill, or hag and mother.

In North America, the Mandan and the Minetaree Indians held a spring festival for the Old Woman Who Never Dies, who makes the crops grow. The Iroquois believed the spirits of corn, bean, and squash to be three fond sisters clad in leaves—a divine trinity known as "Our Life" and "Our Supporters." In Mexico in 3000–2000 B.C., pregnant and lactating figurines were buried in planting ceremonies as offerings to Mother Earth, and in Guatemala a First Fruits ritual involved women sitting on the earth in a circle with their legs straight out before them, vying for the first or last sheaf of corn. In Europe the corn spirit was sometimes conceived as the young (green) corn and sometimes as the old (standing) corn. In a ritual associated with the first version it was seen as a child separated from the mother by a stroke of the sickle while participants call out "you have cut the navel string!" The last sheaf of corn was particularly significant, sometimes treasured and sometimes avoided as it could bring with it unwanted fertility, or infertility.

The conjunction between Earth Mother, Corn Mother, and fertility also merges with the consumption of the sacred body or sacrifice. At First Fruits festivals in ancient Europe the new corn was ritually eaten as the body of the corn spirit, sometimes in the form of cakes or a loaf buried under the first plowed furrow; sometimes the loaf itself was in the form of a little girl. In Sweden a dough-man was hung on a fir tree in the harvest wagon. In Rome a loaf called *Mania* was associated with the Mother or Grandmother of the Spirits and hung in effigy on doors as substitutes for human sacrifice on Witch's Eve.

Maryanne Caruthers-Akin works in Portland, Oregon, from the common Indian belief that you ingest the spirit of the food you eat. This was the inspiration for her *Rhythms/Cycles/Periods* (1978) in which she planted radish seeds in an art gallery during an autumn equinox performance. The changes in the growing plants, accompanied by an audiotape of a person breathing rhythmically, constituted the show. It ended with a ritual harvesting and preparation and feast of radish soup. Similarly, her *Bean House III* (1978) grew from a practical gardening device into a meditative space enveloped by leaves. In *Chestnut Walk* (1978)—a plan for a grove-path that would produce food for mind and body, made in homage to the Milk Way—she echoed the Cochiti Pueblo spiral field patterns. From 1976 to 1978, Caruthers-Akin tended her sculptural garden, consisting of 12 earth mounds or raised "beds"—places for sleeping, dreaming, and seeding. In winter they resemble graves; in summer they grow. Altogether they play a dual role as a symbolic art cycle and a nutrition-testing unit for the University of Oregon Medical School.

The conjunction of female body and food is equally traditional. The Kwakiutls in northwestern America made huge wooden dishes for potlatch feasts in the shape of a legendary woman who opened her body to serve vast quantities of food. (This sounds positive enough, but she was also a *Tsonaqwa,* from a mythical race of cannibalistic giants, and the females of the species were used to scare children into good behavior.) In a Navaho puberty ritual, the girl grinds corn, makes a batter of it, and then lies on the earth to inherit its fertility. In Europe women or couples, or even the priest, once rolled around in the first furrows.

Death was always a tangible part of the life-giving harvest celebrations which marked the end of one fertile year and the beginning of germination. The menacing side of the corn dolly is reflected in other customs listed in *The Golden Bough.* In Europe strangers happening by a harvest might be bound into a sheaf, beaten, and even killed. In Mexico lepers were sacrificed to the Goddess of the White Maize (part of a complex symbolic chain of images of whiteness, moon, leprosy, Demeter, and the pig or sow). In West Africa a young girl was impaled alive to ensure crops after the spring equinox. In East Africa a girl who had reached puberty was crushed to death between two branches on a harvest hill, recalling the firesticks, and the millstones. Among the Berbers, mock rapes and weddings of a straw female figure are part of the agricultural cycle. Corn dollies were usually female, but sometimes an Oatsman and an Oatswoman were swathed in straw and danced together at the harvest. At times the tradition merges with that of the year god or John Barleycorn. The Old Man of the Harvest was killed and his young counterparts— Wild Man or Leaf Man—were sacrificed in the spring, or Jack in the Green was symbolically drowned.

In all such rites, the sun and rain and astronomical alignment and timing also played important parts. As far apart as Peru and Borneo the constellation of the Pleiades (Seven Sisters) was associated with seeds. For Pueblo Indians the ear of corn was a symbolic composite of these beliefs. It represented earth and sky and body; the ear was female and its juice was a nourishing milk for people and animals; the tassels were male; the corn grows upwards in a spiral ending in four kernels that

16A, B, C, D. Maryanne Caruthers-Akin. Four phases of 12 Mounds S. ½ lot 8 and 9, Block 75, Irvington. *March to November 1977 (complete work, spring 1976–spring 1978). Portland, Oregon. Earth, water, air, sun, earthworms, seeds, compost; 75' × 30'. The mounds were seeded with common vegetables of varying growth cycles, metaphorically mixing mounds for gardening and mounds for burial. Changes were documented every week for two years and became part of* Rhythms/Cycles/ Periods *(1978). "People will wonder how a garden can be art," the artist writes, but to me art is not so much product as it is process. Art is 'growing' from the known to the unknown. Art is taking responsibility for energy in an appropriate form." (Photos: Maryanne Caruthers-Akin.)*

16A. 16B.

16C. 16D.

represent the four directions. Similarly, the straw-woven Bride's Cross of Ireland represents the four directions and the four seasons.

All over the world the natural cone-shaped hill and mountain and its human-made imitations are seen as mediators between earth and sky, entrances to the underworld, sites of visionary aspiration. They are frequently associated with sun and moon worship, with fertility, the snake, and water. The ziggurats of ancient Egypt, Babylonia and Mesopotamia were in fact artificial hills with terraced gardens that added the sacred grove element. Seen as the first parks, they were built later than Silbury Hill at Avebury (Queen Hatshepsut's ramped garden at Deir-el-Bahari was built c. 1540 B.C., and ziggurats go back to c. 2350 B.C.). As yet unexcavated, La Venta, in Mexico, is perhaps the earliest "pyramid" in Mesoamerica; it is a ten-tiered, "fluted, flat-topped cone" like Silbury. Arthur G. Miller suggests that it was an imitation of a volcano, like those in the nearby Tuxtla mountains, and that, like the later Mayan and Olmec pyramids, it was "a functional counterpart to the sacred mountains of the highlands. In other words, man-made mountains stood for natural ones in an environment devoid of them. If this is true we may have at La Venta an early example of remaking the landscape for ritual purposes."[15] (An amusing counterpart is the little mound in City Park in New Orleans, built to show the children of flat, southern Louisiana what a hill looks like.)

Such connections between human-made and natural formations suggest ways to interpret the innumerable flat-topped, conical "Indian mounds" found in the South and West, but particularly in the Mississippi Valley, into Ohio and bordering states (see p. 23). The apparently random arrangement and shapes of the Hopewellian Mound City in Ohio suggest that it might have been a microcosm of the surrounding hilly landscape. Burials, handsome copper ornaments, pipes, and an amazing mica-lined "mirror chamber" have been found there. In nearby Newark, Ohio, the mounds and enclosures are huge geometric forms, including an octagon. But both sites are minute compared to what was once perhaps the largest city north of Mexico—Cahokia, in Illinois, built around 700–800 A.D. Now mostly destroyed by developers' greed, at its peak, around 1200, it incorporated 100 large mounds and a population that has been estimated up to 30,000. It had large wooden "sun circles," suggesting astronomical use, and huge "platform mounds," the largest of which—Monk's Mound—has been called the "American Woodhenge." Archeologists speculate that the 100-foot-high mound, covering 14 acres, was built over two centuries by women carrying baskets of earth weighing up to 50 pounds.[16] A module similar to Thom's megalithic yard has been found both at Cahokia and at Teotihuacán in Mexico. Little is known about the use of the mounds, though ceremonial games may have been played on them. The art shows that wind, sun, and fire were important elements of the fertility cults and that a hierarchal society passed chieftainship through the female line.[17]

For me, the most affective monument in the Avebury complex is Silbury Hill (see plate 13). According to Dames, it was the site of the First Fruits festival at the beginning of August, when its foundations were laid

17.

around 2660 B.C. Rising from earth toward the sky, it may have commemorated that transitional moment in the androgynous birth/death cycle when the son rises from horizontal subterranean germination to vertical growth above ground. A flat-topped cone 130 feet high, it took millions of human hours to build; some 35 million basketloads of chalk were moved, and generations were committed to its completion. Silbury has been the object of great curiosity for centuries. Originally it was thought to be the culmination of Bronze Age barrow building, until corrected radiocarbon dating proved it to be Neolithic. A patriarchal fondness for the notion that it was the grave of a Great Hero—a fictitious King Sil—has died hard over the years. In search of tomb and treasure, excavations were made in 1776; again in 1849; again in 1922; the final anticlimax took place in 1967 when the BBC sponsored and filmed the excavation to end all excavations, anticipating discovery of the treasure right on the little silver screen. Headed by Professor Richard Atkinson, in collaboration with a bevy of respected geographers, geologists, zoologists, miners, environmentalists, and the Nature Conservancy Board, this too failed to turn up any sepulchral or fiscal remains.

What the BBC did find, confirming earlier archeological work by John Merewether, was a carefully constructed, round, seven-tiered pyramid of chalk blocks; the walls were circular and centered on radiating spokes like "a gigantic three-dimensional Spider's web."[18] At the very base was a 65-foot-diameter circular core, directly below the flat summit; there a two-dimensional "web" of radiating woven grass strands had been laid out. Around it was a wicker fence; over it a mound of clay with flints, fragments of hazel, moss, turf, bushes (still green when excavated), covered with four conical layers of chalk, gravel, and soil, like a microcosm of the hill's final form. Then came sarsens, chalk, and the earth covering. Among the artifacts found in Silbury were snail shells, stone spheres, an antler tine, deer or ox ribs, and mistletoe, which Burl suggests formed altogether "a 'spirit' representation of the fecund world desired . . . a gathering together of fertile earth, vegetation, edible animals, flint and stone, a concentration of richness sealed under the great mound close to

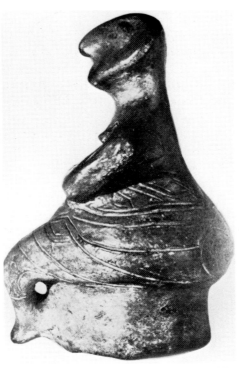
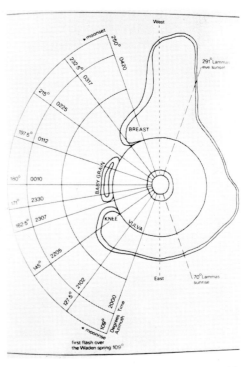

18A. 18B. 18C.

18A. Aerial view of Silbury Hill, printed upside down, showing shape of vanished moat. (Photo: Aerofilms Ltd.)

18B. The Lady of Pazardžik, Central Bulgaria. East Balkan civilization, c. 4000 B.C. (Collection: Naturhistorisches Museum, Vienna.)

18C. Michael Dames, "Diagram of Lammas Eve sunset and moonrise over Silbury Hill."

life-giving water."[19] (A similar conglomeration was found at the cove within the Avebury Henge.)

Silbury is surrounded by a quarried moat. On its "front" is an oval causeway that has baffled archeologists. Dames has ingeniously explained this very specific form by comparing the aerial view with Old European sculptures of squatting goddesses, such as Our Lady of Pazardžik (c.4000 B.C., found in Bulgaria). The outline is identical.

Significant to Dames' argument that Silbury was built as a figure of the pregnant vegetation goddess in labor, giving birth to the first or infant grain in early August, are the following factors: The hill was begun in early August (evidenced by insects found in the core); Lammas (a Celtic First Fruits festival dedicated to Lugh, the sun god) also falls in the first week of August; it is connected in turn to a rich body of lore about corn dollies and cone-shaped and spiral "harvest hills."[20] The spoked web found in Silbury's core also recalls the "sunwheels" carved in rocks all over Britain, along with the enigmatic "cup-and-ring" marks, associated in turn with labyrinths and spirals. To go further afield, I can't help wondering about connections to the mysterious geometric "garden beds" visible from the air in Wisconsin and Michigan, built perhaps around 500 and abandoned by 1500 A.D.; one of them is a 16-spoked wheel, another is a maze, another is a checkerboard recalling ancient calendar figures.

They seem to supersede the effigy mounds of the area but may have coexisted with them in some areas.[21]

The spoked wheel has also been associated with the stars and the moon, and with the various star-shaped white flowers, like wild parsley, that grow near water and are attributed healing powers for ills of the eye. (Other monuments, such as the Rollright Stones near Oxford, have been associated with white blossoms, with water, milk and fertility, and with midsummer festivals.) Silbury's spring, as well as the two rivers and various wells in the environs, suggests that its name may relate to the Greek moon goddess Selene, who governed all water, including the moistures of the human body. Burl says the name *Silbury* may mean "mound where willows grow"; willows too were sacred to the Great Goddess. Dames' far denser version traces Silbury's earliest written form—*Seleburgh* (*burgh* meaning mound)—to the obsolete word *Sele* (derived from the Old Norse, meaning happiness, prosperity, favorable time), connected with barley and the start of the harvest. *Seleburgh* would have meant a working harvest hill. The autumn quarter is indeed still known as the "Silly Season," and "silly" is also applied to women and witches, who were said to assemble on Lammas.

Within a few miles of Silbury were two other huge, roughly contemporary, human-made, nonburial hills, both of which yielded caches of red deer antlers. The Giant of Marden was destroyed by 1818. The Marlborough Mound, at a bend in the Kennet River and reputed to have a spring beneath it, was converted in the eighteenth century into a terraced garden walk with a summerhouse on top; now it looks like an overgrown natural hill, supporting, perhaps appropriately, a water tank. Whether these were "hill altars," charnel houses, or "harvest hills" associated with corn mothers and daughters remains to be seen. An old British nursery rhyme says, "There was an old woman/lived under the hill/and if she's not gone/she lives there still." The Irish *banshee*—the wailer, mourner and Celtic priestess of the dead—meant "woman of the hill." Also in Ireland, at the beginning of August, celebrants climbing a conical hill would signal the end of summer by wearing a flower and then burying it in a special hole. (The tradition of burying flowers as an image of resurrection is as old as the Neanderthals.[22])

Dames' speculations on Silbury culminate in his view of the hill as "a topographic deity giving birth" in an astronomically aligned light-and-shadow nativity ritual he has devised or intuited for Silbury's birth night at the rare times when the full moon coincides with the solar quarter.[23] In brief, he suggests that the moon rose over the silhouetted Sanctuary in the distance and touched first Silbury's vulva and then the "seed" (the unexplained protrusion at the "belly" formed by the causeway). This is when the child is born, and perhaps the first green corn was cut then. Subsequently, the moonlight would have hit the "breast," delineated by the moat, and "turned it to milk," thus providing the communal "child" with nourishment and assuring another year of generation. This beautiful conceit—indirectly supported by the surviving local legend that Silbury was "raised while a posset of milke was seething"—is Dames' answer to Meno's dilemma: How do you describe something unknown by its relation to what is known already?

19. *Nerthus (Earth Mother), found in Danish swamp. Iron Age. Birchwood. The four grooves carved horizontally across the goddess' belly have been called "furrows," recalling the Roman custom of youths whipping maidens at sowing time. Dames says she was carried annually from her sacred grove to the surrounding fields. However, this is in fact an abstract phallic post, which makes one wonder if "she" is not hermaphroditic. Similarly what Burl calls a "bisexual god-dolly," found upside down in the mud in Somerset, could easily be interpreted as female, perhaps a spread-legged birthing goddess, since its "phallus" is round and resembles an emergent head. (Photo: Buus Jensen, courtesy Danish National Museum, Copenhagen.)*

20A. *Sheela-na-gig. Corbel on Church of St. Mary and St. David, Kilpeck, Herefordshire, England.*

20B. *"Erotic knob" attached to shard of black Romano-British pottery found in Dorchester, England. Female figure, perhaps giving birth, with face formed of male genitals. (Photo: Colin Graham, Dorset County Museum, Dorchester.)*

In a church two miles from Silbury there is a rather graphic representation of a nude vegetation goddess giving birth to a plant. It connects Dames' theories about the hill's composite image of head, womb, eye, and vulva with the curious tradition of the *sheela-na-gig*—an "obscene," goggle-eyed,[24] big-headed naked female grinning lewdly as she holds open her voluminous cunt. Called "Celtic survivals," these figures are carved on some 100 Saxon and Norman churches in the British Isles. (If they are Celtic, the paucity of examples in Scotland and Wales needs explaining.) The *sheelas* were called "idols" or "whores" in Britain, which has led Brian Branston to surmise that a Great Goddess cult survived through the Middle Ages and into the present.[25] He relates the figure to the Cretan Goddess of Animals because an eleventh-century *sheela* at Whittlesford Church is flanked by a figure with a man's body, animal's head, and erect penis. The name is supposed to come from Celia or Julia of the Breasts (which seems odd, since the figures' breasts are usually absent or deemphasized, though it does make the connection with the breastlike hills of the fertility goddess). He cites an account of brides being forced to look at the *sheela* on the way to their weddings.

Such "grotesquely exaggerated" images of female sexuality are still greeted by fastidious scholars as the "crude" and "repellent" side of fertility rituals. A similarly critical response greeted the introduction of biological female imagery in contemporary art. When Hannah Wilke began to show her little red clay "cunts" in the mid-'60s, they came as a shock to all of us who were accustomed to graphically phallic sculptures, but not to their counterparts. With the rise of the new feminism, "vaginal imagery" became popularly associated with Judy Chicago, Faith Wilding, Miriam Schapiro, and other artists on both American coasts, but it was in fact ubiquitous among women artists—feminist and nonfeminist, consciously and unconsciously. The frequent emphasis on pain rather than fertility and the reception of naturalist female content with embarrassment rather than celebration are of course modern. Given the vast number of prehistoric figures like the *sheela-na-gigs* (such as pre-Columbian vessels through whose orifices the crops were symbolically watered), it is clear that such prudery was nonexistent then, though today these objects tend to be hidden away in the "private parts" of museums, unfit for innocent modern eyes. The male version, such as the Nazca watering pots with penis spouts (often exaggerated, often born by skeletons), is somewhat more acceptable.

Rodney Legg, in an essay on the Celtic cult of the head, decries the "prudery" with which such images are treated by scholars, and at the same time describes a bisexual birthing figure as having "an horrific beauty" (see p. 219).[26] This mixed response is perhaps appropriate to these androgynous figures, found in every culture and usually associated with fertility rituals and the transcendent unity of opposites. Often, however, they seem to be confused with the *sheela* type of "exaggerated" sexual female.

Sheela-na-gigs are sometimes double-sexed, with emphasis on the head—which becomes a phallic pun, with lowered eyes as testicles and raised noses as penises. One of these in Romano-British black pottery was found in Dorchester. With its neatly triangular vulva and unmistakably

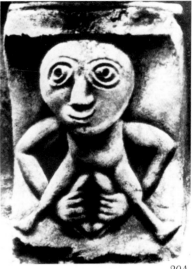

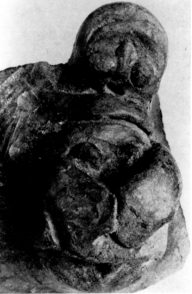

19.

20A.

20B.

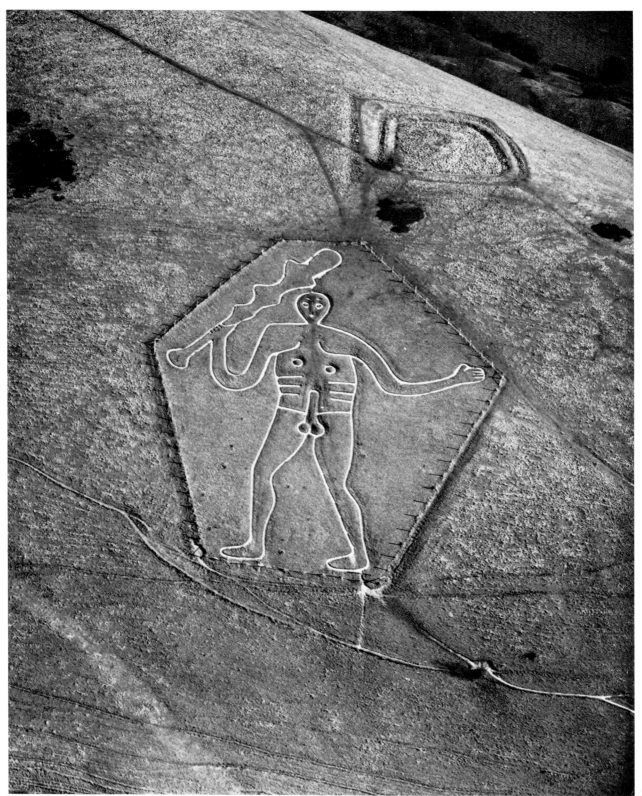

21.

21. *Cerne Giant, Cerne Abbas, Dorset, England. 1st or 2nd century* A.D. *Figure, 180' high; club, 120' high; phallus, 30' high; cut into chalk hillside with a trench c. 2' × 2'. Thought to be the god Helith, or possibly Hercules. The small, banked enclosure at the upper right may be an Iron Age tomb and was long the site of May Day celebrations.*

22. *Mattachine Dance. Taos Pueblo. December 1974. (Photo: Charles Simonds.)*

23. *Fay Jones.* Veiled Cow. *1974. Acrylic. 18" × 24".*

phallic head, it provides an apt bridge between Silbury Hill and her male counterpart—or perhaps her grandson—the Cerne Giant, a 180-foot-long chalk-cut Hill Figure in Dorset. The Giant, proudly displaying his sexual prowess, has been maintained by ritual seven-yearly scourings on a lunar schedule over 66 generations, amazingly surviving Puritan backlash and Victorian prudery. There is some proof that the White Horse of Uffington—the oldest British Hill Figure—was once ridden by a phallus, long since erased. No *sheela* Hill Figures have survived, although some 20 years ago, John Lethbridge unearthed a goddess in a chariot, which has since been allowed to grow over, due to lack of scholarly support.[27] Many more chalk-cut figures may be lurking under the turf, waiting to be discovered, like dormant seeds of history.

The Cerne Giant's festival is the agricultural May Day, the time of spring sowing (and the pastoral Celtic Beltane, when the herds returned to the hills). For centuries, the first of May, celebrated with the traditional Maypole, remained the most overtly sexual of vestigial ancient ceremonies. A siteline taken up the Giant's penis on May Day points directly to the sun rising over the crest of the hill, and toward the Maypole that once stood in a rectangular enclosure above, where the revelers greeted the day after a wild night.

The Maypole in its broadest interpretation is the spindle axis on which the earth spins, the pole or measuring rod of time, as in the gnomon; it is the house post, supporter of the sky, connector of sky and earth, conjunction of pole and snake, pole and male (both sexual and sacrificial, as in the Crucifixion). Ceremonies involving the "sacred marriage" often included the "May tree," as in the relief from Maltegard, Denmark (c. 2000 B.C.), where a man and a woman reach for each other within a braided ring; behind her is the tree and between them is the earth-hole.

22.

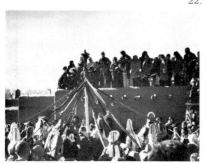

Maypoles are still used by Pueblo Indians in the secular Mattachine Dance. It is influenced by a Spanish-Mexican import, but Plains Indians had Maypoles too, as did the English. A 134-foot Maypole was erected in London during the Restoration and remained in place 50 years. Also in Britain, milkmaids once danced around garlanded cows on May Day and a heavy dew that day predicted a good milk yield. In the Middle Ages, Maypoles were painted, and decorated with flowers and herbs. The two traditions came together in Colonial America, according to a 1628 account from Merry Mount (later Quincy), Massachusetts. It described an 80-foot pine tree mounted by a pair of buck's horns, around which there was "drinking and dancing for many days together." The "Puritans" invited the Indian maidens as their "consorts, dancing and frisking together like so many fairies or furies rather."[28]

23.

Legend also had it that the huge, now-toppled Obelisk Stone in the south circle of the Avebury Henge once served as a Maypole. When it fell, other posts were annually erected. Burl, noticing the male bodies buried at the feet of the diamond-shaped "female stones" in Kennet Avenue, imagined "excited participants at the spring festival moving between these evocative stones towards the great rings of Avebury, passing the sarsens where the bodies lay buried, three of them."[29] He also notes the presence of the ("generally believed" to be female) symbol of deer antlers and the connection with ritual spring seed sowing, because the stags

were shedding their antlers in nearby woods at just that time of year. Dames goes further and suggests that the three-sided "cove" in the south circle (a similar cove is found near the wedding-associated circles at Stanton Drew) was "horned," assuming that both side stones were taller. Burl sees coves as originating in the cave or dolmen, and fulfilling a funerary function—not necessarily a contradictory interpretation (see also Chapter II).[30]

The horned serpent brings together male and female forces, and like the snake alone, is constantly associated with "wedding" motifs. For the Hopi, the snake is the female symbol of Mother Earth, from which all life is born; its horns are those of the antelope, representing the highest spirit. In the Near East, the water/earth/cool/snake image was crowned by the horns and beard of the ram, representing fire, the sky and the head. (The Neolithic Age was the Age of Aries, the ram, which is my own sign.) The androgynous snake is Oceanus as well as the rainbow; put together, the two halves form a world-encircling uroboros of sky and earth—a "snake disc" which Native Americans believe makes the world roll. Coiled, the snake is a spiral. In motion, it is a meander. The spiral is both sun and water symbol—"burning water." Coiled, the snake evokes destructive forces in nature (whirlpool, tornado) and uncoiled, it evokes creation (the umbilical cord, healing waves).

The snake on the egg, or spiral on mound, is the ultimate fertility symbol (see also Chapter II). Creation myths involving egg, snake, and water go back to Paleolithic times. The egg, like the snake, is a spiritual/sexual pun—both cave and seed, as the snake is both womb and phallus. The African Dogon snake disgorges its twin in a pattern of stones as seeds, representing rain. In the South African Bavenda tribe, during ceremonial days after the rains, a line of virgins rhythmically collapse and revive in a spiral to evoke the movements of the python serpent force and the seasonal cycles; the old women initiating the virgins sit at the center as pivot. In Australia, Aborigines draw a relief of the Rainbow Serpent with coiled tail in the dust.

In Ohio, the 1350-foot-long Serpent Mound has a three-coiled spiral tail, three prominent loops in its seven curves, and apparently an egg in its triangular head/mouth. No artifacts have been found in the layered clay Serpent Mound itself, but a conical burial mound 400 feet to the south seems to have been made by the Adena (c. 1000 B.C.–700 A.D.). Other, later Indians in the area believed that their ancestors received the gift of copper from the horns of a serpent in Lake Superior. (Perhaps snakelike veins of ore appeared to be growing in the earth.) Later the Lakotas considered the horned serpents living in rivers and lakes to be evil except for the fact that they brought rain. The Ohio Serpent Mound is built on a curving bluff that in itself resembles a serpent, suggesting that this was yet another instance of a meaningful land form eventually being refined by sculptural or architectural techniques. There are other animal effigy mounds in the Midwest—bears, a turtle, a 1,200-foot eagle—and another serpent mound on Rice Lake in Otonabee, Canada. It too has three convolutions and an oval mound just beyond the head, but its tail is not spiraled. A third serpent effigy, on Loch Nell in Argyllshire, Scotland, is 300 feet long and nearly 20 feet high; the head is a circular cairn with

24.

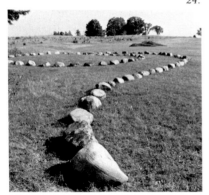

25.

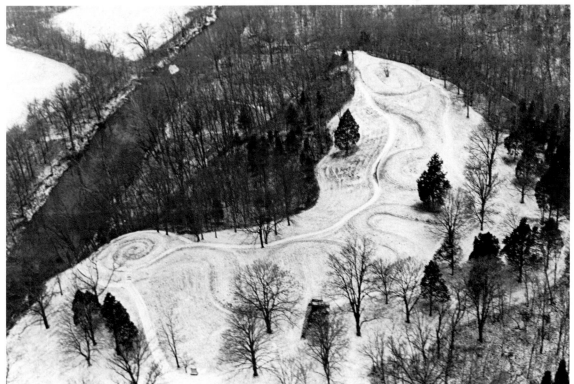

26.

27A.

27B.

27C.

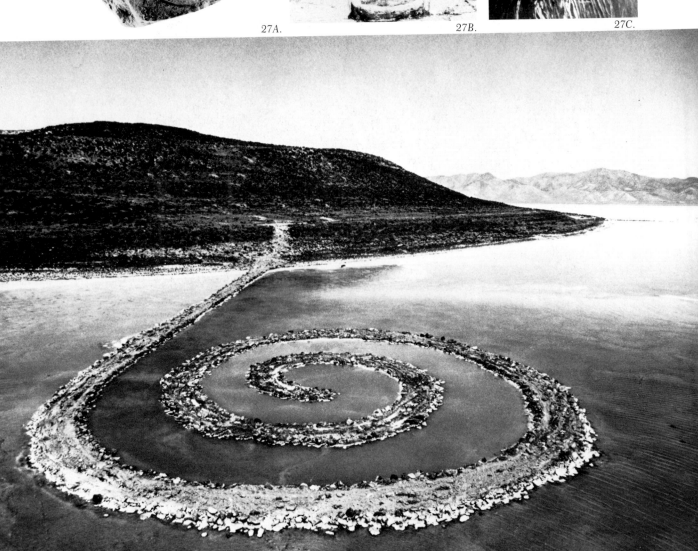

28.

an interior chamber, and early accounts mention a line of symmetrically placed stones along its crest.[31]

The creative, or clockwise, spiral has been a universal symbol of growth. The Maoris believed that their spiral tattoos disappeared at death, taken away by spirits because they were so integrally entwined with the life force. As Paul Leveson has observed, "the circle embodies the excitement of motion with the security of going nowhere, while the spiral is an unfinished form."[32] Robert Smithson's favorite form was the spiral, and he loved and collected snakes as a child, seeing himself as "reptilian, cold, earthbound."[33] His *Amarillo Ramp* (1973) in Texas is an incomplete uroboros, raised at its wide "head" in an irrigation lake. Smithson's best-known work is *Spiral Jetty* (1970) in the Great Salt Lake in Utah, which has become emblematic of all earthworks. Submerged in water for several years now, it resembles all the more the primeval serpent. (In fact, local legends claim that the lake is connected to the ocean by a whirlpool.)

Made of earth, black basalt, and limestone, *Spiral Jetty* extends 1,500 feet into the lake from a barren shore cluttered with the detritus of abandoned oil drilling. The surrounding water is blood red with algae. In a film about *Spiral Jetty*, Smithson wove together geological time, history, entropy, cataclysm, dinosaurs, the primal ooze—all his personal obsessions. He recounted the way the form came to him when he visited the site:

It reverberated out to the horizons only to suggest an immobile cyclone while flickering light made the entire landscape appear to quake. A dormant earthquake spread into the fluttering stillness, into a spinning sensation without movement. This site was a rotary that enclosed itself in an immense roundness. From that gyrating space emerged the possibility of the Spiral Jetty.[34]

At the end of the film the artist is seen running the spiral to its end/center in what might have been a conscious reiteration of innumerable initiation rites.

It is no accident that Eve "fell" with a herpetological accomplice. With Christianity, both the goddess and the snake were banished to underworld burial and condemned to wholly negative symbolism. Carl Sagan says there are three inborn fears in humans and primates—of falling, of snakes, and of the dark.[35] Significantly, all three are associated with the mythical matriarch. The snakes banished by Saint Patrick from Ireland were no doubt the remains of Celtic matriarchal cults. Saint Michael and Saint George vanquished their share of dragons on prehistoric mounts and tumuli, where Christian churches were erected to commemorate their triumphs. (For instance, Mont Saint Michel in Normandy, Saint Michel in Carnac, and Saint Michael's Mount in Cornwall.)

Francis Huxley interprets the serpent in the garden as a positive "figure for collective man," whose function in Genesis is to "transform the act of creation into one of generation."[36] If the garden is a symbol of nature "under control," the snake could represent the "revolutionary" forces of instinct and motion. Eve/Mary, too, was "contrary" enough to let her garden *grow*.

Artist Glenn Lewis sees the Fall as emblematic of that point where

29.

30.

31.

humanity was condemned to be never again "naked in nature."[37] Expulsion from this "happy hunting ground" is also said to have condemned humanity to agriculture, and consequently to labor, which Karl Marx defined as the pivot between humanity and nature: "By the sweat of thy brow shalt thou eat thy bread." Paul Shepard has observed that "agriculture dealt the male ego a blow so terrible that his vengeance may yet destroy most of nature"[38] Woman's biblical punishment was total subjection to man and the pain of childbirth, but historically it also implied the male's assumption of all her other creative powers. Barren land was seen as communal punishment, and barren women were thought to affect the land's fertility. Like nature, woman was doomed to be mistress and muse, but not independent maker of anything, art included.

Loss of the garden as nature dominated and domesticated represented, to Francis Bacon, man's loss of sovereignty over the animals (including women, no doubt) and "dominion over creation." Science was rationalized in the seventeenth century as an attempt not to take over God's own dominion, but to restore the biblical promise that Man is the Lord of the Earth.[39] Monotheism rejected not only nature itself, but its multiplicity, just as the linearity of Christianity rejected the repetitive circles of paganism. "By destroying pagan animism, Christianity made it possible to exploit nature in a mood of indifference to the feelings of natural objects," wrote William Leiss. He has detailed how the process of "despiritualization of nature," in which external domination overwhelms internal needs, was reflected in the process of the Industrial Revolution, when the working day was lengthened and child and female labor were more intensely exploited. Labor was then secularized into work as "the last vestiges of its sacred attachments disappeared"; the festivals and holidays connected with agricultural life were drastically reduced.

Gardens as romantic and/or cosmological abstractions provide insulation from the real world of nature. At the same time, the snake that "reared its ugly head" in the garden was not just guilt but sex. In pagan times, the snake, as a symbol of growth, belonged in gardens and was a good omen. The traditional maze in the garden provided a place to "get lost." Like the worm in the apple, it was the core of disorder within the order of civilization. This was in fact probably its function in churches, and in the gardens of utopian communities. The garden is the domain of women, from the ancient Greeks who worshiped Adonis by bringing him "little 'gardens' symbolizing their own private parts, their femininity,"[40] to Eve, to witches with their healing herbs, to the Virgin and her unicorn, to contrary Mistress Mary, to the suburban housewife with "nothing better to do" than cultivate her garden.

Paul Shepard has traced the history of the garden from imitations of sacred groves and mountains to erotic enclaves to images illustrating medieval moral texts and "sanctuaries from the evil world" where Christian monks lived "peculiarly dichotomous lives" (in seminaries where they couldn't sow their seeds). He shows how the garden came to be seen as territory between maternal home and threatening world, the formalization and domestication of nature's sinful seductions and of her fearsome aura. In much of this history, gardens are double-pronged allegories overlaying Christian rhetoric on pagan beliefs. In Sanskrit, the word *para-*

desa meant the other world, or death, and Persian gardens, called Paradises, were fundamentally erotic enclosures. The Old Saxon word for paradise was *meadow*—a clearing in the wood (also a "ley"), a place of light, sanctuary from the dark, beast-infested forests that still covered England.[41]

When Canadian artist Glenn Lewis began in the mid-1970s to work on an ambitious installation/exhibition called *Bewilderness, the Origins of Paradise,* he was attracted to Joseph Campbell's definition of myths as "public dreams." His piece grew out of his interest in the connections between working people's little frontyard gardens and Paradise. As he began to collect images and data, he found his efforts "were a 'literal' entrance to myth, that organizing my work around a myth gave a public frame of reference beyond my individual artistic interest." The final installation included a book of stories, quotations, an essay, and photographs of parks, fields, paths, and gardens all over the world. The photos, by Lewis and Taki Bluesinger, were often almost featureless, offering a place to wander, a provocative counterpoint to the meaning-laden texts. The installation was arranged as a journey from birth to death, from Paradise through the "Gateway," along paths, through fields, down waterways, to the "Metaphorest" and eventually to "Hollowland"—the grotto and cave inside the mount. In the process, wrote Lewis, "the garden revealed itself as a kind of language to assist man's comprehension of his origins, his life and death."[42]

Robert Smithson focused on the "duplicity" of gardens. "The sinister in a primitive sense seems to have its origin in what could be called 'quality gardens' (Paradise)," he mused. "Dreadful things seem to have happened in those half-forgotten Edens. Why does the Garden of Delight suggest something perverse? . . . Too much thinking about 'gardens' leads to perplexity and agitation. Gardens . . . bring me to the brink of chaos. This footnote is turning into a dizzying maze, full of tenuous paths and innumerable riddles. The abysmal problems of gardens somehow involved a fall from somewhere or something. The certainty of the absolute garden will never be regained." He sardonically called the idealized "vista" and "beautiful scenery," "Nature with class."[43]

The garden was, indeed, the first bit of nature to be "owned." Like woman, it became property. Many socialist writers have equated the evolution of the domination of nature with that of oppression of the underclasses. William Leiss points out that as increased mastery of nature provides increased productivity, there is a qualitative leap in social conflict. "Mastery of nature without apparent limit becomes the servant of insatiable demands made upon the resources of the natural environment."[44]

In the eighteenth century, the "English Garden" "leapt the fence," as Horace Walpole put it, and all of nature was perceived as a garden. The task of domination had been accomplished and, like the African antelopes running "free" in the Bronx Zoo, nature could now have her "freedom." (Not fortuitously, that eighteenth-century "leap" or "escape" coincided with the beginning of the struggle for women's rights and with the Chartist movement in England.) Shepard sees the English Garden as a rebellion against the upper-class taste for opulent formalism that was the

29. Ann Mills. Leaf Room. *1973. From* Womanhouse, *a project of the Feminist Art Program, California Institute of the Arts. (Photo: courtesy Judy Chicago.)*

30. Nancy Stout. Sunflower Pantheon. *1977. Photo documentation of a growing "history of architecture."*

31. Adam Purple. The Garden of Eden. *1975– . Eldridge Street, New York City. This beautiful structure of concentric rings filled with flowers is in the heart of a devastated Lower East Side community where it provides a symbol of hope—now threatened by development. (Photo: Lucy R. Lippard.)*

antithesis of democratic ideals.[45] It didn't last long. With the Industrial Revolution, all land became potentially exploitable, and the alienation from nature began in earnest. Economically necessitated moves away from the countryside also cut ties between family, place, and individual. Today few of us even have a "home town." Annette Kolodny has traced through literature a parallel development in Colonial America, where land was seen first as a virgin, then as a mother, and then as a mistress, who was finally just plain raped for profit.[46]

Shepard shows how the notion of land as mother was eventually replaced by the cow, also paralleling woman's loss of status when industrialization replaced her functions as grower and maker of all domestic necessities. The Native Americans' protestations that the land/mother could not be owned, bought or sold, led to their culture's downfall, as well as to the loss of their land. Similarly, they perceive all objects as art because of their organic and useful relationship to the rest of life. The sacred societies "view the unnecessary proliferation of artifacts, utensils and goods as a form of blasphemy, provoking a loss of meaning"[47]—an all too perfect description of our consumer society.

Francis Huxley shows how the use of standing stones as property markers indicated the process by which "ritual thought gave birth to the principle of land tenure."[48] With increased urbanization, even the garden became a luxury accessible only to the upper classes. A late nineteenth-century English gardening book declaimed haughtily that only among "the classes for whom this work is intended" was there an appreciation for "what is tasteful and elegant in gardening."[49]

In recognition of this phenomenon, the "park" was offered as a democratic use of nature, as a public amenity—often rather patronizingly. Nevertheless, the park in the city *is* a potent metaphor for a public art, an overlay of cyclical stability on growth and variety, with memory (nostalgia, some would say) as compost. Like the garden, it has a double meaning (especially in present-day New York City) in its aura of safety and danger, privacy and controlled freedom. Just as a city is overlaid on nature as an escape from its whims, a park or garden in the city reasserts the earth beneath the concrete and serves to remind city dwellers that all the world's not a city. The park is probably the most effective public art form there is, as an interface between nature and society. Thus Charles Eliot Norton could say of Frederick Law Olmsted, designer of Central Park and Prospect Park, that he stood "first in the production of great works which answer the needs and give expression to the life of our immense and miscellaneous democracy."[50]

In 1928 Walter Benjamin recommended the "mastery not of nature itself but of the relationship between nature and humanity."[51] Ian McHarg has imagined an ideal society called "The Naturalists," who make no division between the natural and the social sciences.[52] Rather than dominating nature, they are dominated by a quest to *understand* nature—by definition including humankind. In a sense this returns to the notion of natural order as a social model proposed by early socialists, from Saint-Simon to Feuerbach. Even Marx and Engels briefly flirted with theories based on Francis Morgan's data on the matriarchal structures of the Iroquois.

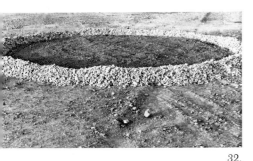

32.

32. *Alan Sonfist*. Pool of Virgin Earth. *1975. On chemical waste dump, Artpark, Lewiston, New York*.

The way in which the modern world perceives nature as a neutral material, whose use is "value-free," parallels the rejection of content in the modernist notion of "art for art's sake," where only the material nature of the medium is significant. McHarg's Naturalists, on the other hand, understand meaningful form, but they prefer the term "fitness" to "art" because it embraces natural as well as artificial creativity.

Art is, or should be, like seeding, and this is the central theme of several artists working as contemporary gardeners. Dames says the Neolithic peoples made "farm art." In 1970 Carl Andre wrote an ironic statement opposing the Vietnam war called "Art is a Branch of Agriculture," in which, among other things, he noted that artists must be "fighting farmers and farming fighters."[53] At the same time, Alan Sonfist had been literally developing the notion of art as a means of propagation with his international *Seed Distribution* project and a subsequent work at Artpark in which, sensing the location of a past forest, he made a circular pool of virgin soil to catch blowing seeds and begin the forest's rebirth. Poppy Johnson's *Earth Day* piece, planted in a vacant lot near her New York loft in 1969 and celebrated in 1970, resulted in an art harvest of 24 marigolds, 8 sunflowers, 2 rows of dill, 3 ears of corn, 18 cosmos, 3 Iceland poppies, 22 zinnias, 12 cornflowers, and 19 summer squash. Also in 1969, Hans Haacke, whose work was concerned with natural and social systems, made an indoor museum piece by seeding a cone-shaped mound of soil with quick-growing winter rye, which was sprouting by the time the show opened. He wasn't interested in the history or the sculptural shape but in "growth as a phenomenon, with the interaction of forces and energies and information." His catalogue statement was initially going to be "Grass Grows."[54]

Smithson quipped that art degenerates as it approaches gardening. When Haacke was asked how his mound differed from gardening he replied, by *intent*. I, for one, quite enjoy the notion that it did *not* differ from gardening. In a system like ours, where art is separated from life, and art is simply supposed to be about art, only the separation validates the making of art. If there is no separation, what have we lost? Or gained? Lawrence Alloway has pointed out that "the notion of interdependence between spectator and work of art is of course profoundly anti-formalist, as it weakens the absoluteness of the subject-object relationship."[55] Smithson also recognized the importance of providing a "needed dialectic" between ecology and industry:

Nature for the dialectician is *indifferent* to any formal ideal. . . . A lesson can be learned from the Indian cliff dwellings and earthworks mounds. Here we see nature and necessity in consort. . . . It is possible to have a direct organic manipulation of the land devoid of violence and "macho" aggression. . . . The farmer's, miner's or artist's treatment of the land depends on how aware he is of himself as nature. After all, sex isn't all a series of rapes. If strip miners were less alienated from the nature in themselves and free of sexual aggression cultivation could take place.[56]

Ecological art—with its emphasis on social concern, low profile, and more sensitive attitudes toward the ecosystem—differs from the earth-

works of the mid-1960s. Iain Baxter in Vancouver, through his N.E. Thing Co. (then consisting of himself, his wife Ingrid, and their two children), pioneered this direction, though his interest in archeological and anthropological sources was minimal. Robert Morris has noted the contradictions involved in the large-scale earth-moving to which he and others are committed:

The act of digging and piling carried out in an organized way and at an intensified scale has produced sunken gardens and ziggurats on one hand and gigantic geographical scars and ore tailings on the other. The forms are basically the same. The purposes and details vary, labeling one construction sublime, another abysmal. . . . What marks [art] off from all other organized human activity, is that it does not seek control through explanation, that it offers the freedom to experience and question.[57]

Herbert Marcuse said that "man's struggle with nature is increasingly a struggle with society."[58] Nowhere is this so overt as in the area of "reclamation art," in which artists attempt to intervene in social interaction with nature. Manipulation of consciousness is the major weapon of both the powerful and the powerless. Art is supposed to affect consciousness of life, but today's reclamation artist is fighting (or being bought out by) multinational giants which have the mass media and whole governments at their disposal. An art resisting commodity status also resists the abuse of natural resources to provide these commodities. In the last few years of his life, Smithson fought hard to get the despoilers of the land to let him remodel their devastations. He preferred to relatively virgin nature those "infernal regions" like slag heaps, strip-mined wastelands, and polluted rivers—places where society had made such a mess that only the artist playing god could change it. Minerals Engineering Company of Denver alone welcomed his proposals for disposing of their tailings detritus. For them, Smithson suggested projects for a *Meandering Ring* and a characteristic double water-and-earth piece—a four-tiered *Tailing Terrace* with four correspondingly formed ponds, which would have taken years to execute. Since then, Morris has executed a similar but less grandiose project near Seattle as part of an optimistic plan to make landscape art less expensive than the "ordinary," legally required reclamation would be.

Alan Sonfist is now working on just the sort of project Smithson hoped to find. As an alternative to the engineers' original and very costly plan of covering a whole polluted flood plain in Texas with an artificial lake, he is planning a series of islands, each of which will reflect a different local Texan ecology. Sonfist's most interesting work so far has been in the cities. He is interested in "historical nature"—nature that no longer exists in that particular place. By no coincidence he got his art education from New York's Museum of Natural History, which as a child he much preferred to the Metropolitan Museum of Art. He was raised in the South Bronx, and his other major influence was the Hemlock Forest there, with which he had a childhood obsession. He still maintains an identification with trees, from which much of his art has grown. All of his work has been autobiographical. "My body is my museum," he says, "it's my his-

33.

34.

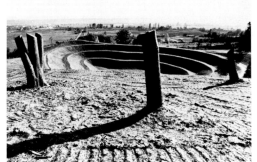

33. Robert Morris. Untitled. 1979. 3½-acre site south of Seattle. Trees preserved with tar; land seeded with grass. Commissioned by Kings County Arts Commission.

34. Alan Sonfist. Time Landscape. *1965–78. Houston Street and La Guardia Place, New York City. 8000' square. (Mural in background unrelated.)*

tory." (And he has bequeathed it to the Museum of Modern Art, so its decay will be part of its art cycle.)

The earth and nature are Sonfist's subject, not just his material. He points out that public monuments have traditionally celebrated events in human history—acts important to the whole community—and he is offering as an alternative the inclusion of nonhuman elements in this community. "As in war monuments that record the life and death of soldiers, the life and death of natural phenomena such as rivers, springs and natural outcroppings should be remembered."[59] He suggests that the natural character of an area be recalled by street and area names ("Landmark Nature") and that old roads and trails be marked in cities. His *Time Landscape* series, which began as a small plot of ground (8,000 square feet) in downtown Manhattan, recreates the history of nature in New York through the carefully researched planting of three stages of forest. It is an image of wild pre-Colonial land in the midst of a colonized and exploited urban site. I live near it, and can vouch that it's not one of those unreal projects that has forgotten death. In winter the *Time Landscape* is a tangle of brush, its beauty ravaged and hidden. In spring you watch it awakening, and in summer it's green and lush—though in some ways less interesting, more conventionally parklike.

In the South Bronx, Sonfist made a photo-mural of trees painted on a building next to the site to show how the lot he had planted will look in 20 years. In Atlanta he made an *Earth Wall* which displays the actual strata of earth beneath the city, topped by plants with their roots visibly descending down through the strata in a metaphor for collective and individual histories as well as natural roots. In all these projects he is trying to suggest ways in which cities can rediscover their natural identities within contemporary frameworks.

Helen and Newton Harrison, working in San Diego, are also "artist

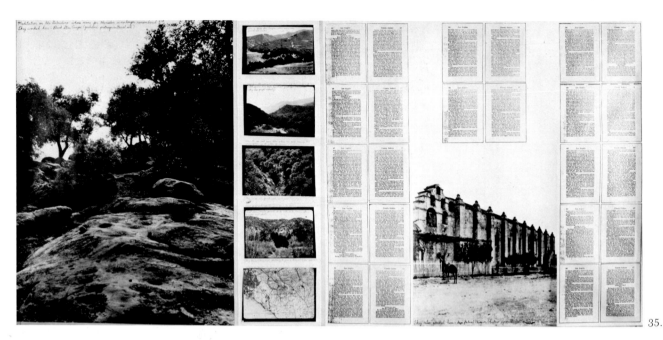

35.

36.

farmers," concerned with imaginative, large-scale recycling of wastes, community, and labor, resulting in a "polyculture" rather than simply culture or horticulture. They too are trying to break down the artificial barriers between medium and disciplines, using any technique that will further their aims. They too stress the metaphorical aspects of their work, framing their esthetic and scientific present with the history of land use in America and "the anomalies that exist between the natural environment and cultural systems." For example, a piece about a vanished southern California Indian tribe is called *Meditation on the Gabrielino Whose Name for Themselves Is No Longer Remembered Although We Know That They Farmed with Fire and Fought Wars by Singing.* It compares the ecocide and accompanying genocide of the "Gabrielino" to what we are doing today to our portion of the earth. The Harrisons have specialized in watershed reclamation and life chains. They have worked with brine shrimp, fish farms, and so extensively with crabs that they received funding from scientific organizations. At Artpark in 1977, the Harrisons and their son Joshua set out to reclaim the huge chemical spoils pile by starting from scratch, literally "making earth." They planted a whole forest and hoped to cooperate with the nearby Indian Village in planting Native American crops. The project was as much process as product. Eventually, the Artpark administrators halted construction. The area where the Harrisons worked was also where Oppenheim's *Identity Stretch* (p. 204), Simonds' *Growth House* (p. 237), and Sonfist's forest seeding project were executed, so the deadly chemical dump has ironically become an esthetically fertile overlay in its own right.

To those who can't understand why the relatively powerless artist would grapple with such vast concepts against the system's odds, Newton Harrison has said: "Sometimes I think about Zen gardens. For a small group with changing numbers to spend hundreds of years creating a miniature universe while going about the business of everyday life is art. I see the cave drawings as survival instructions with references to space, time, movement, magic, location, ordinance and tactics. All religious art has that quality. The end game stands between decoration, special craft and magic."[60]

The most ambitious and successful work of ecological art in this country is the offspring of Bonnie Sherk, who founded Crossroads Community/The Farm in San Francisco in 1974 and devoted all her energies to directing it until 1980. Like the Naturalists, Sherk sees a "hope for richer humanity and positive survival lying in the integration of the *human* creative process—art—with those of other life forms." In the early '70s she was doing performances in which she identified with animals, even eating a meal in a zoo cage. (Sonfist has also put himself on display in a zoo.) With Howard Levine, she made a series of portable parks in the city center, laying down turf, adding a bale of hay, a picnic table, a real cow and palm trees, to show the need for such oases in the city.

The Farm is on five and a half acres, under and within a freeway system. Four separate ethnic neighborhoods join there. The site was once a working farm, and Sherk had always felt a psychic attraction to it. Later she discovered that it was also the meeting place of three springs—just

37.

the sort of place prehistoric peoples would have chosen to build their monuments. (The *I Ching* says that while you may move towns, the wells remain.) The Farm serves multiple functions. It is a resource center for the study of land use and food as well as an art center. Sherk sees it as a work of performance art in its entirety. There are demonstration projects on responsible agriculture, children's art and dance classes, activities for psychiatric patients and senior citizens, pottery and printmaking workshops, a solar greenhouse and a Savonius windmill, flower, vegetable and herb gardens, crops and animals. Because the Farm is also an environmental and social artwork, it has unexpected twists, such as the way it nonchalantly incorporates the incredible technical monolith called the "Freeway," like a garden beside a cathedral. At one point a procession of cardboard cows "came home" along the Freeway. Inside the building there is an old-fashioned farm kitchen; outside, a suburban touch is made by white iron lawn furniture. An "international living room" was planned to show that elegance is part of the natural life, and negotiations have been under way to import an old Japanese farmhouse for further transcultural communication. In the sensorily rich environment of The Raw Egg Animal Theatre (TREAT), rabbits, chickens, goats, and other animals interact with each other, with houses, trees, toys, mirrors, and observers. The Farm looks like a real farm; it smells of manure, and includes muddy fields and other cosmetically unattractive areas. Sherk sees it as "a life-frame . . . a juxtaposition of environments, esthetics and moods."[61]

In Mexico in 1973, Patrick and Flora Clancy made an artwork about the implacable force of plants driving through cement. They subtly destroyed a rented cement "garden" by bombarding it with the leftover seeds of their fruits and vegetables. These fragile shoots are parables for the means by which the "powerless" artist can manipulate space and consciousness. It has been suggested that the Mayans met their doom because they were so busy with culture they forgot to keep nature at bay. In the center of the New Zealand city of Auckland is a cemetery in which the stones are totally overgrown with vines, resembling bushes more than human-made monuments—a classic image of the triumph of nature over culture.

From the little Neolithic Greek goddess shrines to the miniature objects and houses of the Andean winter solstice festival (which once represented spiritual offerings and now represent material desires), tininess has held a ritual fascination. Art that combines psychobiology with the collective unconscious, with communication, or with social change is also the result of what might be called "wishful making."

Charles Simonds' awareness of the force the microcosm can exert on the macrocosm has lent a dimension of social effectiveness to his miniature fantasy landscapes built in the streets (see Chapter II). His work, which ranges between the favored miniature-scale and full-scale park projects within the same symbolic vocabulary, upholds the Dogon belief that "there is no right size"; as for Simonds' Little People, the Dogon house "is a small city and the city is a large house and both reflect the world picture." A person in her or his own house "will be able to inhabit, simultaneously, all the places to which s/he is emotionally linked—in memory

and anticipation but also through mental association."[62] By daily contact, the Little People establish their own history and mythology within the real life of the community, offering a dreamlike peephole into other times and possibilities. Each dwelling goes through a birth/life/death cycle before the eyes of the concerned spectators. The landscapes' ephemeral nature does not destroy the sense that they are part of the fabric of time. Like Navaho and Aboriginal sand paintings or Pueblo cornmeal paintings, they are destroyed when they have fulfilled their function. They disappear when any one person tries to take them out of their public context, or make them into "private property."

Simonds' personal fantasies expand into political consciousness-raisers for his street audiences in part because by reinstating a sense of their pasts he allows them to identify with their own patches of the city and to consider molding their own futures. His tiny adobe houses and sensuous clay landscapes are a surprisingly universal image. In workers' neighborhoods in New York they recall Puerto Rico; in Paris, Tunisia; in Germany, Turkey. Though he loses himself in his own fantasies while building these "pieces," he also says that "making a dwelling in the streets is like holding hands with your audience."[63] In several cases this esthetic intimacy has led to communal resistance to prevailing conditions: If the Little People can build, survive, and live out their culture in such hostile surroundings, so can we.

For instance, when Simonds had worked for over a year on the Lower East Side of New York, he became sort of a folk hero, showing up almost daily with his pack of clay, sticks, and tiny bricks to propagate the Little People—his symbolic offspring. The means of propagation were present in the "ritual places" with their overtly sexual (sometimes androgynous) forms, which seemed to connect the Little People's "primitive" existence to the earth below the garbage and rubble in the vacant lots they overlooked. Conversations about environmental change began to spring up as the residents looked about them with fresh eyes. The result—after two years of planning, redtape-severing, and hard work—was "La Placita/ Charles' Park," a playlot centered on a natural-looking hillock. His original "art idea" had been to make this a "mountain" rising incongruously from beneath the asphalt, but in the planning stages the community's needs and the collaborative process took over, the mountain shrank and ended up with a kids' slide on it. The projected "wild" landscape was domesticated into a garden—with the enthusiastic consent of both artist and community. In Cleveland, Simonds worked with the residents of a large lower-income housing project to make a garden, ritual place/ sculpture, and barbecue/picnic area, the form of which reflected the ground plan of the buildings around it. This communal endeavour brought together people who had never met and precipitated a rent strike as well as a recreation area.

Another Lower East Side project was the resurrection of an abandoned tenement into a museum of the history of the neighborhood, which has housed every immigrant wave into New York City. The museum was to house oral and visual history and to combine human life with a local natural history section; a garden hanging from the upper floors would transform exterior wall and adjacent lot into a park nourished by the in-

38.

38. *Charles Simonds. Proposal for Stanley Tankel Memorial Hanging Gardens. 1976. Colored ink on photograph.*

39. *Charles Simonds.* Growth House. *(A) Pen and ink drawing. 1975. 25″ × 29½″. (B) Detail of execution at Artpark, Lewiston, New York. Fall 1975. (Photo: Lucy R. Lippard.)*

terior past. In a proposal for the *Stanley Tankel Memorial Hanging Gardens* at Breezy Point, Simonds suggested that two high-rise eyesores in one of New York's few natural recreation areas (their construction had been halted through community opposition led by Tankel) should not be torn down at great expense, but should remain as a warning, converted into hanging gardens and a youth hostel.

In his 1975–76 *Growth House,* Simonds found an image encompassing many of the complex ideas about myth and nature that pervade his art. Preceded by smaller "growing" clay sculptures, planned as a permanent but always changing public monument, *The Growth House* was partially constructed in Artpark in 1975 from massive "growth bricks"— sacks of earth containing a huge variety of carefully organized seeds. It consisted of a circular double wall enclosing a bellylike dome like that of the *Circular House* (see p. 98). Beginning as a closed dwelling place for winter, gradually destroyed in spring by the sprouting plants, and becoming in summer a food-producing field, the circle would end in harvested devastation. New bricks were to be made from the mulch to build a new shelter, and the cycle would begin again. Within the span of five months at Artpark, *The Growth House* evolved from a closed and defensive-looking fortress to a delicately green-sprigged "home" (with rooms made of single or multicolored flowering "wallpaper") to a fully green summer continuum. Finally, bulging with vegetables, it burst its architectural confines by autumn. At this point it was destroyed. (Art, at Artpark, is as short as life.)

Simonds has described *The Growth House* as "uroboric," and as "the analogous inverse of a termite." It is also an androgynous fusion of nature (growth) and culture (building). The "wrinkled" earthen center doesn't change as the cosmological/biological clock revolves; it shelters seeds, nurtures them to fruition (in the process destroying the "house/mother"), consumes them at harvest and begins again. In biological terms, the house/body is grown, eaten, digested, and replanted. The whole idea echoes not only the cyclical rituals of the Little People and the continuity/impermanence of their existence, but also the films in which Simonds is born from the earth and then creates its land forms (see Chapter II). As a whole, his symbolic vocabulary evokes any number of ancient myths—for instance, that of the Norse giant Ymir—the "Mud Seether" who, when killed and mutilated, formed the earth. (The sexualized ritual forms where the Little People worship often resemble isolated body parts.) In particular, Simonds' work recalls one of the "seminal" myths to which much of the art in this book harks back—that of the "sprouting" Osiris, dismembered and thrown into the Nile. When an earth-molded and mummy-bound image of Osiris was "resurrected" from King Tut's tomb, it was found to be made of Nile mud, into which seeds had been pressed; Osiris had literally "sprouted."

Simonds sees no separation between his "social work" (which criticizes the system and suggests environmental improvements) and his "art" (the dwellings and time architectures based in a personal sense of time, body, earth, and fantasy). He has explained how the Lower East Side dwellings and La Placita "both articulate the earth, how people live on it and what they believe about it. . . . The park reinstates an image of the earth

39A.

39B.

40. *Bed-gravestone, Rockingham, New Hampshire. (Photo: Margaret I. Lippard.)*

41. *Silbury Hill, Wiltshire, England. (Photo: Chris Jennings.)*

which becomes a receptacle for the energies of the people already living there."[64] Simonds is not afraid to use the word *religious* (though in a noninstitutionalized sense) as mortar for his varied production—public and private, large and small, personal and social. He might be illustrating Durkheim's perceptions:

It is in spiritual ways that social pressure exercises itself. . . . Since religious forces are conceived of under material forms, they could not fail to be regarded as closely related to material things. Therefore they dominate two worlds. . . . They animate minds and discipline them, but it is also they who make plants grow and animals reproduce. It is this double nature which has enabled religion to be like the womb from which come all the leading germs of human civilization.[65]

Our culture is often said to have no sense of death. Even the origins of the American park system in the replacement of urban churchyards by spacious suburban cemeteries can be seen as a removal of the reminders of death from everyday life. Yet this too recalls the garden's double meaning, the fact that like the mythical mound, graves become gardens, and vice versa. The notion of resurrection, of winter as sleep, is epitomized by the leafless stone trees and a marble bed in a New England graveyard.

The mounds, circles, rows, and shelters of stone that have survived prehistoric "gardens" offer a frame for looking at "sculpture gardens" in museums, parks, bank plazas, or private estates. Commodified indoor sculptures enlarged at great cost and condescendingly plunked down in semi-public spaces deny the continuity with nature, site, and community that is a necessity for a living art. In this sense, Smithson was right when he said: "Parks are idealizations of nature, but nature in fact is not a condition of the ideal. . . . Nature is never finished. . . . Parks are finished landscapes for finished art. The museums and parks are graveyards above ground."[66]

On the other hand, these graveyards are also gardens. If the human race continues to be part of nature, then neither parks nor cities are "finished landscapes." They are the organic, and often monstrous, progeny of social life and value systems. Only when the art that forms their spiritual core can respond to and change with social life can it be restored to its original communal meanings. Archeology is not the only valid method of gardening in graveyards. It is perhaps in this spirit that Aubrey Burl concedes that speculation on the significant interconnections between ancient sites "is more a matter for the visionary than the archeologist."[67]

40.

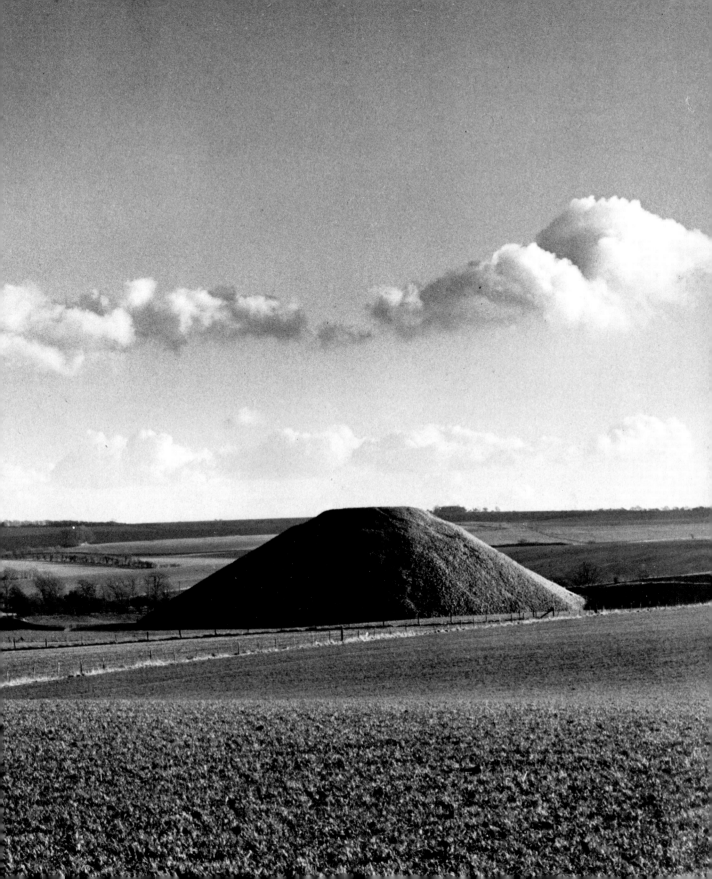

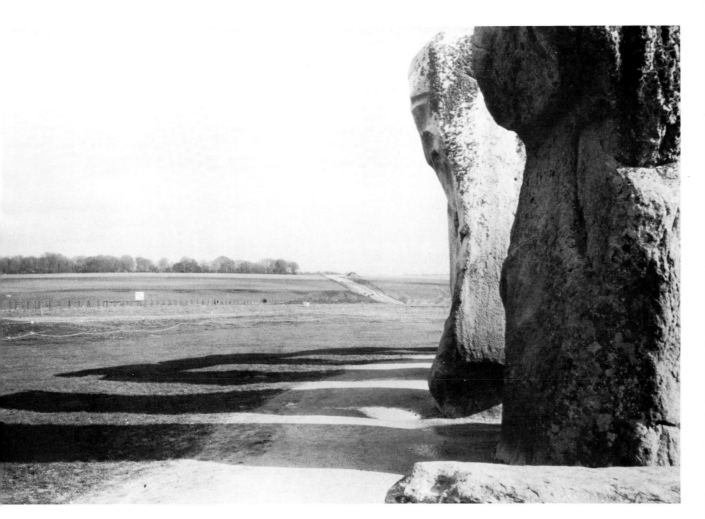

Notes
Further Reading
Index

Notes

Introduction

1. Anton Ehrenzweig, *The Hidden Order of Art* (Berkeley & Los Angeles: University of California Press, 1967), p. 77.

2. See Irving Sandler, "The Myth-Makers," in *The Triumph of American Painting* (New York: Praeger), pp. 62–69.

3. Otto Rank, *Art and Artist* (New York: Agathon Press, 1968), p. 361. Myth and ancient imagery have provided sources and formal surfaces for a great deal of modern art. I will make no attempt here to catalogue their appearance in art history. I go back no further than the late 1960s because I am primarily interested in what turns up in the overlay of distant past on immediate present. However, I refer those interested to Robert Goldwater's brilliant book *Primitivism in Modern Art* (New York: Vintage Books, 1967), which analyzes the general notion of so-called primitivism as a major resource of modernism.

4. Herbert Molderings, "Art as Memory," in *Charles Simonds: Floating Cities and Other Architectures* (Munster: Westfälischer Kunstverein, 1978), p. 7.

5. Émile Durkheim, *The Elementary Forms of the Religious Life* (New York: The Free Press, 1965), p. 466.

6. Jack Burnham, *Great Western Salt Works* (New York: George Braziller, 1974), p. 139.

7. Dennis Oppenheim, "It Ain't What You Make, It's What Makes You Do It: An Interview with Dennis Oppenheim by Anne Ramsden," *Parachute* (Winter 1977–78), pp. 33, 35.

8. "Less is more, but it's not enough" was a public billboard and postcard work done by Robert Huot in 1977 (*Billboard for Former Formalists*). The initial phrase was borrowed from Mies van der Rohe.

9. Franz Kugler, quoted in Rank, *Art and Artist*, p. 13.

10. Rank, *Art and Artist*, pp. 86, 360.

Stones

1. Mircea Eliade, *The Forge and the Crucible* (New York: Harper & Bros., 1962), p. 44.

2. *Ibid.*, chapt. 3; see also the chapter on sacred stones in Eliade, *Patterns of Comparative Religion* (New York: Sheed & Ward, 1958).

3. Erich Neumann, *The Great Mother* (Princeton, N.J.: Princeton University Press, 1972), p. 260.

4. Abram Tertz (André Sinyavsky), *A Voice from the Chorus* (New York: Farrar-Straus, 1976), pp. 172–73.

5. Thor Heyerdahl, quoted in Marie-Louise von Franz, *Problems of the Feminine in Fairy Tales* (New York: Spring Publications, 1972), p. 150.

6. John Michell, *The Old Stones of Land's End* (London: Garnstone, 1974), p. 131.

7. Plotinus, quoted in *Ibid.*, p. 101.

8. Douglas Huebler, in *January 5–31, 1969* (New York: Seth Siegelaub, 1969). Huebler has since qualified this statement; see *Artforum* (May 1982), p. 76.

9. Paul Leveson, *A Sense of the Earth* (New York: Anchor Natural History Books, Doubleday, 1972), p. 149.

10. Robert Smithson, in *The Writings of Robert Smithson*, ed. Nancy Holt (New York: New York University Press, 1979), pp. 179–85 (for this and following quotations).

11. René Dubos, "Foreword," in Leveson, *A Sense of the Earth*, p. 11.

12. Robert Smithson, *Writings*, p. 67.

13. Michelle Stuart, *Return to the Silent Garden* (unpublished journal, ongoing).

14. Michelle Stuart, quoted in Eleanor Munro, *Originals: American Women Artists* (New York: Simon & Schuster, 1979), p. 445.

Feminism and Prehistory

1. See *Heresies*, issue 5 (1978), on "The Great Goddess," and *Chrysalis*, no. 2 (1977).

2. Gina Blumenfeld, in *Liberation* (February 1975), p. 14.

3. See Lucy R. Lippard, *From the Center* (New York: E. P. Dutton, 1976).

4. See *Heresies*, issue 13 (1981) on "Feminism and Ecology," especially Joan L. Griscom, "On Healing the Nature/History Split in Feminist Thought," pp. 4–9; Ynestra King, "Feminism and the Revolt of Nature," pp. 12–16; and Ruby Rohrlich and June Nash, "Patriarchal Puzzle: State Formation in Mesopotamia and Mesoamerica," pp. 60–65.

5. Sherry B. Ortner, "Is Female to Male as Nature Is to Culture?" *Feminist Studies*, vol. 1, no. 2 (1972), p. 25.

6. Such an urge, with its respect for values traditionally attributed to women, seems to be behind both Paul Shepard's *Man in the Landscape* and Philip Slater's almost obsequiously feminist *Earthwalk*. Robert Smithson was also interested in "psycho-ecology."

7. Robert Graves, *The White Goddess* (New York: Farrar, Straus & Giroux, 1948), pp. 446–47, 481.

8. Otto Rank, *Art and Artist* (New York: Agathon Press, 1968), p. xxiii.

9. Tania Mouraud, quoted in Lippard, *From the Center*, p. 134.

10. Géza Róheim, *The Origin and Function of Culture* (Garden City, N.Y.: Doubleday, 1971), p. 106.

11. Stanislao Pacus, quoted in Lea Vergine, *Il Corpo Come Linguaggio* (Milan: Giampaolo Prearo, 1974).

12. Jack Burnham, *Great Western Salt Works* (New York: George Braziller, 1974), p. 140.

13. Hayden Herrera, "Frida Kahlo," *Artforum* (May 1976), p. 39; see also Herrera's book, *Frida, A Biography of Frida Kahlo* (New York: Harper & Row, 1983).

14. *Ibid.*, p. 44.

15. See Rohrlich and Nash, "Patriarchal Puzzle."

16. Doris Shadbolt, *Emily Carr* (Vancouver: Vancouver Art Gallery, 1975), p. 36. Shadbolt's book on Carr has since appeared in another edition (Seattle: University of Washington Press, 1979).

17. Georgia O'Keeffe, quoted in Laurie Lisle, *Portrait of an Artist: A Biography of Georgia O'Keeffe* (New York: Seaview Books, 1980), p. 190.

18. Willard H. Wright, quoted in *Ibid.*, p. 75.

19. O'Keeffe, quoted in *Ibid.*, pp. 343, 211.

20. Vincent Scully, *The Earth, the Temple and the Gods* (New York: Frederick A. Praeger, 1969), pp. 1, 3.

21. John Michell, *The Old Stones of Land's End* (London: Garnstone, 1974), p. 128.

22. Harry Chapin, quoted in "Earthworks," *The Arts*, vol. 8, no. 7 (July 1979), p. 3.

23. Jackson Pollock, quoted by Lee Krasner, interviewed by Bruce Glaser, *Arts Magazine* (April 1967), p. 38; also quoted in Ellen Johnson, *Modern Art and the Object* (New York: Harper & Row, 1976), p. 115.

24. Francis Bacon, quoted in William Leiss, *The Domination of Nature* (New York: Beacon, 1974), p. 55.

25. Martha McWilliams Wright, "Washington," *Art International* (January 1978), p. 62.

26. Joseph Campbell, *Creative Mythology* (Princeton: Princeton University Press, 1970), p. 137.

27. Max Horkheimer, quoted in Leiss, *Domination of Nature*, p. 160. The "revolt of nature" is "the rebellion of human nature which takes place in the form of violent outbreaks of persistently repressed instinctual demands."

28. Dennis Oppenheim, "Dennis Oppenheim Interviewed by Willoughby Sharp," *Studio International* (November 1971), pp. 193, 191.

29. Dennis Oppenheim, *Dennis Oppenheim Retrospective—Works 1967–1977* (Montreal: Musée d'art contemporain, 1978), pp. 49, 45.

30. *Ibid.*, p. 53.

31. Michael McCafferty, in conversation with the author, 1976. McCafferty sees the cosmic circle on the land as a vehicle for bringing together natural and human forces, self and surroundings.

32. Michael Heizer, "Discussions with Heizer, Oppenheim, Smithson," *Avalanche*, no. 1 (Fall 1970), p. 24.

33. All quotations in this section come from the original English transcript of an interview with Charles Simonds by Daniel Abadie, in *Charles Simonds* (Paris: SMI Art/Cahier 2, 1975).

34. O'Keeffe, quoted in Lisle, p. 260.

35. See *Ms.* (May 1981), p. 26.

36. W. Roscher, cited in Rank, *Art and Artist*, p. 192.

37. Rank, *Art and Artist*, p. 144.

38. Dennis Oppenheim, *Retrospective*, p. 55.

39. Rank, *Art and Artist*, p. 125.

40. Marija Gimbutas, *The Gods and Goddesses of Old Europe* (Berkeley: University of California Press, 1974), pp. 13, 237.

41. Louise Bourgeois, quoted in Dorothy Seiberling, "The Female View of Erotica," *New York Magazine* (February 11, 1974), p. 46.

42. Rohrlich and Nash, "Patriarchal Puzzle," p. 60.

43. Anne Ross, *Pagan Celtic Britain* (London: Routledge & Kegan Paul, 1967), p. 359.

44. *Ibid.*, p. 366.

45. Erich Neumann, *The Great Mother* (Princeton: Princeton University Press, 1972), p. 260.

46. Rohrlich and Nash, "The Patriarchal Puzzle," p. 62.

47. Aubrey Burl, *The Stone Circles of the British Isles* (New Haven: Yale University Press, 1976), p. 83.

48. Carolee Schneemann, *More Than Meat Joy* (New Paltz, N.Y.: Documentext, 1979), p. 164.

49. Jamake Highwater, *Dance: Rituals of Experience* (New York: A & W Publishers, 1978), p. 36.

50. Nor Hall, *Mothers and Daughters* (Minneapolis: Rusoff Books, 1976), p. 7.

51. Judy Chicago, quoted in Lucy R. Lippard, "Judy Chicago's Dinner Party," *Art in America* (April 1980), p. 115. See also Judy Chicago, *The Dinner Party* (New York: Anchor Press, 1979), and *Embroidering Our Heritage: The Dinner Party Needlework* (New York: Anchor Press, 1980).

52. Peter T. Furst, "The Roots and Continuities of Shamanism," *artscanada*, no. 184–87 (December 1973–January 1974), pp. 50–51.

53. See Scully, *The Earth, the Temple and the Gods*.

54. Michael Dames, *The Avebury Cycle* (London: Thames & Hudson, 1977), p. 160.

55. Mary Beth Edelson, "Goddess Imagery in Ritual," interview by Gayle Kimball, in Kimball, *Women's Culture* (Metuchen, N.J.: Scarecrow Press, 1981), p. 94; and Edelson, *Seven Cycles: Public Rituals* (New York: Edelson, 1980), p. 8.

The Forms of Time: Earth and Sky, Words and Numbers

1. Robert Rosenblum, "Toward the Tabula Rasa," in *Transformations in Late Eighteenth Century Art* (Princeton, N.J.: Princeton University Press, 1967), pp. 146–91.

2. Giorgio de Santillana and Hertha von Dechend, *Hamlet's Mill* (Boston: David R. Godine, 1977), p. 119.

3. Cicero, quoted in Jamake Highwater, *Dance: Rituals of Experience* (New York: A & W Publishers, 1978), p. 44; Frithjof Schuon, quoted in Keith Critchlow, *Time Stands Still* (London: Gordon Fraser, 1979), p. 11.

4. Sol LeWitt, "Sentences on Conceptual Art," in Lucy R. Lippard, *Six Years* (New York: Praeger, 1973), p. 75.

5. John Michell, *City of Revelation* (New York: Ballantine Books, 1972), p. xi.

6. Ad Reinhardt, "Art-as-Art," *Art International* (December 1962), pp. 36–37.

7. Edmund Carpenter, "Silent Music and Invisible Art," *Natural History* (May, 1978), p. 99.

8. Ernst Cassirer, quoted in Michael Dames, *The Silbury Treasure* (London: Thames & Hudson, 1976), p. 118.

9. Mel Bochner, quoted in Ellen Johnson, *Modern Art and the Object* (New York: Harper & Row, 1976), pp. 212–13.

10. See Lucy R. Lippard, "Homage to the Square," *Art in America* (July–August 1967), pp. 50–57.

11. Francis Hitching, paraphrasing Alexander Thom, in *Earth Magic* (London: Picador, 1976), p. 71.

12. Alexander Thom, *Megalithic Sites in Britain* (Oxford: Oxford University Press, 1967), p. 27.

13. Plato, quoted in Critchlow, *Time Stands Still*, p. 134.

14. W. T. Chan, *The Way of Lao Tzu* (New York: Library of Liberal Arts, Bobbs-Merrill, 1963), p. 176.

15. Critchlow, *Time Stands Still*, pp. 179, 133. An octagonal stone ball has also been found on a New England "pre-Columbian" site, according to Salvatore Trento.

16. Michell, *City of Revelation*, pp. 112–13.

17. Critchlow, *Time Stands Still*, p. 148.

18. Francis Huxley, *The Way of the Sacred* (Garden City, N.Y.: Doubleday, 1974), p. 86.

19. De Santillana and von Dechend, *Hamlet's Mill*, pp. 345–46 (for this and following quotations).

20. Claude Lévi-Strauss, paraphrased by Jean McMann in *Riddles of the Stone Age* (London: Thames & Hudson, 1980), p. 147. This book includes a clear summary of the history of writing in regard to the marks on the stones.

21. Michell, *City of Revelation*, pp. 131–33; Robert Morris on Alexander Marshack's theories about the origins of writing, in "Aligned with Nazca," *Artforum* (October 1975), p. 38.

22. See Stuart Piggott, *The Druids* (Harmondsworth, England: Penguin Books, 1974).

23. Otto Rank, *Art and Artist* (New York: Agathon Press, 1968), p. 274.

24. Christopher Lasch, *The Culture of Narcissism* (New York: Warner Books, 1979), p. 261.

25. Denise Schmandt-Besserat, "The Earliest Precursor of Writing," *Scientific American* (June 1978), pp. 50–59.

26. Claude Lévi-Strauss, quoted in Dames, *Silbury Treasure*, p. 125.

27. Max Raphael, quoted by Guy Brett, in *Block,* no. 4 (1981), p. 25.

28. Marija Gimbutas, *The Gods and Goddesses of Old Europe* (Berkeley: University of California Press, 1974), chapt. 6.

29. Patrick Ireland, in conversation with the author, June 1981.

30. Patrick Ireland, letter to the author, March 1982 (for this and following quotations). The shapes and edges of standing stones may have indicated orientations and symbolic directions as well as symbolic associations. The "edge" that is Ogham's base may have emerged from such considerations. Thom has shown in detail how the Ballachroy stones in Scotland, with their functional flat and rough edges, could have been used in a solar observatory, and he has found similar data elsewhere, concluding from it that the megalith builders used a precise, 16-part calendar. For a clear explanation of this process, see Evan Hadingham, *Circles and Standing Stones* (New York: Anchor Press/Doubleday, 1976), chapt. 7.

31. Rank, *Art and Artist*, pp. 39–40, 324.

32. Ernst Cassirer, *Theory of Language and Myth* (New York & London: Harper & Bros., 1946), p. 90.

33. John Edwin Wood, *Sun, Moon and Standing Stones* (Oxford: Oxford University Press, 1980), p. 184 (though of course even the solar aspect of New Grange was only recently discovered).

34. John D. Palmer and Judith E. Goodenough, "Mysterious Monthly Rhythms," *Natural History* (December 1978), pp. 64–69.

35. Critchlow, *Time Stands Still*, p. 179.

36. Bart Jordan, in Steve Sherman, "The Secrets of Stonehenge," *New Hampshire Times* (January 12, January 19, and July 6, 1977).

37. Michell, *City of Revelation*, p. 67.

38. Cassirer, *Theory of Language and Myth*, p. 148.

39. De Santillana and von Dechend, *Hamlet's Mill*, p. 342. They point out that Kepler and Copernicus, like Robert Smithson, "recoiled from unboundedness."

40. LeWitt, "Sentences," pp. 75–76; the "sentences" were (appropriately) first published in *0–9* (January 1969).

41. Douglas Huebler, in *January 5–31* (New York: Seth Siegelaub, 1969).

42. Ian Wilson, in Lippard, *Six Years,* p. 182.

43. See Rank, *Art and Artist,* chapt. 14, "Deprivation and Renunciation."

44. Hanne Darboven, quoted in Lucy R. Lippard, *From the Center* (New York: E. P. Dutton, 1976), p. 187.

45. Michel Melot, "Camille Pissarro in 1880," *Marxist Perspectives* (Winter 1979–80), p. 32.

46. Marie-Louise von Franz, *Time: Rhythm and Repose* (London: Thames & Hudson, 1978), p. 10.

47. Lasch, *Culture of Narcissism,* pp. 166–67.

48. Charles Simonds, *Three Peoples* (Genoa: Samanedizioni, 1976).

49. Anna Sofaer, in brochure for her exhibition at Doris Gaines Gallery, New York (February–March 1977).

50. Anna Sofaer, in letter to the author, September 30, 1980; all other data on the sun dagger from conversations, unpublished notes, and articles by Sofaer and her colleagues in *Science* (October 16, 1979) and *Science 80* (November/December 1979).

51. Charles Ross, "Sunlight Convergence/Solar Burn," *Co-Evolution Quarterly* (Winter 1977–78), p. 27.

52. Steve Katz, in *Charles Ross* (La Jolla: La Jolla Museum, February 6–March 14, 1976), p. 17.

53. Ross, *Ibid.,* p. 18.

54. John Beardsley, *Probing the Earth: Contemporary Land Projects* (Washington, D.C.: Smithsonian Institution Press, 1977), p. 74.

55. Campbell Grant, *Canyon de Chelly* (Tucson: University of Arizona Press, 1978), p. 230.

56. Nancy Holt, all quotations on *Sun Tunnels* from *Artforum* (April 1977), pp. 33–37.

57. Edward Fry, "Introduction," in *Robert Morris/Projects* (Philadelphia: Institute of Contemporary Art, 1974).

58. Michelle Stuart, all quotations from conversation with the author, June 1981.

59. Paul Sutinen, "Sunlight and Stones," *Williamette Week,* July 30, 1979, p. 7.

60. My main source here is John Michell, *A Little History of Astro-Archeology* (London: Thames & Hudson, 1977); all quotations below are from this brief but efficient book unless otherwise cited.

61. Alexander Thom, quoted in Hitching, *Earth Magic,* p. 73.

62. Wood, *Sun, Moon and Standing Stones,* p. 188.

63. Gerald S. Hawkins and John B. White, *Stonehenge Decoded* (New York: Dell, 1965), p. 173. *See also* C. A. Newham, "Stonehenge: a Neolithic 'observation,' " *Nature* 211 (1966), pp. 456–58. Newham's work paralleled Hawkins' in some areas, challenged it in others.

64. Gerald S. Hawkins, in *Science,* vol. 147 (January 8, 1965), pp. 127–30.

65. Hadingham, *Circles and Standing Stones,* p. 162. See also p. 153 ff. for a very readable explanation of the astronomical significance of the Carnac groups.

66. *Ibid.,* pp. 105–06.

67. Wood, *Sun, Moon and Standing Stones,* p. 140.

68. Giovanna Neudorfer, "Vermont's Stone Chambers: Their Myth and Their History," *Vermont History,* vol. 47, no. 2 (Spring 1979), pp. 79–146.

69. See Salvatore Michael Trento, *The Search for Lost America* (New York: Penguin Books, 1978), Appendix 2, for a list of active groups.

Time and Again: Maps and Places and Journeys

1. Paul Shepard, *Man in the Landscape* (New York: Ballantine Books, 1972), p. 31.

2. Paul Leveson, *A Sense of the Earth* (New York: Anchor Natural History Books, Doubleday, 1972), p. 149.

3. Nancy Graves, quoted in Lucy R. Lippard, *From the Center* (New York: E. P. Dutton, 1976), p. 119.

4. Robert Smithson, *The Writings of Robert Smithson,* ed. Nancy Holt (New York: New York University Press, 1979), p. 89; John Michell, *The Old Stones of Land's End* (London: Garnstone, 1974), p. 128.

5. All quotations in these paragraphs from interviews with Carl Andre by Achille Bonito-Oliva, *Domus,* no. 515 (October 1972); Peter Fuller, *Art Monthly,* no. 16/17 (1978); Phyllis Tuchman, *Artforum* (June 1970).

6. Ian L. McHarg, *Design with Nature* (New York: Doubleday/Natural History Press, 1971), p. 72.

7. Georgia O'Keeffe, *Georgia O'Keeffe* (New York: Viking, 1976), p. 100.

8. Sol LeWitt, "Sentences on Conceptual Art," in Lucy R. Lippard, *Six Years* (New York: Praeger, 1973), p. 77.

9. In fact, Stanley ("This Way") Brouwn, working in the Netherlands, had already made this particular "breakthrough"; he had been making urban walking pieces and "asking directions" pieces since around 1960, but their highly conceptualized and nonvisual nature focused them not on nature so much as on behavioral attitudes and spatial perception, so while they were as innovative as Long's later work, they do not belong in this book.

10. All quotations from Richard Long, *Five, Six, Pick up Sticks, Seven, Eight, Lay Them Straight* (London: Anthony d'Offay, 1980).

11. Hermann Kern, in "Labyrinths: Tradition and Contemporary Works," *Artforum* (May 1981), criticizes Long's labyrinth as a mere copy, a work not of art but of craft, which misses the point of its triple time and place overlay.

12. Weiner's mature work, beginning in the late 1960s, incorporates this idea into complex land/word/action concepts which, among other things, ingeniously avoid ownership and often exist in the public domain without ever being bought or sold.

13. Robert Morris, "Anti-Form," *Artforum* (April, 1969), p. 35.

14. Michael Heizer in *Michael Heizer* (Essen: Museum Folkwang, 1979), pp. 22, 36.

15. Richard Demarco, *The Artist as Explorer* (Edinburgh: Demarco Gallery, 1978), p. 27.

16. Tony Morrison, *Pathways to the Gods: The Mystery of the Andes Lines* (New York: Harper & Row, 1978), p. 173.

17. Coincidentally, my own rather restless great-grandfather—Congregational minister and amateur mineralogist in Colorado—wrote a book about the American Rockies called *My Mountains*, taken from the same Isaiah quotation. I have to admit to a particular fondness for Underwood's book, since it was the first thing I read about the Stones; here again, whether or not it was factually accurate, it made me see and sense things in my environment I never would have seen and sensed otherwise. Francis Hitching in *Earth Magic* gives a good synopsis of this and similar theories.

18. Tom Graves, "Earth Energies," in *Earth Mysteries* (London: RILKO, 1977), p. 48.

19. John Michell, *The Earth Spirit* (London: Thames & Hudson, 1975), pp. 12–16.

20. Francis Hitching, *Earth Magic* (London: Picador, 1976), pp. 105–07.

21. Morrison, *Pathways to the Gods*, pp. 181–182, 191.

22. Robert Morris, "Aligned with Nazca," *Artforum* (October 1975), p. 39.

23. Cesar Paternosto, "Stone Sculpture of the Inca" (unpublished manuscript); other quotations from conversations with the author.

24. Carl Andre, in Enno Develing, *Carl Andre* (The Hague: Haags Gemeentemuseum, 1969), p. 40.

25. Athena Tacha, in a letter to the author, August 26, 1978.

26. Gillian Jagger, "Origins and Endings" (unpublished manuscript from a taped conversation with Balcomb Greene, April 13, 1979).

27. Vincent Scully, *The Earth, the Temple and the Gods* (New York: Frederick A. Praeger, 1969), p. 2.

28. Dennis Oppenheim, "Dennis Oppenheim: An Interview by Allan Schwarzman," in *Early Work by Contemporary Artists* (New York: New Museum, 1977).

29. Gaston Bachelard, *The Poetics of Space* (Boston: Beacon Press, 1969), p. 203.

30. Jack Burnham, *Great Western Salt Works* (New York: George Braziller, 1974), p. 141.

31. Michael Dames, *The Silbury Treasure* (London: Thames & Hudson, 1976), p. 12.

32. Peter T. Furst, in his article "The Roots and Continuities of Shamanism," doesn't go this far, but quotes Mircea Eliade: "The mythology and rites of magical flight peculiar to shamans and sorcerers confirm and proclaim their transcendence in respect to the human condition" (*artscanada*, no. 184–87 [December 1973–January 1974], p. 45).

33. Mimi Lobell has written extensively on this. See, for instance, "Temples of the Great Goddess," *Heresies*, issue 5 (1978), pp. 32–39.

34. Luis Marden, "Titicaca, Abode of the Sun," *National Geographic* (February 1971), p. 294.

35. Patricia Johanson, *Patricia Johanson* (Montclair, N.J.: Montclair State College, 1974), p. 1.

36. Kern, "Labyrinths," p. 60.

37. See Ronald Onorato, "The Modern Maze," and Janet Kardon,

"Interviews with Some Modern Maze-makers," *Art International* (April–May, 1976).

38. Hera, in *Betty Voelker: Lifeways* (Boston: Institute of Contemporary Art, 1977).

39. Terry Fox, quoted in Kern, "Labyrinths," p. 68.

40. Bill Vazan, *Bill Vazan* (Montreal: Musée d'art contemporain, 1980), p. 51.

41. Bill Vazan, letter to the author, August 29, 1979.

42. George Kubler, *The Shape of Time* (New Haven: Yale University Press, 1962), p. 21. This book influenced several of the artists mentioned here, often through Ad Reinhardt, who wrote a review of it and gave it to friends.

43. Bill Vazan, "Amenagement conceptuel," *Urbanisme*, no. 168/169 (1978), p. 104; translated from the French by the author.

44. Bill Vazan, letter to the author, December 29, 1979.

45. Vazan, "Amenagement conceptuel," p. 106.

46. Paul Heyer, in *Bill Vazan*, p. 86; Diana Nemiroff, "Bill Vazan," *Vie des arts*, (Summer 1979), p. 86.

Ritual

1. Émile Durkheim, *The Elementary Forms of the Religious Life* (New York: The Free Press, 1965), p. 29.

2. *Ibid.*, p. 51.

3. Dennis Oppenheim, "Dennis Oppenheim: An Interview by Allan Schwartzman," in *Early Work by Contemporary Artists* (New York: New Museum, 1977).

4. Eva Hesse, quoted in Lucy R. Lippard, *Eva Hesse* (New York: New York University Press, 1976), p. 5.

5. Yvonne Rainer, quoted in Lucy R. Lippard, *From the Center* (New York: E. P. Dutton, 1976), p. 270.

6. Mary Beth Edelson, in "Goddess Imagery in Ritual," interview by Gayle Kimball, in Kimball, *Women's Culture* (Metuchen, N.J.: Scarecrow Press, 1981), pp. 91, 96.

7. Vincent Scully, *Pueblo: Mountain, Village, Dance* (New York: Viking, 1975), p. 61.

8. Judith Todd, "Opposing the Rape of Mother Earth," *Heresies*, issue 5 (1978), p. 90.

9. Michelle Stuart, *Return to the Silent Garden* (unpublished journal). See also her artist's book *The Fall* (New York: Printed Matter, 1977).

10. Jamake Highwater, *Dance: Rituals of Experience* (New York: A & W Publishers, 1978), p. 32.

11. Mircea Eliade, *The Myth of the Eternal Return* (New York: Pantheon, 1954), p. 34.

12. John Martin, quoted in Highwater, *Dance*, p. 37.

13. Salustius, quoted on title page of Highwater, *Dance*.

14. John Sharkey, *Celtic Mysteries* (London: Thames & Hudson, 1975), p. 92.

15. Francis Huxley, *The Way of the Sacred* (Garden City, N.Y.: Doubleday, 1974), p. 156.

16. *Ibid.*, p. 106.

17. The topographical "Glastonbury Zodiac" or "Temple of the Stars" (thought by some to be strictly hypothetical) was "rediscovered" by Katherine Maltwood in 1929. Since then a few other such zodiacs have been researched. See Janet and Colin Bord, *Mysterious Britain* (London: Paladin, 1974), pp. 218–225, for maps and details, and John Michell, *City of Revelation* (New York: Ballantine Books, 1972), pp. 39–49, for application of gematria to the site.

18. Bruce Lacey and Jill Bruce, "Bruce Lacey and Jill Bruce Interviewed by Andrea Hill and James Faure Walker," *Artscribe* (December 1978), pp. 22, 24.

19. Peter Kiddle, unpublished statement, 1981.

20. Christine Oatman, all quotations from *The San Diego Union*, January 26, 1978.

21. Much of this information comes from Sir James Frazer's *The Golden Bough,* as well as from Francis Huxley and Otto Rank.

22. Huxley, *Way of the Sacred,* pp. 160, 190.

23. *Ibid.*, p. 115.

24. *Ibid.*, p. 114.

25. Carl A. P. Ruck, in R. Gordon Wasson, Carl A. P. Ruck, and Albert Hollmann, *The Road to Eleusis* (New York: Harcourt Brace Jovanovich, 1978), p. 75.

26. R. J. C. Atkinson, quoted in Michael Dames, *The Avebury Cycle* (London: Thames & Hudson, 1977), p. 11.

27. Aubrey Burl, *Prehistoric Avebury* (New Haven: Yale University Press, 1979), p. 240.

28. *Ibid.,* p. 176.

29. Mircea Eliade, *Patterns of Comparative Religion* (New York: Sheed & Ward, 1958), pp. 32–33.

30. Giorgio de Santillana and Hertha von Dechend, *Hamlet's Mill* (Boston: David R. Godine, 1977).

31. Jacquetta and Christopher Hawkes, *Prehistoric Britain* (Harmondsworth: Penguin Books, 1943), p. 55.

32. Burl, *Prehistoric Avebury,* p. 203.

33. *Ibid.,* pp. 36, 198, 177, 123.

34. Dames, *Avebury Cycle,* p. 11.

35. *Ibid.,* p. 9.

36. *Ibid.,* p. 93.

37. Dames, *The Silbury Treasure* (London: Thames & Hudson, 1976), p. 112.

38. Dames, *Avebury Cycle,* p. 191.

39. Judith Todd, "Hill Reclamation Ritual" (unpublished manuscript, 1978).

40. Donna Henes, from Xeroxed notes on her "Spider Woman Series," 1976–77; published in *High Performance* (March 1979), p. 61.

41. Henes' project journal from *Dressing Our Wounds* is a wonderful conglomeration of ancient and modern references to functioning art; it has been published by Astro Artz, Los Angeles (1982), with photos by Sarah Jenkins.

42. Adrienne Rich, *Of Woman Born* (New York: W. W. Norton, 1976).

43. John G. Neihardt, *Black Elk Speaks* (New York: Washington Square Press, 1972), p. 164.

44. Jack Burnham, *Great Western Salt Works* (New York: George Braziller, 1974), p. 161.

45. Highwater, *Dance,* pp. 20, 37.

46. Miriam Sharon, unpublished notes, late 1970s.

Homes and Graves and Gardens

1. Frederick Kiesler, *Inside the Endless House: Art, People and Architecture* (New York: Simon & Schuster, 1964), p. 566.

2. All quotations from *Jody Pinto: Excavations and Constructions: Notes for the Body/Land* (Philadelphia: Marian Locks Gallery, 1979), pp. 14, 22.

3. C. G. Jung, *Memories, Dreams, Reflections* (London: Collins, 1969), pp. 182–83. See also a marvelous article by Clare Cooper: "The House as Symbol of the Self," in John Lang, Charles Burnette, Walter Moleski, and David Zachon, eds., *Designing for Human Behavior* (Stroudsburg, Pa.: Dowden, Hutchinson & Ross, 1974), pp. 130–46.

4. Mary Douglas, *Natural Symbols* (New York: Pantheon, 1970), pp. 10–11.

5. Colette, in *The Arts in Ireland,* vol. 3, no. 2 (1975), p. 60.

6. Poppy Johnson, "From the Pink and Yellow Notebooks," *Heresies,* issue 2 (1977), p. 94.

7. Joseph Rykwert, *On Adam's House in Paradise* (New York: Museum of Modern Art, 1972), pp. 191–92.

8. Susan Saegert and Roger Hart, quoted in Susana Torre, ed., *Women in American Architecture* (New York: Watson Guptill, 1977), p. 146.

9. Terry Straus, "The Tipi: A Cultural Interpretation of Its Design," *Field Museum Bulletin* (April 1981), pp. 14–20.

10. Dennis Oppenheim, "Dennis Oppenheim Interviewed by Willoughby Sharp," *Studio International* (November 1971), p. 192.

11. The description of Whiten's piece is taken from Eileen Thalenberg's first-hand account of it in *artscanada* (October–November 1977), p. 19.

12. Cited in Marija Gimbutas, *The Gods and Goddesses of Old Europe* (Berkeley: University of California Press, 1974), p. 37.

13. Quotation from Michele Oka Doner, interviewed by Mary Jane Jacob, in *Michele Oka Doner: Works in Progress IV* (Detroit: Institute of Arts, 1978), pp. 7–9 and "I am in my element," *Monthly Detroit,* December 1980, pp. 103–106.

14. A Maori craftsman, quoted in press release for Brian Blake,

James McNeigh, and David Simmons, *The Art of the Pacific* (New York: Abrams, 1980).

15. Arthur G. Miller, "The Temple Pyramids of Mesoamerica," in *Pyramid Influence in Art* (Dayton, Ohio: Wright State University, 1979), p. 21.

16. Ann Daniel-Hartung, quoted in *The New York Times,* June 19, 1979.

17. Aubrey Burl, *Prehistoric Avebury* (New Haven: Yale University Press, 1979), p. 168.

18. Dames, *The Silbury Treasure* (London: Thames & Hudson, 1976), p. 42.

19. Burl, *Prehistoric Avebury,* p. 130.

20. Burl suggests that the builders of Silbury were not farmers, because they would have been busy with the harvest at this time of year. But ritual necessities might well have demanded that the first layer be made precisely then (perhaps by the women, though they might also have been the farmers), and continued after the harvest.

21. See Thomas J. Riley and Glen Freimuth, "Prehistoric Agriculture in the Upper Midwest," *Field Museum Bulletin* (June 1977), pp. 4–8.

22. Jean M. Auel, "Foreword," in *Clan of the Cave Bear* (New York: Bantam, 1980), p. xii.

23. He also shows how it works, though less spectacularly, in less auspicious years, and notes that Thom has found "conclusive proof that the solar Lammas quarter day was marked in Neolithic Britain by monumental megaliths."

24. For the roots of the words *gog* and *goggle* in relation to the *sheela-na-gig* and the Hill Figures, see T. C. Lethbridge, *Gogmagog: The Buried Gods* (London: Routledge & Kegan Paul, 1957).

25. Brian Branston, *The Lost Gods of England* (New York: Oxford University Press, 1974), p. 155. Mary Beth Edelson's *Toothless* also refers to the *sheela* and the "vagina dentata" image; it is a large black sculpture, like an oval cleft in a rock; the viewer is invited to sit in it and calm her (his) fears. Frank Waters in his *Book of the Hopi* reproduces a possibly similar figure, seven inches high, called *The Vernon Image,* which was found in an adobe-sealed crypt in an Arizona *kiva.*

26. Rodney Legg, "Dorset and Cerne's God of the Celts, Part Six: The Cult of the Celtic Head," *Dorset County Magazine* (n.d.), p. 33.

27. Lethbridge, *Gogmagog.* He speculates that this was the Celtic horse goddess Epona, later made into a moon goddess, and he ties the image into that of Lady Godiva (another fertility figure) and the Black Diana. When excavating the figures, Lethbridge found pits filled with red earth at the goddess' left breast and the horse's eye; an oval pit at her crotch was filled with "dark material"—rootlets, charcoal, potsherds, and liquid.

28. Alice More Earle, *Customs and Fashions in Old New England* (Rutland, Vt.: Charles Tuttle, 1973), p. 228.

29. Burl, *Prehistoric Avebury,* p. 220.

30. *Ibid.,* pp. 137, 219–20.

31. Merson F. Greenman, *Serpent Mound* (Columbus: Ohio Historical Society, 1970), pp. 7–8; the major source of information on the mounds remains Ephraim G. Squier and Edwin H. Davis' classic *Ancient Monuments of the Mississippi Valley* (Washington, D.C.: Smithsonian Contribution to Knowledge, I, 1848).

32. Paul Leveson, *A Sense of the Earth* (New York: Anchor Natural History Books, Doubleday, 1972), pp. 40–41.

33. Dale McConathy, "Keeping Time: Some Notes on Reinhardt, Smithson and Simonds," *artscanada* (June 1975), p. 52.

34. Robert Smithson, *The Writings of Robert Smithson,* ed. Nancy Holt (New York: New York University Press, 1979), p. 111; see also Robert Hobbs on *Spiral Jetty,* in Robert Hobbs, ed., *Robert Smithson: Sculpture* (Ithaca: Cornell University Press, 1981), pp. 191–97.

35. Carl Sagan, *Dragons of Eden* (New York: Random House, 1977), pp. 137–50.

36. Francis Huxley, *The Way of the Sacred* (Garden City, N.Y.: Doubleday, 1974), p. 272.

37. Glenn Lewis, *Bewilderness: The Origins of Paradise* (Vancouver: Vancouver Art Gallery, 1979); and "Journey Through an Earthly Paradise," *Impressions,* no. 20 (November 1978).

38. Paul Shepard, *Man in the Landscape* (New York: Anchor Natural History Books, Doubleday, 1972), p. 98.

39. William Leiss, *The Domination of Nature* (New York: Beacon, 1974), pp. 30, 89, 184–85 (references for the rest of this paragraph as well).

40. Branston, *Lost Gods of England,* p. 158.

41. Shepard, *Man in the Landscape,* chapt. 3 ("The Image of the Garden").

42. Lewis, "Journey," p. 1.

43. Smithson, *Writings,* p. 91.

44. Leiss, *Domination of Nature,* pp. 156–58.

45. Shepard, *Man in the Landscape*, pp. 80–81.

46. Annette Kolodny, *The Lay of the Land* (Chapel Hill: University of North Carolina Press, 1975).

47. Jack Burnham, *Great Western Salt Works* (New York: George Braziller, 1974), p. 156.

48. Huxley, *Way of the Sacred*, p. 167.

49. This book by Kemp was published in the last half of the nineteenth century. The same tone predominates in Anthony Huxley's *An Illustrated History of Gardening* (New York: Paddington Press, 1978).

50. Charles Eliot Norton, quoted in Smithson, *Writings*, p. 126. Smithson's essay—"Frederick Law Olmsted and the Dialectical Landscape"—offers an imaginative modernist view of parks.

51. Walter Benjamin, quoted in Leiss, *Domination of Nature*, p. 198.

52. Ian L. McHarg, *Design with Nature* (New York: Doubleday/Natural History Press, 1971), pp. 117–125.

53. Carl Andre, in *Artforum* (September 1970), p. 35.

54. Hans Haacke, in *Earth* (Ithaca: Andrew Dickson White Museum, Cornell University, 1969).

55. Lawrence Alloway, "Time and Nature in Sonfist's Art," in *Alan Sonfist* (Boston: Museum of Fine Arts, 1977), p. 3.

56. Smithson, *Writings*, p. 123.

57. Robert Morris, quoted in *The Arts* (July 1979), p. 4.

58. Herbert Marcuse, quoted in Leiss, *Domination of Nature*, p. 22.

59. Alan Sonfist, "Natural Phenomena as Public Monuments," *Natura Integrale* (February–March 1981), p. 13.

60. Newton Harrison, in *10* (Houston: Contemporary Arts Museum, 1972), p. 14.

61. Bonnie Sherk, "The Farm" (flier from the San Francisco Art Institute, 1976).

62. Aldo van Eyck, in Charles Jencks and George Baird, *Meaning in Architecture* (New York: George Braziller, 1970), p. 212.

63. Charles Simonds, interview by Daniel Abadie, in *Charles Simonds* (Paris: SMI/Cahier 2, 1975), p. 9.

64. Charles Simonds, "Microcosm to Macrocosm/Fantasy World to Real World," *Artforum* (February 1974), p. 36.

65. Émile Durkheim, *The Elementary Forms of the Religious Life* (New York: The Free Press, 1965), pp. 255, 239.

66. Smithson, *Writings*, p. 133.

67. Aubrey Burl, *The Stone Circles of the British Isles* (New Haven: Yale University Press, 1976), p. 95.

Further Reading

Andre, Carl, and others. *Carl Andre*. The Hague: Gemeentemuseum, 1969.

Arte Prehispanico de Venezuela. Caracas: Fundación Eugenio Mendoza, 1971.

Atkinson, R. J. C. *Stonehenge and Avebury*. London: H. M. Stationery Office, 1959.

Aveni, A. F., ed. *Archeoastronomy*. New Haven: Yale University Press, 1975.

Beardsley, John. *Probing the Earth: Contemporary Land Projects*. Washington, D.C.: Smithsonian Institution Press, 1977.

Berndt, Ronald, and Phillips, E. S., eds. *The Australian Aboriginal Heritage*. Sydney: Australian Society for Education through the Arts and Ure Smith, 1973.

Bord, Janet, and Bord, Colin. *A Guide to Ancient Sites in Britain*. London: Paladin, 1979.

———— and ————. *Mysterious Britain*. London: Paladin, 1974.

———— and ————. *The Secret Country*. London: Paladin, 1978.

Branston, Brian. *The Lost Gods of England*. New York: Oxford University Press, 1974.

Brown, Peter Lancaster. *Megaliths and Men*. Poole: Blandford Press, 1976.

Burl, Aubrey. *Prehistoric Avebury*. New Haven: Yale University Press, 1979.

————. *Rites of the Gods*. London: J. M. Dent & Sons, 1981.

————. *The Stone Circles of the British Isles*. New Haven: Yale University Press, 1976.

Burnham, Jack. *Great Western Salt Works*. New York: George Braziller, 1974.

Campbell, Joseph. *The Masks of God: Creative Mythology*. New York: Penguin, 1970.

Cassirer, Ernst. *Philosophy of Symbolic Forms*. New Haven: Yale University Press, 1953–57.

Cirlot, J. E. *A Dictionary of Symbols*. New York: Philosophical Library, 1962.

Coxhead, David, and Hiller, Susan. *Dreams*. London: Thames & Hudson, n.d.

Critchlow, Keith. *Time Stands Still*. London: Gordon Fraser, 1979.

Czaja, Michael. *Gods of Myth and Stone: Phallicism in Japanese Folk Religion*. New York: Weatherhill, 1974.

Dames, Michael. *The Avebury Cycle*. London: Thames & Hudson, 1977.

————. *The Silbury Treasure*. London: Thames & Hudson, 1976.

Daniel, Glyn. *Megaliths in History*. London: Thames & Hudson, 1972.

Demarco, Richard. *The Artist as Explorer*. Edinburgh: Demarco Gallery, 1978.

De Santillana, Giorgio, and von Dechend, Hertha. *Hamlet's Mill: An Essay on Myth and the Frame of Time*. Boston: David R. Godine, 1977.

"Discussions with Heizer, Oppenheim, Smithson." *Avalanche*, no. 1 (Fall 1970), pp. 48–70.

Doczi, Gyorgy. *The Power of Limits: Proportional Harmonies in Nature, Art and Architecture*. Boulder & London: Shambhala, 1981.

Durkheim, Émile. *The Elementary Forms of the Religious Life*. New York: The Free Press, 1965.

Dyer, James. *Southern England: An Archeological Guide, the Prehistoric and Roman Remains*. London: Faber & Faber, 1973.

Edelson, Mary Beth. *Seven Cycles: Public Rituals*. New York: Edelson, 1980.

Eliade, Mircea. *The Forge and the Crucible*. New York: Harper & Bros., 1962.

———. *Gods, Goddesses and Myths of Creation*. New York: Harper & Row, 1974.

———. *Shamanism: Archaic Techniques of Ecstasy*. Princeton: Princeton University Press, Bollingen Series, 1964.

Fell, Barry. *America B.C.* New York: Pocket Books, 1976.

Ferguson, George. *Signs and Symbols in Christian Art*. New York: Oxford University Press, 1961.

Fowler, P. J., ed. *Recent Work in Rural Archeology*. Bradford-on-Avon: Moonraker Press, 1975.

Frazer, Sir James George. *The New Golden Bough*. New York: Criterion Books, 1959.

Frazier, Kendrick. "The Anasazi Sun Dagger." *Science 80* (November–December 1979), pp. 57–67.

Gimbutas, Marija. *The Gods and Goddesses of Old Europe*. Berkeley: University of California Press, 1974.

———. "The Temples of Old Europe." *Archeology* (November–December 1980), pp. 41–50.

Giot, P.-R. M. *Menhirs et Dolmens*. Chateaulin: Jos le Doaré, 1976.

Glob, P. V. *The Bog People: Iron-Age Man Preserved*. London: Faber & Faber, 1977.

Grant, Campbell. *Canyon de Chelly*. Tucson: University of Arizona Press, 1978.

Graves, Robert. *The White Goddess*. New York: Farrar, Straus & Giroux, 1948.

Hadingham, Evan. *Ancient Carvings in Britain*. London: Garnstone Press, 1974.

———. *Circles and Standing Stones*. New York: Anchor Press/Doubleday, 1976.

Harding, Esther. *Woman's Mysteries: Ancient and Modern*. New York: Harper Colophon Books, 1976.

Hawkes, Jacquetta. *A Guide to the Prehistoric and Roman Monuments in England and Wales*. London: Cardinal/Sphere Books, 1973.

——— and Hawkes, Christopher. *Prehistoric Britain*. Harmondsworth: Penguin Books, 1943.

Hawkins, Gerald S., and White, John B. *Stonehenge Decoded*. New York: Dell, 1965.

Hemming, John, and Ranney, Edward. *Monuments of the Incas*. New York: New York Graphic Society/Little, Brown & Co., 1982.

Herity, Michael. *Irish Passage Graves*. New York: Barnes & Noble Books, 1975.

Highwater, Jamake. *Dance: Rituals of Experience*. New York: A & W Publishers, 1978.

Hitching, Francis. *Earth Magic*. London: Picador, 1976.

Huxley, Francis. *The Way of the Sacred*. Garden City, N.Y.: Doubleday, 1974.

Jaynes, Julian. *The Origin of Consciousness in the Breakdown of the Bicameral Mind*. Boston: Houghton Mifflin, 1976.

Jessup, Ronald. *Southeast England*. London: Thames & Hudson, 1970.

Jordan, Bart, and Sherman, Steve. "Roots: One Man's Search for the Origins of Ancient Symbols." *New Hampshire Times* (January 12, 1977), pp. 16–19.

——— and ———. "Roots: Unlocking the Secrets of the White Goddess and the Cretan Maze." *New Hampshire Times* (January 19, 1977), pp. 13–15.

——— and ———. "The Secrets of Stonehenge." *New Hampshire Times* (July 6, 1977), pp. 20–21.

Kern, Hermann. "Labyrinths: Tradition and Contemporary Works." *Artforum* (May 1981), pp. 60–68.

Knott, Robert. "The Myth of the Androgyne." *Artforum* (November 1975), pp. 38–45.

Kosok, Paul. *Life, Land and Water in Ancient Peru.* Brooklyn: Long Island University Press, 1965.

Kramer, Samuel Noah. *History Begins at Sumer.* Garden City, N.Y.: Doubleday, 1959.

Kuhn, Herbert. *The Rock Pictures of Europe.* New York: October House, 1967.

Leiss, William. *The Domination of Nature.* New York: Beacon Paperback, 1974.

Leroi-Gourhan, André. *Treasures of Prehistoric Art.* New York: Harry N. Abrams, 1967.

Lethaby, W. R. *Architecture, Mysticism and Myth.* New York: George Braziller, 1975.

Leveson, Paul. *A Sense of the Earth.* New York: Anchor Natural History Books, Doubleday, 1972.

Lévi-Strauss, Claude. *The Raw and the Cooked: Introduction to a Science of Mythology.* New York: Harper Torchbooks, 1969.

Lewis, Glenn. *Bewilderness: The Origins of Paradise.* Vancouver: Vancouver Art Gallery, 1979.

Lippard, Lucy R. *Six Years: The Dematerialization of the Art Object. . . .* New York: Praeger, 1973.

Long, Richard. *Richard Long.* Eindhoven: van Abbemuseum, 1979.

McConathy, Dale. "Keeping Time: Some Notes on Reinhardt, Smithson and Simonds." *Artscanada,* no. 198/199 (June 1975), pp. 52–57.

McHarg, Ian L. *Design with Nature.* New York: Doubleday/ Natural History Press, 1971.

McMann, Jean. *Riddles of the Stone Age.* London: Thames & Hudson, 1980.

Marshack, Alexander. *The Roots of Civilization.* New York: McGraw-Hill, 1971.

Matthews, W. H. *Mazes and Labyrinths.* New York: Dover, 1970.

Mellaart, James. *The Neolithic of the Near East.* New York: Charles Scribner's Sons, 1975.

Michell, John. *City of Revelation.* New York: Ballantine Books, 1972.

———. *The Earth Spirit.* London: Thames & Hudson, 1975.

———. *A Little History of Astro-Archeology.* London: Thames & Hudson, 1977.

———. *The Old Stones of Land's End.* London: Garnstone, 1974.

Morris, Robert. "Aligned with Nazca." *Artforum* (October 1975), pp. 26–39.

———. "The Present Tense of Space." *Art in America* (January–February 1978), pp. 70–80.

Morrison, Tony, and Hawkins, Gerald S. *Pathways to the Gods: The Mystery of the Andes Lines.* New York: Harper & Row, 1978.

Muir, Richard. *Riddles in the British Landscape.* London: Thames & Hudson, 1981.

Neff, John; Beardsley, John; and Abadie, Daniel. *Charles Simonds.* Chicago: Museum of Contemporary Art, 1981.

Neudorfer, Giovanna. *Vermont Stone Chambers: An Inquiry into Their Past.* Montpelier: Vermont Historical Society, 1980.

Norman, Dorothy. *The Hero: Myth/Image Symbol.* New York: World, 1969.

O'Kelly, Claire. *Illustrated Guide to Newgrange.* Blackrock: Wexford, 1978.

Oppenheim, Dennis, and others. *Dennis Oppenheim.* Montreal: Musée d'art contemporain, 1978.

Packard, Gar, and Packard, Maggy. *Suns and Serpents.* Santa Fe: Packard Publications, 1974.

Piggott, Stuart. *The Druids.* Harmondsworth: Penguin Books, 1974.

Pinto, Jody. *Excavations and Constructions: Notes for the Body/Land.* Philadelphia: Marian Locks Gallery, 1979.

Purce, Jill. *The Mystic Spiral.* New York: Avon, 1974.

Rank, Otto. *Art and Artist.* New York: Agathon Press, 1968.

Reiche, Maria. *Geheimnis der Wuste—Mystery on the Desert.* Stuttgart: Offizindruck AG, 1968.

Renfrew, Colin. *Before Civilization.* Harmondsworth: Penguin Books, 1976.

Research into Lost Knowledge Organization (RILKO). *Earth Mysteries*. London: RILKO, 1977.

Ridley, Michael. *The Megalithic Art of the Maltese Islands*. Poole: Blandford Press, 1971.

Rohrlich, Ruby, and Nash, June. "Patriarchal Puzzle: State Formation in Mesopotamia and Mesoamerica." *Heresies*, no. 13 (1981), pp. 60–65.

Ross, Anne. *Pagan Celtic Britain*. London: Routledge & Kegan Paul, 1967.

Ross, Charles. *Charles Ross: The Substance of Light: Sunlight Dispersion, the Solar Burns, Point Source/Star Space*. La Jolla: La Jolla Museum, 1976.

Rothenberg, Jerome, ed. *Technicians of the Sacred*. New York: Doubleday, 1968.

Rykwert, Joseph. *On Adam's House in Paradise*. New York: Museum of Modern Art, 1972.

Schaafsma, Polly. *Indian Rock Art of the Southwest*. Albuquerque: University of New Mexico Press, School of American Research, 1980.

Schneemann, Carolee. *More Than Meat Joy*. Edited by Bruce McPherson. New Paltz: Documentext, 1979.

Scully, Vincent. *The Earth, the Temple and the Gods*. New York: Frederick A. Praeger, 1969.

———. *Pueblo: Mountain, Village, Dance*. New York: Viking Press, 1975.

Service, Alastair, and Bradbery, Jean. *Megaliths and Their Mysteries: A Guide to the Standing Stones of Europe*. New York: Macmillan, 1979.

Sharkey, John. *Celtic Mysteries*. London: Thames & Hudson, 1975.

Shepard, Paul. *Man in the Landscape*. New York: Ballantine Books, 1972.

Simonds, Charles. "Microcosm to Macrocosm/Fantasy World to Real World." *Artforum* (February 1974), pp. 36–39.

———. *Three Peoples*. Genoa: Samanedizioni, 1976.

Sjoo, Monica, and Mor, Barbara. *The Great Cosmic Mother of All*. Huntington Beach, Cal.: Rainbow Press, 1981.

Smithson, Robert. *The Writings of Robert Smithson*. Edited by Nancy Holt. New York: New York University Press, 1979.

Sofaer, Anna; Zinser, Volker; and Sinclair, Rolf M. "A Unique Solar Marking Construct." *Science* (October 19, 1979), pp. 283–91.

Spence, Magnus. *Standing Stones and Maeshowe of Stenness*. Crawley: RILKO Trust, 1974.

Squier, Ephraim G., and Davis, Edwin H. *Ancient Monuments of the Mississippi Valley*. Washington, D.C.: Smithsonian Contributions to Knowledge, I, 1848.

Stone, Merlin. *When God Was a Woman*. New York: Harcourt Brace Jovanovich, 1976.

Stones, Bones and Skin: Ritual and Shamanic Art (special issue). *Artscanada* (December 1973/January 1974).

Stuart, Michelle. *From the Silent Garden*. Williamstown: Williams College, 1979.

Thom, Alexander. *Megalithic Lunar Laboratories*. Oxford: Clarendon Press, 1971.

———. *Megalithic Sites in Britain*. Oxford: Clarendon, 1967.

———. and Thom, Archibald. *Megalithic Remains in Britain and Brittany*. Oxford: Clarendon, 1978.

Trento, Salvatore Michael. *The Search for Lost America*. Harmondsworth: Penguin Books, 1978.

Tuan, Yi-Fu. *Space and Place*. Minneapolis: University of Minnesota Press, 1977.

———. *Topophilia*. Englewood Cliffs, N.J.: Prentice-Hall, 1974.

Ucko, Peter J., ed. *Form in Indigenous Art*. London: Duckworth, 1977.

Underwood, Guy. *The Pattern of the Past*. London: Sphere Books, 1972.

Vazan, Bill. *Bill Vazan*. Montreal: Musée d'art contemporain, 1980.

Von Franz, Marie-Louise. *Time*. London: Thames & Hudson, 1978.

Wasson, R. Gordon; Ruck, Carl A. P.; and Hollmann, Albert. *The Road to Eleusis*. New York: Harcourt Brace Jovanovich, 1978.

Waters, Frank. *Book of the Hopi*. New York: Ballantine Books, 1969.

———. *Masked Gods*. New York: Ballantine Books, 1970.

Watkins, Alfred. *The Old Straight Track*. London: Sphere Books, 1974.

Weatherhill, Craig. *Belerion: Ancient Sites of Land's End*. Penzance: Alison Hodge, 1981.

Wood, John Edwin. *Sun, Moon and Standing Stones*. New York: Oxford University Press, 1980.

Worth, R. Hansford. *Worth's Dartmoor*. Edited by G. M. Spooner and F. S. Russell. Newton Abbot: David & Charles, 1967.

Wunderlich, Hans Georg. *The Secret of Crete*. Glasgow: Fontana/Collins, 1976.

Index

Note: Italicized page numbers refer to illustrations. References to footnotes follow the roman numeral chapter designation, *e.g.,* VI/n. 25.

*Beth Ames Swartz. Solomon's Pillars—
The Queen of Sheba. 1980. The red
sandstone formation known as
Solomon's Pillars was chosen to honor
the Queen of Sheba because it was at
Solomon's court that she challenged
him with three complex riddles. The
"paper, fire, earth, sunlight" piece that
resulted from this outdoor ritual/
process was part of a series of homages
to women in ancient Israel, based on
the Kabbalah.*

About the Author

Lucy R. Lippard is a writer and activist, author of thirteen books including *Ad Reinhardt, Eva Hesse, Changing: Essays in Art Criticism, Six Years: The Dematerialization of the Art Object, From the Center: Feminist Essays on Women's Art, Get the Message? A Decade of Art for Social Change,* and a novel, *I See/You Mean.* Born in New York City, she received her B.A. from Smith College, her M.A. from the Institute of Fine Arts, New York University, and an honorary doctorate of fine arts from Moore College of Art in Philadelphia. She has also received a Guggenheim fellowship, two National Endowment for the Arts grants for criticism, and the College Art Association's Mather Award. She is a contributing editor to the magazine *Art in America,* and writes a monthly column for the *Village Voice.* Co-founder of *Heresies,* Printed Matter, and P.A.D.D. (Political Art Documentation/Distribution), she has curated and organized over thirty exhibits in the United States, Canada, Europe, and Latin America.

Lucy Lippard lives in New York City.

A Note on the Type

The text of this book was set by the Clarinda Company, Clarinda, Iowa, on the V.I.P. in Primer, designed originally by Rudolf Ruzicka in the 20th century. Ruzicka is also known for the elegant Fairfield typeface. On the computer the face is more condensed than Ruzicka's original design but does not sacrifice legibility, and this, as the name implies, makes it especially accessible to readers of all ages.

The display face is Bembo italic, designed in Bologna in the 16th century by Francesco Griffo and named after Pietro Bembo, the celebrated Renaissance writer who became a cardinal and served as secretary to Pope Leo X.

Black and white printing by the Murray Printing Co., Westford, Mass.
Color printing by Coral Graphic Services, Long Island City, N.Y.
Production by Kathy Grasso and Rebecca Woodruff.
Design by Sara Eisenman.